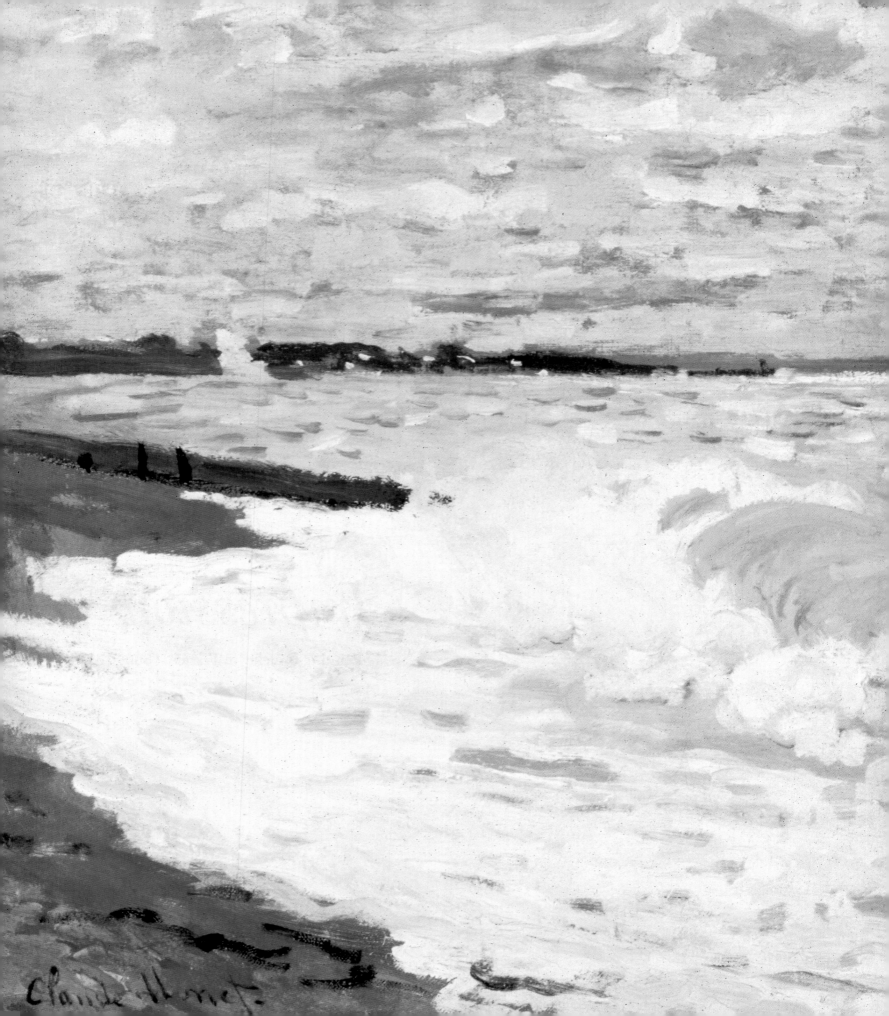

Claude Monet

Impression

Painting Quickly in France, 1860–1890

Richard R. Brettell

YALE UNIVERSITY PRESS, NEW HAVEN AND LONDON
in association with the
STERLING AND FRANCINE CLARK ART INSTITUTE
WILLIAMSTOWN, MASSACHUSETTS

Published on the occasion of the exhibition
Impression: Painting Quickly in France, 1860–1890

The National Gallery, London
November 1, 2000 – January 28, 2001

Van Gogh Museum, Amsterdam
March 2 – May 20, 2001

Sterling and Francine Clark Art Institute,
Williamstown, Massachusetts
June 16 – September 9, 2001

Published by Yale University Press in association with
the Sterling and Francine Clark Art Institute
© 2000 Sterling and Francine Clark Art Institute

Edited by Jane Havell
Designed by Gillian Greenwood

Typeset in Baskerville by Helen Robertson
Printed in Italy by Amilcare Pizzi S.p.A., Milan

ISBN 0 300 08446 3 (cloth)
ISBN 0 300 08447 1 (paper)

Library of Congress Card Number 00-108611
Catalogue records for this book are available from
The Library of Congress and The British Library

PAGES 2–3: Claude Monet, *The Sea at Le Havre* (detail of fig. 65)

PAGE 8: Edouard Manet, *The Races at Longchamps* (detail of fig. 37)

Contents

Directors' foreword

Recent decades have witnessed an impressive number of international exhibitions and scholarly studies devoted to almost every aspect of Impressionist painting. They have thrown vital new light on our understanding of the artistic movement that, 125 years ago, transformed inherited traditions of western painting. Scenes of Paris street life, for example, of amiable suburban sociability, of the French countryside and sea coast, however straightforward they appear—and a sense of immediacy and directness is among their greatest charms—we now know were often the results of complicated decisions as the artists made their depictions into vivid and complex commentaries on contemporary society. Innovative research has also revealed the important role that changing material factors played in the creation of these images, including the availability of paint in tubes and of prepared canvases, and for the first time in history, thanks to rail, rapid access from city center to remote country. Most important, perhaps, has been the realization, augmented by scientific investigation of individual paintings, that many Impressionist painters did not always work as quickly as was once assumed. Rather, they often painted very deliberately and methodically, returning to their canvases over and again, adding layer upon layer of color to achieve, only slowly, the fleeting light effects that are today so admired in their paintings. Moreover, much of this work, we now know, was carried out in the studio rather than out-of-doors in front of the subject. Thanks to such expansive investigations, our appreciation of the Impressionist achievement has steadily deepened.

And yet, for many students of Impressionism, as well as for visitors to the always-crowded Impressionist rooms of museums and galleries in Europe and America, a chief attraction of these joyous works remains the sense of spontaneity they impart, the pure pleasure they suggest in the artists' act of looking and in the ability to capture a quick visual impression, seemingly without second thought or the aid of theory. In fact, many early critics of Impressionism, writing in the 1860s and 1870s, reacted to exactly these characteristics of these paintings, only their response was often ferociously hostile. Where we admire the unblinkered eye and a bravura painterly shorthand, they saw formlessness and the failure of technique. Indeed, for many of them the very term Impressionism carried the implication of a dangerous insubstantiality that lay outside the province of true art.

Impression: Painting Quickly in France, 1860–1890 returns attention to those aspects of Impressionist painting, spontaneity and improvisation, that so challenged many of its early viewers. It brings together paintings by the leading artists of the movement—Manet, Monet, Renoir, Morisot, and Sisley—that were made rapidly in one or only a few working sessions. Though these paintings were thought to resemble oil sketches, traditionally conceived as mere preparations for more elaborately executed works, they were in fact complete artistic statements, paintings that were signed, often dated, and, audaciously enough, sent for sale or exhibition as "finished" works of art. This is the first exhibition to group together this particular category of Impressionist painting and to study it in depth. It includes many of the most beautiful and evocative "impressions" painted in France over three decades of the late nineteenth century, and it returns attention to what was most vital, and to some most threatening, about Impressionism at its origins. It also explores the immediate antecedents of rapid painting and its evolution in artists as diverse as Degas and van Gogh. By re-examining these works in their technical as well as thematic dimensions, we hope to recapture an essential characteristic of Impressionist painting—the seductive charm of speed.

We wish to thank Richard R. Brettell, who conceived the exhibition, selected the works, and wrote the catalogue. His study will, we expect, constitute a fundamental new contribution to the appreciation of Impressionism. As always, the success of the exhibition has depended entirely on the generosity of many lenders, both private collectors and public institutions, from around the world; we are grateful for their enthusiastic support of the project.

Michael Conforti, STERLING AND FRANCINE CLARK ART
INSTITUTE, WILLIAMSTOWN, MASSACHUSETTS
Neil MacGregor, THE NATIONAL GALLERY, LONDON
John Leighton, VAN GOGH MUSEUM, AMSTERDAM

Edouard Manet, *Before the Mirror* (detail of fig. 48)

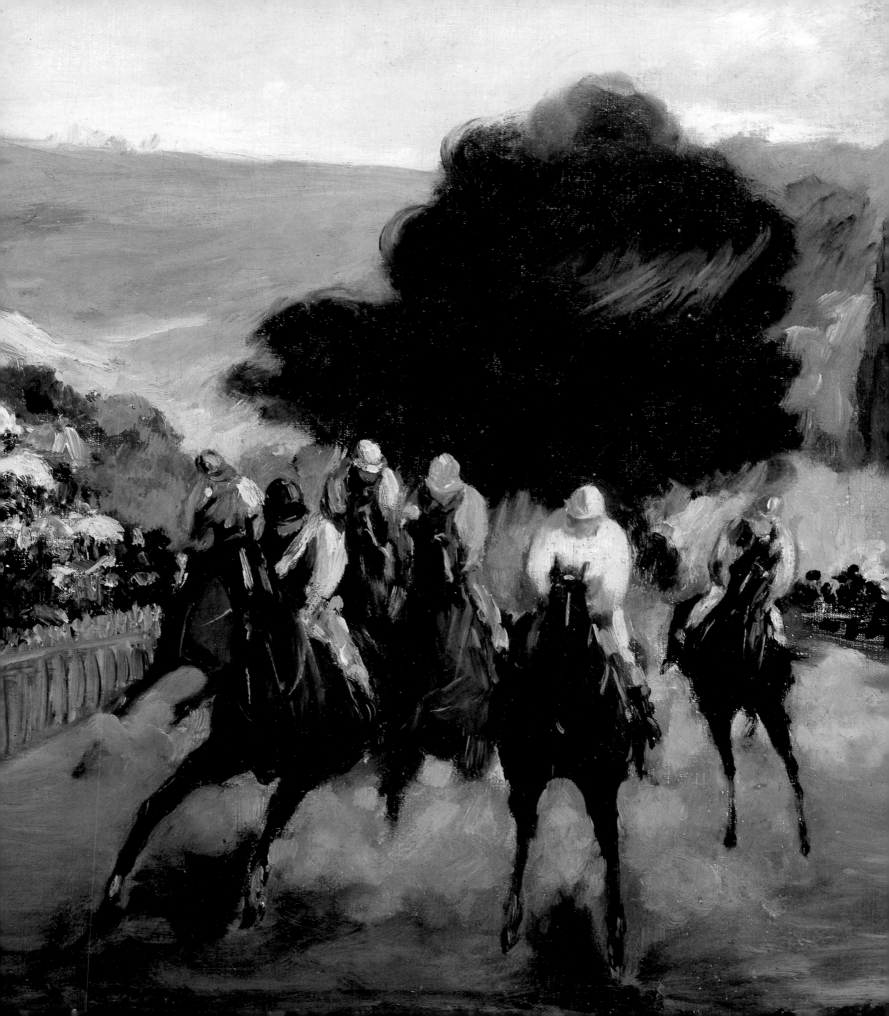

Lenders to the exhibition

AUSTRIA
Österreichische Galerie Belvedere, Vienna

BELGIUM
Musée d'Ixelles, Brussels

CANADA
The Montreal Museum of Fine Arts
National Gallery of Canada, Ottawa

DENMARK
Ny Carlsberg Glyptotek, Copenhagen
Ordrupgaard, Copenhagen

FRANCE
Conseil Général du Val d'Oise, Pontoise
Fondation Bemberg, Toulouse
Musée d'Orsay, Paris
Private collection, Paris, courtesy of Galerie
 Hopkins-Thomas-Custot

GERMANY
Fondation Corboud, permanent loan at the
 Wallraf-Richartz-Museum, Cologne
Staatsgalerie Stuttgart

IRELAND
National Gallery of Ireland, Dublin

THE NETHERLANDS
Gemeentemuseum, The Hague
Museum Mesdag, The Hague
Private collection
Van Gogh Museum, Amsterdam

NORWAY
Nasjonalgalleriet, Oslo

SPAIN
Carmen Thyssen-Bormenisza Collection

SWEDEN
Nationalmuseum, Stockholm

UNITED KINGDOM
Ashmolean Museum, Oxford
Cecil Higgins Art Gallery, Bedford
 Borough Council, Bedford

Courtauld Gallery, London
Fitzwilliam Museum, Cambridge
The National Gallery, London
National Museums and Galleries of Wales,
 Cardiff
Private collection, courtesy of Pyms Gallery,
 London
Tate Gallery, London
The Whitworth Art Gallery, University of
 Manchester

UNITED STATES
Albright-Knox Art Gallery, Buffalo
The Art Institute of Chicago
Carnegie Museum of Art, Pittsburgh
Columbus Museum of Art
Dixon Gallery and Gardens, Memphis,
 Tennessee
Fogg Art Museum, Harvard University Art
 Museums, Cambridge, Massachusetts
Charles B. Key, M.D., Dallas, Texas
Memorial Art Gallery, University of
 Rochester
The Metropolitan Museum of Art, New York
The Minneapolis Institute of Arts
Museum of Fine Arts, Boston
National Gallery of Art, Washington, D.C.
Philadelphia Museum of Art
Portland Art Museum, Portland, Oregon
Private collection, Connecticut
Private collection, Dallas, Texas
Saint Louis Art Museum
Shelburne Museum, Shelburne, Vermont
Solomon R. Guggenheim Museum,
 New York
Sterling and Francine Clark Art Institute,
 Williamstown, Massachusetts
The John M. and Sally B. Thornton Trust,
 San Diego
Toledo Museum of Art, Ohio
Virginia Museum of Fine Arts, Richmond
Yale University Art Gallery, New Haven,
 Connecticut

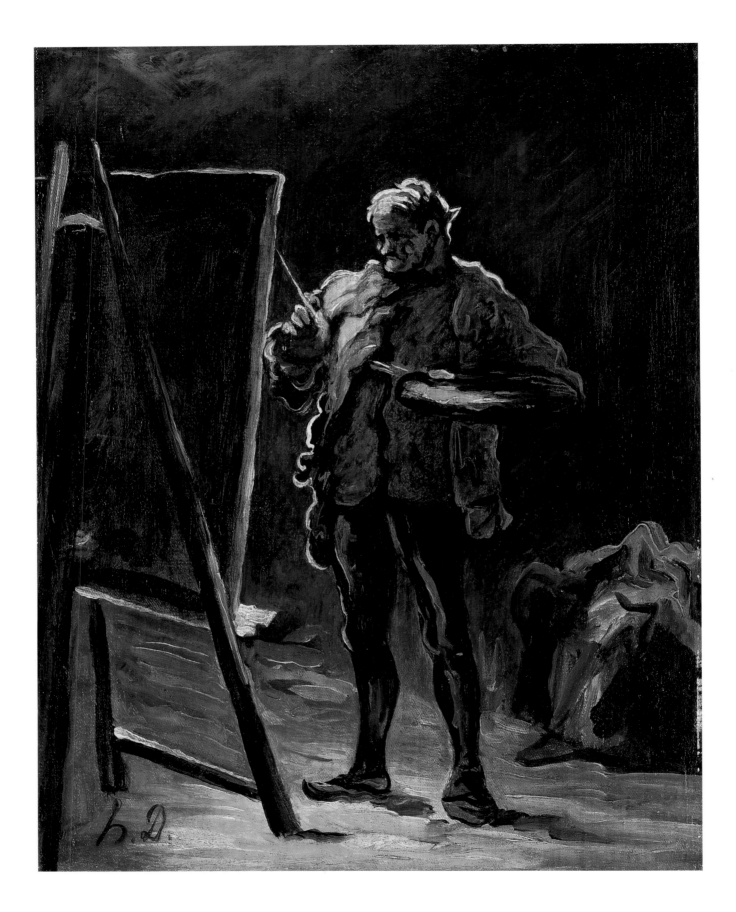

Preface and acknowledgments

"The veil long violated by
Caresses of the hand and eye."
Theodore Roethke, "Epidermal Macabre"

"The hand wrenches the sense of touch from its merely receptive passivity
and organizes it for experimental action. . . . Because the hand fashions a
new world and leaves its imprint everywhere upon it, it struggles with the
very substance it metamorphoses and with every form it transfigures.
Trainer of man, the hand multiplies him in time and space."
Henri Focillon, *The Life of Forms in Art*

Daumier's *An Artist* in the Sterling and Francine Clark Art Institute, Williams-town, Massachusetts (fig. 1) would not, at first glance, play a role in an exhibition about Impressions. It is, after all, so dark. Yet what it communicates with undeniable vivacity is that paintings are not so much thought as made. The subject of Daumier's painting may be middle-aged and overweight, and he may have come to his task in the middle of the night. But he is defined with a series of brilliant gestures of the brush—gestures that Daumier may have rehearsed over and over (we are not surprised to learn that there are other versions of the painting), but that are so alive and so immediate that we feel his actual presence. Careful inspection reveals that Daumier was using the blunt, or "wrong," end of the brush and that he formed the lines by moving the wooden tip through wet or tacky paint to expose the white ground beneath. The whole performance of those white lines must have taken no more than a couple of minutes. How more immediate, how much quicker, could Daumier have been?

Art history generally concerns itself with studies of the mind or the eye of the artist; as a rule, it has neglected the hand. We know that artists make things, but we have always been taught that their transformations of the world derive much more importantly from their reading, their experience, their visual memories, and their knowledge of other works of art than from what we might call their manual dexterity. Stories of many great artists—I think immediately of Constable and Cézanne—often stress their technical awkwardness and their success in attempting to overcome a lack of fluency. On the other hand, artists who are naturally fluent—Andrea del Sarto, van Dyck, Fragonard, Sargent—are often criticized for the apparent ease of their production, as if it does not contain what one could call the "intelligence" of gesture. This idea of the artist as both mental and visual has more to do with the skills and proclivities of writers about art, however, than it does with the artists themselves.

The aim of this exhibition and catalogue is to reopen the question of manual dexterity and to reconsider the physical intelligence of artists by directly confronting paintings that are, in themselves, direct. For this endeavor to work, viewers need to look beyond the ostensible subjects of the pictures—the trains, rowboats, boulevards, café scenes, and the like—which have fascinated art historians for two generations. Instead, all of us can become involved in an experiment in looking—an experiment that presumes that making is a form of expressed thought and needs no other evidence than itself to be interpreted. It is an endeavor related, in a sense, to the

1 Honoré Daumier
An Artist, c.1870–75
Oil on panel, 35.3 x 27 cm
Sterling and Francine Clark Art Institute,
Williamstown, Massachusetts

radically reductive methods of what literary historians called "The New Criticism" four decades ago—criticism rooted in a direct appraisal of the text itself, without relying much on biography and the veils of context that had made poetic texts, like paintings, so contingent and so academic.

Like all experiments, this one takes place in a laboratory, or rather three laboratories: the National Gallery, London; the Van Gogh Museum, Amsterdam; and the Clark Art Institute, Williamstown, Massachusetts. It is significant that each of these three institutions gives itself a different description (a gallery, a museum, and an institute); each, therefore, presumes different relationships between works of art and their various users. The staff and visitors in the three locations will have a different experience of the same exhibition. In London, visitors will be able to go immediately afterwards to the permanent collections of the National Gallery, where they can see powerful precedents for Impressions in the paintings of the late Titian, of Hals, Velázquez, Hogarth, Constable, and Turner. Visitors to Amsterdam can see the Impressions, then immerse themselves in the oeuvre of van Gogh, the most direct painter in the history of art, for whom the Impression was his most important influence. And, at Williamstown, in the Institute's renowned research library, people can study literature that constitutes a counter-discourse to the one proposed by the exhibition.

The honor and pleasure I have taken in working with the staff in these institutions cannot be exaggerated. Were it not for their power and commitment, this project could never have been launched. The people most important to the project—its toughest critics and staunchest advocates—have been Neil MacGregor, David Jaffé, Michael Wilson, Kathy Adler, and Chris Riopelle at the National Gallery; John Leighton and Andreas Blühm at the Van Gogh Museum; and Michael Conforti, Brian Allen, Richard Rand, Nicholas O'Donnell, Alexis Goodin, Curtis Scott, and Jordan Love at the Clark Art Institute. And, as anyone who knows museums will immediately recognize, it is the support staff who bring every decision into action: the wonderful voice on the telephone, the patient answers to queries, the reader of e-mails for technologically challenged curators, the maker of airplane and hotel reservations—all these are crucially important to an exhibition's success. It has been a pleasure as well to work with the talented and conscientious staff of Yale University Press, especially John Nicoll, who shepherded the catalogue from its inception. I would also like to thank Jane Havell for her patient and sensitive editing, and Gillian Greenwood for her imaginative and responsive design.

The permanent collection of each institution has been of vital importance. Although major loans have been secured and difficult-to-find works tracked down, the main reason for success will lie in the holdings of the member museums. The National Gallery in London has been most generous; the exhibition is a testament to the real strength of its recent acquisition of Impressionist painting and of the cooperative spirit in London that has enabled the Tate Gallery to loan its major French nineteenth-century works to the National Gallery. Thirty years ago, no one seriously interested in Impressionist or Post-Impressionist painting would have rated London's National Gallery in the top fifteen places to visit; now, anyone would. The Van Gogh Museum has also been enormously helpful, not only in the loan of its precious and much-requested paintings by van Gogh, but also of fascinating Barbizon paintings from the

superb collections of the Museum Mesdag, which it administers. The Clark Art Institute has been similarly generous with loans, and I am grateful that its founder, Sterling Clark, in the course of amassing his outstanding collection, often fell under the spell of gesture.

There is no adequate way for me to thank the Clark Art Institute for its perseverance and brilliance in the complex endeavor of organizing an international Impressionist exhibition. Not only did it serve as organizer of the exhibition, but it also sponsored my writing of this catalogue. The Institute itself, which combines a noted center for art historical research with a distinguished art museum, provided the ideal location for such an ambitious undertaking.

Our collective aim in this exhibition is to radicalize ideas about the Impressionist movement. We are presenting to contemporary viewers pictures that remain contingent, experimental, and risky more than a century after they were made. The most benignly attractive movement in western painting deserves to retrieve a little of the oomph that it had in the nineteenth century. Though the exhibition will permit viewers moments of intense pleasure, success for the organizers will lie in its pictorial chaos and messiness, brought about by our attempts to invigorate a kind of painting whose power has become sadly diminished through over-exposure. We have seen so many Impressionist paintings so many times that we have all but forgotten the risks that their makers took. While the bourgeois drawing room and the general art museum have ensured that Impressionism has become the first globally known art movement, they have also gradually robbed it of its sheer inventiveness and daring. Perhaps they can now help us to regain them.

Richard R. Brettell

1 Introduction

Impression: the word appears countless times in nineteenth-century literature, science, art criticism, letters, and diaries. The "first impressions" of places like Mount Etna, the Pantheon, the Alps, or St. Peter's Basilica were recorded in innumerable accounts sent home by travelers to their families and friends. In European literature, characters going on tours were usually given the opportunity by their creator-novelists to wax eloquent about their "impressions" of the sights they were privileged to witness.[1] What exactly was meant by this kind of "impression"? To begin with, almost all dictionary definitions of the word (and fortunately it is the same in English and French) involve the related word "pressure." The first of the eight definitions in *The Shorter Oxford English Dictionary* is: "the action involved in the pressure of one thing upon or into the surface of another; also, the effect of this." The other definitions deal with printing and other forms of "pressure," which result in an "impression."

One wonders, therefore, just what it meant in 1874 for Claude Monet to call one of his paintings *Impression, Sunrise* (fig. 2). The effect of this simple title on the subsequent history of art and its popular manifestations is so great that we stagger under its weight. The word "Impressionism" has virtually stamped out the word "impression" in our imagination, making it difficult for us to recover some of the excitement, risk, and daring involved in the meanings of the root word. It is the purpose of this study to reintroduce the "impression" to "Impressionism" and to allow readers (and viewers of the exhibition) access to the most radical aspect of the movement, an aspect that has been underplayed or overlooked in the art criticism and historiography of recent years.

Clearly, pressure must be involved in an impression. Conventionally, that pressure was direct—the action of an inked plate on a piece of blank paper literally created an impression on the paper. But the word was dematerialized rather early, as we learn from travel literature.[2] The fourth definition in the *Oxford English Dictionary*, dating the usage from 1390 through 1888, makes this clear: "The effective action of one thing upon another; influence; the effect of such an action; a change produced in some passive subject by the operation of an external cause." Here, in a definition of staggering vagueness, we confront the essential problem of the meaning of the "impression" for modern consciousness, a problem that I intend, in this book, to confront head on.

Art-lovers have known for the last hundred years that "impressions" were created by artists called Impressionists. Today, these works are held in very high regard: they fetch extraordinary prices at auction and enjoy massive popular attendance at blockbuster exhibitions. It is important to realize, however, that Impressionist paintings, and the manner of their creation, have not always been regarded in this favorable light.[3] A good deal of the current popularity of Impressionism is rooted in the fact that the painters were so persistently misunderstood when their aesthetic advances were new. John Rewald's pioneering historical narrative of the movement, first published in 1946, charts the personal struggles of each artist and exposes a good deal of the most intense invective against them.[4] Thus readers were taught to feel morally and aesthetically superior to the contemporaries of the Impressionists—a formula that has proved difficult to resist, despite the efforts of some post-war scholars. For much of the past century, these artists were thought to be simply transcribing their sensations directly onto canvas, without thought or planning. They were, to use the ultimately damning word employed by Arnold Hauser, "passive"—vessels through which sensations passed,

[1] The most accessible source of such material is John Julius Norwich, *A Taste for Travel: An Anthology*, London, 1985.

[2] See Malcolm Andrews, *The Search for the Picturesque: Landscape Aesthetics and Tourism in Britain, 1760–1800*, Stanford, 1989; Elizabeth Helsinger, *Ruskin and the Art of the Beholder*, Cambridge, 1982, and Bernard Smith, *European Vision and the South Pacific*, Yale University Press, New Haven and London, 1985.

[3] For the background to this negative criticism of the Impressionists, see chapter 2.

[4] John Rewald, *The History of Impressionism*, Museum of Modern Art, New York, 1946.

Claude Monet, *Impression, Sunrise* (detail of fig. 2)

without conscious intervention by the artist.[5] Canvases became a translation of those sensations, which were themselves fleeting or ephemeral rather than permanent and enduring records of actual form. The Marxist Hauser was at his most scathing when he decried this condition as arising from the socio-political conditions of capitalism, in which the root values of society were competition and the desire for individual economic success at the expense of others; the moral rootlessness of urban capitalist life resulted in a passive state of mind, which reached its representational apogee in the work of the Impressionists. We might feel somewhat uncomfortable today in recognizing that Impressionism has become the art form most admired by high society in developed capitalist countries.

Hauser was not alone in his condemnation of Impressionism. The attack on what were considered to be its fundamentally passive and ephemeral characteristics began immediately, and did not come only from conservative journalists who wanted art to project the existing values of the state and of religious institutions.[6] The enemies of the Impression were, and are, so varied that we cannot categorize them in any simple way.[7] Many of them will be discussed in the course of this text, but here I must stress both their virulence and their variety. Some of them were contemporaries of the artists, who viewed the enterprise of the Impression as morally and politically subversive, because the paintings looked sloppy and careless. Others were important artist-critics, both within and outside the French tradition—Paul Signac, Fernand Léger, and Henri Matisse come to mind. These writer-painters were troubled by what they considered to be the formlessness of Impressionism and its lack of a clearly articulated theoretical structure. Still others were historians and writers, such as Julius Meier-Graefe, Roger Fry, and Alfred Barr, who decried the anti-intellectual sensualism of the movement and, at their most sympathetic, saw it merely as a necessary "baby step" in the history of the creation of a truly lasting pictorial modernism. To help us understand this critical history, we need a clear-headed reappraisal of the Impression itself.

While planning for the exhibition *Impression: Painting Quickly in France, 1860–1890*, it became clear that in all the hundreds (or thousands) of exhibitions devoted to Impressionism in the past half-century, not one has attempted to gather works that might be called Impressions. Works have been gathered by artist, medium, site, subject, or time-period. These exhibitions have always included works that were painted rapidly as a direct translation of the artist's sensations, but curators have not really ever considered them in that specific light. It is the aim of this exhibition and book to fill that gap.

The word "Impression" in our title is singular by choice. We wanted to address the larger conditions of the Impression, rather than gather a group of Impressions, as if we knew exactly in what they consisted. The subtitle, *Painting Quickly in France, 1860–1890*, proved controversial even before the exhibition opened. Certain prospective lenders took offence at the implication that their works had been painted "quickly." Others thought the subtitle in some way trivialized the exhibition and the works within it. Yet it is the very rapidity of execution that lies at the root of the Impression, however it is defined. Jules Laforgue (1860–1887), the great French poet and art critic, claimed in 1883 that the time taken to record an Impression was, hypothetically, fifteen minutes.[8] Words like "rushed" and "hurried" vie with "unfinished" in the immense criticism about the movement in its early years.

[5] Arnold Hauser, *The Social History of Art*, trans. S. Goodman and A. Hauser, 2 vols., New York, 1951; 3rd edn., London, 1999. In undated paperback editions, which divide the text into four volumes, the essay on Impressionism appears in vol. IV, pp. 166–225.

[6] Ruth Berson et al., *The New Painting: Impressionism, 1874–1886, Documentation, Vol I. The Criticism*, The Fine Arts Museums of San Francisco, 1996, is the most complete record.

[7] The enemies of Impressionism merit serious study, of a rigor comparable to that of Christopher Green's monumental book, *Cubism and its Enemies*, Yale University Press, New Haven and London, 1987.

[8] Jules Laforgue's comments were written to accompany an exhibition at the Burlitt Gallery, Berlin; see Appendix, pp. 233–35.

In thinking about rapid painting, we confront a dilemma central to the idea of landscape painting. Nature—the subject of most painting—is not fixed, but constantly changing. As industrialism was brought more and more into nature during the nineteenth century, this remained as true when applied to man-based or urban "nature" as to the sort that exists without the apparent intervention of man. Flux came to be perceived as the central condition of modernity and, like it or not, painters needed to find form for it. Certain of them—chiefly the Impressionists—rushed enthusiastically to do battle with flux; they made images of modernity that, by virtue of their physical survival today, have in fact created *une impression durable* (a lasting impression).[9] In order to do that, however, they had to make works that looked as rapidly painted as their subjects were short-lived. Sunsets, trains rushing over bridges, sailboats turning, carriages coming down a boulevard, horses rushing toward a finish line, gusts of wind, flowers just cut from the plant, people chatting animatedly in a café, etc.—these were the subjects that the Impressionists chose to investigate.

But it is not merely the rapidity of the "represented time" in the painting that constitutes an Impression. Rather, it is the use of pictorial gestures to create an accord between represented time and "time of representation"—gestures that often have a directional character and a decisive momentariness. If the motif of the painter was in flux, then the painter too had to be in flux, moving rapidly to transcribe accurately the motif's fleeting character. This idea coincided with the widespread popularization of the *croquis*—a sketch, usually in pencil, executed by the artist who looked fixedly and exclusively at the motif as he made the work of art. He was expected to have such a secure command of the medium (pencil, pen and ink, paint and brush, etc.) and the support (notebook, paper, canvas, etc.) that he could transcribe the motif using marks that he did not need to verify by comparison during the period of transcription. The purpose of the *croquis* was the practice of rapid visual analysis and the building up of a repertoire of gestures and marks that would gradually become automatic to the transcriber.[10]

This brings us to a point that is crucial to an understanding of my intention in this study: all the paintings under discussion were not necessarily painted quickly. Rather, they were done in such a way as to *look* as if they were painted quickly. Even works that might have been executed in the course of a few hours required two or three discrete sessions, between which the work was allowed to dry.[11] What links the works chosen here is the suggestion of an aesthetic accord between represented time and time of representation—a symbiotic link between style and subject in which the rushed or rapid quality of the former reinforces the corresponding qualities of the latter.

The language of this symbiosis involves "gesture," the precise record of the artist's movement while working in his or her chosen medium—the way that the paint has been dragged, laid, or jabbed onto the canvas support. Recent art historians have lagged in the study of gesture, perhaps as a reaction against two previous generations of what were called "formalist" critics and historians, who concentrated on color and touch in their analyses of the modern picture.[12] There is also the simple fact that most art historians and critics inevitably work from photographs—representations of representations, in which the physical character of the original is considerably minimized.

[9] The phrase is from Jean Baptiste Deperthes, *Théorie du paysage*, 1818, describing the aim of the landscape painter; see chapter 2.

[10] See Gustave Fraipont, *L'Art de prendre le croquis et de l'utiliser*, Paris, 1886; English edn., London, 1911. Fraipont was among the most prolific writers of instructional art books and manuals for use by amateurs in the late nineteenth century; interestingly, his book on the *croquis* is the only such publication on the subject. Investigation is needed of the role of the *croquis* in artistic practice, especially in France, from Delacroix through Vuillard; further knowledge would help with the study of the graphic origins of Impressionist gestures.

[11] This has been made clear by physical analysis of the majority of the paintings discussed.

[12] The canonical example of this reductive formalism is the American critic Clement Greenberg, whose scattered essays have been gathered in *The Collected Essays and Criticism*, ed. John O'Brien, 4 vols., University of Chicago Press, 1986–94.

Painters and lovers of painting will find within the works presented here a startling variety of gestures. Each artist had a highly personal way of manifesting his or her character through gesture, and the works are arranged in groups by artist because most contemporary critics thought of the impression as the most personal kind of painting, one most indicative of individual character. Because the artist was working with such spontaneity, his or her intrinsic nature was thought to be revealed precisely because so much of the activity was not subject to second thoughts or control; this study will clearly demonstrate that the Impressions of several artists were, indeed, highly individual. Clearly, however, these artists were also working on a collective project, each of them supremely aware of the experiments of the others. For that reason, we decided to recognize the shared achievement of the Impression by including several artists who never exhibited with the group, but affected their production. We also elected to include one Post-Impressionist artist, Vincent van Gogh, whose oeuvre would be unthinkable without the Impression. Our aim was to gather works that appear to be rapid transcriptions of shifting subjects, and that were considered finished by their makers (either because they were signed in the artist's lifetime, or because we know that they were exhibited shortly after being made). There are some exceptions, however: Manet's *The Funeral* (fig. 38) and Pissarro's *Dulwich College, London* (fig. 150), for example, are included because they clearly deal with the artist's emotional response to the motif and to concepts of finish.

Perhaps the most common criticism of Impressionist works has been that they were not "finished." This is not by chance: one of the principal collective projects of avant-garde painters in the second half of the nineteenth century was an assault on conventions of finish, and the Impressionists were in the forefront of that battle. Another, somewhat more insidious, criticism is that the Impression represents a kind of painting that can be called facile and hence superficial—a notion based on a fear of anything that appears easy in art. A third fear is that the Impression is art without planning or forethought—and, therefore, art that questions by its very nature certain traditionally accepted values of education, memorization, and collective knowledge. In its attempt to privilege immediate experience as a value in itself, Impressionism has always been seen as anti-hierarchical and, consequently, subversive.

We must not forget that Impressionism raised these issues before the development of jazz and other forms of improvised and spontaneous music which, at the end of the nineteenth and the beginning of the twentieth centuries, changed popular culture forever. This study sets out to explore the link between the creative mind and modern consciousness, and attempts to find roots for the Impression in previous painting, science, contemporary philosophy, and public life. But even allowing for such precedents, it would be impossible to undercut the sheer vitality of the Impression as a development in art—one that can truly be called the most important of the nineteenth century. No other pictorial advance of the time had, and continues to have, such widespread implications for the future of art and for public taste. Before we smother it in our embraces, it is time for us to look again at "the appearance of spontaneity" and to reassess the real meaning of the Impression.

Camille Pissarro, *Dulwich College, London* (detail of fig. 150)

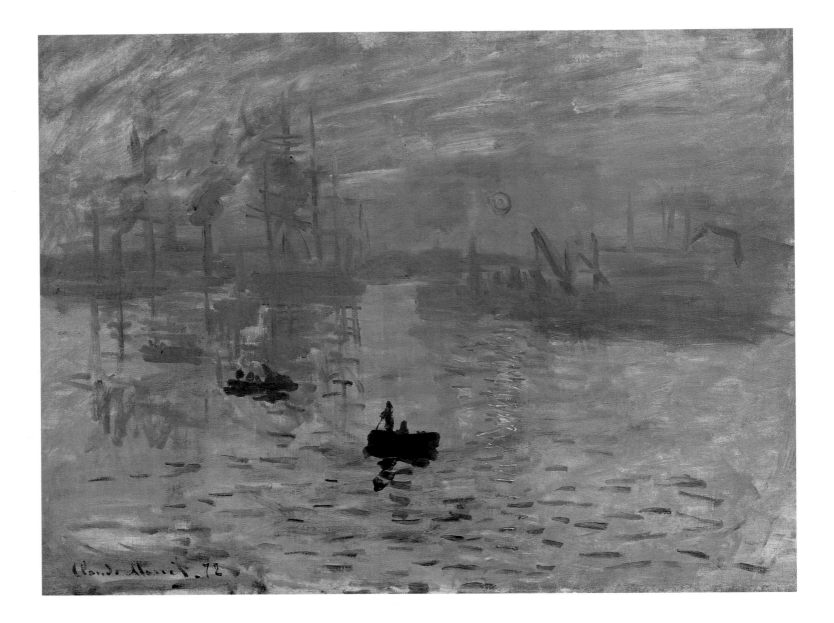

2 Claude Monet
Impression, Sunrise, 1872
Oil on canvas, 48 x 63 cm
Musée Marmottan-Claude Monet, Paris

2 The Impression in 1874

[1] For the most thorough and accessible discussion of the political and aesthetic conditions behind this exhibition, see Paul Tucker, "The First Impressionist Exhibition in Context," in Charles S. Moffett et al., *The New Painting: Impressionism 1874–1886*, The Fine Arts Museums of San Francisco, 1986, pp. 93–117. Ruth Berson et al. have gathered the criticism identified by many scholars in a companion volume, *The New Painting: Impressionism*, 1874–1886, op. cit.

[2] Philippe Burty, "The Paris Exhibitions: *Les Impressionnistes*," *The Academy*, London, May 30, 1874, p. 616; reprinted in Berson et al., op. cit., pp. 9–11.

[3] Bracquemond's contributions to the first Impressionist exhibition have been listed and reproduced, but rarely discussed, in the vast literature, perhaps largely because their style is so premeditated. Yet, in many ways, Bracquemond's prints can be interpreted as a key to the critical and historical context intended by certain of the artists themselves. With representations of the critics Gautier and Baudelaire, the positivist philosopher Comte, and the arts patron and capitalist Hoschedé, his gallery of printed portraits suggest the intellectual, social, political, and aesthetic range inhabited by the artists. Reproductive prints of works by Rubens, Ingres, Manet, and Turner indicate the range and depth of time of their artistic precedents. Interestingly, Bracquemond also submitted a group of freely made and possibly plein-air landscape prints, many of which were to form a kind of gestural precedent for later landscape paintings by Monet, Sisley, Pissarro, and Gauguin.

[4] They were referred to as "anonymous," "independent" and "intransigent" before the Parisian art world settled on "impressionist." See Stephen F. Eisenman, "The Intransigent Artists or How the Impressionists Got Their Name," in Charles S. Moffett et al., op. cit., pp. 51–57.

On April 15, 1874, an exhibition of more than 165 works by thirty artists opened in Paris in the galleries built for the great Parisian photographer Nadar on the Boulevard des Capucines. Today, we most often call this "the first Impressionist exhibition," and the label is not completely wrong.[1] Yet the artists themselves, wary of being pigeonholed, chose to call themselves "The Anonymous Society of Artist Painters, Sculptors, Printmakers, etc." and thus tried to evade name-calling either by critics or by the large public who circulated on the newly built fashionable boulevards of Paris north of the Louvre. Although the exhibition contained more works than most blockbuster shows of today, it was small by comparison with the exactly contemporary, government-sponsored Salon exhibition. And, according to the articulate critic Philippe Burty, it was installed to recreate the informal viewing conditions that prevailed in artists' studios, as opposed to the mind-numbing grandeur of the great rooms of the official exhibition.[2] Works were separated from each other on the wall rather than hung frame to frame, and the exhibition was held on the top floor of the studio which had a north-facing wall made of glass. Thus works of art were seen individually, and in the kind of natural light that then prevailed in the studios of modern Parisian painters.

Among the works listed in the official catalogue, only one had the word "impression" in its title—Monet's now famous *Impression, Sunrise* (fig. 2). However, many other works had titles that clearly conveyed to the public that they were either unfinished or made as part of a preparatory process. The printmaker Bracquemond submitted one work— a freely reproductive etching after Turner's famous *Rain, Steam, and Speed: the Great Western Railway* of 1845—with the proviso that its plate was "unfinished."[3] In numerous other instances, words like *esquisse* (a freely painted preparatory oil sketch) or *étude* (more generally an oil study) presented the viewer with a chance to evaluate the working methods of these thoroughly modern artists. Prints and drawings were shown along with paintings, suggesting both that the artists wanted to purvey their work to an economically diverse clientele and that they wanted the entire range of their production to be represented, from initial idea to reproductive print. Even Manet, who avoided joining the society, was represented by a reproductive etching by Bracquemond after a painting that he had dedicated to the photographer Nadar.

Yet the men and women who joined together in various coalitions between 1874 and 1886 were never called "esquissistes" or "étudistes."[4] Rather, and almost immediately, they were called "impressionnistes," and the works of a small group of these thirty artists have come to dominate world understanding of early modern painting since the late 1870s. But only a handful of works among the 165 in the 1874 exhibition could ever qualify as Impressions. The vast majority were meticulously painted with layer after layer of paint applied with small brushes to carefully prepared canvases. The surfaces of most of the works—even those by Monet, Renoir, Pissarro, and Sisley—were highly wrought and deliberate, in spite of the occasional informality and, hence, modernity of their subjects. Few revealed much evidence of their modes of preparation, and even fewer looked as if they were painted quickly. Just half a dozen among this small group of works have the character of performative painting— painting whose gestural appearance forces the viewer to think directly about the painter's process—and these provide a starting point for my discussion. What emerges

3 Paul Cézanne
A Modern Olympia, Oil Sketch, 1873–74
Oil on canvas, 46 x 55.5 cm
Musée d'Orsay, Paris

from an analysis of them is that, even in 1874, rapid, gesturally positive painting was aesthetically complex and elusive rather than simply transcriptive.

The first, by Paul Cézanne, was titled in French *Une Moderne Olympia, Esquisse* (fig. 3) and listed as the second of three works submitted by this controversial Provençal painter. Interestingly, it was the only one of the three that had been sold (it was in the private collection of the physician Dr. Gachet), which suggests that its radically free and loose facture had already been found appealing. Few people today would call this painting an Impression: it was clearly not painted from life, but was rather a pictorial idea conceived in the mind of the artist and relayed quickly onto canvas. Its subtitle, "*esquisse*," suggests that it was made in preparation for a larger and more highly finished work, which was not yet ready. Its informality could therefore be excused by

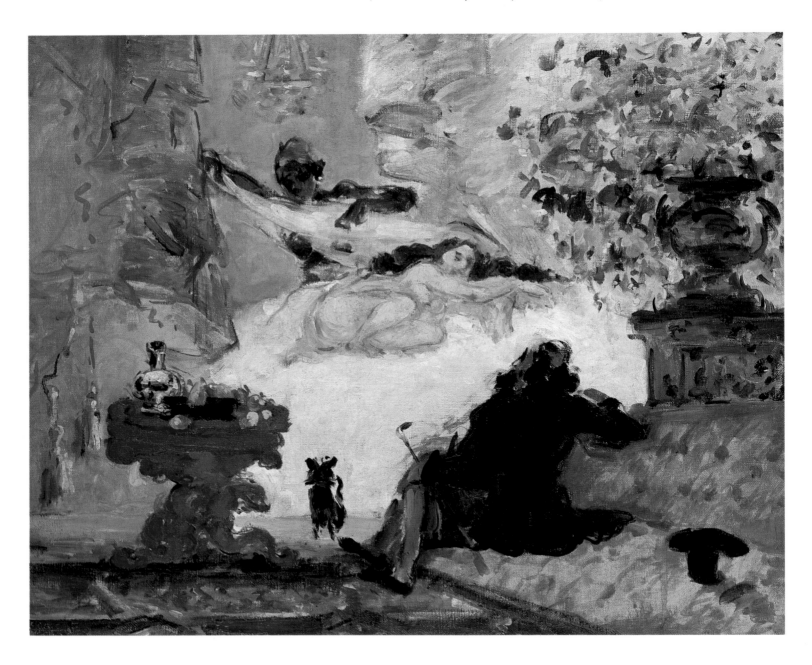

the painter's own admission that it was part of work in progress. Yet its sheer gestural abandon, its brilliant palette, and its shocking subject matter combine to give it an extraordinary drama.

Cézanne tells us by his title that the work is a modern comment on what was presumably the traditional version of the subject, a work by Edouard Manet shown eight years earlier in the Salon of 1865 (fig. 4). Manet's *Olympia* is cool, still, and comparatively restrained in its palette and handling. For Cézanne, everything is rushing— the painter's hands push and jab at the canvas with pink, red, yellow, and green paint, making no attempt to modulate or disguise the force of his gestures. Olympia herself seems to recoil on the vast bed, as the protective drapery is literally ripped from her by an athletic attendant of African descent. Even the middle-aged gentleman customer

4 Edouard Manet
Olympia, 1863
Oil on canvas, 130.5 x 190 cm
Musée d'Orsay, Paris

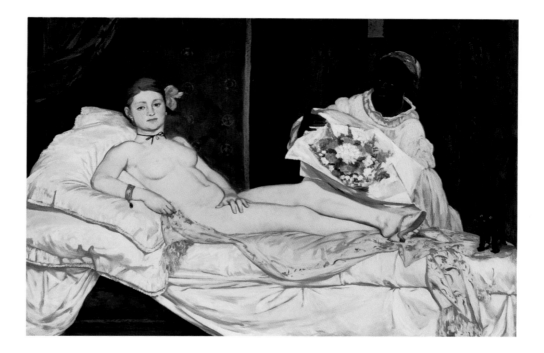

seems to be oddly active in his role as an onlooker, as his trousers, hair, and jacket quiver with the life imparted to them by the viscous paint. It is almost as if Cézanne was conspiring to create an *esquisse* for Manet's earlier painting, temporarily reversing a process of pictorial preparation that had been uni-directional for centuries. Cézanne's oil sketch is the "before," and Manet's famous painting the "after." As we will see, Manet had already accomplished the same feat with his free copy of Delacroix's *Barque of Dante*.

Cézanne wanted us to think that he painted this picture quickly. Few areas of color overlap any others—no messy passages of blue-over-yellow create unpleasant greens, for example—and the whole has as much brio as any oil sketch by Rubens, Fragonard, or Delacroix. Indeed, it seems almost whipped up, improvised as a spontaneous joke or a *bon mot* at a dinner party. With this fabulously wicked and ironical painting, we confront both Cézanne's intelligence and his thorough knowledge of the history of performative painting. Its inclusion in the 1874 exhibition makes clear that the men

5 Paul Cézanne
House of Père Lacroix
(*Etude: Paysage à Auvers*), 1873
Oil on canvas, 61.3 x 50.6 cm
National Gallery of Art, Washington, D.C.
Chester Dale Collection

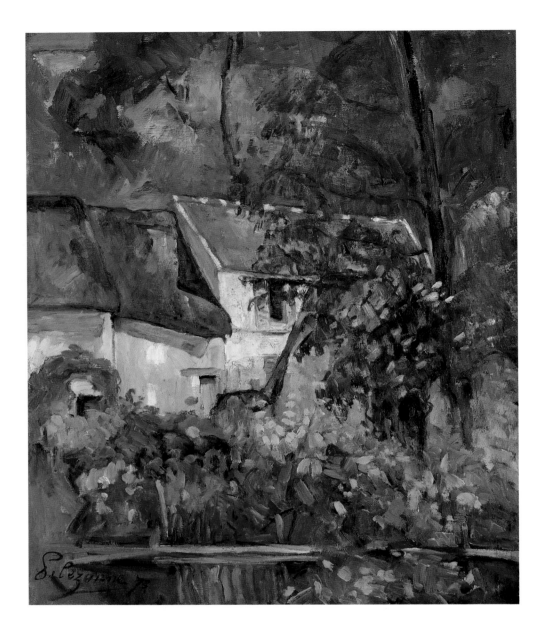

and women who painted Impressions in the 1860s and 1870s did so knowing that their seemingly new manner of painting had ample precedents in both Old Master and Academic painting. This "oil sketch" was made as a technical and iconological homage to earlier painters, and its comparatively large size (approaching that of a *tableau* or finished picture) forced every viewer at the exhibition to contend with it.

The third of the three works by Cézanne listed in the catalogue was entitled *Etude: Paysage à Auvers*. The word *étude* has a different meaning from *esquisse*, a difference that lies almost completely in its relationship to the visual world. Oil sketches (*esquisses*) tended to translate a scene from the mind (usually with origins in literature or other works of art) into concrete visual terms; they were inspirational and imaginative. Studies (*études*) tended to stick much more closely to nature—whether a whole view or a part—such as drapery, a figure, hands, clouds, a tree, or an aspect of a building.

6 Paul Cézanne
House of the Hanged Man at Auvers-sur-Oise, 1873
Oil on canvas, 55 x 66 cm
Musée d'Orsay, Paris

Because the title is so vague and because no review of the 1874 exhibition contained a precise enough description of this work for it to be identified, scholars have struggled to select one among the eight to ten works painted by Cézanne in Auvers before 1874 in an apparently "unfinished" manner. We can never know conclusively which one it was, but the word *étude* means that it must have been of another level of observation from the *esquisse* of the Modern Olympia. *House of Père Lacroix* (fig. 5) is the most plausible contender;[5] if we accept this, the logic of Cézanne's submissions becomes clear.

The first work listed by Cézanne in the catalogue, *House of the Hanged Man at Auvers-sur-Oise* (fig. 6), contains neither the word *esquisse* nor *étude* in its title, and was thus submitted as a fully finished work of art. Its densely painted, layered surface, although thought crude by certain contemporary critics, represents a long period of gestation, thought, reconsideration, and reworking. The other two works seem to have a different relationship to process. *A Modern Olympia* is the most direct and rapid in its mode of transcription, and the most imaginative. *House of Père Lacroix* is more thoroughly worked, with wonderfully rich brushstrokes laid over painted surfaces after they were dry; it is the result of cumulative study of the motif (near where the artist was staying in Auvers). What differentiates it from the "finished" *House of the Hanged Man* is that each step in the process was made with forthright gestures and jabs of paint. Thus, in his *étude*, Cézanne preserved the performative verve of his *esquisse*. Taking the three works together, it seems clear that Cézanne intended to give the viewer of this "studio" exhibition a real sense of the working methods of a modern artist.

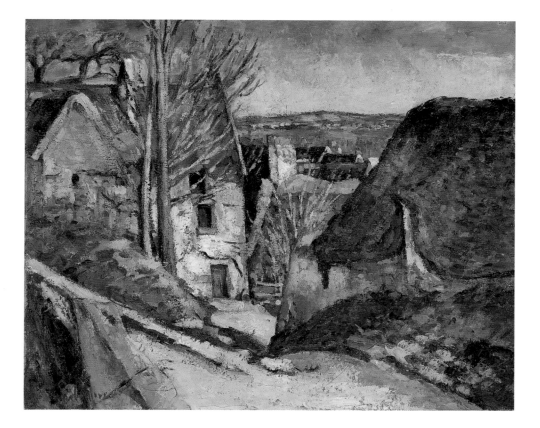

[5] Identified by John Rewald in Charles S. Moffett et al., op. cit., p. 126.

Of the three, however, only *House of Père Lacroix* could be called an Impression. Only with this painting do we seem to be in the presence of an artist who is improvising his picture as he paints, who derives stimulus from nature, but who clearly communicates the results of that stimulus in a direct, gesturally positive way. Thus the "impression" of the scene on the mind and sensibility of the artist is the subject of Cézanne's painting. The work is at once objective and subjective, as if it is an impression not on the eye, but on the mind of the artist. Cézanne's hand has translated chromatic and emotional impulses onto canvas. A study of this painting reveals him adjusting with great care the planes of the houses in the center and the layering of forms in the background. Yet, in completing the work, he seems to have scattered brushstrokes of thick, wet paint all over the surface, creating a random flurry of painted marks, most of which read as leaves. These lend the whole canvas a sense of immediacy that allowed him to entitle it *étude*.

From *House of Père Lacroix* it is not a long aesthetic journey to Monet's *Impression, Sunrise*.[6] Monet worked with large brushes all over the surface of the canvas. The viewer can almost imagine painting along with him, as he lays in the water with pale blue-grays and the sky with an orange-beige; each long gesture is clearly readable. When this initial layer was dry or at least tacky, Monet worked with blues, green-blues, oranges, and brown-grays, each manipulated with its own brush to improvise the scene. The scrubbed blue-gray on the left represents the smoke from steam-powered engines revving to go. The painted lines of blue-gray, green-gray, and reddish purple on the right form masts, hulls, and loading cranes. And the entire watery surface of the painting's center is aquiver with small boats, their reflections, and the dramatically orange emanations from a huge rising sun, whose color seems to tinge almost everything in the painting. For the most part, the hues are narrow enough in their range for Monet to have worked them easily wet-on-wet without risking any unfortunate or unforeseen color mixtures. Yet the brown-grays of his signature, its smudged halo, and the two nearest row boats suggest a completely separate third session of painting, possibly in conjunction with the orange of the sun and its reflection.[7]

Most fascinating, however, is that the painting appears to have been painted in one continuous sitting, because Monet worked in an identically broad and rapid manner in each of the two (or three) discrete sessions he actually needed to complete it. This aura of improvisation was deliberately maintained by Monet, just as it was by Cézanne in both his *étude* and his *esquisse*. If analysed together, these three works make a clear case for the efficacy, variability, and eloquence of performative painting at the very beginning of Impressionism. Philippe Burty put it simply: "they depend upon . . . lightness of touch, boldness of masses, blunt naturalism of impression."[8] If others were less flattering (preferring to stress the crudity rather than the lightness of these works), most critics agreed that rapid painting was essential to the very idea of the Impression.

If we look a little more carefully at these three works, we find that they represent performative process in three different ways, with three completely different kinds of motifs. Cézanne, with the oil sketch, makes a humorous representational elision of a stage set and a large room in the home of a great Parisian courtesan. With its ridiculously caricatured elements—the dog, the lacquered table, the immense bouquet of

[6] The work of this title in the 1874 exhibition has long been identified with a painting kept by Monet throughout his life which is now in the Musée Marmottan, Paris. Yet the recent acquisition by the Getty Museum, Los Angeles, of a work of the same size, date, subject, and style, called *Sunrise (Marine)*, casts a grain of doubt on the traditional identification. The two paintings are so closely related that it is impossible to select one over the other. Monet exhibited a picture with a nearly identical title in the fourth Impressionist exhibition of 1879, which could indicate that one painting was shown in 1874, and the other in 1879.

[7] Scholars have noted that the date on the canvas, 1873, must be wrong because Monet's visit to the harbor took place in 1872. There are two plausible explanations: the first, and simplest, is that the painting was not completed, signed, and dated until 1873, in Monet's studio; the second, and more cumbersome, is that Monet signed and dated the painting so long after its completion (possibly for the 1879 exhibition) that he had by then forgotten the true date and made an error. To me, the first explanation is more likely.

[8] Philippe Burty, 1874, in Berson et al., op. cit., p.10.

flowers in an over-scaled urn, and the African servant—it has as many elements of fantasy as a garden scene by Fragonard. Indeed, Cézanne, like virtually every advanced French painter of the 1860s and 1870s, had read the brilliantly evocative essay on Fragonard by Edmond and Jules de Goncourt which did so much to revive that eighteenth-century painter's reputation.[9] Also like other painters, he had surely rushed to the Louvre to see the wonderful group of painterly works bequeathed by La Caze in 1869.[10] His fantastic Olympia was more modern than that of Manet because it showed evidence of an up-with-the-latest sensibility which was, in itself, modern, although many of its sources were Old Master. Like Cézanne, who used La Caze pictures as inspiration throughout his working life, Manet was deeply affected by the works in the bequest, and began painting a modern remake of a major Chardin within a year of their appearance in the Louvre.

The two landscapes each mine a visual realm for personal ends. In each case, the artist was actually looking at his motif—Monet from a hotel window, and Cézanne after a short walk from his rooms in nearby Auvers. Also, in each case, the artist wanted to seize the motif by trapping, in quickly made gestures of paint, the major qualities of its form. The subjects had plenty of precedent in French painting, but in neither case was the particular motif noteworthy or important. In fact, of the two, only Cézanne chose to tell us of the place he was in while painting; Monet's title tells us about time rather than place. But each of them communicates an urgency of execution or performance, despite their evident differences in color and facture. Monet's motif is clearly modern—steam power, dredged harbors, and the like. It is also completely in flux: water and air become color and paint as the sun rises in Le Havre.

Cézanne's time of representation may not have been any longer than that of Monet, but his represented time—that of a walk in the village of Auvers in 1873—is surely longer. The summer is full, perhaps with a hint of autumn in the yellows. No figures betray activity. No seasonal or diurnal clues interrupt our immersion in the painter's observation of masses, hues, and values. Monet, specifically, paints dawn; Cézanne paints what French historians and anthropologists of rural life have called *la longue durée*—the long duration of provincial time. The three times—of a moment in a modern harbor, of theatrical urban fantasy, and of the endless rhythms of rural life in a provincial town—are each represented in virtually the same way, with large brushes, freely made gestures, and a sort of performative innocence which is, in itself, modern. Manner, not matter, is the modern component in these three works. As the great critic Jules Castagnary put it, "it is not *Landscape*, it is *Impression* that the catalogue calls Monet's Sunrise."[11]

Taken together, these three works—*Impression, Sunrise*; *A Modern Olympia*; and *House of Père Lacroix*—are the introduction to my study.[12] When we see them, even reproduced in the pages of a book, we realize that rapid painting was neither simple nor aesthetically unified, even at its onset. They make us hunger to know just why their appearance in 1874 was such a seismic event in the history both of modern art and of popular taste.

[9] The essay by the brothers de Goncourt was first published in the *Gazette des beaux-arts* 18, 1865, pp. 32–41, 132–62, and revised for *L'Art au dix-huitième siècle*, 1873, pp. 241–342.

[10] The La Caze bequest was hung together in a prominent gallery in the Louvre until World War II. Its effect on the history of art has never been systematically studied. It remained a potent source through the 1920s when Vuillard depicted it as the sole room of paintings in his series of decorations devoted to the Louvre; see Musée de l'Orangerie, *Edouard Vuillard, K.-X. Roussel*, Paris, 1968, p. 254.

[11] Jules Castagnary, 1874, in Berson et al., op. cit., p. 17.

[12] Unfortunately, lending restrictions and other concerns preclude these works from being included in the exhibition.

3 Painting as performance: Spontaneity and its appearances in painting, and the intellectual origins of the Impression

Why paint quickly? Most of the literature about the craft of painting stresses its difficulties—the securing of materials, the laborious period of training, the layered processes of preparation, and the much interrupted sessions devoted to creation, reconsideration, and finally "finishing" the work of art. Leonardo's gestation periods were long and he found it very difficult to finish; Michelangelo slaved in solitude on scaffolding; Degas made repeated scrapings of whole sections of paintings he found inadequate; Cézanne suffered lengthy and even agonizing periods of waiting before making a single stroke on the canvas, and van Eyck's ability to transform ground pigments and egg into leaves, shiny drapery, and carpets still confounds us. Those who study European paintings almost always begin with Cennino Cennini's *Il Libro dell'Arte*[1] and come away with the idea that the making of a painting is so technically complex and so over-determined that any spontaneity is out of the question.

Yet rapidity of execution does feature in the history of western painting; at least by the mid-sixteenth century, a certain type of artist had evolved whose very identity was connected with skill in rapid transcription. The painterly identities of Titian, Tintoretto, Rubens, Jordaens, Velázquez, Hals, Giordano, Tiepolo, Boucher, Giaquinto, Gainsborough, Fragonard, and Delacroix cannot be considered without addressing their sketches, their loose and free paint application, or their bravura technique. All of them strove to create works in which the viewer can almost follow the artist through his process of creation, works in which the act of painting itself is a vital part of their meaning and character.

Paintings by these great artists form a kind of Old Master precedent for the extraordinary flowering of rapid painting in France during the second half of the nineteenth century. Most of the great Impressionist practitioners of rapid painting both admired and studied the gestural techniques of Frans Hals, Diego Velázquez, and Jean-Honoré Fragonard as they searched for inspiration in the Louvre and other museums. It is interesting just how diverse these works are; they vary in scale, palette, even mode of brushwork. The staccato accumulation of painted lines that coalesce to form a ruffle or a hand in a Hals portrait differs in degree, kind, and quality from the loose gestures of Velázquez, gestures that seem almost to caress the forms they represent. Fragonard's painted lines energize form as they define it, borrowing from Giordano and others the hysteria of windswept drapery evoked with juicy paint. Certain of the most freely painted works of art can best be characterized as "sketches" —works that approach preparatory drawings in their scale, informality, and exploratory character. They are smaller in scale than either standard easel paintings or the large-format works for which they were most often made. And, even if we now know that many were in fact painted *after* the work for which they appear to be preparatory, they preserve the illusion of captured thought.

Many of the words applied to these works of art—*bozzetti*, sketches, *sprezzatura*, *bravura*, improvisations—carry associations of rapidity and experimentation. Others have a negative association—unfinished, indeterminate, or chaotic (all words used by Sir Joshua Reynolds to characterize the paintings of his rival Thomas Gainsborough) —and are often linked with moral laxity and even, to some critics of the Impressionists, to outright evil.[2] The idea that paintings ought not to *look* painted has had currency

[1] Written in about 1390, this treatise is the earliest known source describing specific painting techniques, from the preparation of the surface and mixing of pigments to the final varnishing. The standard edition in English is Cennino Cennini, *The Craftsman's Handbook*, trans. Daniel V. Thompson, Jr., New York, 1954.

[2] These claims are most usefully summarized in the pages on *sprezzatura* in Ernst Gombrich, *Art and Illusion: A Study of the Psychology of Pictorial Representation*, Princeton, 1960, pp. 193–99.

Edouard Manet, *Study for "The Surprised Nymph"* (detail of fig. 13)

7 Peter Paul Rubens
The Capture of Samson, 1610–11
Oil on cradled panel, 50.4 x 66.4 cm
The Art Institute of Chicago
Robert A. Waller Memorial Fund

ever since the Greeks. A real fly is supposed to land on the painted fruit, and the viewer is supposed to reach for the proffered knife. Spontaneity, even if rehearsed, has few staunch adherents among art theorists, who prefer on the whole to write about the meanings of represented subjects rather than about the modes of representation.

Perhaps this is why many quick paintings made before 1860 were rarely intended for exhibition. They were either exploratory or private, often made to convince a patron to let work begin on an altarpiece, an allegorical ceiling, or a heraldic portrait. They were often given the character of inspiration by being made to look as fresh as possible, and many of them were surely made over and over until they appeared to be at once spontaneous *and* successful as representational compositions. If we had access to the thousands of works made in preparation for these seemingly preparatory works, the history of art would be littered with the corpses of failed spontaneity. We do have

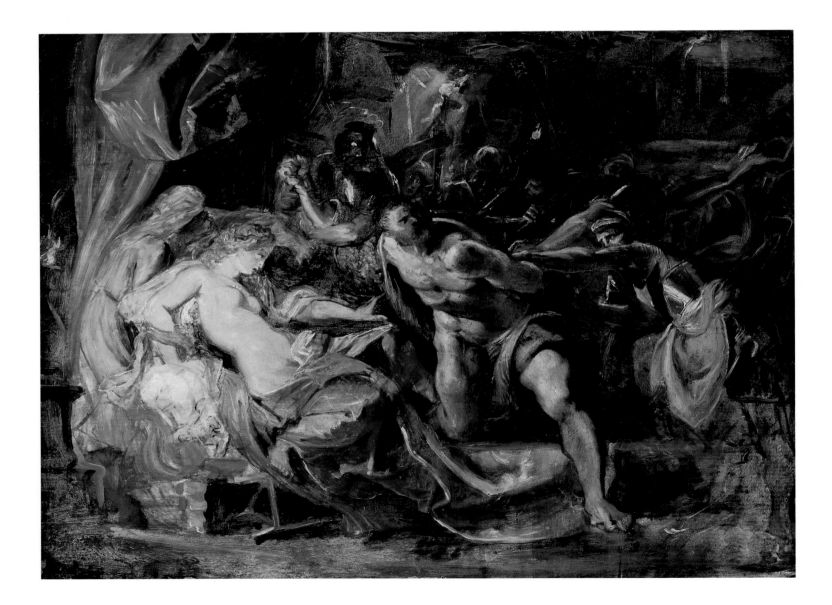

8 Jean-Honoré Fragonard
Figure de fantaisie: portrait de l'abbé de Saint Non,
*c.*1769
Oil on canvas, 80 x 65 cm
Musée du Louvre, Paris

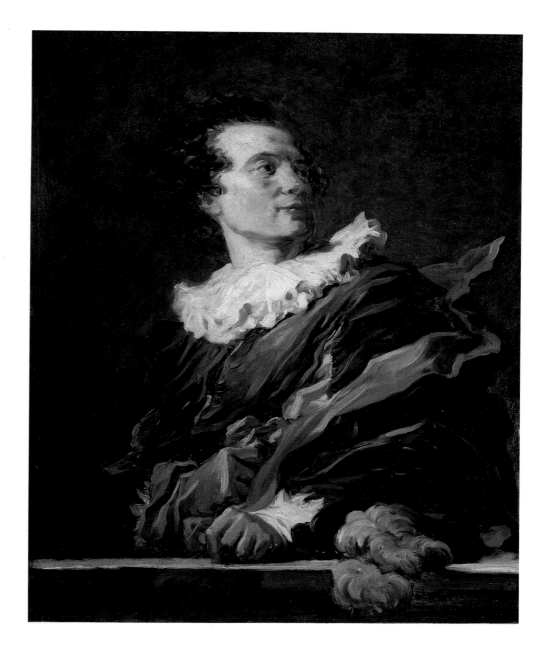

works by Rubens, such as his early sketch for *The Capture of Samson* (fig. 7), which are so charged with emotion and drama that we almost feel that he painted the scene from life. But in others (which I will leave unnamed) even Rubens himself seemed to flag, his energy dissipated as if he was only half-interested in his bravura task. Even brilliance can become formulaic.

Just as apparently quick paintings may not always have been executed quickly, so rapidly made paintings do not always *look* rapidly painted. The aesthetic of rapid painting can be a "look" or a series of visual codes as much as the result of true rapid execution. To make this point, let me contrast two works of art, both pre-Impressionist and both painted in comparatively short periods of time. One, Fragonard's *Figure de fantaisie* (fig. 8), bears an old inscription on the back of the canvas stating that it was

painted by Fragonard in one hour. The inscription is not in Fragonard's hand, but we can tell that the artist was at pains to let us know how quickly he made this work. He selected a good-sized canvas and represented his motif with curvilinear gestures created with lusciously viscous paint and large brushes. Each of these gestures can be

read as a step in a visual improvisation. In certain passages he worked wet-on-wet: the area of yellow drapery at the center of the body was painted before the blue under-painting was dry, thus creating passages of green where the two pigments mixed. Whether the work was indeed painted in one hour we can only guess, but its appear-ance in no way belies the claim.

The second painting, Louis-Léopold Boilly's *Portrait of a Gentleman in a Black Coat* (fig. 9), was painted in about two hours.[3] But whereas Fragonard wanted his viewers to re-experience his own bravura performance, Boilly (and, presumably his anonymous client) wanted a finished likeness which betrayed no haste in its execution. Hence while Fragonard almost fetishized the brush stroke, Boilly worked with tiny brushes in a layered process of creation. His under-painting of the monochrome areas of the garment, the background, and the face was tacky enough not to mix when he added the deftly applied surface strokes that represented hair, eyebrows, garments, and the other details required for a portrait likeness.

[3] We know about Boilly's proto-industrial mode of production from Paul Marmottan, *Le Peintre Louis Boilly (1762–1845)*, H. Gateau, Paris, 1913, still the definitive account of this painter's remarkable works.

Boilly painted, drew, and printed thousands of small portraits during his lifetime, and the majority of these were made in one, two, or at most three short sessions. For Boilly, every aspect of his working method was preconceived: a portrait's format, materials, and the time it took to produce resulted in a variable pricing structure, designed to afford the painter and his large family some financial security, and to free him to do uncommissioned works of art. The speed of execution was one of the chief novelties of Boilly's portrait business. It enabled him to make more money than his competitors—not only because he was a better artist, but also because in the same space of time he could produce more works.

These two artists, both speedy, were in every way opposite in their aesthetic. Boilly effectively disguised, or visually de-emphasized, the short time of execution through his use of small formats, small brushes, pre-ordained compositions, and standardized procedures. Fragonard worked in a wet-on-wet style so that the paint became a medium for the transcription (one might even say the representation) of his own gestures—these gestures become, to a large extent, the very subject of the work. Boilly's subjects were individual men and women who paid for recognizable likenesses. Fragonard's subjects can be more easily described as inspiration, fantasy, spontaneity, or even the performance of painting itself. For Fragonard, the entire painting became a signature, and the graphism of his gestures makes his work instantly recognizable. Hence we can see that speed of execution does not in itself determine the look or style of a rapidly painted work of art. Instead, we can contrast actual and apparent speed, and can turn to Fragonard as the one artist in the history of French art who best exemplifies the latter. His was an aesthetic of rapid painting.

PERFORMATIVE PAINTING AND MODERNISM: A CRITICAL ABYSS

Much of the literature of art written in the last century assumes artists to be complex, highly mediated members of society, the best of whom create works that are dense with meanings and pre-determinations, both conscious and not. But art historians and conservators have a vested interest in the layered, the contextual, and the "difficult" aspects of an individual work of art. Rarely in their vast literature do scholars allow works of art to be simple, spontaneous, or, to put it negatively, under-determined. And, when they do, they either dislike them or disbelieve their apparent ease. This situation has meant that professional writers on art have actively undermined the numerous attempts by artists to create works in a simple, direct, unrehearsed, informal, or "open" manner.[4] The professional prejudice against such art has become so grounded in art theory that it is very hard for us today to understand one of the most powerful strands of painting, particularly of modern painting.

Perhaps the strongest example of this negative criticism involves Impressionism. An entire edifice of pictorial theory, developed for modern painting, has been based on a denial of the importance of the movement. In many early commentaries on pictorial modernism, Impressionist painting was treated in a largely negative way. Paul Signac and Henri Matisse both attempted to denigrate Impressionism through a caricatured reading of the movement as merely spontaneous or interested simply in the transient and ephemeral aspects of form. After a brilliant series of paragraphs in his important essay of 1899 praising the contribution of the Impressionists to his progressive history

[4] The phrase is from Umberto Eco, "The Open Work in the Visual Arts," *The Open Work [Opera Aperta]*, trans. Anna Cancogni, intro. David Robey, Harvard University Press, Cambridge, MA, 1989.

5 Paul Signac, *De Delacroix au Néo-Impressionnisme*, 1899.

6 Henri Matisse, "Notes d'un peintre," *La Grande Revue* 2/24, December 1908, pp. 731–45; English translation from *Matisse on Art*, ed. Jack Flam, Berkeley, 1995, p. 39.

7 The most succinct discussion of Renoir's personal crisis is in Joel Isaacson, *The Crisis of Impressionism, 1878–1882*, University of Michigan, Ann Arbor, 1980, particularly pp. 22–3 where the artist's famous synopsis is quoted: "I had wrung Impressionism dry." See also Amboise Vollard, *Renoir, An Intimate Record*, New York, 1925, p. 118.

8 Unpublished until 1996; see "The Philosophy of Impressionism," pp. 12–20, in *A Roger Fry Reader*, ed. Christopher Reed, Chicago, 1996.

9 Roger Fry, *Transformations: Critical and Speculative Essays on Art*, London, 1926, p. 218.

10 Exemplified brilliantly by Arnold Hauser in *The Social History of Art*, op. cit., vol. IV, especially pp. 168–73, and by Pierre Francastel, *L'Impressionnisme*, Paris, 1937, upon which Hauser drew extensively.

11 Although it has been enlarged and improved many times, the essential character of John Rewald's *The History of Impressionism* remains unchanged since its first edition in 1946.

12 See below, on John House and Robert L. Herbert.

13 The writings of these painters constitute a kind of minority counter-discourse, demonstrated perhaps most persuasively by Patrick Heron, in *Painter as Critic: Patrick Heron, Selected Writings*, ed. Mel Gooding, London, 1998, and in the remarkable writings by Richard Kendall, especially his three exhibition catalogues devoted to the art of Edgar Degas: *Degas's Landscapes*, 1993; *Degas: Beyond Impressionism*, 1996, and *Degas: The Little Dancer*, 1998, all Yale University Press, New Haven and London.

14 From his remarkable essay, "Moment and Duration," in Robert Gordon and Andrew Forge, *Monet*, New York, 1983, pp. 191–97.

15 This "formalism" in pictorial analysis was common up to the 1960s, but has been routinely derided since, and is now left to conservators, technically minded curators, and teachers who use outmoded texts. Few professional art historians outside museums have cared to dirty their hands with such materialist methods, prefering to treat a work of art as a representational image, the critical reception of which is more important to its meaning than is its form.

of modern painting, Signac then attacked them for their "absence of method," their tendency to "err in the application of contrasts," their "arbitrariness," their "polychromatic turmoil," and claimed that their colors "neutralize each other."[5]

And Matisse, though a more subtle theorist, gave scarcely more praise in a famous essay of 1908. After gushing about the Impressionists' "charm, lightness, freshness—such fleeting sensations," Matisse asserted that he preferred "to risk losing charm in order to obtain greater stability."[6] Both Julius Meier-Graefe and Roger Fry echoed these two painters by treating Impressionism as a sort of necessarily experimental prelude to the creation of great painting (i.e. painting of the level of the Old Masters), which was achieved by Cézanne, Seurat, van Gogh, and the late Renoir.[7] This view is particularly strongly expressed in the criticism of Roger Fry, perhaps the greatest English-speaking art critic of his time, who wrote a brilliant essay about the philosophy of the Impression in 1894.[8] He then became an outright enemy of the movement, scornfully denigrating its rhetorical use of science as a justification for its methods, and writing insulting paragraphs that today seem almost irrational. The Impressionists' "extreme preoccupation with atmospheric effects," he wrote in 1926, "tended to destroy any clear and logical articulation of volumes in pictorial space. It also destroyed the surface organization of their pictures more completely than ever done hitherto."[9]

This idea of Impressionism as painting about the ephemeral persisted in art criticism through World War II.[10] The only counter to the trend was John Rewald, who attempted to write a solid, documentary history of the movement through the letters, reviews, and ephemera produced by the artists themselves as well as their friends and critics.[11] On this edifice, Rewald's followers in Britain and the United States have built a discourse of history and criticism that stresses the deliberate aspects of Impressionist practice and theory. Many recent art historians now claim that the Impressionists were highly complex, mediated artists, whose work can best be understood as premeditated and decidedly *un*spontaneous, since they were expressing nothing less than a planned critique of the art academy, the art markets, contemporary critical discourse, and the social structure of Third Republic France.[12] Whereas earlier writers thought of the movement as a contribution to a generational history of "painting *qua* painting" (an internal professional history without sociopolitical or psychological dimensions), the most recent writers have embedded the works of art in the very cultural, political, and aesthetic contexts that those earlier writers sought to avoid.

The writings of painters can sometimes give us exceptional insights into the practices of other painters. Patrick Heron, Andrew Forge, Lawrence Gowing, and Richard Kendall enable us to gain entrance to Impressionist works in startlingly different ways.[13] Forge is perhaps the most direct, asserting, in the case of one painting by Monet from the 1870s, that "to unravel its meaning is in a sense to enter into its making. The layering of crisp brushstrokes is sequential, each accent a note in time, the painter's present, to be read by a kind of archeology." His detailed analysis of the strokes of paint in various parts of the picture deconstruct it in ways that assume it to be a static embodiment of an actual performance.[14] Obviously, this kind of analysis is easier for another painter to understand than a non-painter.[15]

Such close viewing has also been practiced by a few art historians, particularly those who look carefully at the paintings of Monet. Two of the ablest, John House and Robert L. Herbert, have done much to transform contemporary understandings of Monet's practice.[16] For both, Monet's works emerge as highly complex because many (perhaps most) of them were made in layers of painted marks (this is Andrew Forge's archeology in practice). Wet strokes placed atop dry ones, color-coordinated highlights, scumbled strokes over deliberately crusted under-layers—revelation of these practices leads to the realization that the act of painting must have had a much longer duration than was allowed by Signac, Matisse, and other early critics. We have learned that many Impressionist paintings were made in several discrete sessions, over long periods of time (oil paint is slow to dry), and were often finished in the studio. This latter revelation would have been inconceivable a generation ago, when it was believed that Impressionism was an exclusively plein-air movement. House also differentiates between the types of painting that Monet called variously *esquisses*, *pochades*, *études*, and *tableaux*. Thus those very elements of spontaneity, so essential to the earliest idea of Impressionism, have been gradually stripped away from it by its most sympathetic commentators. The merely spontaneous Impressionism described by Signac and Matisse is replaced by an idea of Impressionism as, literally, layered.[17]

WHAT *IS* AN IMPRESSION?

[16] John House, *Monet: Nature into Art*, 1986, and Robert L. Herbert, *Impressionism: Art, Leisure, and Parisian Society*, 1988, both Yale University Press, New Haven and London.

[17] House also analyses and publishes a fair number of works that are either unlayered or that were painted in no more than two sessions; that he allows this true Impressionism to act as an integral part in a hierarchical process of picture-making seems ironically academic. His Impressionism is remarkably like academic practice, with the important exception that artists could declare a work finished at any point in its process, and that a work could be signed, exhibited, and sold after as few as one or two short sessions of painting.

It is odd, even perverse, that the immense bibliography devoted to Impressionism contains not a single sustained definition of "Impression," nor a clear analysis of the works that might be called Impressions. This is perhaps because the name seems to have been accidentally applied to the movement by outsiders; it was never adopted enthusiastically by the artists themselves or by their friends.

It is true that what a large number of Impressionist works reproduced in the catalogues raisonnés and picture books have in common is that they look as if they were rapidly painted. In contrast to the *ébauche* (a rapidly made compositional sketch or rough outline for a complex figure painting) and plein-air sketches of their predecessors, these are *not* sketches made as part of a preparatory process, intended only for the eyes of the artist. Many of these works, tentative and chaotic as they first appeared, were signed, sold, and exhibited shortly after they were made.

In order to gather a varied sampling of such works, we have had to tackle the thorny issues of spontaneity and directness in French vanguard paintings of the years 1860 to 1890. Certain of the paintings attain the scale of *tableaux* (finished easel pictures) made for sale and exhibition; others are smaller in scale and deal with the transcription of complicated scenes such as urban settings or figures. Still others are large-scale exhibition pictures that, although very deliberately worked, are finished with the style and bravura of an Impression in order to approach the power of that mode of direct painting.

What is meant by direct painting? Simply put, it is painting in which the artist works on the canvas without intermediate steps or preparatory processes. There are no preparatory drawings, smaller-scale versions, or chromatic studies that are synthesized in the final work. Direct painting is also generally done in front of the motif in a way that is forthright enough to communicate to the viewer that he or she is intended to

think as much about the nature of the process of painting as about the represented subject. Brushstrokes, for example, are often exaggerated in their scale to convey a meaning that is not intended to be purely representational.

The artists themselves did not use the word *impression* to describe these directly painted works. Manet, Monet, Pissarro, and Cézanne were more comfortable with *pochade*, *ébauche*, or *étude*; on certain occasions, they used these terms to oppose the word *tableau*. An Impression, therefore, would seem to be accorded a hierarchically lower status as a work of art than a *tableau*, even by the artists. The truth, however, may not be so simple. From the mid-1860s Manet signed, exhibited, and sold rapidly painted works; Monet and Renoir soon followed suit. They all also began to paint larger and larger direct paintings, and to tell friends and colleagues that they *were* painted rapidly (many of the early stories about Impressionist practice stress both the rapidity and the immediacy of the artists' working methods). Before dealing in detail with the rapid painting of the Impressionists, it is necessary to understand the idea of rapid painting in France during the second half of the nineteenth century. The following topics do not all involve painting; it is the very range of concerns that lay behind the Impression that makes it so vital a part of pictorial practice.

EN FACE DU MOTIF: THE OIL SKETCH AND ARTISTS IN FRONT OF NATURE

One of the most important forms of direct painting was developed in seventeenth-century Europe and reached its apogee in the first half of the nineteenth century. The plein-air oil sketch has been much studied, collected, and exhibited recently, as museums and scholars have combed the history of art in a search for adequate precedents for Impressionism.[18] This research has a profound subtext—that the idea of painting one's sensations directly originated *not* with Impressionism but, rather, with European artists of the late eighteenth century.

Some critics have stressed the grammatical aspects of the oil sketch: artists studied aspects of nature—such as water, sky, trees, architecture, rock formations, or figures—in relative isolation in order to be ready to create a syntactical work of art from these ingredients. They were less interested in nature than in a predetermined and fundamentally linguistic analysis of its components. Other artists who worked directly *en face du motif* seem to have been preoccupied with the value and chromatic structure of a view, and their tonally conceived landscapes could then be used as a kind of sub-structure when creating a finished painting. Both aspects of nature and the character of a landscape view could be legitimate subjects of the plein-air oil study.

In the majority of the oil sketches from the eighteenth and nineteenth centuries, the artists worked on sheets of paper, which might later be mounted on stretched canvas supports and occasionally be sold or given away. The works tend to be small, carefully done, and private, with more of the character of Boilly's small-scale portraits than of Fragonard's broadly painted works. Although the idea of the plein-air oil sketch surely underlies the practice of the Impression, very few Impressions actually look like plein-air oil sketches of the period 1770–1850. The smallness of scale of the latter, and their complex surfaces, covered with many small strokes of paint, are decidedly different from the comparatively large surfaces and broad gesturally positive strokes of paint that characterize the Impression. This is perhaps best

[18] Examples include detailed studies of the oil sketches of Corot; investigations of oil sketching in and around Rome after Pierre-Henri de Valenciennes in the late eighteenth century; analyses of oil sketches in northern Europe, particularly Denmark and northern Germany; and, most recently, careful research on the oil sketch in nineteenth-century America. See Peter Galassi, *Corot in Italy: Open-Air Painting and the Classical Landscape Tradition*, 1991; Philip Conisbee et al., *In the Light of Italy: Corot and Early Open-Air Painting*, National Gallery of Art, Washington, D.C., 1996; Catherine Johnston et al., *Baltic Light: Early Open-Air Painting in Denmark and North Germany*, National Gallery of Canada, Ottawa, 1999, all three Yale University Press, London and New Haven; and Eleanor Jones Harvey, *The Painted Sketch: American Impressions from Nature, 1830–1880*, Dallas Museum of Art, 1998.

Paul Cézanne, *House of Père Lacroix* (detail of fig. 5)

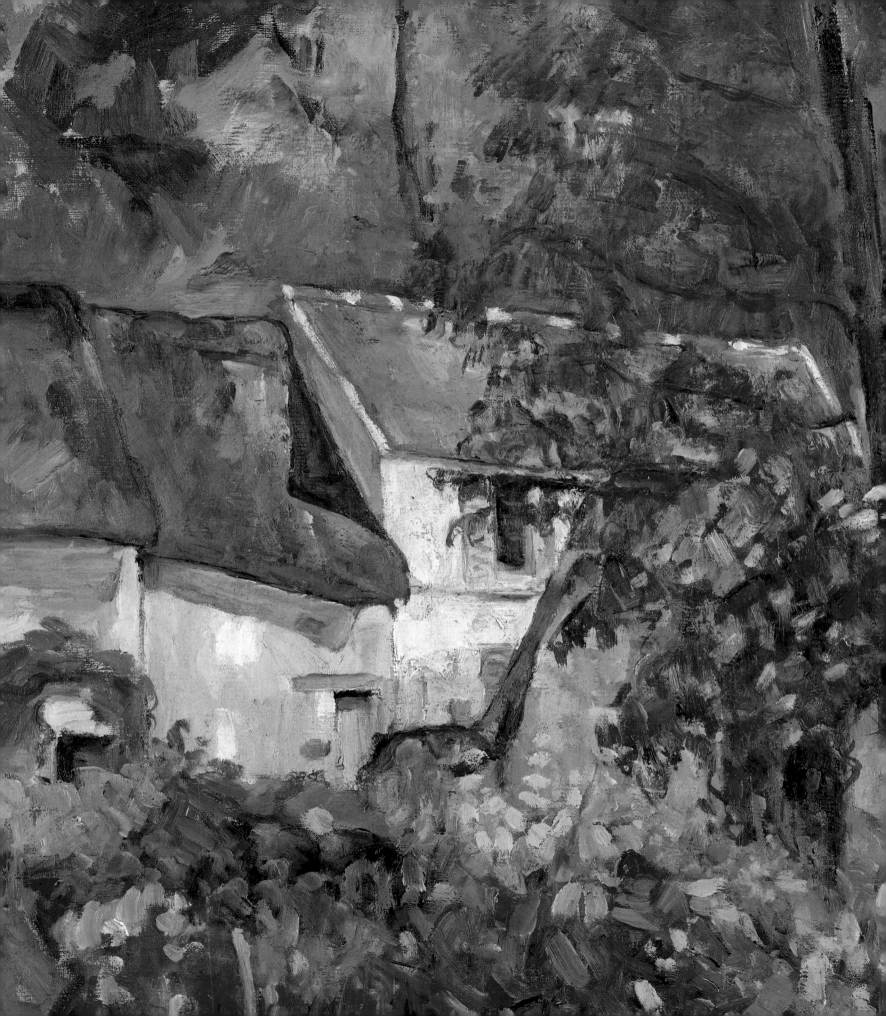

10 Simon Denis
Torrent at Tivoli, 1789–93
Oil on paper laid on a plastic support
21.2 x 27.9 cm
The Gere Collection, on long-term loan to
The National Gallery, London

11 Claude Monet
Storm at Belle-Ile, 1886
Oil on canvas, 60 x 73 cm
Private collection, United States

demonstrated by figures 10 and 11, an oil sketch by Simon Denis made in Italy around 1790, and an Impression by Monet of a similar subject made almost century later (they are reproduced here in their correct scale relationship). Clearly, the precedent does not account fully for the progeny.

It is the informal nature of the composition of plein-air oil sketches that is more important for the Impression than the styles or factures prevalent in this mode of painting. The prescient and modern nature of plein-air oil sketch compositions has been consistently recognized in modern studies of the genre; parallels have even been drawn with photography.[19]

Many of the most important masters of the plein-air oil sketch in France died in the 1860s and 1870s. The consequent sales from their studios released large numbers of these works into the discourse, and the collections, of Parisians. Thus the young Impressionists had access to the working methods and "unfinished" works of Troyon (d. 1865), Rousseau (d. 1867), Corot (d. 1875), Courbet (d. 1877), Daubigny (d. 1878), and Daumier (d. 1879), long before they themselves had wearied of their experiment in direct painting.

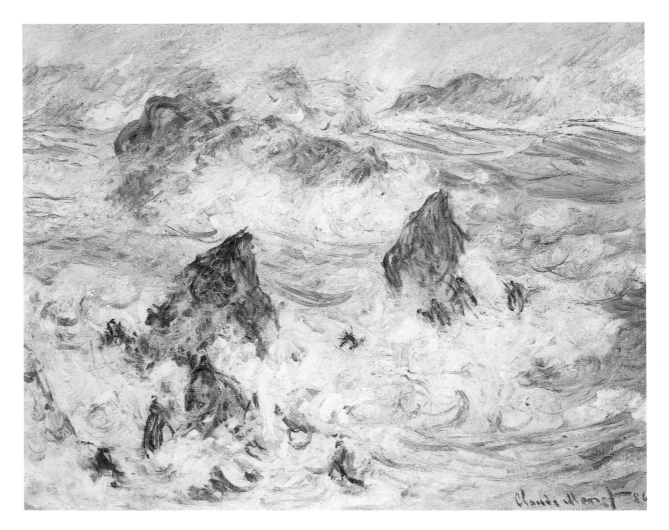

THE *ÉBAUCHE* AND GESTURAL PAINTING IN ACADEMIC PAINTING

It might seem odd to look for precedents for Impressionist gestural painting in the academic practice of pictorial construction rather than in the comparatively free realm of the plein-air oil sketch. Yet it is precisely in the inspirational paintings made in preparation for complex allegorical and historical representations that we find the closest tie with the style or manner of paint application in the Impression. With their patches of paint, their rapid gestures, their uses of brilliant, unmixed color, the compositional sketches of academic painters have been seriously collected and studied in the twentieth century, in recognition of their seeming modernism. The oil sketches of Rubens and Tiepolo were well known to French nineteenth-century artists, and Fragonard's small-scale works made with large brushes were widely accessible in public collections.

The extraordinary sketch for *Judith and Holofernes* by Henri Regnault (fig. 12) provides an example of an artist who appears to be thinking with his brush. Although Regnault went back later to the torso of Holofernes in a deliberate manner, the composition was clearly laid in very rapidly, as if under the influence of a sudden inspiration. The artist seems to have rushed to complete his compositional thoughts,

12 Henri Regnault
*Judith and Holofernes, c.*1869
Oil on panel, 15.6 x 23.8 cm
Private collection

suggesting that a slower mode of work might have failed him in his search for the elusive totality of his idea.[20] Such free or rapid painting was encouraged during the preparatory stage when the artist was inventing a composition; rapid painting in the academic process has everything to do with the concept of composition. The *croquis* (inspirational compositional study) was the first step, followed by careful study of all aspects of the composition in drawn and painted form. The painter would then re-ignite his process by laying in the basic outline on the larger canvas in the form of an *ébauche* which was, in turn, covered with carefully blended passages of paint, the qualities of which were suggested by the period of study. Thus the correct academic process had two stages of rapid painting—the miniature one at the beginning (*croquis*) and the full-scale one at mid-point (*ébauche*).

[19] In a revealing study, Peter Galassi has claimed that most aspects of form considered to be photographic have undeniable prototypes in the plein-air oil sketch. The style of photographs is as much part of a larger visual discourse as any style of painting. And many landscape photographs were made by the same kind of artists and for the same reasons (those of study and analysis) as those who made plein-air oil sketches. See Peter Galassi, *Before Photography: Painting and the Invention of Photography*, Museum of Modern Art, New York, 1981.

[20] Albert Boime has studied this type of painting with great care; see *The Academy and French Painting in the 19th Century*, Phaidon, London, 1971.

13 Edouard Manet
Study for "The Surprised Nymph", 1860
Oil on board, 35.5 x 46 cm
Nasjonalgalleriet, Oslo

For artists who were embodying narrative passages in visual terms, it was necessary to translate the essence of the subject into a composition that would unify the disparate elements that made up the scene—figures, attributes, gestures, setting, props. In order to achieve this unity, the composition had to be conceived *in toto* before its elements were considered in detail. If the entire process was successful, the finished work of art would retain the freshness and unity of the *croquis* in spite of the complex processes of study and finish that were necessary to complete it. Speed of execution was thus associated with spontaneity, which was, in turn, associated with both inspiration and unity. The fact that these qualities of form were not intended for public eyes, but were, rather, a necessary part of a layered process of creation in no way lessens their importance for the theory of art. And, in the same way as the plein-air oil

14 Edouard Manet
Copy after Delacroix's "Barque of Dante," c.1854
Oil on canvas, 33 x 41 cm
The Metropolitan Museum of Art, New York
H. O. Havemeyer Collection, Bequest of
Mrs. H. O. Havemeyer, 1929

sketch, *ébauches* and other freely painted oil sketches began to make their way onto the market after the deaths of artists such as Chenavard (d. 1845), Delacroix (d. 1863), and Regnault (d. 1871). Several of the amateur collectors of Impressionist paintings were also purchasing small-scale *ébauches* by mid-century artists at the same time.

When Manet was painting his own *ébauche* for an important early exhibition picture, *The Surprised Nymph* (fig. 13), and even when he was making a free copy (fig. 14) of Delacroix's famous *Barque of Dante*, he demonstrated complete familiarity with both the academic theory and the practice of the *ébauche*. Manet wanted his "copy" after Delacroix to be the precise opposite of a slavish imitation. He wanted to ensure that his own work could never be mistaken for one by Delacroix, and yet to be inspired by Delacroix to the same levels of compositional invention that would have enabled the

earlier artist himself to complete a *croquis* or an *ébauche* for his own finished painting. Theoretically, this free copy used the armature of the object to be copied as a source of inspiration in composition, rather than as a series of lessons about surface organization.

It is also fascinating, and important, to look at the *ébauches* of the greatest academic painters in France during the era of Impressionism—Pierre Puvis de Chavannes (1824–98) and Gustave Moreau (1826–98). Although Puvis was known for complex and carefully constructed compositions,[21] he planned them by making freely painted *croquis*. In working these out in session after session, he altered them—adapting certain segments and leaving others relatively unchanged—until he had a whole that suited him for use as the basis for the figure drawings and the under-painting (*ébauche*) of the final composition. In *The Greek Colony, Massilia* (fig. 15) the entire setting was defined with viscous paint in the simple zones of sky, mountain, sea, and earth (with the last left simply as primed canvas). On this ground, the various figures and figure groups were laid down with large brushes and calligraphic strokes; many were left without change, while others were painted over until he was satisfied. At no point did he bring any one part of the composition into a state of finish, but rather worked rapidly, considered his work, and then worked equally rapidly to adapt it. Puvis in fact rarely brought his works of art to the level of verisimilitude that would have been required by the neo-classical

academic artists with whom he is routinely compared. He allowed the same uniform surface texture and almost featureless facture of his *ébauche* to carry over into his finished works of art—in contrast to an artist like Jean-Léon Gérôme, whose painting surfaces were completely smooth and gestureless and who found Puvis's to be banal and dry, more like underpaintings than truly finished works of art.

If the *ébauche* was crucial to the aesthetic of Puvis, it was even more so in the oeuvre of Gustave Moreau, yet their *ébauches* were as different as their completed

[21] These were greatly admired by Maurice Denis and Paul Gauguin.

16 Gustave Moreau
*Sketch, c.*1878
Oil on cardboard, 47 x 33 cm
Musée Gustave Moreau, Paris

[22] Most historians of nineteenth-century art would be shocked by the attempt to find anything other than a superficial resemblance between such works by Moreau as *Sketch* and *Study after a Model for Salome* (Musée Gustave Moreau, Paris, inv. nos. 1141, Des. 1588) and works by the most important teacher of chromatic abstraction in America, the German painter Hans Hofmann. However, the idea intrinsic to Moreau's "abstract" studies is that painting communicates as much through chromatic interaction as it does through representational forms, which is surely analogous to the pictorial principles of Hofmann. Although certain of Hofmann's paintings of the 1940s and 1950s are significantly larger than Moreau's sketches, the majority of his work is strictly comparable in scale.

works of art. Whereas Puvis minimized gesture, Moreau gloried in it, and his oil *ébauches* (fig. 16) look almost as if they could have been painted by Hans Hofmann in the early 1950s.[22] Strongly gestural and reveling in the materiality of the paint, they have been assumed to be related to specific works of art, but scholars have struggled to identify which. Many of them do not contain any identifiable representational forms. They are among the earliest abstract works of art, not because they have no

attachment to a representational enterprise, but because that attachment is so sublimated that it cannot be measured. For this reason, these works are frustratingly difficult to date, and it is tempting to assume that they are very late simply because they *are* so seemingly abstract. However, the sheer number of them within Moreau's oeuvre makes it clear that he painted in this manner at least as early as the 1860s. Therefore it is completely valid to consider them within the larger context of rapid painting in France.

GESTURE IN OLD MASTER PAINTING: A GESTURAL TOUR OF THE LOUVRE

17 Sébastien Bourdon
Descent from the Cross (detail),
second quarter of the seventeenth century
Oil on canvas, 303 x 157 cm
Musée du Louvre, Paris

To spend half a day in the Louvre, strolling through the galleries in search of gestural painting, is a fascinating exercise. We know that Manet, Degas, Cassatt, Cézanne, and Renoir haunted the Louvre, and that even Pissarro, after threatening to burn it in order to "save" painting from the strangulation of precedents, went furtively in the 1870s and with increasing openness in the last two decades of the century. Many art historians have followed Cézanne in his wanderings, mostly in search of the works of art that he copied in his small-scale sketchbook.[23] Others have gleefully recounted the tale of Monet obtaining a license to copy in the Louvre so that he could take his canvas and easel up to the balcony or gallery window to "copy" the view of Paris![24]

Where to begin such a tour? You could rush instinctively for Delacroix, avoiding Ingres, and you could favor Frans Hals and Rembrandt over Vermeer and van Mieris. Yet there would be many surprises along the way. You would think, for example, that the Rubens cycle in the Marie de Medici Gallery would be chock full of juicy passages and gloriously autograph gestures, but these are in fact confined to the areas of water, drapery, and clouds. It would be difficult to predict that the big historical machines of the classicist Baron Antoine Gros would yield the same qualities of form expected from Rubens, yet the snow, hair, and foreground limbs of the victims in Gros's great *Napoleon on the Battlefield of Eylau, February 1807* (1808, Musée du Louvre, Paris) have as great a gestural panache as anything in the Medici cycle. You would not hurry to Sébastien Bourdon's *Descent from the Cross* (fig. 17) in search of gestures, nor think that Simon Vouet could paint with real abandon in *Portrait of a Young Man* (fig. 18), made in the 1620s. Less surprising, but equally revelatory, are paintings by Jos de Momper and by Rembrandt, including the latter's famous *Self-Portrait with a Cap* of 1660, acquired by Louis XV, and the infamous *Slaughtered Ox* (fig. 19), which entered the Louvre in 1857. In the Italian galleries, works by Titian, Tintoretto, and Bassano cry out for attention.

The truth is that little in academic instruction actually taught an artist a language of representational gesture. Instead, solitary wanderings through the Louvre provided several generations of artists with lessons in how to gesture with brushes and paint. Scumbling could be learned from Gros, Géricault, or Delacroix; deft curvilinear gestures in areas of drapery and clouds from others such as Fragonard, and wonderful jabbings of the brush from Hals. The repertoire of gestural painting in the Louvre was increased immeasurably when the La Caze bequest made its appearance, all in one room, in 1869. The wonderfully free and loosely painted works by van Dyck, Rubens, Hals, and Ribera were just many and varied enough to have sent contemporary painters back to their studios, inspired.[25]

18 Simon Vouet
Portrait of a Young Man (detail), *c.*1620
Oil on canvas, 55 x 41 cm
Musée du Louvre, Paris

19 Rembrandt Harmensz van Rijn
The Slaughtered Ox (detail), 1655
Oil on panel, 94 x 69 cm
Musée du Louvre, Paris

[23] See Lawrence Gowing, *Cézanne: The Basel Sketchbooks*, Museum of Modern Art, New York, 1988; Theodore Reff and Innis Howe Shoemaker, *Paul Cézanne: Two Sketchbooks*, Philadelphia Museum of Art, 1989.

[24] There are many accounts of Monet's views from the Louvre; perhaps the most succinct is Kermitt Champa, *Studies in Early Impressionism*, Yale University Press, New Haven and London, 1973, pp. 15–17.

[25] The taste for such sketches and freely painted works among the Old Masters is a modern one. The most freely painted pictures in the Italian seventeenth- and eighteenth-century galleries of the Louvre were not acquired until the twentieth century.

20 Jusepe de Ribera
The Clubfooted Boy (detail), 1642
Oil on canvas, 164 x 93 cm
Musée du Louvre, Paris

Certain works from the La Caze bequest can be singled out as demonstrating an entire range of chromatic and gestural lessons, which were assiduously absorbed by the artists in this study. In Ribera's *Clubfooted Boy* of 1642 (fig. 20), although the figure is conceived in a series of rather tight, dry passages of paint, both the tree and the background elements were painted with remarkable gestural abandon, with such sheer love of paint that Manet, Degas, and Renoir must have looked at it long and hard. Frans Hals's *La Bohémienne* (fig. 21) combines linear gestures with deft curves that seem at once to define contour and to communicate a sort of private calligraphy without representational meaning. Then there are the oil sketches by van Dyck and Rubens which entered the Louvre just in time for Manet and Renoir to see them.[26] Van Dyck's *Martyrdom of St. Sebastian* (fig. 22) is loosely painted throughout the field,

[26] One wants them to have been there for Boucher and Fragonard to study, but this was not the case.

21 Frans Hals
La Bohémienne (detail), *c.*1628–30
Oil on panel, 58 x 52 cm
Musée du Louvre, Paris

22 Anthony van Dyck
Martyrdom of St. Sebastian (detail), *c.*1615–16
Oil on canvas, 144 x 117 cm
Musée du Louvre, Paris

23 Peter Paul Rubens
Abraham and Melchisedech (detail), *c.*1620
Oil on panel, 49 x 65 cm
Musée du Louvre, Paris

24 Peter Paul Rubens
Head of an Old Man (detail), *c.*1610
Oil on panel, 51 x 40 cm
Musée du Louvre, Paris

and Rubens's *Abraham and Melchisedech* (fig. 23) and his *Head of an Old Man* (fig. 24) must have been revelatory for young painters of the 1870s and 1880s. La Caze was also fascinated by the portraits of Fragonard, such as the *Abbé de Saint Non* (see fig. 8) and *Monsieur de La Bretèche* (1769; Musée du Louvre, Paris).

Many of the most freely painted works in the Louvre share walls and galleries with works that are utterly unlike them. A gestural tour of the museum needs to cover virtually the entire suite of paintings galleries, and the gestures seem like scatterings in the history of painting—composition is a much more obvious issue. Ernst Gombrich would have to walk a long way in the miles of the Louvre to find "one single unlabored line, a single brushstroke, drawn with ease so that it seems that the hand moved without any effort or skill and reached its end by itself, just as the painter intended it."[27]

"UNE IMPRESSION DURABLE": THE ENTRAPMENT OF TIME IN FRENCH LANDSCAPE BEFORE IMPRESSIONISM

At the heart of a certain strand of French landscape theory is a virtual obsession with time. In his immensely important *Traité de perspective, etc.*, of 1800, Pierre-Henri Valenciennes created a temporal conundrum for the landscape painter by stressing the importance of *paysages historiques* (classical historical landscapes) and simultaneously exhorting the painter to study the most immediate and fleeting aspects of natural scenery. The great painter of the historical landscape, he suggested, could create vivid and immediate images of history by setting them in landscapes that were in complete accord with contemporary experiences of nature. In this way the past was made present, creating an oddly hybrid sense of time.[28]

Valenciennes's most theoretically persuasive follower, Jean Baptiste Deperthes, published his *Théorie du paysage* in 1818, in which the temporal dimension of the landscape and its representation are fully dealt with. For Deperthes, the precise aim of the landscape painter was the creation of what he called *une impression durable* (a lasting impression). This important text discusses landscape representation in ways little different from those of Jules Laforgue, writing more than sixty years later.[29] Both the landscape itself and the painter who attempted to transcribe it were in the throes of constant movement. Light and temperature were ceaselessly transforming the landscape itself, giving the painter no time to capture his fleeting sensations before those sensations themselves had changed. As the painter attempted to grasp the fleeting, temporally charged landscape, he or she was also changing, adapting eyes, mind, and sensibility to the shifting world of appearances in a symphony of change.

This situation of flux, the ultimate logical conundrum, was seen to be at the very core of landscape painting, and the artist's degree of success at combating the inherent impossibility of his task came to be a new rallying cry. Far from being the easiest form of art—the lowest end of the hierarchy of genres, as the academy had taught—landscape painting became, in its own theoretical literature, the most difficult of the genres. An increasingly important aspect of that theory was the notion that the true motif of the landscape painter was not form, but time itself. Painters were aiming to represent such unpaintable or unstable phenomena as wind, sunsets, the rustling of leaves, waves that move across the surfaces of water, and clouds that form and re-form in the sky. The effect of light upon form came to obsess artists as much as form itself. In this way, landscape painting came to be associated with ideas that border on abstraction: artists recognized clearly that their task was, theoretically, impossible. The *idea* of landscape became so ultimately elusive in the theory of landscape that the artist who chose this genre was tempting fate.

It is in the link between the rapid painting associated in academic theory with inspiration and the idea of landscape as endlessly transformative that the theoretical underpinnings of Impressionism are to be found. Whereas the plein-air oil sketch failed in its project, the *croquis* and the *ébauche* provided the artist with the technical means to produce the Impression—or, at least, a painting that looked like an Impression. This situation, conjoined with an art market developing independently of State support and domination, provided both a forum and a market for painting that was informal and improvisational.

[27] Ernst Gombrich, *Art and Illusion*, op. cit, pp. 193–4.

[28] Although Roger de Piles had written eloquently about the landscape in the seventeenth century, the genre more or less lapsed until the late eighteenth century. Valenciennes's book was the first great text on the subject.

[29] Laforgue's famous essay of 1883 (see Appendix, pp. 233–35) is the single most important piece of theoretical writing on the subject of rapid painting in Third Republic France.

RAPID PAINTING AMONG BARBIZON ARTISTS AND IN THE SALON

Painters of the Barbizon school—Théodore Rousseau, Corot, Troyon, Diaz de la Peña, and Daubigny—have long been contrasted with their followers, the Impressionists. The contrast is generally made in two ways: first, by asserting that the majority of landscapes produced by Barbizon artists were painted in the studio from studies that were not, in themselves, finished; and, second, by noting that Barbizon landscapes tend to be constructed by contrasts of light and dark rather than in terms of color. Impressionist landscapes are at once more spontaneous and brighter than their predecessors.

This is in large measure true, but other critical aspects of form associated with the Barbizon school are directly linked to the rapid gestural painting that became the Impression. One important aspect is perhaps the least obvious. In the passages of their Salon paintings that represent vegetation, water, and clouds, Corot, Rousseau, Diaz, and Daubigny often painted with real abandon, using large brushes to create gestures that the viewer is encouraged to read as gestures. A stroll through the early galleries at the Musée d'Orsay or the nineteenth-century European painting galleries in the Evans Wing of the Museum of Fine Arts, Boston, or the Meyer Galleries in the Metropolitan Museum, New York, reveals that many of the largest landscapes of these artists were painted with very large brushes, and that many of the subsidiary forms or the forms in movement were painted quickly, often with a loaded brush. Daubigny's and Corot's tree branches are often lyrical gestures, and many of their passages of water and sky were done in ways that their contemporaries would have found crude. The fact that the largest of their landscapes had the crudest passages of paint was not accidental: when these works were hung high on the huge Salon walls few viewers could actually see the strokes, and the painters were well aware of this. However, the young Impressionists often saw the submissions of the Salon exhibitions before they were hung—and would have been inspired by them to be bolder in their factures. Furthermore, a good deal of the vast canvases of Courbet and the backgrounds Manet's Salon paintings were painted quickly in order to remain in the background, like blurred passages, around the central figures. An avant-garde painter of the 1860s looking to find a repertoire of gestures to act as a grammar of rapid painting would have been able to find it at, of all places, the Salon!

The second aspect is to be found in the smaller-scale pictures intended for commercial galleries. Barbizon painters made such works in increasing quantity in the 1860s and early 1870s; many of them were bought by the Dutch artist Hendrik Willem Mesdag (1831–1915), who was among the most important early European collectors of Barbizon painting outside France.[30] The Mesdag works tend to be tonal, often with only the sun or the moon acting as an accent in the dark realm of the landscape (figs. 25–28). Others, particularly those by Rousseau, employ overlapping wet-on-wet strokes to represent the shifting movement of leaves or the effect of wind on water or clouds. The aesthetic and commercial conditions under which these works were created were little different from those of the Impressionists. The men and women who bought them wanted works that were completely personal and individual, in which the hand of the artist affected every aspect of the completed painting.

The third aspect of Barbizon production crucial to the establishment of a viable prehistory for the Impression is plein-air etching and printmaking. Both Corot and Daubigny were intensely involved in the production of inexpensive landscape prints

[30] Mesdag built a large and important house in The Hague in 1887 to house his collections and to make them available on a limited basis to other artists and to the public. The collection of over 360 paintings, half Dutch and half French and all but a handful from the nineteenth century, was given to the State at the artist's death in 1915. It has had an uneven history, but since 1990 it has been administered by the Van Gogh Museum in Amsterdam. Van Gogh himself knew its contents, which is why we decided to choose from it works by great Barbizon painters as the first "parenthesis" to this exhibition, with the work of van Gogh as its second. The collection is thoroughly published in English by Fred Leeman and Hanna Pennock, *Catalogue of Paintings and Drawings: Museum Mesdag*, Amsterdam, 1996.

25 Charles François Daubigny
The Banks of the Oise, 1872
Oil on panel, 34.7 x 58.3 cm
Museum Mesdag, The Hague

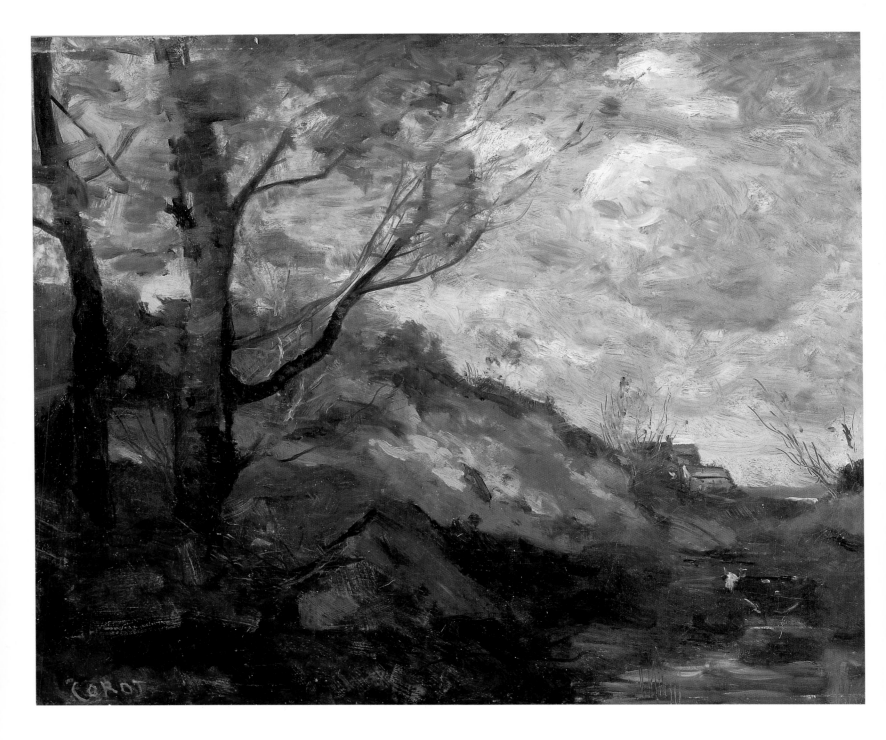

26 Jean Baptiste Camille Corot
*Well among the Dunes, c.*1854
Oil on panel, 46 x 56 cm
Museum Mesdag, The Hague

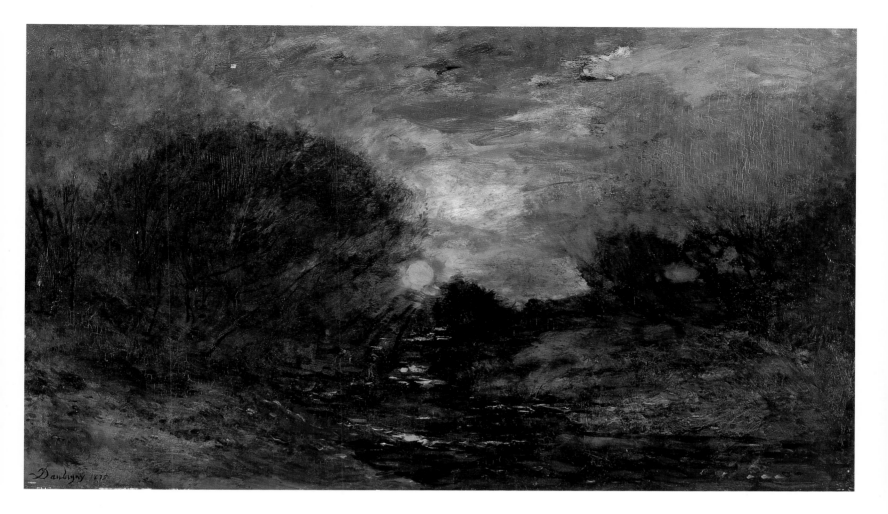

27 Charles François Daubigny
April Moon (*La Lune Rousse*), 1875
Oil on panel, 65 x 110 cm
Museum Mesdag, The Hague

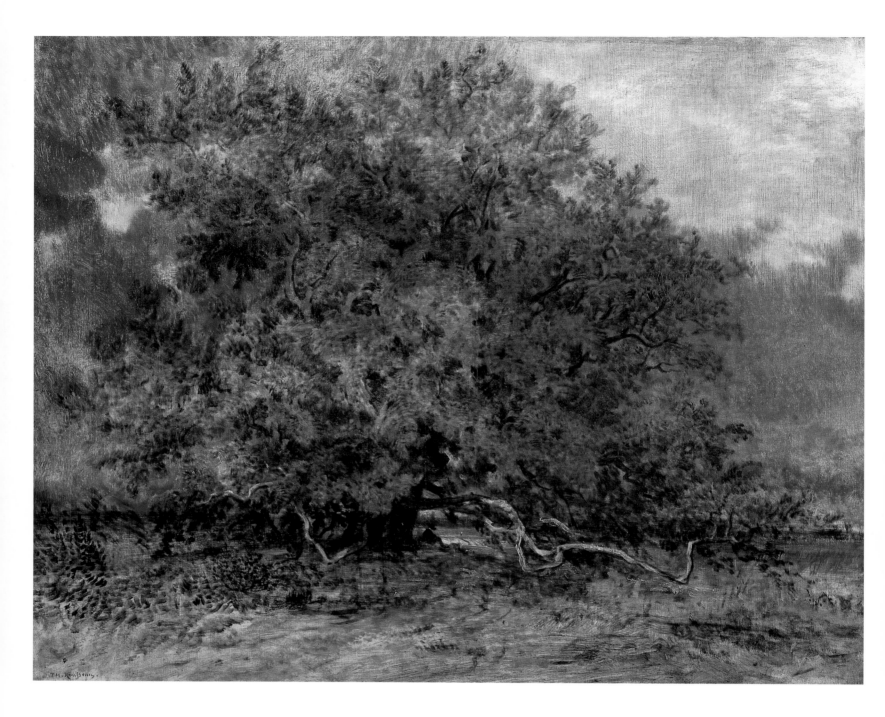

28 Théodore Rousseau
The Crooked Tree by the Carrefour de l'Epine, 1852
Oil on canvas, 81.8 x 100.6 cm
Museum Mesdag, The Hague

29 Jean Baptiste Camille Corot
Souvenir of Bas-Bréau, 1858
Cliché-verre, 20 x 16.2 cm
Sterling and Francine Clark Art Institute,
Williamstown, Massachusetts

for friends, amateur artists, and collectors during the 1850s and 1860s; many of these are among the freest and most rapidly made works in any medium produced in the nineteenth century. The most important for our purposes are *clichés-verre* and etchings.[31]

[31] For more on these, see Elizabeth Glassman and Marilyn F. Symmes, *Cliché-Verre, hand-drawn, light-printed: A Survey of the Medium from 1839 to the Present*, Detroit and Houston, 1980, and the discussion of plein-air etching by Barbara Shapiro and Michel Melot in *The Impressionist Print*, Yale University Press, New Haven, 1996.

The more technically innovative of these mediums was the *cliché-verre*, a photographic technique in which the artist either painted the whole composition on a glass plate, or brushed a ground on the plate and then used needles and other tools to remove it selectively. When dry, the glass was placed in direct contact with a photosensitized sheet of paper, and light exposed the paper in the negative areas of the plate. Of the many artists who made *clichés-verre*, Corot was the most important in the 1850s and 1860s (fig. 29). His works are generally so remarkably loosely painted and so nervous in their linear structure that they seem to have been produced in states of intense emotional excitement.

30 Charles François Daubigny
Cow at the Watering Place, 1862
Cliché-verre, 16.5 x 20 cm
Sterling and Francine Clark Art Institute,
Williamstown, Massachusetts

Clichés-verre were occasionally, but rarely, exhibited in the 1860s and 1870s; most of those by Corot are better known through posthumous reprints than from prints made under the artist's own supervision. The originals were generally made for members of the colony of artists and amateurs who worked in and around Barbizon, Chailly, and the other villages around the rim of the Forest of Fontainebleau. Shared among like-minded individuals, they formed part of a private visual language that was outside the realm of public culture because it was unregulated.[32] Of particular interest to us here is a superb *cliché-verre* by Daubigny (fig. 30), painted with variously viscous and variously transparent liquids on a glass plate, which was subsequently printed. Because Daubigny spent the vast majority of his time in the 1860s and 1870s in Auvers, his *clichés-verre* could have been accessible to such artists as Pissarro, Morisot, and Cézanne.

Starting in the late 1850s and increasingly in the early 1860s, Barbizon artists began to take prepared copper plates and tools directly into the landscape, and to create etchings *en face du motif*. In spite of the inherent indirectness of the printmaking technique, etchings of this type have an immediacy that is almost totally absent from plein-air landscape oil sketches of the early and mid-nineteenth century. Corot and Daubigny re-created natural appearances with thousands of small-scale gestures, many of which overlap to produce a flurry of graphic incidents. Their plein-air etchings form one of the most important series of gestural prototypes for the Impressionist stroke, and have undeniable formal affinities with the Impressions of, in particular, Renoir and Sisley. An overall field of short, wrist-motion gestures that form comma-like lines is common enough to be called standard practice in Impressionism

[32] The registration and publication of lithographs, wood-engravings, and other types of graphic print were all governed by French law.

of the mid-1870s; no works in the previous history of art share this mode of gestural construction more fully than the plein-air etchings of the Barbizon school.

THE CHALLENGE OF
PHOTOGRAPHY:
SPEED AND DURATION
IN MECHANICAL
REPRESENTATIONAL ART

Of all representational media in western art, none has caused more serious questioning of the temporal nature of art than photography. Although exposure times in the mid-nineteenth century were notoriously long—too long to produce any visual effect of immediacy—the time needed to take a photograph was so much less than that required by any other representational media that commentators were forced to link photography with time. Photographs "stopped" or "froze" time in a way that made them as much about time as about the forms that were represented. The sense of actuality conveyed by a photograph had to do with the fact that it recorded the actual time of its making. The fact that Napoleon III, say, looked like this on a particular day at a certain time, in a photograph made on that day and at that time, was a quality unique to the medium. Painted portraits do not carry the same value as documents of record. The challenge to non-mechanical media to compete with this sense of immediacy was great indeed.

Countless essays on photography in its early years considered the new medium to be a real threat to painting.[33] The arguments were both simple and powerful. The most pervasive was that photography, because of its accuracy, immediacy, and relative ease of production, would gradually usurp from painting its historic representational role, forcing the older medium into smaller and smaller aesthetic arenas. The record-keeping and indexical roles of painting, drawing, and printmaking would be the first to go—and, indeed, they were. Photographers could record buildings, people, plants, products—indeed, all things—more accurately than artists who used their hands. Only technical draftsmanship, architectural or mechanical, could produce work that vied with photographs for accuracy.

Yet if photography could stop or freeze time, creating an eternity out of a moment, painting and drawing could represent time by recording motion. The flowing water in Simon Denis's *Torrent at Tivoli* (see fig. 10) has a good deal more veracity than the waterfalls of early photographs, which are reduced to a white blur (fig. 31). And painters were considerably more faithful in their representation of wind, clouds, and other atmospheric ephemera than their contemporaries who used cameras. Painters increasingly turned their attention to aspects of landscape that were inaccessible to photographers, who were limited by their fledgling technique. It is perhaps no accident that by the time it became possible to photograph in color and with short enough exposure times to record short duration, Impressionism was already dead. As cameras developed better, easier, more efficient, and more accurate ways of representing time via motion, the Impressionist movement in painting became obsolete.

Another topic of mutual interest to both photography and the Impression was blurring of form. In both media, this became a visual code for motion. The long exposure times and the grainy nature of the paper negatives in early calotype photography made all moving forms blurred or contourless. The gestural oil sketch had exactly the same qualities. Since drawing (bounding forms with line) was unimportant in the creation of an *ébauche* or an Impression, both of these modes of painting shared

33 The most succinct and accurate discussion of early reactions to photography from the world of painting remains Aaron Scharf's pathbreaking book *Art and Photography*, London and New York, 1968, especially pp. 11–28. No serious attempt has been made since to collect and analyse the many texts published in art and photography journals of the 1840s and 1850s. In independent enquiries and exhibition reviews, many writers dealt probingly with the nature of representational reality in terms of the questions raised by photographic images and their discourses.

31 Thomas Moran
Great Falls on the Limón River, 1871
Albumen print, 27.5 x 20.2 cm
George Eastman House, Rochester, New York

with early photographs a sense of motion temporarily compressed. This quality often has to do with the gesture and directionality of represented motion. In an early photograph, a blurred form was blurred in a certain way because the form was moving in a certain, recordable direction. So, too, the painter's gesture. In recording drapery or a cloud, or the effect of wind on foliage, the artist's hand moved in a certain direction in wet paint, and this very directionality conveyed a similar directionality to the represented motion of the form. Viewers familiar with the blurred forms in early photographs will be better able to read *ébauches* and Impressions than those who have looked mostly at paintings, whether in galleries or in reproduction.

THE COLOR OF NATURE: LIGHT AND COLOR THEORY

[34] Of the early writers about Impressionism, Paul Signac was the most fervently attached to the movement's chromatic advances; see note 5.

[35] The most accessible single source for these scientific writers is Robert L. Herbert et al., *Georges Seurat, 1859–1891*, Metropolitan Museum of Art, New York, 1991, which contains separate short chapters on David Sutter, Michel-Eugène Chevreul, Ogden Rood, and Charles Henry. These notions are also well discussed in *Paul Signac and Color in Neo-Impressionism*, ed. Floyd Ratliff, Berkeley, 1990.

[36] Zola is extensively discussed in connection with Impressionism in the scholarly literature, both with regard to Manet and to the urban realism of Degas, Caillebotte, and Forain. Certain paintings have been specifically linked with Zola's suburban novels. Works by Degas have been associated both with *Thérèse Raquin* (1867) and *L'Assommoir* (1877), while Renoir made at least one illustration of the latter novel. Manet created a painting entitled *Nana* in the years just before the appearance of the novel of the same name (1879–80). See also Werner Hofmann, *Nana: Mythos und Wirklichkeit*, Cologne, 1973, and Robert J. Neiss, *Zola, Cézanne, and Manet: A Study of "L'Oeuvre,"* Ann Arbor, 1968.

[37] Charles Cros first published "Procédé d'enregistrement et de reproducton des couleurs, des formes et des mouvements" in *Les Mondes* in February 1869. Louis Ducos du Hauron's text, "Procédé pratique d'obtenir et la fixation des couleurs," was published in *Cosmos* the same month. The same year, both enlarged their texts into books: Louis Ducos du Hauron, *Les Couleurs en photographie, solution du problème*, A. Marion, Paris, 1869, and Charles Cros, *Solution générale du problème de la photographie des couleurs*, Gauthier-Villars, Paris, 1869 (they are both reprinted in *Two Pioneers of Color Photography: Cros and du Hauron*, ed. Robert Sobieszek, Arno Press, New York, 1979). Cros circulated widely in artistic circles and his text was probably available to a larger audience than Ducos du Hauron's. The argument between the two over precedence became a subject of lively interest in Parisian photographic circles, so it is likely that a wider circle of artists learned of the debate.

For many, the value of Impressionism lay not so much in its touch or its achievements in composition, but in the radical new way its artists saw color.[34] Rather than conceiving of a picture as the representation of a series of discrete, separately colored three-dimensional forms in illusionistic space, the Impressionists sought a visual field of vibrating color sensations. This philosophical dematerialization of pictorial reality is crucial to the idea of Impressionism and its central achievement, the Impression. All the evidence indicates that the origins of this theory can be found in the sciences.

Georges Seurat read the writings of the scientists Rood, Helmholtz, Chevreul, and others as he prepared to make his representational project modern by allying it to this most modern arena of human thought.[35] His idea was to create a scientific Impressionism, to counter the "romantic" Impressionism that preceded him. He was scarcely the first to follow such a strategy. The novelist Emile Zola, the poet Charles Cros, and many writers of the 1860s and 1870s annexed the natural sciences to their art. Zola and Cros were friends of the artists whose work is central to this study. Zola was a childhood friend of Paul Cézanne, wrote eloquently about Manet, Monet, Renoir, Sisley, and Pissarro, and collected their works as his own career brought him the wealth to do so. In both his art criticism and his great project of novels, he linked contemporary art with new forms of observation and natural transcription based in the experimental sciences, particularly medicine. Artists, for Zola, were not on earth to serve politicians and people of power by idealizing either form or society. Rather, their function was to analyse through representation the actual character of society, of the individual in it, and of the moral structures that govern their interactions. This project was grounded in the "science" of observation and analysis, rather than in improvement or idealization. If it was at once subtle and sophisticated, a work of art could actually help society in its attempts to understand, and thus improve, itself.[36]

The young scientist-poet Charles Cros was an associate of Manet. Independently, but at about the same time, he and Louis Ducos du Hauron invented (or, at least, announced the invention of) color photography in 1869. The publications of both came just as the young Impressionists gathered for their first systematic painting adventure in the linked suburban villages of Bougival, Louveciennes, and Marly. Unfortunately, none of the early photographs of Cros or Ducos du Hauron survives, but their two texts do; Charles Cros's was widely enough published to be read by many educated Parisians.

Powerful conceptual links exist between their project, the printing of color photographs, and that of the Impressionists, the creation of color transcriptions of optical reality. Both Cros and Ducos du Hauron began their projects by conceiving of nature perceptually—as colored light that could be systematically analysed and thus reproduced. Three-dimensional forms revealed by light and given illusionist authority by shadows (the traditional reality of painters) were replaced conceptually with a single, vibrating field of light. Light attained character through its interaction with forms, but the aim of the color photographer was to reproduce the light itself, not the forms. Because Cros and Ducos du Hauron worked independently of each other, each was shocked by the publication of the other, and they wasted a good deal of emotional energy over the next decade in their attempts to prove priority of invention and announcement.[37]

Both men referred to nature in terms of what Cros called *le champ de vision* (the field of vision). This field was filled with points of light that could be read by the eye or, according to their new processes, by color-sensitive gels in transparent layers, the combination of which could produce a fully and accurately colored photograph. Color was divisible into components, there were primary and secondary colors, and the juxtaposition or superimposition of points of those colors could produce a flat facsimile of reality. Black and white, not being natural colors, were eliminated from their photographic palettes, at precisely the same moment that the painters achieved the identical conceptual breakthrough. They also eschewed line and never discussed the illusion of depth or shadows, referring only to color sensations. Their photographs were much discussed in scientific circles. The earliest prints by Ducos du Hauron that survive (from the later 1870s) have a pale and compositionally conventional quality, suggesting that it was not the photographs themselves but the theory behind their creation that could be linked with early theorizing about the Impression.

Cros and Ducos du Hauron were both influenced by Edmond Becquerel's massive book on light of 1867–8, which analysed the competing wave and particle theories of light as well as the concept of ether (the invisible substance through which waves of light travel).[38] This ether is remarkably similar to the "completely transparent vapor" through which Pissarro viewed a landscape motif in 1869.[39] Theories of light and of color have many similarities, especially as applied to color photography and the pictorial theory of the Impressionists. Becquerel's text ended with a remarkable analysis of the human eye, based on the premise that because the eye was the most sophisticated recording device for light, an analysis of it could help us to a more sophisticated understanding of light.

Opticality in science and in representation were of simultaneous concern, indicating that the worlds of science and art were more closely linked in the mid-nineteenth century than they have been since. It was the sciences that led to a conceptual shift in thinking about vision—and this, in turn, produced the conditions for an analogous shift in pictorial theory. No earlier artists had been able to consider landscape as an optical, rather than a physical, condition. No earlier artists were as aware that they painted not reality itself but an optical image of it, and that it was their minds, not nature, that produced this image. This dissociation from the material or three-dimensional and the concomitant embrace of the optical or two-dimensional is a primary paradigmatic shift in artistic consciousness, the radical nature of which has not yet been properly appreciated. When it became possible to link the visual with the project of recording and analysing movement or motion, then the conditions for the Impression were fully in place.

The Impressionists, like their friend Zola, underpinned many of their pictorial advances by reference to the natural sciences.[40] It is because Seurat made direct links with physics and light theory in his writings that his followers were called scientific Impressionists in contrast to those who preceded them, but there is really no such dramatic distinction between the two groups. The Impressionists of the 1870s made important advances in painting because they were liberated to do so by scientific theories.

[38] Edmond Becquerel, *La Lumière, ses causes et ses effets*, 2 vols., Paris, 1867–8.

[39] See Richard R, Brettell, "Pissarro in Louveciennes: An Inscription and Three Paintings," *Apollo* 136/369, November 1992, pp. 315–19.

[40] Indeed, Roger Fry's brilliant analysis of Impressionism of 1894 criticizes the painters for their reliance on science, accusing them of betraying art and beauty by straying into such territory. Interestingly, his criticisms came just as the scientific Impressionism of Seurat and his disciples had begun to wane.

TIME, MOTION, AND SPEED, 1840–1880

Few periods in European post-Renaissance culture were as obsessed with time and speed as the nineteenth century. Racked by political and social turmoil, governments were perceived as being as unstable and temporary as women's fashions (this was particularly the case in France). Virtually all writers about culture in Europe contrasted their bustling and unstable cultures to what were perceived (incorrectly, of course) to have been the traditional cultures of the *ancien régime*. Carts and carriages were replaced by faster and lighter forms of horse-drawn transport, and eventually by trains that moved with increasing rapidity through the landscape. Intensely bred horses ran faster and faster around better and better prepared tracks. Cities were rethought, rebuilt, expanded, and altered with such speed and assurance that many European urban dwellers hardly recognized as adults the neighborhoods where they had lived as children. As if the transformation in the environment was not enough, an ever-changing panoply of inventions and novelties in shop windows, industrial display buildings, and world's fair grounds forced people to feel that time was moving ever more quickly. This temporal shock created an industry of cultural nostalgia—in itself as modern as the sense of rapid time it sought to slow or even to stop. The restless and rapid were countered by the slow—theoretically, enduring—time of the museum, the university, and the academy.

Art played a central role in this nostalgia. From Ingres through Puvis de Chavannes to Maillol and Denis, artists sought to create works that stood forthrightly outside the onrushing time that was thought to encapsulate the modern condition. This anti-modern painting is, of course, also modern, but in ways that assume the artist's role in society to be fundamentally different from those analysed by Baudelaire.[41] His essays form a kind of verbal aesthetics of the modern in the visual arts, and exalt the artist who is immersed in the flux of modern urban reality, creating works that embody its transience and temporal fragility. This idea of the modern has been linked to Impressionism since the 1870s.[42]

What kind of time is there in Impressionism? We see trains—stopped in stations, raring to go, rushing over bridges, and scoring the landscape with their plumes of white steam. We see pedestrians in various combinations as they move through cities and suburbs. We see the flux of seasonal and diurnal time. We see wind, rain, fog, snow, hoarfrost, and other weather conditions that define the seasons. We see clouds of all sorts, and water in virtually every form—placid, unrushing, falling, breaking over rocks, gliding. We see boats, ships, canoes, and barges. We see factories, some of which pour smoke or steam into the sky. All of this seems like modern time.

But we also see rural workers chatting by the sides of roads, working in fields, and trudging to and from markets to sell produce, poultry, or meat. There is as much slow, natural, or pre-modern time in Impressionist painting as there is rapid time. There are mealtimes, times to read, and abundant, slowly moving leisure time. We also have in Impressionist painting a sense in which the time of *painting* is also represented—this is surely as modern as what one might call illusory time. All of these overlapping or co-penetrating times make it clear that, if modernity is largely defined by the sense that time moves more quickly and with less control by individuals, then Impressionism both celebrates and represents modern time. Many hundreds of Impressionist paintings convey a kind of temporal structure that is, essentially, unprecedented in painting; not

[41] In his crucial essays of 1846, 1855, and 1863; see Charles Baudelaire, *Art in Paris 1845–1862* and *The Painter of Modern Life*, trans. Jonathan Mayne, Phaidon, London, 1965, 1964. The last, inspired by the death of Delacroix, was his most daring. Ostensibly about the popular, but minor, draftsman Constantin Guys, "The Painter of Modern Life" was Baudelaire's most sustained analysis of pictorial modernism; it provided a model for essays by later poet-critics, such as Mallarmé, Laforgue, Verlaine, Apollinaire, Pound, and Valéry.

[42] Particularly in the suggestive criticism of Mallarmé and Laforgue; art historians from Francastel to Clark have discussed the ways in which Impressionist style and imagery court transience; for Mallarmé's review of the 1876 Impressionist exhibition, see Charles S. Moffett et al., op. cit., pp. 27–35.

[43] The presence of the train in novels, short stories, guidebooks, and letters has been synthesized by Wolfgang Shivelbusch in his brilliant book, *The Railway Journey: the industrialization of time and space in the 19th century*, New York, 1977. It conveys with utter authority and urgency the sense of onrushing time, of speed from a static position, and of the strangely erotic privacy granted to those who hurtled through space in a raised and cushioned compartment. It was the stillness and comfort of the rail passenger, contrasted with the rushing sensation of the world outside, that led Einstein to begin his reflections on relativity.

[44] In George Kubler's words; see *The Shape of Time: Remarks on the History of Things*, Yale University Press, New Haven, 1963. The most powerful expression of these notions is to be found in the eloquent writing of Kubler's teacher, the great French art historian Henri Focillon; see *The Life of Forms in Art*, trans. George Kubler, New York, 1992.

until the Futurist canvases of 1911–12 do we find works that are worthy successors to the rushing landscapes and cityscapes of the Impressionists. Earlier paintings made quickly tend to represent stabile motifs—seated figures, figure groups, cities dominated by architecture. For the Impressionists, the momentariness of the subjects was linked to the rapid temporalities of fashion and the machine.

For Baudelaire, modernity was defined by motion. The seeker after modernity is almost always moving, and Baudelaire has him walking, quickening his pace, or roaming. Even looking, for Baudelaire, is active, involving physical motion; the modern artist consumes the world while he is on the move. Both the beholder and the world in which he is immersed are in flux. Yet Baudelaire's aesthetics of motion seems timid when compared with the almost omnipresent anxiety about the rapidity of change in the second half of the nineteenth century, an anxiety that filled all forms of popular written discourse in France. In novels and plays, Parisians seem always on the move—moving house, dodging creditors, changing clothes for an evening out, preparing to leave the city for a little quiet time, or returning home exhausted from all the stimulation. This anxiety is not about time *per se*, but about its sheer rapidity and the sense of being immersed uncontrollably in perpetual movement. The symbolic focus for all this anxiety was, of course, the train.[43] Zola, in his terrifying novel *La bête humaine* (1890), treats us to intoxicatingly immediate evocations of the noises and smells of the steam train; his characterizations of it as it rushes through the landscape are unforgettable.

Parisians were worried about the banality of new buildings, the loss of old neighborhoods, the effective removal of their beloved river Seine caused by the construction of new quays, the traffic in the newly widened boulevards, and the fact that they knew fewer and fewer neighbors. In most of these anxieties, modern time was blamed for such inexplicable, rapid, uncontrollable changes. The phrase *ancien régime* increasingly came to embody the belief that, before the Revolution, time moved slowly, governments were stable, and families remained together. The political structure may have been unjust, but at least there was stability. The enterprise of the Impression took place in this historical context, when time was being perceived as uncontrollable. Impressions served both to stop and to shape time.[44]

THE WORK WITHOUT END: THE PROBLEMS OF "FINISH" AND THE EXHIBITION PICTURE

One of the principal problems of modern pictorial aesthetics, and one of the most frequent criticisms of Impressionist exhibition pictures, involves the concept of "finish." European critics and the public had been shown hundreds of thousands of paintings since the beginning of the century that had uniform, gestureless surfaces— a level of finish that was thought to be acceptable. Although there were notable exceptions to this rule (Constable, Turner, Courbet, Rousseau), they remained exceptions, and the vast majority of paintings were exhibited with smooth, varnished surfaces that were intended to be penetrated almost as one penetrates a window to view a landscape. Rough paintings were usually linked with low subject matter, reinforcing the notion that crudity of surface meant crudity of subject.

Throughout the 1860s, avant-garde artists were attacking the cozy illusionism of this notion and increasingly exhibiting works painted with large brushes, even with palette knives. The background of Manet's *Déjeuner sur l'herbe* of 1863 was painted in

almost the same manner as the stage flats at the Paris opera, but the latter were not intended to be viewed in a gallery. By the later 1860s, most of the Impressionists—including Monet, Pissarro, Renoir, Cézanne, and Bazille—sent large paintings to the Salon that were constructed with very large brushes and palette knives, in defiance of the concept of finish. The most obvious and the most common way of dealing with this was to describe the paintings as "unfinished," and to apply to them a pejorative language of "daubs" and "sketches," in which the most positive term was "study." The works were treated as if they were the products of students who were not yet ready, and whose works were not yet finished enough, for public exhibition.

The Impressionists were united in their defiance of these standards, and they were not alone. A quick examination of the Salon paintings of Corot, Rousseau, Daubigny, and Diaz de la Peña reveals that artists of the older generation were just as rebellious in their technique, but they were not accused so strongly of incompetence (once artists had proved themselves, it seemed, they were awarded greater freedom from critical judgment). The idea that a finished work needed to be both smooth and varnished held great sway, not just among academicians but also in public opinion—criticism of artists for producing unfinished works persisted well into the twentieth century in conservative circles. Degas, Monet, Cézanne, and Matisse all painted works that seemed to conventional critics and viewers as if they had been taken off the easel while they were still in process. If a work might be unfinished, how could it be judged as the final embodiment of the artist's intention?

This sense of a process without a clear termination point, of arrested time, created real anxiety in viewers—anxiety that progressive critics often treat with contempt, seemingly without realizing that it is precisely the response that the artists most likely wanted to provoke. Philippe Burty wrote: "The chief object of these gentlemen . . . was to present their works almost as in the same conditions as in a studio . . ."[45] He meant two things by this: first, that the style of presentation was informal and stressed the individual object rather than the exhibition as a whole; and, second, that the atmosphere of the studio allowed the artists the chance to exhibit works of different types and degrees of finish with appropriate informality. The artists themselves encouraged this informality by including words such as *esquisse*, *étude*, and *croquis* in their titles, as well as presenting works in various media from drawings and watercolors to prints.[46]

The social implications of the notion of finish involve concepts of decorum and proper behavior. If society deems it necessary to wear certain clothes appropriate to certain occasions, if speech is regulated by social practice, and if the press is controlled by government censors, then the painter lives in a regulated society accustomed to rules and to the orderly progression of life, rules that extend to the realm of art. Lawlessness within artistic circles was routinely connected in the critical press to radical politics or, at the very least, to socially unacceptable behavior. An unfinished work of art was an affront to accepted standards of artistic behavior. Conversely, when libertarian or anarchist critics judged these supposedly unfinished works, they praised them for what they saw as their embodiment of individual liberty and freedom of expression, both of which were antithetical to the workings of the academy and the state-sponsored systems of artistic judgment.

[45] See Berson et al., op. cit., p. 10.
[46] Emile Cardon called them "des ébauches imparfaites, des impressions hatives"; see Berson et al., op. cit., p. 11.

THE IMPRESSION: THE "OPEN" WORK OF ART, AND AN AESTHETIC OF INFORMALITY

It should now be possible to re-attempt a definition of the Impression, as a work that

1. was begun under the direct stimulus of a motif selected by the artist;
2. was brought to form without a clear plan as to its finished appearance;
3. makes frank use of its materials without attempting to disguise its process;
4. is composed in a mode of gestural language both unique to the artist and essential to its appearance;
5. seems to have been made in a short period of time, and
6. was completed by the artist, through the act of signature or exhibition.

The Impression is thus an open or informal work, whose structure is left largely to be discerned by its beholder, and whose relationship to its motif is less important than is our sense of the vitality or immediacy of its making. An Impression is a performative act of visual representation embodied in oil paint applied directly to canvas in discrete gestures. It records a temporarily compressed series of acts as much as it represents a motif.

When looked at this way, the Impression seems to be a kind of painted precursor to the modern works of art discussed by Umberto Eco in his brilliant essay of 1962, "The Open Work in the Visual Arts." Although Eco focused on paintings and sculpture by European artists of the 1950s and 1960s, his definition of open works of art is precisely analogous to my definition of an Impression:

> Art tries to give a possible image of this world, an image that our sensibility has not yet been able to formulate, since it always lags a few steps behind intelligence. . . . The discontinuity of phenomena has called into question the possibility of a unified, definitive image of our universe: art suggests a way for us to see the world in which we live, and, by seeing it, to accept it and integrate it into our sensibilities. The open work assumes the task of giving us an image of discontinuity. It does not narrate it, it *is* it. It takes on a mediating role between the abstract categories of science and the living matter of our sensibility. . . .
>
> The richest form of communication—richest because most open—requires a delicate balance permitting the merest order within maximum disorder. . . . This problematic, liminal situation is characteristic of painting that thrives on ambiguity, indeterminacy, the full fecundity of the informal, the kind of painting that wants to offer the eye the most liberating adventure while remaining a form of communication.[47]

Like many aesthetic philosophers investigating modernism, Eco wants art to be associated with what he calls vitality. This embrace of the informal and the unplanned has clear roots in the Baudelairean experiment as well as in the French obsession with *élan vital*.[48] If this strand in modern art is recognized as having been largely invented in the experiments of the Impression, we will come close to an appreciation of the radical nature of those late nineteenth-century paintings. Far from being a sort of baby step in a progressive history of painting that culminates in the obsessively formal art of Cézanne, the Cubists, and the masters of geometric abstraction, Impressionism at its most experimental commences an aesthetic journey that leads to the action painters and *tachistes* of the years following World War II.[49] This kind of open painting can be

[47] Umberto Eco, *The Open Work*, op. cit., pp. 90, 98.

[48] Vitalism was an important concept for the turn-of-the-century philosopher Henri Bergson (1859–1941); see Frederick Burwick and Paul Douglas, eds., *The Crisis in Modernism: Bergson and the Vitalist Controversy*, Cambridge University Press, 1992.

[49] These painters include Franz Kline, Willem de Kooning, Joan Mitchell, Pierre Soulages, Paul Borduas, and many others.

read as a counter-discourse to the more deliberate and slower modernism of Seurat, Cézanne, Gauguin, Picasso, Braque, Léger, Mondrian, Duchamp, Dalí, Magritte, and their various successors in the second half of the twentieth century. The Impression precedes, and presages, the Fauve experiment, a good deal of Matisse, the automatic drawing and painting of certain Surrealists, and all forms of post-war gesture painting —from Fautrier and Soulages through Pollock and Kline to Borduas and Riopelle.

THE PRODUCTION, EXHIBITION, AND SALE OF THE IMPRESSION

After Corot began to exhibit and sell freely painted works through the private art market in the late 1860s, the young Manet established a pattern of making and exhibiting rapid painting in the shops of private dealers. This practice paralleled his much-studied career as a Salon painter, and enabled young *boulevardiers* to see medium-scale, informally painted works of modern subjects in shop windows and private galleries. This "art of the boulevards" was an essential part of Manet's modernism, and a model for Monet, Renoir, Morisot, and Sisley in their production of paintings for sale. It also served as a model for the private exhibition, or works in urban contexts.

Manet continued in this practice until his death in 1883, even opening his studio to friends, critics, and clients throughout the 1870s, working while he chatted and served refreshments. This informal mode of production, in which artist, audience, and activity were temporarily conjoined, is at the core of a certain kind of Impressionist practice, one that was also followed by Renoir. Manet also practiced a related kind of informal painting on his trips and summer holidays, passing the time in rapid representation, undoubtedly destroying or scraping down more works than he completed. This private and isolated form of encounter was the model adapted by Monet, Sisley, and, to a lesser extent, Morisot, all of whom preferred to practice the difficult art of open painting in the country and alone. But they all exhibited works in private urban exhibitions, controlled largely by themselves, selling their works to clients through private dealers or by auction.

It must be borne in mind, of course, that none of the artists in this study limited their experimental production to Impressions. Even Monet and Morisot, the most faithful of the group to this mode, balanced such works within their larger production. They created highly mediated and complex works on the scaffolding of failed Impressions and conceived of large-scale exhibition pictures in ways that have their truest precedent in academic landscape and genre painting. In this they followed their hero, Delacroix, who died in 1863.

The works discussed in this study can be categorized in five general types. First, there are whole views, in which the artist conveys, by means of large-scale patches of paint, the overall character of his represented subject. Second, in contrast, are gestural accumulations, pictures built up through the layering of short, grammatically conceived strokes of paint that activate the entire surface. Third (and here I think of Manet and, to some extent, Renoir) are representations made with eloquent gestures, rooted fundamentally in the painterly tradition of Titian, Rubens, Giordano, and Fragonard. Here, the gesture simultaneously plays both a calligraphic and a representational function. Fourth, there is a certain type of rapid painting which is ineloquently gestural—it glories in the wetness of paint and in the painter's freedom to play in it

with various tools. Fifth, there are paintings (and here I think of Sisley and Morisot) that seem almost to be pictorial scribbles, in which the painted gestures are neither eloquent nor grammatical. They court the chaos and messiness adored in the twentieth century by Fautrier, Bataille, and Eco with an aggressively unsystematic welter of lines turned upon themselves. Interestingly, all five types of gestural painting exist simultaneously in French practice during the period 1860–1890, each of them making their own contribution to painting *qua* painting.

PREPARING AND MAKING AN IMPRESSION: WAITING AND RISKING

The fact that the painters represented here were understood by their enemies to be slapdash or sloppy in no way indicates that they thought of themselves in this way. We must look more deeply into the modes of performative painting to establish a subtle and fair aesthetic system for our responses to it.

It is clear, for example, that the element of risk in making a rapid drawing or painting with pencil or ink on paper is less than that in painting a tableau-sized Impression on canvas. With the latter, there is more material at risk, and it is more difficult to recover from failure when working at a comparatively large scale on stretched canvas with oil paint. Even the physical gestures needed to control the larger canvas format create additional pressure on the painter, for whom the practicing of such gestures on a smaller scale does not prevent failure at the larger scale. The risks are physical as well as aesthetic: a large gesture is much more difficult to assimilate into a composition and, should it fail, harder to remove.

Then there is the matter of what is painted and when. The selection of a motif from nature has been a topic of artistic discussion since the seventeenth century; later writers (especially those concerned with landscape painting in the nineteenth century) spilled considerable ink in their attempts to help painters identify paintable motifs and to be ready (i.e. both receptive and prepared) to paint them. There was a sort of two-part struggle to prepare to paint *en face du motif*. The first involved the selection of the motif, and the second was the mental and physical preparation required for the activity of representation. If motif selection required physical movement (a walk from the house or studio, for example), then the activity itself had to be compressed in time, and painters were taught to make the most of the time of transcription when the motif was in front of them.

Many painters write about solitary hikes searching for the motif that inspired them to action. Others tell of their despair when, having found the motif, they were not in the right frame of mind to represent it, or did not have the right tools with them (the brushes, canvas, paints, or easel). Most people know that writers can suffer from "writer's block," but do not realize that painters suffer from the same malady. Artists' letters and how-to books from the nineteenth century try to deal with the most effective ways to counter an inability to act. William Hazlitt, in a wonderful essay, admitted that essentially he derived little pleasure from writing, largely because the mental and temporal distance between composition and publication was so great, and because so little of the activity of thought involved in the former made its way into the latter. By contrast, he was "never tired of painting, because you have to set down not what you know already, but what you have discovered. . . . There is a continual creation of

nothing going on. With every stroke of the brush, a new field of inquiry is laid open, a new difficulty arises, and new triumphs are prepared for them. . . . One may look at the misty glimmering horizon till the eye dazzles and the imagination is lost, in hopes to transfer the whole interminable expanse at one blow upon canvas."[50]

Yet Monet's letters and the scant comments of Cézanne and Renoir express just as great a struggle, and as long a duration between start and finish as Hazlitt's lamented time-lag between conception and published writing. These difficulties, even with the most seemingly accomplished of Impressions (such as Monet's *Regatta at Argenteuil*, fig. 77), suggest that spontaneity is probably apparent as much as it is actual. Rapidity of execution is more often an illusion than a reality. The cases are rare in which an artist actually signed an Impression when the canvas was still wet (it applies to Renoir's *The Wave*, fig. 131). More often, the strokes were balanced by thoughtful additions. Mistakes were allowed to dry before being covered by large and apparently spontaneous over-strokes. And, as we know from Monet's mistaken dates (see p. 149), signatures were often added years after the painting had dried and memories had blurred.

In performative painting, the artist wanted to give the viewer a sense of the kind of successful improvisation that had long been part of solo performance in music. Liszt, Paganini, Chopin, Gottschalk, and many great musical performers of the Romantic era extended the kind of improvisation that had previously been confined to cadenzas. This mode of innovative and open performance broke upon the world a generation after the Impression with the independent, but not unrelated, development of jazz in America. So the precedents, physical and conceptual, for the Impression are legion, but none can fully prepare us for this intensely experimental phase in the history of western painting, a phase so powerful that it almost self-destructed within a decade of its announcement in 1874. Its later emanations—with the Fauves, the improvisations of Kandinsky, the expressionist experiments of Kirchner, Nolde, and Marc, the performances of the Dada artists, and the fabulously exaggerated gestures of the action painters—make us realize the power of this direct, personal, and temporally compressed kind of painting. It is central to modernism.

[50] William Hazlitt, "On the Pleasure of Painting," 1820, published in *Criticisms on Art*, London, 1844, pp. 5–6.

4 Edouard Manet and performative painting

Sometime in 1878 or 1879, Manet rallied himself to paint a self-portrait (fig. 32). Perhaps because he was not prone to self-representation, this painting is the only completed such work in his entire oeuvre.[1] In the late 1990s it was purchased for a private art gallery in Las Vegas, Nevada, far from the sophisticated and highly self-conscious Parisian milieu in which, and for which, it was painted. But its authority remains absolute. Manet looks at us—actually at himself in the mirror—and paints himself as the mirror image. Thus his left hand becomes his right hand, his left shoulder his right shoulder, and all the usual reversals of mirroring. But, in staring at us, he faces himself in the mirror—putting us, the viewers, in the position of being the artist confronting the mirror of painting. His paintbrush is suspended as he considers his next move. After his death, Manet's widow apparently considered this work unfinished (she called it an *ébauche*), and did not include it in the 1884 retrospective of his work. Perhaps for that reason, its brilliance as a painting *about* painting was recognized only in the late twentieth century.

The upper two-thirds look, at first, wonderfully fluent and successful as illusion. But the lower third is a confection of gestures: the paintbrushes are represented with jabbed lines of paint, applied with an almost defiant directness; the pigments on the canvas are suggested by thick daubs of paint that represent paint; and the painter's right hand and sleeve are evoked by overlapping wet-on-wet strokes. All is at once suspended and in motion, forcing the beholder to recognize the painting as a thing observed and made rather than the result of a premeditated process of conception, preparation, practice, and finish. And when we move our eyes up again from the gestural abandon of the lower portion to the comparative calm of the upper region, we quickly realize that it, too, is performative. Manet's lapel is represented with fewer than a dozen painted lines, none directly connected, and his ear and face are built up of distinct and overlapping painted strokes, many of which were mixed on the palette before being daubed onto the canvas.

Literature on Manet is littered with stories about his brilliance as a painter.[2] He tossed off small still lifes as gifts throughout his life, waited until his last day on a trip to Venice to begin to capture a view from his hotel, and worked in odd bursts in his Paris studios while friends and their guests looked on, marveling at his skill. All of these stories evoke a self-consciously casual artist, at ease with himself and his craft, operating with an apparently natural facility. The self-portrait projects this public–private air. The first Impressionist exhibition attempted to re-create the atmosphere and viewing conditions of a painter's studio (see p. 21); Manet was one of the many modern artists of the 1860s and 1870s who opened their actual studios to patrons, friends, dealers, and prospective clients. He made a spectacle of the act of painting. And among his favorite works of art was Velázquez's *Las Meninas* (*c*.1656; Museo del Prado, Madrid), the most famous representation of painting as spectacle; he even used it as the basis for his own pose.[3]

This casual, informal Manet seems to be greatly at odds with "our" Manet, the late twentieth-century idea of the definingly intellectual artist of Parisian modernism. The Manet of post-war art history worked in such a mediated and mannered way that little of the casualness and realism of the Manet of Emile Zola, of Marcel Proust, and of Anne Coffin Hanson emerges.[4] Studies of Manet's sources have been a triumph of art

32 Edouard Manet
Self-Portrait, c.1878–79
Oil on canvas, 85.4 x 71 cm
Collection of Stephen A. Wynn

[1] There is an almost exactly contemporary full-length self-portrait (formerly in the Behrens Collection, Hamburg), but it is unfinished.

[2] Anne Coffin Hanson is the most informed and technically minded student of Manet, and she has gathered most of the stories of him painting in her exemplary book, *Manet and the Modern Tradition*, Yale University Press, New Haven and London, 1977; the bibliography details most of the contemporary stories and is a useful counter to the prevailingly iconographical literature devoted to the artist.

[3] Several writers, following the lead of George Mauner, have pointed out the affinities in pose between Manet's self-portrait and the Velázquez; see Charles S. Moffett's catalogue entry in Françoise Cachin et al., *Edouard Manet, 1832–1883*, The Metropolitan Museum, New York, 1983, pp. 405–7, no. 164. Yet while Velázquez painted the life he viewed in the mirror, Manet painted the mirror itself.

[4] See Emile Zola, "Mon Salon: Manet," *Evénement*, May 7, 1866, reprinted in Emile Zola, *Salons*, ed. F. W. J. Hemmings and R. J. Neiss, Geneva, 1959; Antonin Proust, *Edouard Manet: Souvenirs*, Paris, 1913, and Anne Coffin Hanson, op. cit.

historical detective work, and the convoluted arguments that make sense of his layered borrowings reflect as much on their authors' brilliance as on that of Manet himself.[5] The pages devoted to his complex Salon paintings overwhelm those that deal forthrightly with the majority of his production—easel paintings of a small or medium scale made for sale, gift, or private exhibition. Manet's be-sourced and self-conscious masterpieces have all but completely overshadowed the rest of his oeuvre.

It is with some trepidation, therefore, that I have selected this summary group of Manet's occasional paintings for consideration within the context of this study. The group is a little too small to do more than suggest the range of his achievement in this arena, and too little serious documentary work has been done on many of the works to understand the contexts for which they were painted and in which they were originally interpreted. The selection contains several famous works by Manet, but none of his self-consciously "great" paintings, most of which result not merely from a study of life, but from a struggle with a whole variety of visual sources in high and low art. By contrast, in most of the works chosen here Manet was grappling with his view of the visual world around him. Often, he was on vacation or away from Paris; in other cases, he was thinking out loud in paint in his Paris studio. Our one major criterion for selection was simple: we know that these works were considered finished by Manet, either because of an authentic signature[6] or through the more tenuous evidence of exhibition history. Exceptions have been made in the case of *The Funeral* (see fig. 38) and *Sketch for "The Bar at the Folies-Bergère"* (see fig. 55), interesting and successful in their own right, because they raise certain issues associated with performative painting that cannot be dealt with by referring to any other works.

The selection is the first occasion in which Manet's rapid paintings are considered in direct comparison with those by his younger friends the Impressionists, whose cause he championed, but membership of whose society he persistently refused. Manet's career has been read as a series of deliberate moves made with the intelligence of an artistic chess player.[7] If that is true, his major mis-step seems to be that he persistently flirted with the Impressionists, but was mysterious unable ever to join directly in their cause. Yet virtually every aspect of Impressionist practice, marketing, display, and theory was predicted in his practice. Perhaps his desire to be considered a "great" painter made it impossible for him fully to embrace the casual, improvisatory aesthetic he did so much to define and foster. But his absence from the eight exhibitions of the Impressionists, and his continuing absence from Impressionist exhibitions today, is a real failing: how wrong he was—and we are!

The works selected for this study span Manet's oeuvre from the late 1850s until the years just before his death in 1883. They include one *ébauche* and one *esquisse* (for explanations of these terms, see pp. 21, 35). These date from the earliest phase of his career, when his affair with Salon painting was at its most intense. One, made in 1854, is a freely painted "copy" (see fig. 14) of Delacroix's *Barque of Dante* (1822; Musée du Louvre, Paris). This work (perhaps the most copied nineteenth-century painting before Manet's own *Olympia* of 1863; see fig. 4), was Delacroix's announcement picture. The publicity surrounding its first appearance gave the young Romantic painter the celebrity status he both sought and shunned. Its source material in the literature of the Italian Renaissance was sufficiently lofty to stop criticism from those who feared that

[5] The classic text, though not the only one, is Michael Fried's Harvard dissertation, originally published as "Manet's Sources, Aspects of his Art, 1859–1865," *Artforum* 7, March 1969, pp. 28–82; republished, with a long commentary, as *Manet's Modernism and the Face of Painting*, Chicago, 1996.

[6] As opposed to the signatures on certain works in the sale after his death, which many scholars are convinced are not autograph.

[7] See T. J. Clark, *The Painting of Modern Life: Paris in the Art of Manet and His Followers*, New York, 1985.

painting of the time risked becoming too low in subject matter, or too concerned simply with human emotions. Its treatment of the subject of aesthetic passage (from one generation of artist to another, from life through death), its bridging of the eras of European history, and its terrifyingly grim visual assessment of the human condition riveted the Parisian public. Few important French artists in the years after 1830 failed to come to grips with Delacroix's earliest masterpiece through the act of copying, and Manet was no exception. Two oil copies by him survive, a relatively faithful one (in the Musée des Beaux Arts, Lyon)[8] and this considerably looser and more interesting free copy.

Not many of Manet's copies seem to have survived—copies of works by Titian (the majority), Rembrandt, Brouwer, and Delacroix are all that remain, but there must have been considerably more.[9] *The Barque of Dante* is surely the most interesting: even within the corpus of surviving copies by other artists it is extraordinary for its sheer painterly energy and for its apparent lack of interest in the details of the original. It seems almost to exist as a stand-in for an *esquisse* by Delacroix himself.[10] Manet must have taken a deeply detached view of the painting, seeking within it only lessons about color, facture, and pictorial energy. It is almost as if he wanted to compress all of the large canvas's qualities into the small canvas he had with him when he made the copy. He was forced to conceive of densely interactive areas of color, applied directly to the canvas with a loaded brush.

A decade later, Manet produced the *Branch of White Peonies and Pruning Shears* (fig. 33) and *Departure from Boulogne Harbor* (fig. 34), both probably painted in 1864. These two works are paragons of reductive gestural painting, in which the task set by the artist was to analyse the visual qualities of a subject and then attempt a painterly translation of it in as few discrete gestures as possible. Manet made a case for a kind of pictorial mastery in which conciseness of movement was paramount. The *Peonies* came first. On a small, primed canvas, Manet began with the traditional dark brown *ébauche* that had formed the warm middle ground for painterly studies of light–dark value gradations for generations of French academic practice. Like his predecessors, he worked from this tone in varying overlays either lighter or darker, and, with characteristic originality, painted the brown layer as a gradient from lightest to darkest, lower to upper, to suggest gradual depth. For his subject, he elected to deal with the elements of a floral still life before they were arranged, encouraging us to think that he had just cut two perfectly fresh white flowers with the pair of shears that glint at the left of the canvas. He set the blooms on a table so that the weight of their heavy petals can be felt, and chose this moment to analyse them in advance of making—and then painting—a proper still life.

Each flower is a marvel of painterly construction, each stroke of paint separated in an overlapping symphony of gesture. Manet had clearly rehearsed and rehearsed before making this painting, and his mastery allowed him to use pure white, whites mixed on the palette with browns, yellow-grays, and green-grays, to make countable painted marks, each of which represents an individual flower petal. It is almost as if Manet performed the flowers, each petal being represented by a single brushstroke; together, they combine to become a painterly facsimile of the peony. The ridges of paint that give form to each brushstroke suggest that Manet worked with extremely

[8] Interestingly, this was the first painting by Manet acquired through purchase by the French State, in 1908. It was included in the great Manet exhibition held in New York and Paris in 1983 on the occasion of the hundredth anniversary of the artist's death. This decision left the looser copy (acquired by the Havemeyers and given as a bequest to The Metropolitan Museum, New York) to occupy a lesser position in the Manet pantheon, yet it is of far greater significance for the history of nineteenth-century modernism.

[9] Copies by Degas seem to have survived rather better.

[10] If Delacroix made an *esquisse*, it has apparently not survived.

33 Edouard Manet
Branch of White Peonies and Pruning Shears, 1864
Oil on canvas, 56.8 x 46.2 cm
Musée d'Orsay, Paris

[11] It was reportedly given by the artist to the great art critic Jules Husson, called Champfleury, who loaned it to the 1884 exhibition. Although the signature does look like those known to have been made by Mme Manet, it is still odd that an unsigned work of this provenance would suddenly have been signed by his widow.

fat pigments, and occasionally went back into the stroke when it was already tacky to exaggerate these ridges. This gives the painting its look of wetness and a kind of marvelous liquid virtuosity that few painters in the history of art can rival. Few individual works—even by Frans Hals, Velázquez, or Fragonard—act as direct precedents for this small and self-consciously gestural masterpiece.

The signature in the lower right corner was almost certainly applied much later, by his widow, before the painting's first known public exhibition at the posthumous retrospective of 1884. Yet the known provenance of the picture leaves no doubt that Manet considered it to be finished: it was among the first of his small pictorial gifts to friends and admirers.[11] Perhaps he felt it had no need of a signature—it is a signature in itself, covered, as it is, with highly personal gestures of response to the coolest, largest, and most fragrant of flowers.

Departure from Boulogne Harbor is a work of an entirely different, and higher, level of painterly experimentation. Its canvas is larger, its encapsulation of liquidity and movement is absolute, and its complete absence of mistakes or performative faults is extraordinary. Manet set himself a problem: the representation of a calm sea with various boats (sail and steam, fishing and leisure) moving across it. There is no surviving preparatory drawing or compositional study that could have guided him in his decisions as to the placement and direction of the boats. Instead, he seems to have performed the composition over time as he stared out of his window at the harbor as boats sailed or steamed by. The painting represents cumulative observations and transcriptions rather than one single observed scene. It is *because* of this cumulative process that it has such extraordinary freshness—each stroke was, in a sense, a fresh observation.

Manet began by painting the setting—the sky and the water, each of which were worked relatively quickly wet-on-wet. The water is a particularly rich mixture of blues,

34 Edouard Manet
Departure from Boulogne Harbor, 1864–65
Oil on canvas, 73.6 x 92.6 cm
The Art Institute of Chicago
Potter Palmer Collection

gray-blues, green-blues, whites, and muddy browns mixed together so that, even when the paint is dry, the water seems still wet. Atop this paint–water liquidity, Manet arranged ten or eleven boats, all but one of them sailboats, their sails billowing and stretching with the force of an unseeable wind. None of these boats is remarkable in itself—no Dutch marine painter would have dared paint so banal an ensemble. But it is precisely because they are all but drained of iconological significance that they are carriers of gestural meaning. It seems that Manet worked from background to foreground, with carefully calibrated overlappings and adjacencies to make space. The tiny sails of the distant boats are flecks of the brush designed to link water and sky. As we approach the foreground, the construction of each boat becomes more complex, and the sails are represented with three, four, five, even six separate strokes of paint,

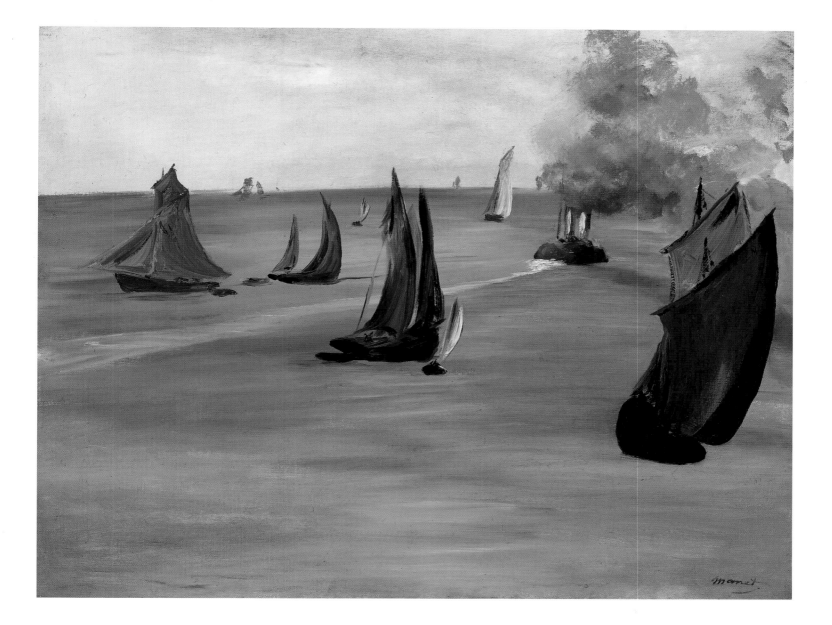

applied with a wrist gesture, moving up, along, or down the surface depending upon the response of the sail to the wind. The central group of sailboats—applied quite late in the process, since they overlap the white trail from the steamboat—are painted with black, brown, and white paint mixed both on the palette and on the surface of the canvas itself in a disciplined calligraphy of movement. The smudges of warm gray that represent the engine-dirty steam from the tug at middle right are appropriately crude and gestural, as the smoke struggles to disappear into the atmosphere of a summer day.

The little marvels of the painting—the tiny, white-sailed boats immediately to the left and right of the central boat—are so quickly painted, so seemingly effortless, that it is easy to forget that Manet could have chosen to put them anywhere on the surface; they, too, are premeditated acts, even if suddenly made. One can imagine him practicing on paper to perfect his control of gestures so completely that, when it came time to paint each boat, he had them perfect. The problems involved in the representation of sails and smoke were sufficiently contained to master in a matter of days; the performance itself probably took no longer than a week of fitful, intense, sporadic work. But it seems hardly to be "work" at all: the sheer effortlessness of this brilliant marine painting makes it quite extraordinary. No earlier work from the 1860s by Manet had so profound an effect on the young Impressionists as this one. They responded to it gradually after seeing it in an 1867 Manet exhibition held outside the Exposition Universelle where it was called, in a charming anglicism, *Le Steam-Boat (Marine)*. It exerted an immediate effect on the painting of the young Claude Monet, whose responses to it continued well into the next decade.

The next fascination for Manet, the painting of rapid motion in a rapid manner, also dates from 1864, when he completed a large canvas that he called *Aspects of a Racecourse in the Bois de Boulogne* and a related gouache, *Race Course at Longchamps*, which is signed and dated (fig. 35). The canvas was cut into several fragments in 1865, none of which now survives; the largest portion, first shown at the 1867 Manet exhibition, seems to have been either destroyed by the artist or lost.[12] A smaller oil sketch, *The Races at Longchamps* (fig. 37) is among the most brilliantly painted of the 1860s, its signature and date (unfortunately illegible) proving that it was considered a finished work by its maker. It relates in its proportion and purpose to other works in Manet's panoramic investigation of modern urban life in Paris, a series that began with the distinguished representation of a crowd of wealthy Parisians in *Music in the Tuileries* (1862; National Gallery, London). It has been dated to 1867, and considered to be a solution to problems that Manet had failed to solve in the 1864 canvas.[13]

As usual, Manet presented himself with an almost insoluble problem—the simultaneous representation of stationary and rapidly moving forms from a vantage point of real danger. Far from the elegant Anglo-French studies of horses and jockeys before and after the race that had become a stock-in-trade of his friend Degas, Manet's horses rush pell-mell toward the viewer, their legs pounding the turf into fine dust and their satin-clad jockeys hanging on for dear life. The element of risk from the viewer's position is perhaps greater than at any previous time in the history of art, and Manet clearly relished this delicious sense of feigned pictorial danger. But even more than its innovative viewpoint, what is extraordinary about the painting are its

[12] Its dimensions in the catalogue of the 1867 exhibition are completely different from those of fig. 37.

[13] All of the relevant literature is surveyed and analysed in Theodore Reff, *Manet and Modern Paris*, Chicago and London, 1982, pp. 132–41.

Edouard Manet, *Departure from Boulogne Harbor* (detail of fig. 34)

35 Edouard Manet
Racecourse at Longchamps, 1864
Watercolor and gouache over graphite
on paper, 22.1 x 56.4 cm
Fogg Art Museum, Harvard University Art
Museums, Cambridge, Massachusetts
Bequest of Grenville L. Winthrop

36 Edouard Manet
Aspects of a Racecourse in the Bois de Boulogne,
1865–72
Lithograph, 38.4 x 50.7 cm
Bibliothèque Nationale de France, Paris

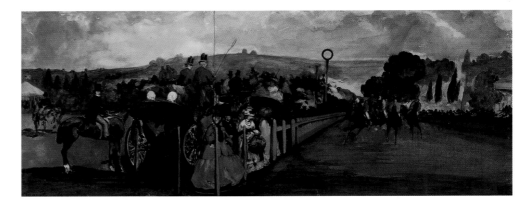

sheer virtuosity and variability of touch. The landscape, surely the most stabile element in the entire composition, is rendered with viscous paint applied with large brushes moved quickly and confidently over the surface. This is in fact a landscape study, with the large masses and most obvious colors (blue sky, green grass, greener trees, white clouds) painted as if to suggest that they are simply a backdrop for the horserace. Manet makes its windswept generality all the more apparent by carefully painting the gray pole with its open circular disc that represents the finish line. This completely static form acts as a kind of keyhole through which we view the windy intersection of land and sky.

Manet's achievement in this painting is in his use of rapid gestural painting to represent both movement and the blurred forms that surround it. The crowd to the

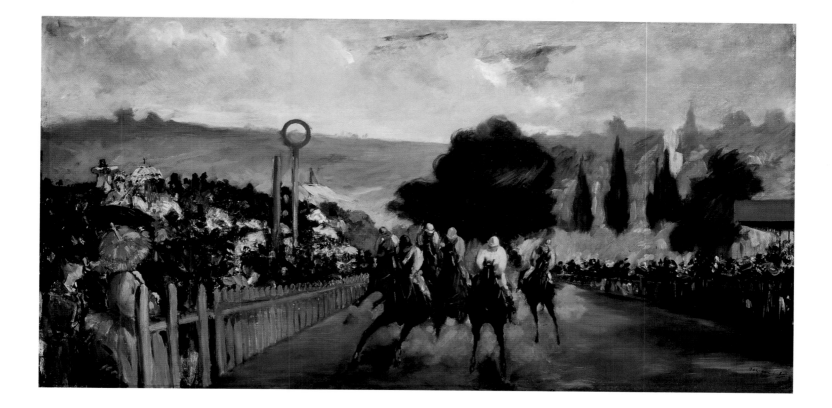

37 Edouard Manet
The Races at Longchamps, 1866
Oil on canvas, 43.9 x 84.5 cm
The Art Institute of Chicago
Potter Palmer Collection

left and right is represented with hundreds of rapidly made daubs and jabs of paint, which coalesce to become a plethora of black frock-coats, parasols, dresses, hats, and the little flags of the well-heeled racegoers. From this mass, Manet picks out five figures —four women and one top-hatted man with binoculars—who vie for our attention with the horses that gallop toward us. Where do we look? Are we more interested in the jostling and excitable crowd, or the race that captivates it? Will a little visual flirtation with the two women at the far left or a wave at the gentleman with his binoculars distract us from getting out of the way of the horses?

In this superb painting, Manet brings together his full knowledge of the various modes of oil sketching perfected by earlier artists with a subject that traditionally, and paradoxically, had been described in a painstakingly detailed manner. Speed of representation, sureness of gesture, and forthrightness of painterly manner are harnessed to the representation of an event that is of very short duration and that finishes in an instant. The painting represents that instant—and we, as judges, cannot quite tell which of the two horses in the foreground has won, because we are looking at them head-on. When we compare the 1864 gouache (fig. 35), it becomes clear that Manet was not quite ready then to paint such a challenging subject at a large scale. By 1867, after considerable practice in rapid painting, he was ready. He even took it further, with an undated, but probably later, lithograph (fig. 36), which takes the gestural abandon of the painting to a new level with squiggles, frantic parallel diagonals, and curved jabs that seem as much like swordplay as painting. For Manet, linear gestures were becoming almost aggressive.

Manet did not summon all his skill in gestural painting only for the representation of rapid movement, he also turned it to the strong and mysterious emotion of grief. *The Funeral* (fig. 38) represents a small Parisian burial on a comparatively large scale with gestures so forceful that they seem almost frantic. This work was never exhibited in Manet's lifetime, and remained in the collection of his widow until 1894, when it was sold to a dealer who probably sold it on to Camille Pissarro. Its inscription at the lower right, certifying its authenticity, is in the hand of Mme Manet. Hence it is impossible to know whether this work was considered finished by the artist. It is commonly linked to the funeral of Baudelaire, which Manet, out of his enormous respect and friendship for the poet, attended on September 2, 1867. One witness, the Belgian painter Alfred Stevens, tells us that the funeral took place on a hot, stormy summer day; that few of the hundred or so mourners at the church went to the cemetery because of the weather, and that, on the procession in the cemetery, a huge thunderclap sent all but a handful running for shelter.[14] This painting reveals to us that Manet was among those at the cemetery, possibly sheltering beneath trees during the storm, and that he memorized the scene so that he could make this embodiment of personal grief. If ever a painting wept, this one does.

To compare the elegantly mannered gestures that Manet used for the peonies or the sailboats at Boulogne to the violent jabbings, scrapings, and daubs that represent clouds, buildings, trees, and sky in this painting is to compare mastery to its opposite—loss of control, anger, and frustration. Manet positioned the viewer not as an eyewitness to an event, but as an eyewitness to his own emotional response to that event. The funeral itself is virtually a caricature—a miniaturization of toy-like mourners and a tiny horse-drawn hearse. It is the reactions to that funeral—the reactions of nature and of Manet—that dominate this canvas. And, as if to prove that one of those reactions was doubt, Manet scraped paint away from the canvas in the middle ground, as if angry with himself for the tentativeness of his gestures. Gesture and anti-gesture vie angrily with one another until we reach the sky, where an almost Wagnerian panoply of frustrated rage cries out. Clearly, Manet expressed himself best and most powerfully in the language of gesture and the medium of oil paint; no more towering representation of displaced grief exists in earlier art. It took more than a decade before Monet rivaled his master in emotional intensity in the portrait of his dying wife, Camille. How could Manet have sold, as a commodity, so personal and so unfinishable a painting? And, when it was sold after Manet's death, who but an artist could have bought it?

When these works are placed in the context of Manet's larger practice of the 1860s, they make clear the centrality of performative painting in his oeuvre. The fact that he felt compelled to allow freely painted areas to play minor parts in his most important Salon paintings proves that he wanted his viewers to think about the essential physical components of the activity of art. Amidst the iconography of borrowed sources and compositional rhymes, one can always find hints in a painting that it was physically made as well as mentally conceived. With Manet this amounted almost to an obsession. The rose-colored scarf in the hand of *Mlle Victorine in Costume as an Espada* (fig. 39); the stage flats behind *Lola de Valence* (fig. 40); the gloriously painterly foliage in *Déjeuner sur l'Herbe* (1863; Musée d'Orsay, Paris); the bouquet of flowers in *Olympia*; the

[14] See Beth Archer Brombert, *Edouard Manet: Rebel in a Frock Coat*, New York, 1996, p. 204.

38 Edouard Manet
The Funeral, 1870
Oil on canvas, 72.7 x 90.5 cm
The Metropolitan Museum of Art, New York
Catharine Lorillard Wolfe Collection
Wolfe Fund, 1909

hands of Christ in *The Dead Christ, with Angels* (fig. 41)—all of these passages have an undeniable physicality and show Manet's devotion to painting as a gestural language.[15] This is especially evident if Manet's Salon paintings are contrasted with those of any other painter with his forthright art historical ambitions. Only Gustave Courbet could compete in forcing a materialist aesthetic into an art of figural allegory, yet Courbet (who dominated avant-garde discourse in the 1850s as Manet did in the 1860s) had a distinctly different materialist aesthetic. Working with a palette knife, Courbet all but troweled paint onto his large canvases, building up a sort of physical textured relief often compared to the work of wall plasterers and other architectural workers. Manet's language was always that of gesture; viscous paint, manipulated with brushes, replaced the thick, stucco-like surfaces of Courbet. There is a personal calligraphy of the brush in Manet's practice which has roots in the oil sketches of Rubens, Velázquez, Hals, and Fragonard.

The most tantalizing aspect of Manet's smaller-scale performative paintings of the 1860s is that certain of them were in fact exhibited outside his studio. The earliest case concerns an infamous and little-documented exhibition, which took place at the shop of the picture dealer Louis Martinet in 1865. Manet had already sent works unsuitable for the Salon to Martinet in 1863, thereby suggesting that he himself differentiated between

41 Edouard Manet
The Dead Christ, with Angels (detail), 1864
Oil on canvas, 179 x 150 cm
The Metropolitan Museum of Art, New York
H. O. Havemeyer Collection,
Bequest of Mrs. H. O. Havemeyer, 1929

[15] Many more examples could be given that cannot all be illustrated here—e.g. the smoke and clouds in *The Battle of the "Kearsarge" and the "Alabama"* (1864; Philadelphia Museum of Art); the fur coat on the orange-turbaned attendant in *Jesus Mocked by the Soldiers* (1865; The Art Institute of Chicago); the still life of straw and oysters in the lower right corner of *The Philosopher* (1865; The Art Institute of Chicago); the left hand of Zacharie Astruc in the great portrait of 1866 (Kunsthalle, Bremen); the quill pen in the *Portrait of Emile Zola* (1867–8; Musée d'Orsay, Paris), and the cigar smoke in *The Luncheon in the Studio* (1868; Neue Pinakothek, Munich).

[16] The exact make-up of the first Martinet exhibition is discussed in the entries for these works in Françoise Cachin et al., op. cit., pp. 96–102, 122–26, 208–12, 221–25.

paintings suitable for daytime viewing in the commercial realm of the boulevard and those destined for the relatively official, and relatively non-commercial, Salon. Paintings exhibited at Martinet's in 1863 included the delightfully casual, though highly finished, *Music in the Tuileries* (1862; National Gallery, London) and the wonderfully wicked homage to Goya, *Young Woman Reclining in a Spanish Costume* (1862; Yale University Art Gallery, New Haven). In late 1864 or early 1865, Manet wrote to Martinet concerning eight paintings he was readying to be sent to the dealer. The list, written in Manet's own hand, is an important indication of the kind of work the artist considered appropriate for the commercial sector. Included was the almost shockingly crude portrayal of Baudelaire's mistress, *Portrait of Jeanne Duval* (1862; Szépmüveszeti Muzeum, Budapest), as well as a group of seascapes and still lifes that includes the *Peonies, Boulogne Harbor* and *Fishing Boats Coming in Before the Wind* (1864; Philadelphia Museum of Art). There is some evidence that only two from the list were ever exhibited, but it is very likely that at least six were sent.[16] These works, and others thought appropriate for

42 Edouard Manet
Snow Effect in Petit-Montrouge, 1870
Oil on canvas, 61.6 x 50.4 cm
National Museums and Galleries of Wales,
Cardiff

shop-window viewing, created an important precedent for the Impressionists, who in 1874 removed their works from the Salon to the boulevards, weakening the Salon forever as a result. In many ways, personal, informally gestural painting became associated thereafter with friendship, connoisseurship, and small-scale commerce.

On December 28, 1870, Manet made two small paintings, and signed and dated them in his own hand.[17] His concern to tell us the exact day on which they were made means that the information must be important to our understanding of the works' image and style. France was at war with Prussia, and Manet was serving in the National Guard; the Siege of Paris, which inflicted great suffering, had already lasted more than three months. *Snow Effect in Petit-Montrouge* (fig. 42) is small and grim, dominated by beiges, grays, and dirty whites applied forthrightly. The place was a *quartier* in the south of the 14th arrondissement in Paris. The motif is St. Pierre de Petit-Montrouge, a church with a very tall bell-tower constructed in 1863, less than a decade earlier. The church seems to struggle to retain our attention as the motif, since the picture is as much about a cold, snowy day in December as the modern Christianity embodied in this Second Empire church. Hope did not spring eternal, as Manet looked from the embankments where he and his comrades were attempting to defend Paris from the inevitable Prussian attack.

This painting has been interpreted as a "soldier's landscape," and described as Manet's first Impressionist picture.[18] This is probably correct, if we believe Manet's indication that it was painted in one day. While his younger friends Monet, Sisley, and Pissarro worked in very different circumstances in self-imposed exile in England, Manet expressed in this small canvas the antithesis of the optimistic modernity normally associated with the Impression. Its time is diurnal and seasonal rather than momentary; if it is an Impression, its function is surely to represent history rather than landscape. By centering his view on the only landmark in sight, Manet made it possible for any Parisian to locate his exact position. The work was dedicated to one H. Charlet; his identity is unknown, but it is likely that he was a fellow soldier, in which case the painting was a gift of complicity in the time they shared together in the service of their nation. Two civilian-soldiers are linked through representation and inscription in an Impression, with emotional and personal consequences that this modest picture has taken pains to hide.

After Manet's experiences in the Franco–Prussian War and the Commune, his doctor recommended travel to settle the painter's nerves. His first foreign trip was to the Netherlands, where he visited the newly opened Frans Hals Museum in Haarlem in late July 1872. There, he could glory more than ever before in the brilliantly original paint-drawing of the great Dutch master. How one would love to have been a gallery attendant when Manet walked into the room containing the late portraits of the Regents and Regentesses of the Old Men's Almshouse (both *c.*1664; Frans Hals-museum, Haarlem). Hals was an artist much less fluent in paint than Manet's other heroes Velázquez and Fragonard, and Manet had by this time gone far beyond Hals in his command of the language of color. There were no chromatic lessons for him in these broodingly dark canvases; it was, instead, their pitiless gestural quality, their presence as representations constructed of gestures, that must have awed him. Hals's task was not to make beautiful gestures, but to compose form from separate painted lines of which no individual one was eloquent, but only the whole.

[17] Only one survives; *The Railroad Station for Sceaux*, last seen in 1944, is presumed lost.

[18] By Hollis Clayson, in a study of the Siege of Paris in the visual arts, forthcoming; I am indebted to her for the information in this paragraph.

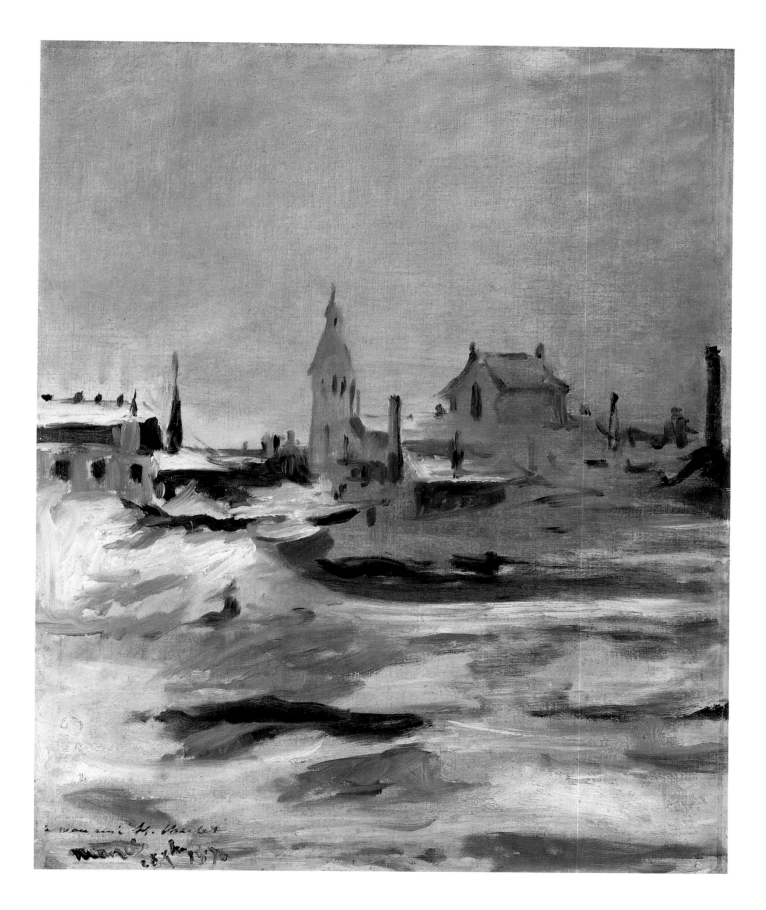

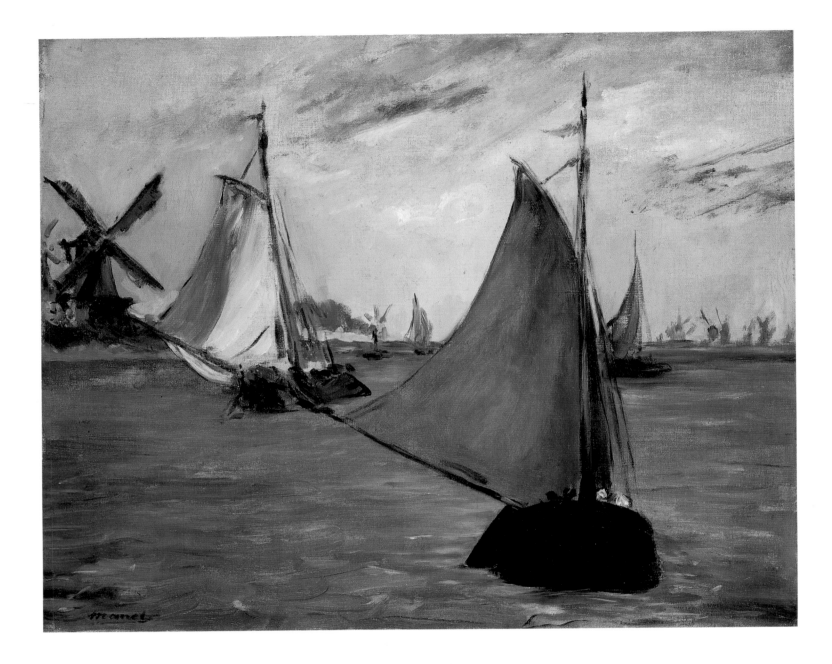

43 Edouard Manet
Marine View in Holland, 1872
Oil on canvas, 75 x 60 cm
Philadelphia Museum of Art
Purchased with the W. P. Wilstach Fund

On his return to Paris in August, Manet moved into a new studio near the Gare St. Lazare. He painted one last homage to Hals and his Dutch colleagues—the famous *Bon Bock* (Philadelphia Museum of Art), exhibited with enormous success at the Salon of 1873. He had looked at Old Master painting in fundamentally new and challenging ways since the 1850s; now, it was the pictorial strivings of the young that were to sustain him, as he commenced the last decade of his life open to the achievements of artists more than ten years younger than he was. He had provided the impetus for all these future Impressionists in the second half of the 1860s, but they now became an inspiration to him (at his funeral on May 3, 1883, the 43-year-old Monet served as the youngest of the six pallbearers).

Manet's painting of the 1870s is among the central achievements of urban modernism. Yet comment about it is mostly confined to extensive analyses of just a few paintings—the *Gare St. Lazare* of 1874 (National Gallery of Art, Washington, D.C.), his last masterpiece; *The Bar at the Folies-Bergère* of 1882–3 (Courtauld Institute, London), and a small group of closely related café paintings of 1877–79. Many of Manet's other paintings are as large and as pictorially ambitious, and all of them show an engagement with the painting of three artists—Monet, Renoir, and Degas. Manet sought to improve upon his younger colleagues' work through borrowings and transformations much more subtle than those he had employed with his Old Master sources. There is almost always an identifiable stream of influence from one or two of these artists in any single late work by Manet, but never one particular source, never one specific pictorial armature that he re-used. Although he still haunted the Louvre and thought a good deal about the exemplars of western easel painting, he learned, like Cézanne, to externalize his aesthetic stimuli and to base his work more on direct experience of nature. In the last decade of his life, Manet began to approach painting in a much more direct manner.

This does not mean, however, that he produced very many actual Impressions. His long-established habits of analysis and transformation rarely allowed him such short-term engagement with a painting. But many more works in the 1870s were made in a few discrete sittings, often directly *en face du motif*, than in the 1860s. Some were produced from figures posed or standing in his studio, others from landscapes visited while away from Paris, and still more from scenes observed in the city and powerfully memorized for later translation. Among these are charming works that were made as gifts—portraits of favorite dogs, of flowers, and rapidly made intimate scenes. Others are delightfully dashed-off evocations of a place, or a corner of the studio. The most intimate, perhaps, is the startlingly fresh and unpretentious still life of asparagus (fig. 44).

44 Edouard Manet
Asparagus, 1880
Oil on canvas, 16.5 x 21 cm
Musée d'Orsay, Paris

45 Edouard Manet
Claude Monet in His Studio Boat, 1874
Oil on canvas, 82.7 x 105 cm
Neue Pinakothek, Bayerische
Staatsgemäldesammlungen, Munich
(Detail opposite)

A single spear of summer asparagus, exactly life-size, rests on the gestural evocation of a table. Complete assurance and casualness are maintained throughout this small work, even down to the simple initial "M" of his name doodled in the upper right corner. He painted it for the critic Charles Ephrussi, who had overpaid him for a larger still life of a bunch of asparagus. Manet's note to him with the small painting —that his bunch of asparagus lacked one spear—is among the most charming versions of correct change in the history of capitalist art!

Manet's close engagement with Monet in 1874 produced a sea-change in the older artist's work. Although he had begun to paint with increasingly brilliant hues, he nevertheless continued to conceive of pictorial reality in terms of light-and-dark relationships, and to treat color as a property of shadowed forms. This notion gave

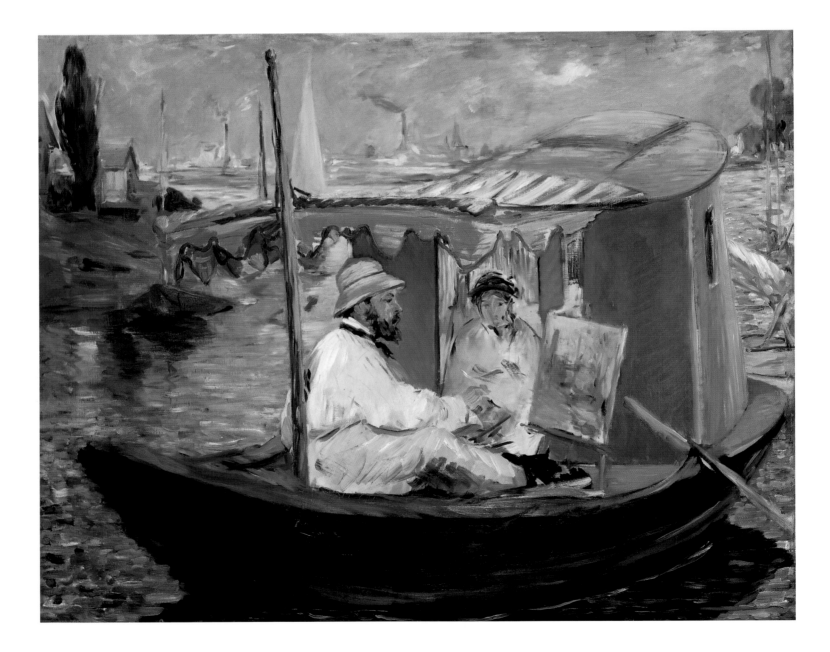

way to a thorough-going attempt to conceive of a picture in chromatic terms. In this, he was never completely successful, as can be seen from a simple comparison of two major works from 1874 by the two artists (now housed in the same gallery of the Neue Pinakothek in Munich). Manet's portrait of Monet shows the younger artist painting a boating picture in Argenteuil from his studio-boat (fig. 45). With his wife Camille, Monet is seated in a wonderful yellow boat, trimmed with blue and black, floating in blue water, which is filled with other boats and reflections of the adjacent landscape. Monet is engaged in painting *en plein air*, but he stares fixedly not at his motif, but at the painting itself. Monet's *The Bridge at Argenteuil* (see fig. 80)[19] shows evidence of the younger artist's greater experience of plein-air painting. For Manet, the landscape is little more than a backdrop or a series of painted stage flats for a figural scene that is conceived fundamentally in black and white. The atmosphere in Manet's work has an airlessness, a heaviness, completely absent in the Monet.

But for eloquence of gesture, Manet wins the competition hands down. Monet's painted marks always serve representational demands, even when they are at their most strident: the creamy yellow and white strokes of thick paint in the left foreground define the precise chromatic and proportional character of the hulls of specific boats observed in particular positions and conditions of light. By contrast, the delightfully expressive black and dark gray lines that define Monet's shoes, brushes, and collar, Camille's hat, even the canopy and boat hull, have what one might call independent graphic eloquence. They are wonderfully lively and variable *as* linear gestures; that they also have a representational function in no way undercuts their calligraphic qualities. Few, if any, of the extraordinary painted marks in Monet's canvas have that quality, but his encapsulation of the chromatic character of a landscape observed at a particular time is infinitely more successful.

The central drama of Manet's painting is his representation of the act of representation. Monet's right hand (detail, left) is defined with no more than three short strokes of paint, each of which has been barely pre-mixed on the palette and shows clear evidence of its component colors—white, gray, and warm beige. It is fascinating, though risky, to read Manet's representation of Monet as if it were accurate—almost photographic. The younger artist leans back from his painting, holding a palette and at least three long brushes on his lap with his left hand. He seems to grasp another brush with which he is painting with his thumb and first two fingers, in a way that would have made it difficult to create a full range of finger and wrist gestures. The canvas is placed between Monet and the oar with which he is steering the boat, making it clear just which of the two activities was of greater concern to the young painter. Manet's "identification" with Monet became complete when he elected to sign the painting in a wonderful blue on the black hull of the boat immediately beneath Monet—almost as if he was re-naming the studio-boat "Manet."

Of the paintings produced by Manet during the summer of 1874, several pay direct homage to Monet. The portrait of Monet, Camille, and their son Jean in the garden (fig. 46) is a wonderfully buttery concoction of wet paint.[20] Even with this brilliantly gestural painting, full of deft little lines of paint overlapping thicker daubs and long, wet strokes, Manet was dissatisfied; there is visible evidence that he scraped off at least one layer of paint to begin again. When painting proceeded without a plan,

[19] Not the painting shown on the easel in the Manet portrait, but done during the same summer season.

[20] It was made with Renoir present and engaged in the same task (see fig. 108). One can only imagine the impromptu critiques that must have gone on; they have been discussed by Barbara Ehrlich White, in *The Impressionists Side by Side*, New York, 1996, pp. 72–3, and by Paul Hayes Tucker, in *The Impressionists in Argenteuil*, National Gallery of Art, Washington, 2000.

46 Edouard Manet
The Monet Family in their Garden at Argenteuil,
1874
Oil on canvas, 58.7 x 71.4 cm
The Metropolitan Museum of Art, New York
Bequest of Joan Whitney Payson, 1975

the results were not always to Manet's liking; ever self-critical, he made good use of the weapon of the palette knife.[21]

Monet was still in Manet's mind the following year, when the older painter elected to go to Venice in September 1875. He started to paint two wonderful cityscapes of the Grand Canal, in a manner that derives absolutely from the Seine landscapes he had made with Monet the previous summer. These two paintings depart very much from the type of Venetian view first popularized in the eighteenth century and then repeated with fanatical devotion by professional and amateur painters alike in the nineteenth century. Here, a fully developed Parisian modernism is applied to the great historical city, giving it an urgency of felt experience that is anything but world-weary or traditional. The sheer freshness of the paintings made them immediately appealing; both were apparently purchased by major collectors before the end of the year. *Grand Canal, Venice* (fig. 47), has the most interesting lore. The painter Mary Cassatt wrote that Manet himself told her that he painted it on the very last day of his stay, having presumably procrastinated up to that point. He was apparently so satisfied with the result that he delayed his departure one more day to finish it. This sense of its having been done in a sudden rush—a desperate late attempt to seize an Impression of the gorgeous city he was about to leave—is preserved in the finished work. Although the central motif of the gondola is carefully and lovingly painted with over-layers of varying blacks, the water, the painted poles, and the cityscape around it are aquiver with

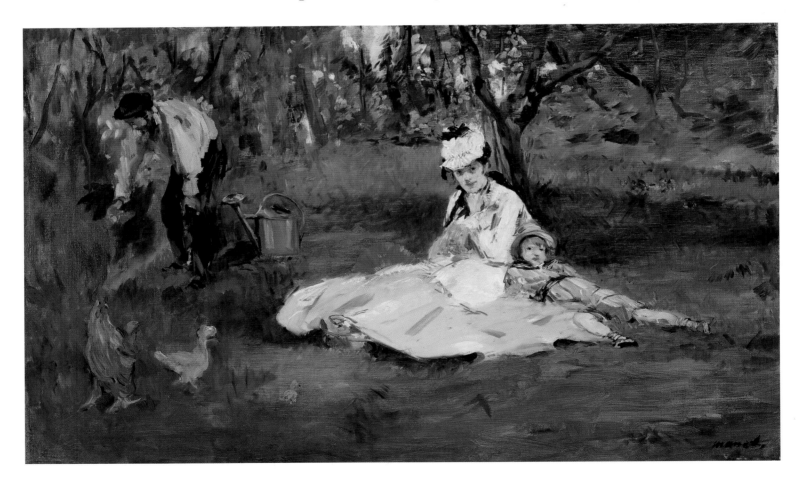

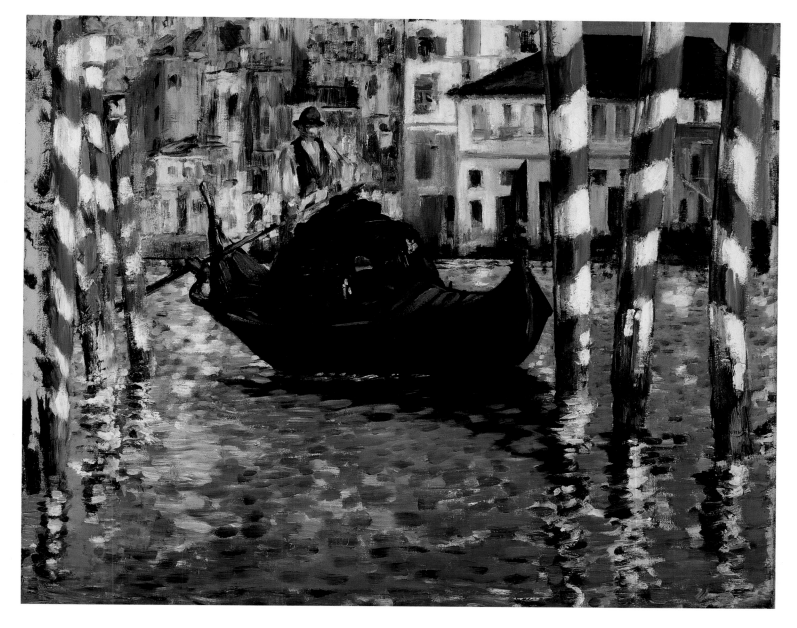

47 Edouard Manet
Grand Canal, Venice, 1875
Oil on canvas, 58 x 71 cm
Shelburne Museum, Shelburne, Vermont

[21] See Charles S. Moffett's brilliant analysis of Manet's painting, which stands among the best in the literature: *Edouard Manet, 1832–1883*, Metropolitan Museum of Art, New York, 1983, pp. 375–77.

the movement of the artist's hands. With a brush liberally dipped in specific blues, green-blues, whites, beiges, and oranges, he seems to have made linear gestures either in vertical bundles or in scatterings across much of the surface. Interestingly, he all but banished the sky to the upper right corner, preferring to focus, not on atmosphere, but on the effect of light upon water, painted poles, and architecture.

The chief achievement of this painting is Manet's breaking up of the landscape into building-blocks of separate gestures. These discrete and mostly non-overlapping painted marks cover virtually the entire surface of the composition in ways that look forward to Cézanne's constructivist stroke developed years later. Manet's gesture has transformed from the eloquent, calligraphic, curvilinear strokes of the 1860s and early 1870s into an almost analytic, non-graphic stroke that stands for a discrete color sensation. Why did this happen at this point in Manet's oeuvre? The answer must be

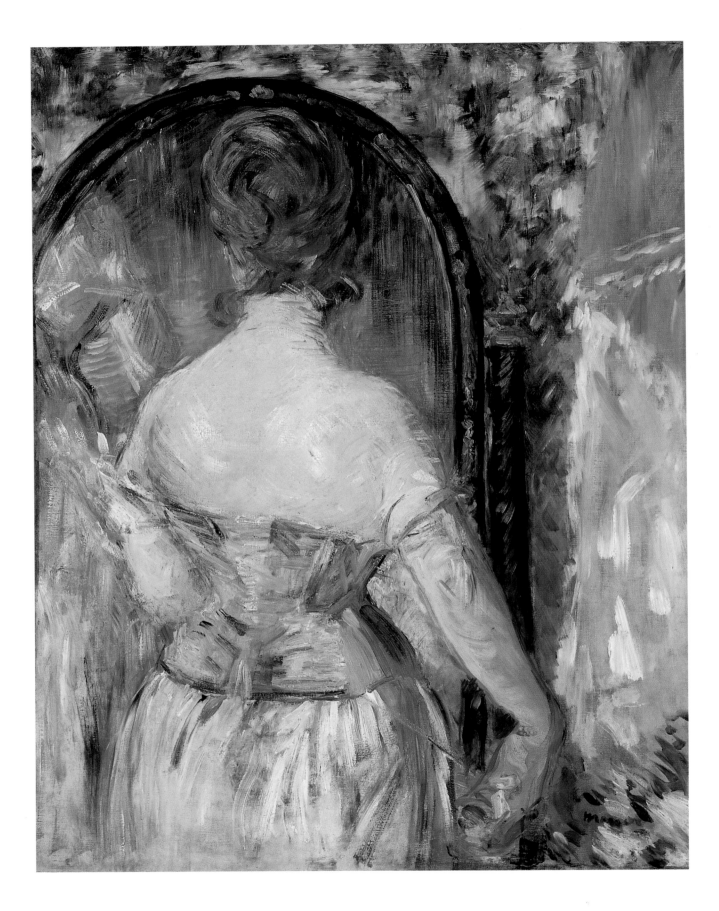

48 Edouard Manet
Before the Mirror, 1876
Oil on canvas, 92.1 x 71.4 cm
Solomon R. Guggenheim Museum, New York
Thannhauser Collection, Gift,
Justin K. Thannhauser, 1978

49 Berthe Morisot
Woman at her Toilette, c.1875
Oil on canvas, 60.3 x 80.4 cm
The Art Institute of Chicago
Stickney Fund

[22] Joris-Karl Huysmans, *L'Art moderne*, G. Charpentier, Paris, 1883, p. 157.

speculative, but surely it has to do with the element of time. If it is true that he waited until the last minute to transcribe sensations he had studied for several weeks, then he had to do it in the most time-efficient manner possible, without needing to wait for paint to dry. He therefore had to construct the entire color-sensation with as few overlapping (and hence muddying) strokes as possible. This mosaic of color sensations was efficient and, in a very un-Manet-like way, grammatical rather than eloquent and casual. It would be highly significant to discover that Cézanne saw this canvas in 1876 or 1877, but there is no evidence that he did.

This experiment in grammatical gestures was a one-off for the ever-elegant Manet, who returned to France having studied not only the medieval city of Venice, but also its painters—Titian, Tintoretto, and Tiepolo. *Before the Mirror* (fig. 48), conventionally dated to 1876 or 1877, is the painting that exemplifies his return to the calligraphic gesture. This masterpiece, signed by Manet and exhibited in 1880 at La Vie Moderne, is among the most completely satisfying performative paintings in his oeuvre. The corsetted woman, seen completely from the back, is angled to the mirror in such a way that we are unable to see her face or her full figure. Hence the painting addresses issues of mirroring and its deceits, but in a way so apparently casual that we might seem to force interpretations upon it. Not only is it a kind of fantasy made in connection with the exactly contemporary (and much more contrived) *Nana* (1877; Kunsthalle, Hamburg), it is also as close a homage as Manet created to the painting of his sister-in-law, Berthe Morisot. Its blond, pale tonalities were described by Huysmans as "caressing beneath its braggart appearance, a spare but intoxicating drawing, a bouquet of lively patches in a blond, silvery painting."[22] It relates very closely to an 1876 canvas by Morisot, *La Toilette* (private collection, Paris), which she included in the third Impressionist exhibition of 1877. She in turn paid homage to Manet's painting in her superb canvas of *c.*1875, *Woman at her Toilette* (fig. 49).

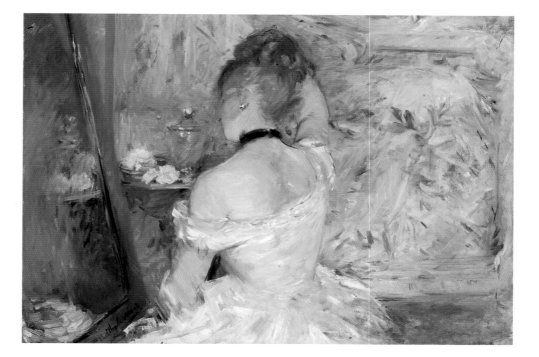

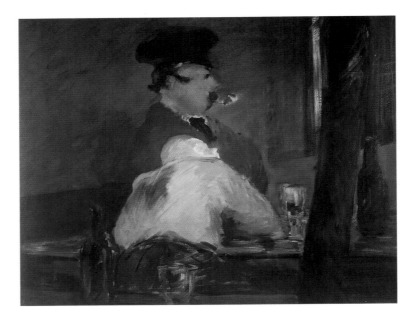

50 Edouard Manet
Open-air Café (Le Buchon), 1878
Wash and pencil on paper, 21 x 28.3 cm
Dallas Museum of Art
The Wendy and Emery Reves Collection

51 Edouard Manet
Open-air Café (Le Buchon), 1878
Oil on canvas, 73 x 91 cm
Pushkin State Museum of Fine Arts, Moscow

Two paintings of urban subjects made in 1878 contribute to the range of Manet's performative painting in his last decade. More compact and rehearsed of the two is the superbly observed urban snapshot, *Open-Air Café (Le Buchon)* (fig. 51). This small canvas, featuring two drunks at a café near the Barrière de Clichy, is so concise that virtually every painted line is essential to our reading of the complex scene. At first, we see past a glass and bottle to a table dominated by a male figure wearing a jaunty hat and smoking. This defiant drunk has a companion whom we make out a little later— a slumped-over figure, drunk and asleep with her head on her arms. To the right, the irregular vertical form that at first looks like a pillar but must surely be a tree, places us in an outdoor café, and the tonalities of the painting make it clear that it is daytime, when drunkenness is most shameful. A small brush drawing related to this painting (fig. 50) makes it clear—particularly in the context of his other brush drawings and lithographs from the 1870s—that Manet did rehearse his gestures, and that many of them have their roots in brush calligraphy. If Manet could record a complex scene in a few black gestures on white paper, he stood a chance of repeating the representation with little trouble on a canvas.

The second city subject was painted on June 30, a national holiday to celebrate the success of the 1878 Exposition Universelle. The first public manifestation of French pride in Paris and the first parade since the Commune in which it was legal to fly the Tricolor, the festivity was painted simultaneously by Manet and Monet. The younger artist made two paintings, both of which were included in the fourth Impressionist exhibition of 1879 (see figs. 83, 84); but Manet seemed never to have completed or exhibited his extraordinarily loose and spontaneous rendering. Interestingly, it was Monet who made preparations to paint the event, renting a room specifically for the task, while Manet simply painted the scene he could see on the street that came to a dead end in front of his studio on the Rue St. Petersbourg (fig. 52). The authenticity of this giddy painting has been questioned, but its frequent inclusion in major books and catalogues suggests that most Manet specialists are inclined to accept it. It stands

52 Edouard Manet
Rue Mosnier Decked with Flags, 1878, 1878
Oil on canvas, 65 x 81 cm
Private collection, Switzerland

with the unfinished *Funeral* as the most extravagantly gestural painting of his oeuvre, and this is surely because it was begun and then abandoned. Manet turned his attention in the lengthy aftermath of the celebration to larger canvases representing complex peopled views of the same street. No canvas of the 1870s is freer or more personal than this, and surely no forger could have conceived of so bold and unprecedented a composition with such incredible scribbles, daubs, doodles, and stains of paint. The huge swathe of red from the flag on Manet's own studio window billows across nearly a quarter of the picture's surface, creating a chromatic counter to the nervous gesticulations in the rest of the canvas. It was a long time in the history of art before such gestures were to reappear.

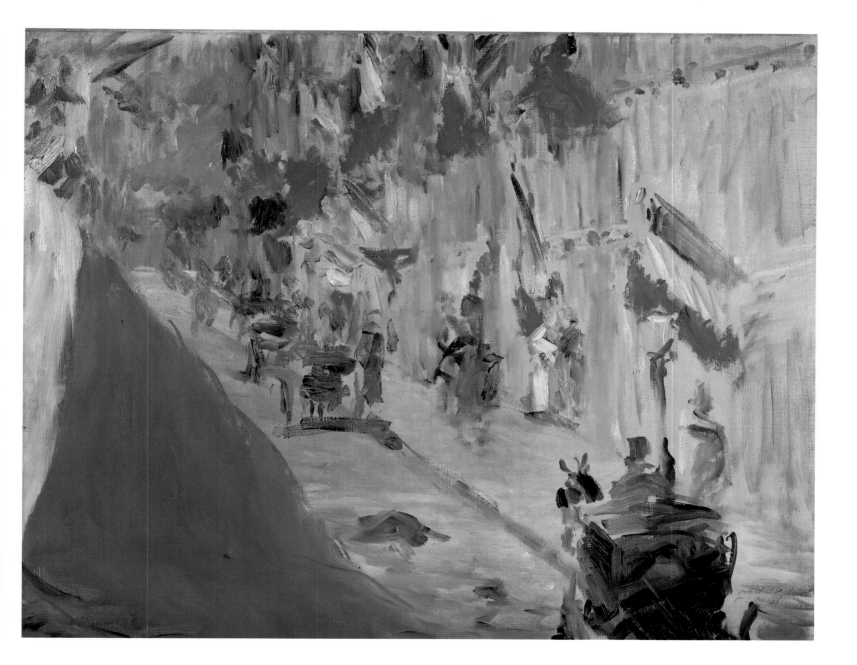

53 Edgar Degas
The Café Concert des Ambassadeurs, 1876–77
Pastel on monotype, 37 x 26 cm
Musée des Beaux-Arts de Lyon

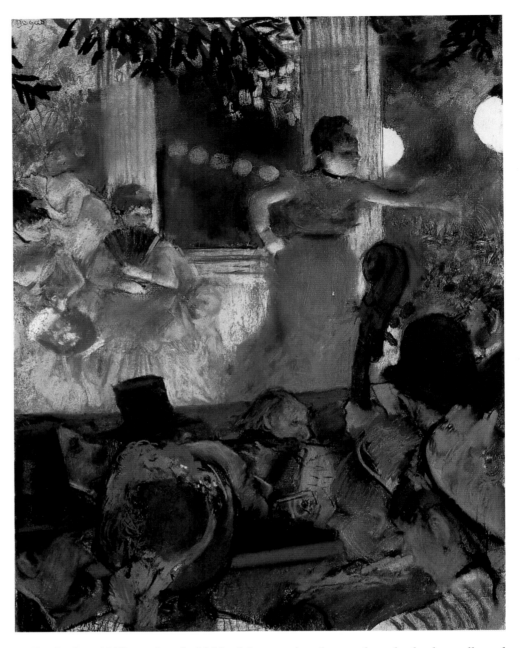

[23] In a private collection in Paris, it has not been publicly exhibited for many years. Few Manet scholars have actually seen it.

In the late 1870s and early 1880s, Manet painted several works, both small- and medium-scale, that pushed his experiments with performative painting to new heights. Two of these represent urban entertainers in their night-time settings, with soft daubs of almost liquid paint that seem still wet on the surface. The larger of the two, *Singer in a Café-Concert* (fig. 54), is surely among Manet's masterpieces.[23] A singer in an outdoor café on the Champs Elysées sings on a stage amid the gardens of night-time Paris. Her ice-blue dress is adorned by a white ruffle that is a whiplash of painted gestures, and her gloved hand is given space by two clusters of gray-brown diagonals that act as shadows from unseen stagelights. Her gloved arm reaches out toward the audience, and, because her mouth is closed, we imagine that she has just finished her song and is acknowledging the applause of her admirers.

54 Edouard Manet
Singer in a Café-Concert, 1880
Oil on canvas, 74.5 x 93 cm
Private collection

The trees in the background are lit to an uncanny green by the city lights, and the crowd is assembled nervously beneath them. This anonymous urban audience is evoked with a scattering of black and light blue daubs (the latter the same color as the singer's dress), which dance across a dark blue ground. Unlike the crowd in *The Races at Longchamps* and the glorious audience in *The Bar at the Folies-Bergère*, no individual emerges from the anonymity of painted marks. There is no hint of gender, age, or class as this tribe of daubs applauds the singer with a rhythmic appreciation, whose origins must lie with Manet himself. Clearly, his iconological touchstone in creating this painting was Degas, and it has often been compared to an exquisite and slightly earlier Degas pastel of a café-concert (fig. 53). Yet two more different works of art could scarcely be imagined. Every color, every gesture, and the position of every figure in the

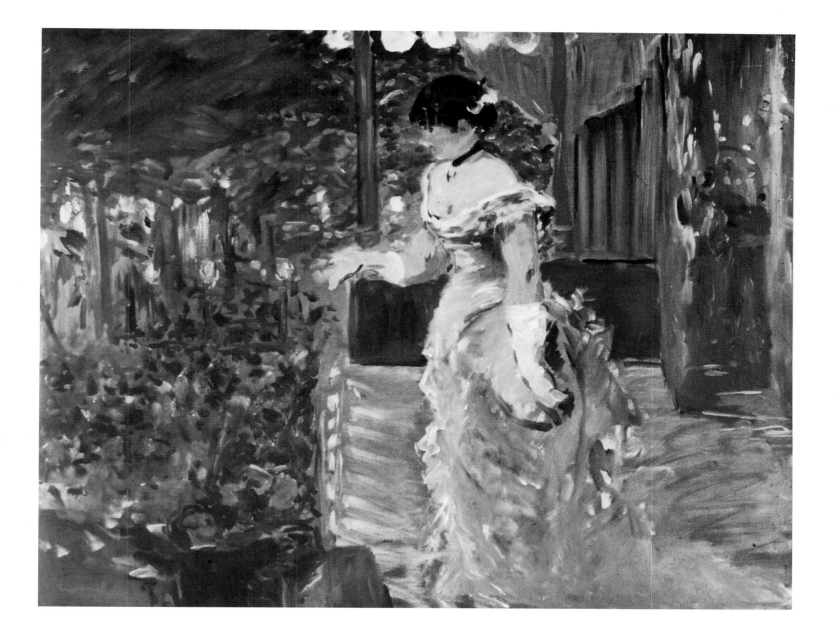

Degas has been studied, deliberated, and constructed. Manet's entire composition seems to be the result of a sudden inspiration, perhaps planned in a schematic way but certainly executed without a clear idea of just where each stroke of paint would go. He seems to be performing just as much as his singer, and, in acknowledging that, he invites our applause.

Nothing else in Manet's oeuvre evolved from this brilliant sketch,[24] suggesting that it was made as an independent exercise without any clear plan for its future use. Parallels can be drawn with a slightly later and somewhat smaller painting (fig. 55), very closely related in style and iconography, which has always been read as a deliberate *esquisse* for Manet's last masterpiece, *The Bar at the Folies-Bergère* (1882–3; Courtauld Institute, London). Manet's son, Léon Leenhoff, identified the male figure as the

[24] Although there is a smaller, related painting of another singer in isolation, *Singer in a Café-Concert*, formerly Steinberg Collection, Saint Louis; see Phoebe Pool and Sandra Orienti, *The Complete Paintings of Manet*, New York, p. 114.

[25] This painting is much discussed by Manet scholars; most follow Françoise Cachin who termed the *esquisse* "an Impressionist memorandum" from which Manet laboriously fashioned "un morceau de peinture" (*The Bar at the Folies-Bergère*). Yet if ever there was "un morceau de peinture," it is the smaller painting. Scholars catalogue the numerous differences between the two, but those do not prove that it was painted as a conscious *esquisse* for the large Salon picture; see Françoise Cachin et al., op. cit., pp. 483–4.

military painter Henry Dupray, and said that the smaller work was made in Manet's studio from sketches (probably pencil *croquis*) made on the site of the Folies-Bergère itself. Leenhof (and most other commentators) think that Manet then asked people he knew to pose for him in the studio, in a manner suggested by the sketches. The work would thus be direct, without being painted in the locale of its conception. Yet Manet's style seems to deny this theory, being fully consistent with direct painting. The wet-on-wet daubs are so palpable and quiver so on the small canvas that they can scarcely have more planning ascribed to them than the one-hour paintings of Fragonard with which he was so familiar. It is perfectly possible that Manet had no clear idea when painting this study that he would later elaborate it in the studio and use it as the basis for his last Salon painting.[25]

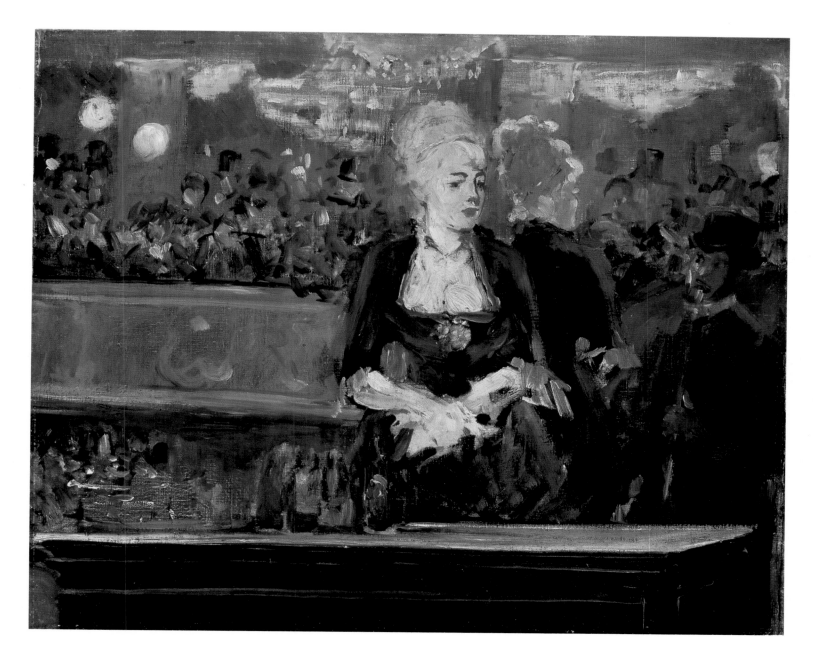

55 Edouard Manet
Sketch for "The Bar at the Folies-Bergère," 1881
Oil on canvas, 47 x 56 cm
Private collection
(Detail opposite)

56 Edouard Manet
Georges Clemenceau, 1879–80
Oil on canvas, 116 x 88.2 cm
Kimbell Art Museum, Fort Worth

57 Edouard Manet
Georges Clemenceau, 1879–80
Oil on canvas, 94.5 x 74 cm
Musée d'Orsay, Paris

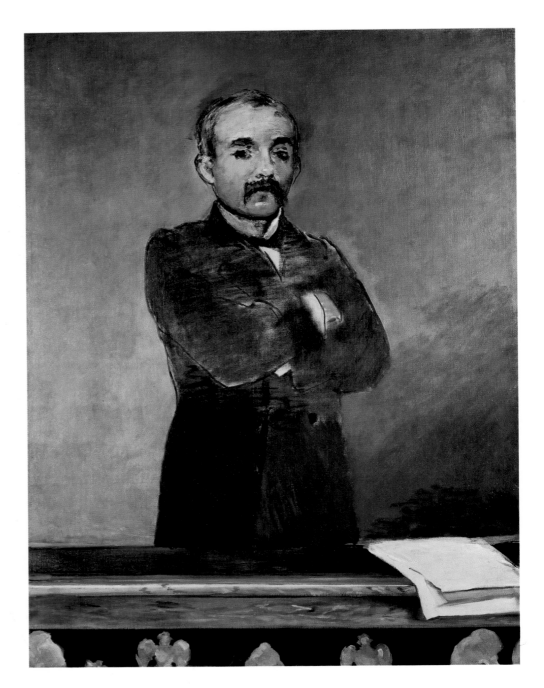

Manet did not confine his performative painting to landscape and urban genre; his "quick" manner was used for both portraits and still lifes. One extraordinary portrait records a stunningly deft and rapid attempt at likeness. Its subject was the young politician, Georges Clemenceau, with whose features Manet struggled for a considerable time in 1879–80. Two paintings survive, a fascinatingly patchy three-quarter-length portrait (fig. 56) and a somewhat smaller (and considerably more famous) version (fig. 57). Manet worked on them from both life and photographs, and he abandoned them both. An undated photograph of fig. 57 shows that it originally contained a

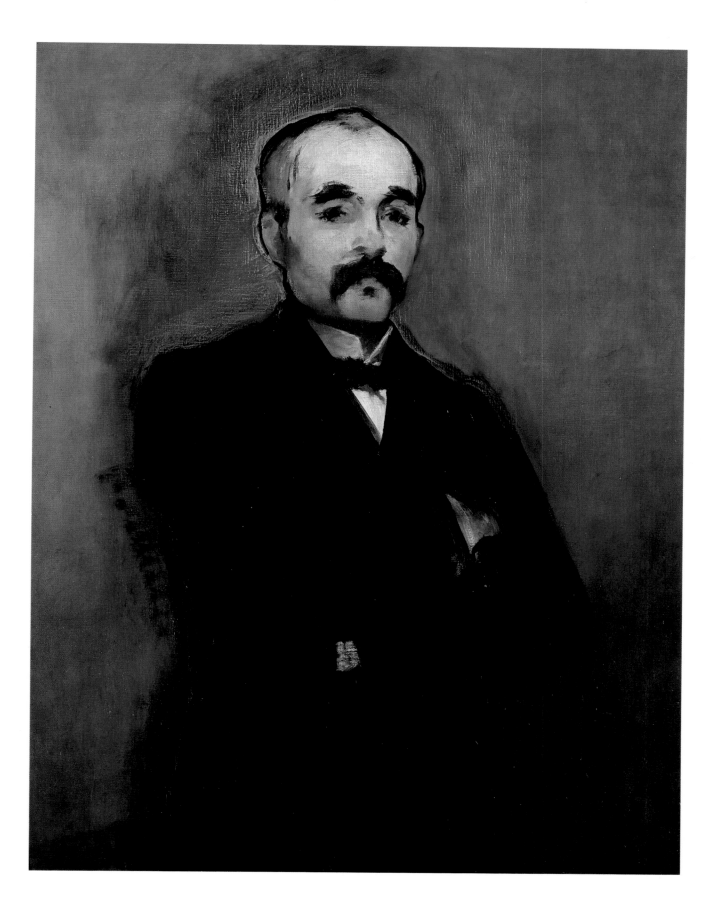

rapidly painted rostrum in the lower right corner, which was cut from the painting when it was reduced to its present dimensions (a practice with a long history in Manet's oeuvre). It is unknown who decided to do this reduction and when, but we should be grateful for the intervention—by being cut down, a canvas full of doubt became a masterpiece of concision and economy. Instead of wondering just what Manet would have done next, as we do when looking at fig. 56, we marvel at the sheer mastery of his craft. The black lines that push Clemenceau's head forward and define his eyes, eyebrows, and mustache are completely assured, the work of a master calligrapher. The contrast between the constrained gestures of the sitter and the performative power of the painter give the work a level of irony that is at once unmistakably critical and deeply moving. As Clemenceau stared confidently out of the confines of the canvas, Manet worked to pare his own gestures to a minimum, thus projecting an authority-of-making that matched the famous oratorical abilities of his sitter. What is particularly important about Manet's performance here is that it was not his first, even on this canvas. The halo around the head and portions of the body allow us to deconstruct the artist's actions as he painted, dissolved in solvent, and scraped at the canvas before a final performance. After this, he left it. The most mysterious gestures are those non-representational marks that form a row of parallel jabs on the left side of the figure. Here, Manet seemed anxious to compete with his subject, whose folded arms remain forever incapable of eloquent gesture.

Among the latest of his performative paintings to have been sold to the distinguished collector and opera singer Faure is a work that was not exhibited in Manet's lifetime, but was signed. *Woman Reading* (fig. 58) is virtually whipped up on the surface of the canvas. Each touch of paint dances lightly along the surface, most often pointing the way to another stroke in a kind of calligraphic choreography. The pose of the young woman is completely conventional—almost like a three-quarter portrait with head and hands—yet she seems unaware that she sits for a painter, as she busies herself with an illustrated journal in an outdoor café. Manet seems almost to be joking at the tradition in French painting of women reading.[26] But whereas Corot's women read books in the quietly contemplative atmosphere of the painter's studio, Manet's well-dressed young lady has ordered her beer in a café, grabbed a magazine off the racks, and started to scan it. Manet seems to have no more time for her than she does for her reading. Everything seems to be in a rush. She is absorbed in a magazine with very few words,[27] and she seems likely to drop her hold on it to take a sip of her beer. Even the beer has just arrived at her table—its frothy head, soon to disappear, still projects above the rim of the glass. Manet's signature beside the glass almost suggests that the painter himself might have sent it over to her table.

Manet seems to have scanned the woman with a knowing eye, as she scanned an illustrated magazine which is, in itself, illegible and unidentifiable to the viewer. As we ourselves scan the painting, we find ourselves in the presence of a work of art about the transience of modern desire in a public place, and about the temporal fragility of modern consciousness. Manet defined her face with no more than twenty separate strokes of paint, most of which float on top of the scraped, primed white of the under-canvas. This attractive female reader is the thinnest and quickest part of the whole performative project, as if she scarcely merited any more of the artist's attention.

[26] A tradition that has been much studied by feminist scholars, and that has claimed the attentions of many other great artists.

[27] Possibly the relatively new journal called *La Vie Moderne*; see Theodore Reff, *Manet and Modern Paris*, National Gallery of Art, Washington, D.C., pp. 84–5.

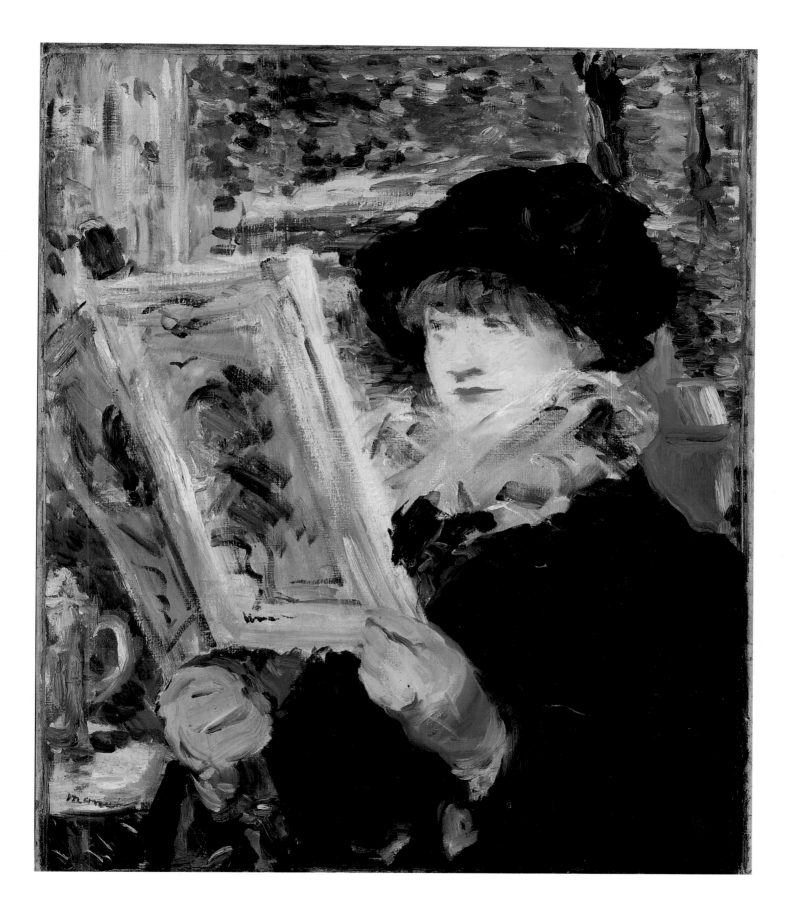

28 Robert Gordon has grouped these stunningly simple works in a book that is among the most satisfying studies of floral still life ever produced: Robert Gordon et al., *The Last Flowers of Manet*, Abradale Press, New York, 1999.

I would like to end this short excursion into the variability of Manet's performative project by returning to the subject of flowers, with which I started. Manet's last paintings were small canvases worked in short periods using as their subject the bouquets brought to the great painter during his last illness.[28] There is a great chromatic and gestural distance between the *Branch of White Peonies and Pruning Shears* of 1864 (see fig. 33) and the seemingly effortless homages to the fragility of life and beauty exemplified here by *Moss Roses in a Vase* of 1882–83 (fig. 59). Without the prodding and example of Monet, Morisot, and Renoir, Manet could never have painted them with so much authority.

59 Edouard Manet
Moss Roses in a Vase, 1882
Oil on canvas, 55.9 x 34.3 cm
Sterling and Francine Clark Art Institute,
Williamstown, Massachusetts
(Detail opposite)

5 Claude Monet and the development of the Impression

"Monet's two great gifts were: first, a miraculously sensitive eye . . . and, second, an exceptionally vital and original wrist. [We can only marvel at] the nervous, yet physically vital energy of all his brush writing. . . . The individual strokes are infinitely varied—blunt strokes; square ended, rigidly horizontal strokes; hooked strokes; semicircular strokes; smeared dots; long calligraphic glides; flat, sideways-smearing slab strokes; flicked comma-like strokes; soft, interweaving scribbles; and so on."[1]

No artist is more fully associated with the Impression than Claude Monet.[2] He began to paint rapidly executed, freely gestural paintings by the mid-1860s and took out-of-door, direct painting to new heights in 1868–9. His production of Impressions continued throughout the 1870s, before declining in the early 1880s, to become a virtual trickle by 1890. Like his colleague Renoir, he mastered this kind of painting but eventually wearied of it. Instead, he internalized the Impression and began to concentrate on a long-term struggle to seize a quality of light that he called "the envelope"; from his letters and paintings we learn that this could be experienced in a rush, but needed long and repeated pictorial encounters to be realized in painted form. Monet seems to have recognized the inherent philosophical impossibility of the Impression, and came to understand that rapid painting did not necessarily mean entrapping nature's own fleeting effects. An apparent desire for an objective painting of light led him away from the personal, and psychologically expressive, kind of painting associated with the Impression.

Monet's Impressions began in the mid-1860s, when he began to make, sign, and sell paintings that would then have been called *pochades*, *esquisses*, or *études*. This production was not unusual for the period either in style or subject, but the fact that Monet signed and sold them demonstrates how integral they were to his image of himself as an artist. One of two versions of *Road by the Saint Siméon Farm* (1864; private collection) was sold in 1864, the year it was painted, to a collector who lived in the town; a friend of Monet's early teacher, Eugène Boudin, bought another similar painting the same year. Monet was painting nature with both his contemporary, Bazille, and the older artists Jongkind and Boudin. They engaged in mutual critiques which helped them to improve their work—probably withering on occasion about specific issues, they were respectful of each other's larger aims. This mutual method of working—at once individual and collective, friendly and critical—was to transform landscape painting, which moved from the fields and villages in the French landscape where it began to shared studios and city cafés.

Towing a Boat, Honfleur (fig. 60) is perhaps the work of 1864 that best exemplifies Monet's status as a direct open-air painter. Nothing is known about its nineteenth-century provenance and history, but its size, signature, and extraordinary boldness set it apart in Monet's production of that year. It represents a moment at sunset when a trio of Normandy fishermen are beaching their boat for the night. Thus its very imagery is of short duration—both the human action of beaching the boat and the fleeting effect of sunset involve the work doubly in issues of the instantaneous. Monet could not have made this work in one sitting. At least a day would have been required for the yellow sky to be dry enough for the nearly black lighthouse to be placed on top

[1] Patrick Heron, "The Revival of Monet," 1957; reprinted in *Painter as Critic: Patrick Heron: Selected Writings*, ed. Mel Gooding, Tate Gallery, London, 1998, pp. 136–7.

[2] All the information about provenance and exhibition in this chapter derives from Daniel Wildenstein, *Monet, Catalogue Raisonné*, Lausanne and Paris, 1974; reprinted Taschen, Cologne, 1996, 4 vols.

Claude Monet, *Towing a Boat, Honfleur* (detail of fig. 60)

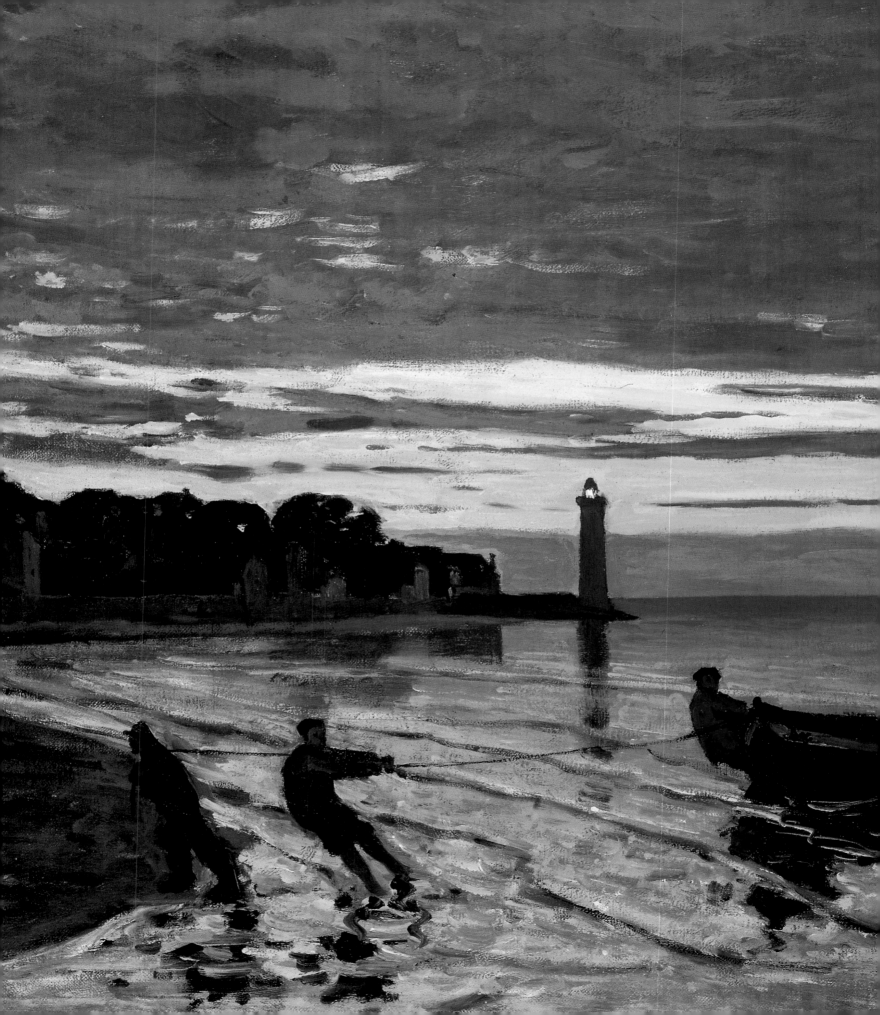

60 Claude Monet
Towing a Boat, Honfleur, 1864
Oil on canvas, 55.2 x 82.1 cm
Memorial Art Gallery of the University
of Rochester, Rochester, New York
Gift of Marie C. and Joseph C. Wilson

of it, and the water was at least tacky enough to resist mixture before the figures of the fishermen with their boat were painted on top. Monet painted the sunset effect first—the sky and the water—before adding the dark details of the landscape, the lighthouse, and the foreground activity. All the elements of the composition are done with loose, free, and countable gestures produced with relatively large brushes. Only in the linear areas of the sail, the rope, the tidelines in the water, and in his signature did Monet draw with the paint. The directness of his attack is strongly felt in this painting, as was his evident desire to make a major pictorial impact on the viewer. The thick strokes of yellow paint, the most dramatic section of the painting, seem so material—so much about the paint itself—that Monet might even have squeezed it from the tube directly onto the canvas before flattening it with the brush. The dancing strokes beneath the feet of the foreground fishermen are mixed in such a way that suggests that the dark ground on which they were painted was not yet dry when they were quickly applied.

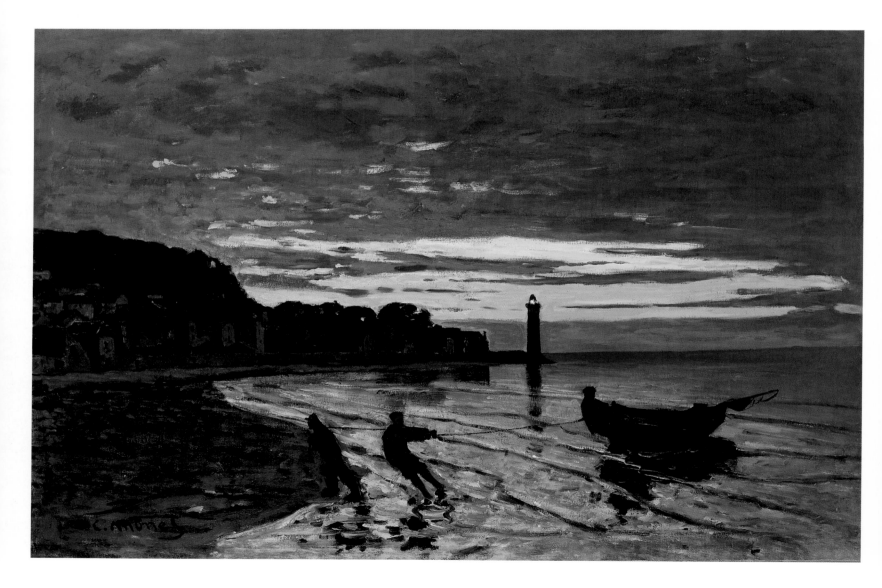

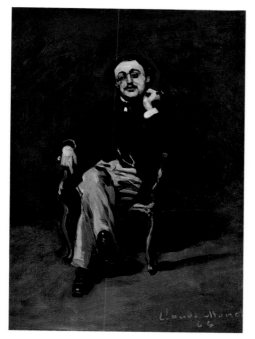

61 Claude Monet
Dr. Leclenché, 1864
Oil on canvas. 45.7 x 32.4 cm
The Metropolitan Museum of Art, New York
Gift of Mr. and Mrs. Edwin C. Vogel, 1951

[3] Letter from Monet to Bazille, dated July 15, 1864; for the full text in the original French, see Daniel Wildenstein, *Claude Monet: Biographie et Catalogue Raisonné, Tome I: 1840–1881*, Lausanne and Paris, 1974, letter 8, p. 420.

[4] For a summary of these difficulties, see Richard R. Brettell, introduction to Kermit S. Champa, *Corot to Monet: The Rise of Landscape Painting in France*, The Currier Gallery of Art, Manchester, New Hampshire, 1991, pp. 19–21.

[5] The other painting is *Portrait d'homme debout*, signed and dated "Claude Monet/64," Collection of Harry Sternberger, Israel (Wildenstein cat. no. 42). Neither of the subjects has been identified.

[6] Monet seems to have made extra money in his youth by drawing rapid caricatures of visitors to the ports of Le Havre and Ste.-Adresse; these are reproduced most accessibly in Daniel Wildenstein, *Monet, ou le triomphe de l'Impressionnisme* (vol. I of the *Catalogue Raisonné*), Taschen, Cologne, 1996, p. 13.

[7] Two large fragments are in the Musée d'Orsay, Paris (Wildenstein cat. nos. 63/1, 63/2).

Monet communicated the urgency he felt in a wonderful letter to his friend Bazille: "Every day I discover still more beautiful things. It's enough to drive me mad, I've got such a desire to do everything, my head explodes . . . I want to struggle, to scrape off, begin again . . . It seems to me, when I see nature, that I want to do it all, write it all down."[3] The notion of direct painting being the result of struggle is an old one in French landscape practice.[4] Monet experienced it with a verbal vividness matched in his painting. This seascape, though not an Impression, is among the most forthright of his early attempts to create a painterly equivalent for immediacy. It was made as he worked on two large landscapes for the Salon, completed in 1865, which were to push his career to a new level and lead to his first meeting with Manet.

Monet also experimented with another kind of quick painting in 1864 when he created, signed, and dated two highly evocative portraits.[5] The male figure seated in an eighteenth-century style armchair is a wonderfully cocky and immediate transcription (fig. 61). He seems almost to engage the viewer in conversation, chatting casually as he is painted. A restricted palette and the complete absence of a background make it easy for us to imagine Monet painting this work from life, probably in the Paris studio where Bazille worked with him on figure studies during the autumn of 1864. The entire figure is evoked with no more than fifty strokes of paint, most of which were directly applied to the canvas with a relatively large brush. After just one serious working session, Monet concluded that the work was finished, and signed and dated it with a flourish in red paint in the lower right corner: "Claude Monet 64." This splash of red is the only pure color in the painting, and is as much part of it as the exaggerated inscriptions on the caricatures Monet made for sale when he was a teenager.[6] With this confident portrait, Monet succeeded in bringing the energy of caricature into the arena of fine art, well before he ever saw a painting by Daumier.

In 1865, he began his most impressive experiment in direct painting. He attempted to create a huge canvas from posed figures in the Forest of Fontainebleau painted completely from life. The immediate impetus for this idea undoubtedly came from the great French landscape painter Daubigny, who had submitted a large painting to the Salon the previous year done completely out of doors. Being young and competitive, Monet set himself an even more difficult task—instead of just a landscape, he elected to add full-scale identifiable figures in contemporary dress, *and* an elaborate picnic. He would directly link the fundamentally separate pictorial practices of landscape, still life, portraiture, and genre into a new and seamless whole. Stories about this project are legion. We know about the trench dug to lower the painting, so that Monet could work on the upper portraits of the huge canvas without climbing onto a ladder (which would have altered his bodily and therefore visual relationship with the motif). We also know that he was unable to persuade enough people to pose as an ensemble all at once, and that he worked around this by re-using his best friend Bazille (who appears four times!), his mistress Camille Doncieux (twice) and another unidentified woman (three times). The huge, ambitious painting was a failure, remained unexhibited, and Monet eventually cut it up.[7]

Bazille and Camille (fig. 62) is a smaller painted study of two figures which were at the far left of the big canvas. Few of Monet's works from this period have the immediacy of this vivid work. He completed it by signing it with his full name at the lower right,

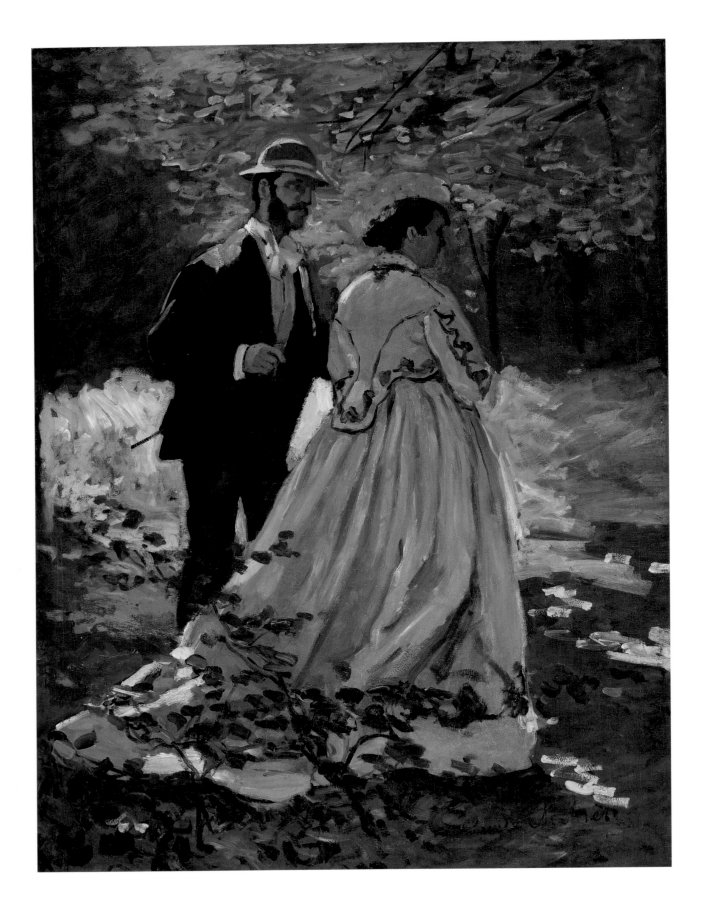

62 Claude Monet
Bazille and Camille, 1865
Oil on canvas, 93 x 68.9 cm
National Gallery of Art, Washington, D.C.
Ailsa Mellon Bruce Collection

and even his signature has a free, graphic nervousness rare in his oeuvre. For the dress of the female figure and the extraordinary landscape, Monet reserved the most slashing and energetic brushstrokes yet used in his career. The irregular dab of almost pure yellow between the two figures sits forthrightly on the surface of the canvas, refusing to be read as the ground behind the figures, and the same can be said for the bright, yellow-enriched greens to the left and right. This most chromatically aggressive area of the canvas is also the most gesturally aggressive, as if Monet was lashing out with his brush in the struggle to realize his sensations as quickly as possible. To finish it, he attacked the composition again with very dark brown and dark green (almost black) paint which forms a small shrub in the immediate foreground. The leaves are quick touches of thick paint daubed on the canvas and pushed with short gestures in one direction or another, giving the entire foreground an almost demonic energy. All of this pictorial aggression is at complete odds with the serene, bucolic, and stabile subject of two upper middle-class urban figures talking a walk on a warm, sunny day. Monet was bolder, more aggressive, and less fearful in this work than he had been even in his wonderful 1864 portraits. However, it is not possible to date this painting definitively to 1865.[8]

Among Monet's most confidently and quickly painted canvases of the late 1860s were seascapes. In this, he participated in a tradition of vacation pictures to which Manet, Whistler, Courbet, Daubigny, Jongkind, and Boudin made distinguished contributions in this decade. The great master of the palette knife, Gustave Courbet, had painted a large series of water and sky pictures in Trouville during the fall of 1865; when a group of these were exhibited at Cadart's gallery in Paris in April 1866, Courbet was reported to have been amazed that seascapes "done in two hours" could sell for such large sums of money.[9] The sea, as a motif, had become closely associated with quick representation and direct transcription in both painting and photography by the mid-1860s, so Monet's contributions, although fascinating, are not unprecedented. Represented here are two small paintings from 1865, *Seascape, Le Havre* and *The Green Wave*, and a comparatively large and much bolder work, *The Sea at Le Havre*, which is conventionally dated 1868.[10]

In composition and tonal structure, *Seascape, Le Havre* (fig. 63) is closely related to the almost monochrome seascapes of the same year by Courbet and Whistler, but Monet could not have seen those works.[11] Broadly speaking, it is a study of the interaction of green, gray-blue, and white with accents of pale orange, dark brown, and a wonderfully fleshy pale pink. The cloud-filled sky is painted almost with smudges of color applied horizontally with no gestural fluency. By contrast, the water dances with lilting, linear marks and shorter smudges enlivened by motions of the artist's arm and wrist. With no evidence of the beach where the artist stood, the viewer seems almost to be floating. *The Green Wave* (fig. 64) could not be more different: whereas the former painting is light-filled, limpid, and gentle, everything about the latter is alive with motion. We seem to participate with Monet, in his unseen boat, in a rollicking, rough day at sea. We experience the swell in the deep, dark green water, represented with such thick paint that the boats seem to float on the paint rather than on water. The dramatic meeting of the foreground fishing boat with the swell creates an eruption of thick white paint dashed onto the canvas. The trails of white water are represented by

[8] It is not known when Monet completed and signed the painting. Its signature is not unlike others from 1865, but the work has no known provenance or exhibition history during the 1860s, and Monet often returned to studio works years later, adding bold pentimenti, signatures, and sometimes early dates that might be incorrect.

[9] See Charles F. Stuckey, *Claude Monet, 1840–1926*, The Art Institute of Chicago, 1995, p. 191.

[10] The two smaller works were both finished, as indicated on Marine by initials at lower right, and on *The Green Wave* by a signature and date. Neither, however, seems to have been shown publicly or sold in the decade of their making, although both were purchased and exhibited during Monet's lifetime. It is therefore difficult to know whether the signatures were done when they were made, or later at the time of a sale or exhibition. *The Sea at Le Havre*, although undated and never exhibited in Monet's lifetime, has been traditionally dated to 1868, presumably because it is thought to be bolder and more fully developed as an Impression than the seascapes of the previous three years. But there is no hard evidence to support this date, and Monet was capable of having painted it as early as 1865. Documentary evidence shows him to have been in Ste.-Adresse every year from 1864 to 1868.

[11] He may, however, have seen *Departure from Boulogne Harbor* (1864) by Manet at Martinet's gallery in Paris, but the evidence is circumstantial and the pictorial resemblance too slight to make any conclusive connection.

63 Claude Monet
*Seascape, Le Havre, c.*1886
Oil on canvas, 42 x 59.5 cm
Ordrupgaard, Copenhagen

jabs of paint with as much energy as the represented energy of the surf itself. The effect is to immerse the viewer in the sea, and to link the sea's forces with those of the painter, making this small canvas among the most daring and articulate Impressions of the 1860s.

The Sea at Le Havre (fig. 65) is Monet's boldest seascape of the period, an extraordinary attempt to recreate in paint the energies of wind and water. The surface is

64 Claude Monet
The Green Wave, 1865
Oil on canvas, 48.6 x 64.8 cm
The Metropolitan Museum of Art, New York
H. O. Havemeyer Collection,
Bequest of Mrs. H. O. Havemeyer, 1929

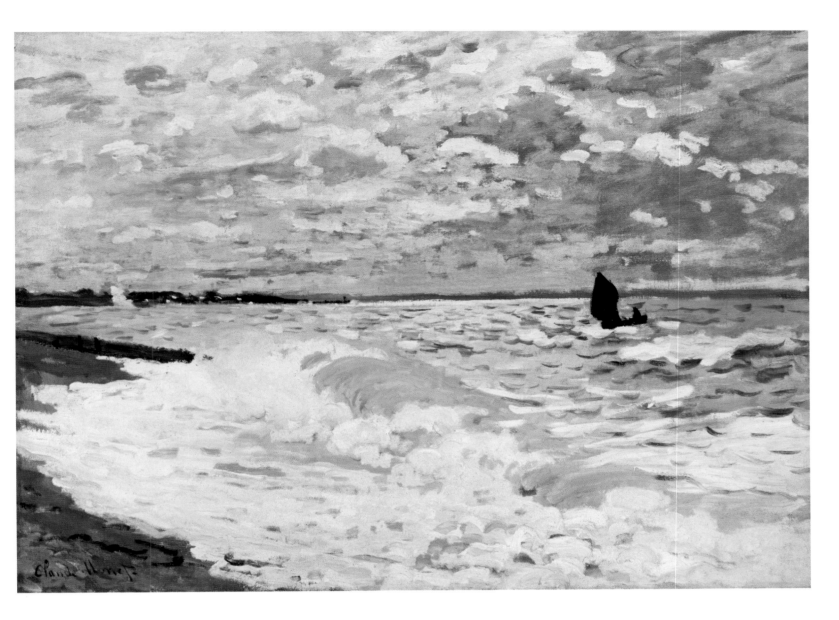

65 Claude Monet
The Sea at Le Havre, 1868
Oil on canvas, 60 x 81.6 cm
Carnegie Museum of Art, Pittsburgh
Museum purchase, 1953

practically a relief sculpture in apparently wet paint, as if Monet wanted no restraint in his use of the medium. The gestures are strong and purposeful, but short, and the combination of the graphic energy of the gray lines (representing the crests of waves) and the sheerly visceral paint-waves of lead-white mixed with yellows and browns (to suggest the waves surging through sand) almost makes the viewer gasp. Monet also made the sky equivalent in manner to the sea, thereby linking their forces through representational acts. The entire painting has the quality of directness, in spite of the fact that it must have taken at least two, perhaps three, sessions, probably with a break between two of the stages of at least a day. But the sense of direct improvisation can be found in every stroke, whether painted in the first, second, or third session. We can imagine Monet standing on the beach, moving his hands and arms with brushes and paint as his eyes darted back and forth across the churning sea. It is the most direct painting of the sea made by anyone in the 1860s.

66 Claude Monet
On the Bank of the Seine, Bennecourt, 1868
Oil on canvas, 81.5 x 100.7 cm
The Art Institute of Chicago
Potter Palmer Collection

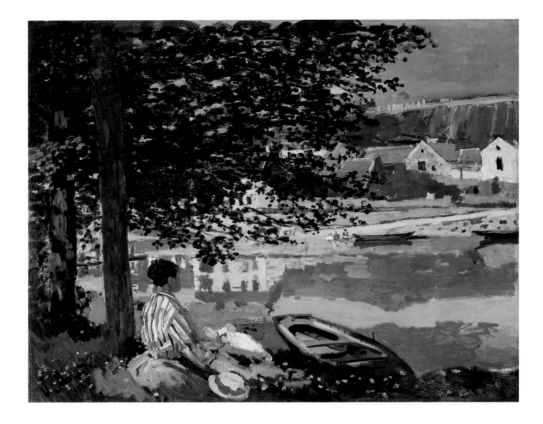

In 1868 Monet made a trip to the small village of Bennecourt, west of Paris, where he painted a large, bold canvas, signed it and dated it.[12] *On the Bank of the Seine, Bennecourt* (fig. 66) is a hallmark of early Impressionist landscape style. Representing a view of the architecturally and historically undistinguished village of Bennecourt, it was painted from a long island in the Seine, to which Monet and his mistress Camille would row from their rented house. Monet brought with him paints, easel, and a large canvas; over the course of several days he painted this large suburban landscape, as the afternoon light illuminated the village. He worked with almost uniformly large brushes in patches of undifferentiated color. There is no portion of the work that does not look, and feel, painted, and the artist was clearly anxious to involve the viewer in his transformative representational process. But whereas *The Sea at Le Havre* seems to represent the forces of nature, this landscape is utterly bucolic and calm. Monet's strokes could not have had the gestural urgency characteristic of seascape—instead, there is an almost lazy inevitability to them. They impart none of the sense of struggle which Monet described in his letter to Bazille.

Just to the right of the seated figure is clear evidence of another, earlier figure—possibly a child in the arms of Camille, or perhaps a leaning figure for which Monet substituted an erect posture. The relationship between the present and the "absent" figures seems mirrored in the two repoussoir trees. The one at the far left is carefully painted, shaded, and surrounded by space-displacing leaves. The one to its right is crude by comparison, and almost sits on the surface of the painting rather than taking its place in the landscape. It seems to have been added to provide the pictorial support for a plethora of dark green foliage that covers more than half of the upper portion

[12] It was not exhibited, however, until 1889, when he sent it to the Monet–Rodin exhibition held at the Gallerie Georges Petit in Paris.

67 Claude Monet
Jean Monet Sleeping, 1867
Oil on canvas, 42 x 50 cm
Ny Carlsberg Glyptotek, Copenhagen

of the canvas. These small brush touches—each a gesture—combine with the touches of yellow light scattered around the foreground to create a dancing super-rhythm over the carefully structured composition of architecture, geology, vegetation, and their reflections. Virtually the entire surface pulsates with these movements, in ways that Monet exploited fully only in 1869.

Two other small Impressions—a tiny still life of fish on a white napkin, and a delightful portrait of Monet's first son, Jean, asleep with a doll in his arms—are among the most intimate works in Monet's oeuvre. Small in both scale and aim, they are all the bolder in treatment due to the artist's self-imposed limitations. In *Jean Monet Sleeping* (fig. 67), the child's ruddy cheeks, wonderfully red lips, and apple-like chin are

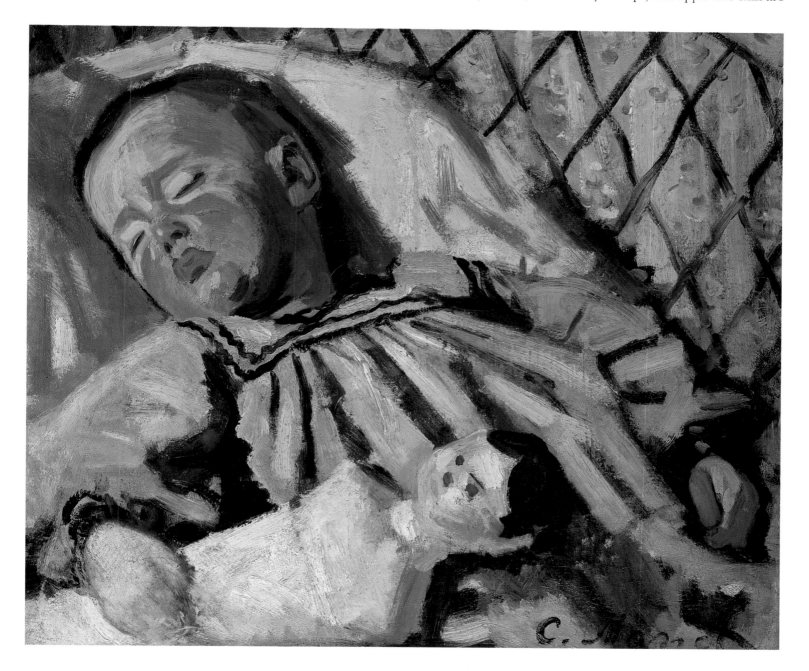

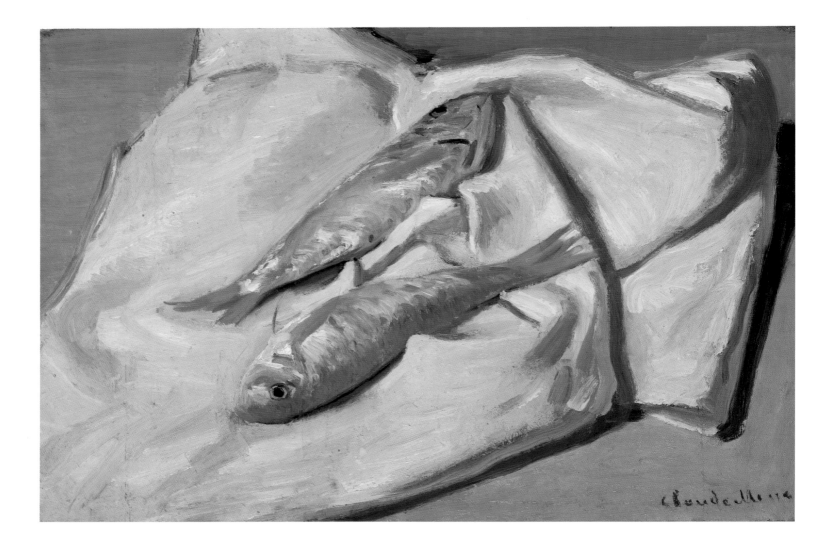

68 Claude Monet
*Red Mullets, c.*1870
Oil on canvas, 31.1 x 46 cm
Fogg Art Museum, Harvard University Art
Museums, Cambridge, Massachusetts
Gift of Friends of the Fogg Art Museum

contrasted with the wan porcelain complexion and pale pink cheeks of his doll. The eyes of the doll, forever staring upward, create a trialogue of systems of sight—sightlessness for the doll, dream sight for Jean, and sight itself for his father. And what a brilliant idea for Monet to paint Jean at the only time he was still, and in a symphonic range of values rather than colors. Because of this narrow range—black through gray to white and varying reddish pinks—Monet's task could be substantially completed, before Jean woke up, without creating mixtures in the pictorial field set for the performance. No yellows, greens, or blues muddy Monet's chromatically tidy little painting.

The same level of chromatic planning allowed Monet to complete *Red Mullets* (fig. 68) in record time as well. The yellow-beige table, the white napkin, and the pink fish are segregated and painted wet-on-wet with no chance of mixture. Perhaps only the dramatic shadows around the napkin and under the fish, along with the fish's eyes, were added at a second stage when Monet signed the painting with his full name. He had probably seen Manet's earlier great *Still Life with Fish* (1864; The Art Institute of Chicago) when it was shown at Martinet's and/or Cadart's galleries in 1865 or at the Manet exhibition at the Place d'Alma in 1867. He avoided the dramatic composition

and the large scale adopted by Manet, but borrowed the slithering wetness of the painting technique.[13]

Monet succeeded in these two small pictures in being bold within a strictly limited context, as if lying in wait for a pictorial seige without constraints. In the summer of 1869, in the company of his friend and rival Auguste Renoir, Monet began two large canvases, probably in preparation for an even larger picture that he submitted to the Salon in 1870 and had refused.[14] These two so-called sketches are among the icons of early Impressionism. Monet himself called them *mauvaises pochades* (bad sketches) in an oft-quoted note to Bazille, but seems later to have thought better of them, because he signed and exhibited them both during his lifetime.[15] Both were painted along a section of the Seine near Bougival, at a swimming place called La Grenouillère (The Frog Pond). They represent the most complex motif yet tackled by Monet in his new manner, and there is evidence that he needed goading by his ambitious friend Renoir in its selection. He chose to study visual and material contrasts—sun and shade, liquid and solid, figures and foliage, stasis and movement—in the two different compositions. Fig. 69 (long the more famous of the two because it has been in a major public collection since 1929), presents the motif in a symmetrical tripartite composition, while fig. 70 is daringly asymmetrical and visually unstable.

Their surfaces are covered with hundreds of individual touches of paint, applied with flat-ended brushes—an entirely new technique in Monet's work. Where previously he segregated color areas in carefully composed patterns in order to achieve visual immediacy, in fig. 70 the color is scattered across the surface, largely because water accounts for more than half of each composition, reflecting a host of visual forms in its trembling surface. Close analysis reveals that Monet first started the composition the other way up, then quickly abandoned this and turned the canvas round. He then worked in several bursts of energy on the surface to bring it all to a uniform state of nervous intensity.[16] The thick lines that represent oars, boat seats, dock, wooden battens, and background tree trunks are daubed onto the surface in single, confident gestures. The brush is loaded with pigment which is applied cleanly and quickly, allowing it to push thickly around the edge of the brush. This gestural immediacy is greatest in the figures and in the reflective surface of the water around them. Here, Monet completely dissolves the distinction between figure and ground, describing each with gestures of equal thickness and directional power. Hence pictorial energy is everywhere on the canvas, no matter what representational form is being evoked in paint. Monet arrived at this radical style in the company of Auguste Renoir, an artist who, although well known to Monet, had never been particularly close to him in aims. There is no greater contrast in modes of rapid painting than between Monet and Renoir in the summer of 1869; clearly, each defined his visual identity partly in opposition to the other.

We know that one of the two sketches was in the second Impressionist exhibition of 1876, and another in the Monet–Rodin exhibition of 1889, but we cannot be certain which was shown when. Therefore we cannot ascertain with any accuracy when the two sketches were signed by Monet as finished. It seems likely that neither had achieved its current state by 1869 when Monet wrote about them to Bazille, and it is perfectly possible that Monet re-worked and signed them up to seven years later,

[13] *Red Mullets* was acquired by Bazille's friend Edmund Maître, one of the earliest quickly painted works by Monet to appeal directly to an advanced connoisseur.

[14] The Salon painting, lost since World War II, is known only from a black-and-white photograph, and even its scale is uncertain. For a reproduction and bibliography, see Wildenstein, op. cit., vol. II, p. 66 (cat. no. 136).

[15] He also dated fig. 70. There is evidence that the other (Metropolitan Museum, New York) was owned at some stage by Manet, who may have acquired it after the second Impressionist exhibition of 1876.

[16] Information from the superb technical analysis in David Bomford et al., *Art in the Making: Impressionism*, The National Gallery, London, 1991, pp. 120–25.

69 Claude Monet
La Grenouillère, 1869
Oil on canvas, 74.6 x 99.7 cm
The Metropolitan Museum of Art, New York
H. O. Havemeyer Collection,
Bequest of Mrs. H. O Havemeyer, 1929

when he selected one of them for inclusion in the 1876 exhibition. The large-brush signature on fig. 69 is more integral with the mode of painting on that canvas; the wiry, fine-brush calligraphic signature and date on fig. 70 is not only a complete contrast in painterly style with the work itself, it was made with a completely different brush from any of those used in the painting.

What is remarkable about both *La Grenouillère* canvases is that Monet preserved the sense of urgency and rapidity of execution throughout all the stages of the process of creation. At least four separate periods of attack must have been required, with at least a day between each. Given the evidence of the differing signatures and considerably later exhibitions of each work, the last phase of pictorial adjustment leading to signature could have been considerably later than the others. Yet Monet was careful to preserve the intensity of plein-air painting throughout the process.

In many senses, Monet had mastered the Impression by the summer of 1869; he spent the next decade applying the lessons he had learned to other motifs in England,

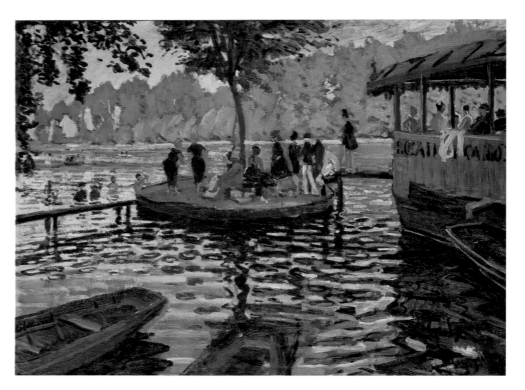

Holland, and France. His confidence as a maker of open-air painting was so great by 1870 that he left few areas of visual experience untouched by this method. He painted night and day, city and country, water and land, architecture and foliage, suburb and village, figures and fashions in works that were usually signed, occasionally dated, often sold, and even exhibited. The number of works that appear to have been painted in one short session increased dramatically in the early 1870s, just as his own confidence seemed to reach a peak. The doubt-filled Monet of the 1860s, the Monet who struggled, is temporarily replaced by a painter fully at ease with himself and his manners, producing at a steady clip to meet both the demands of the market and his own restless desire to paint every effect of nature.

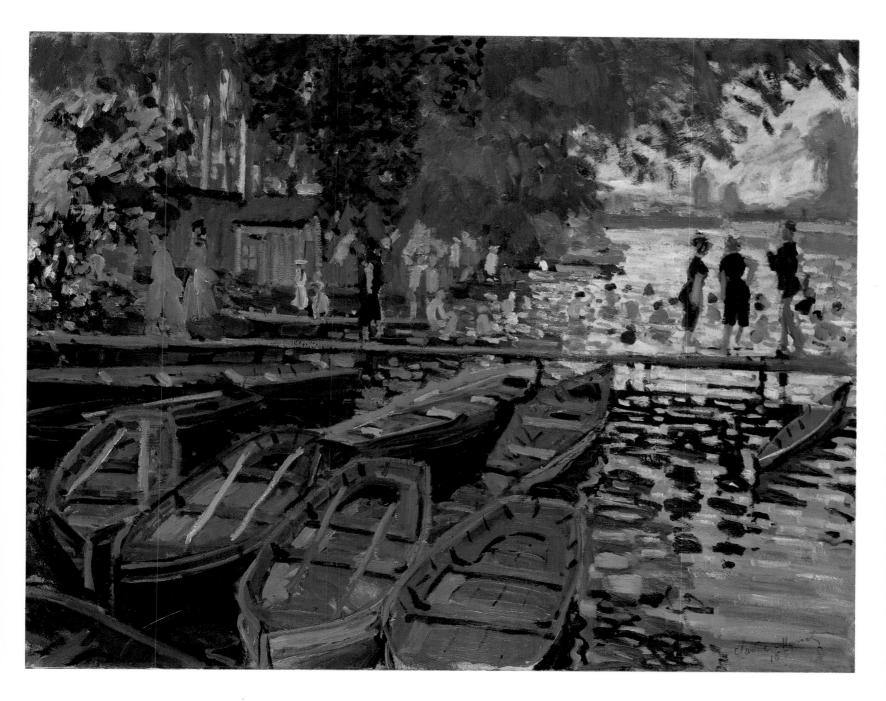

70 Claude Monet
Bathers at La Grenouillère, 1869
Oil on canvas, 73 x 92 cm
The National Gallery, London

Monet produced more than four hundred paintings during the 1870s, an average of forty per year.[17] Of these, well over a quarter are works that have the quality of an Impression. Their surfaces are covered with large, countable gestures with minimal layering, and their approach to their diverse motifs can best be described as summary; it is as if one of Monet's primary activities in the 1870s was the speed reading of nature. He sought to understand and entrap in paint the direct sensation of nature, and to thrive in the midst of the immediacy he sought. He was so satisfied with his Impressions that he seems to have sought to achieve the look of suddenness and rapidity even when he had to plan several sessions to complete a work. In many watery paintings, he painted skies and water in one session, waiting patiently for the paint to dry and impatiently for the weather to return in order to lay in the boats, buildings, figures, trees, other overlapping forms, and their reflections. At other times, he set up his easel in front of motifs in such flux—either human, natural, or mechanical—that he almost dared himself to fail. The competing claims of memory and immediacy vied as flags fluttered, trains steamed by, sailboats turned about, and wind swept through foliage.

Monet also began to work in bundles, taking a group of canvases in varying states of completion into the field. By mid-1870 these study sessions had begun to results in series of canvases, which Monet sent as such to exhibitions. They conveyed the idea that one canvas could never fully entrap the characteristics of a given motif, raising even more serious aesthetic questions about the very nature of motifs. What, he was asking, is essential to a motif? And the answer has to be: very little. The rush of gestures, the flutter of colored marks, the ceaseless representational activity of the artist became less and less representational. The critics, both positive and negative, agreed on this, calling attention to the crudity and forthright presence of Monet's marks, gestures, and patches of paint. In many ways, Monet's transciptions of various visual realms became signatures.

Monet made more than 130 works in the 1870s that can be called Impressions, from which we have selected 22. The selection was made for its iconographic and formal diversity and is presented here in a non-chronological manner. It is our contention that, by the beginning of the decade, Monet was firmly in command of his powers to create Impressions and was seeking new and challenging motifs with which to test and extend his powers.

The simplest group is the earliest—a pair of figure paintings made on the beach at Trouville during his honeymoon in summer 1870. The painter married his mistress Camille, the mother of his son Jean, on June 9, 1870, and the family went immediately to the fashionable Normandy resort for the summer. There, Monet painted the scene in a series of energetic pictorial homages to his teacher Boudin, who visited the young couple with his wife. He also painted a very un-Boudin-like vertical scene of the Hôtel des Roches Noires (fig. 71), one of his earliest serious studies of wind. Almost the entire upper left corner of the composition is dominated by a flag (probably the American flag), the flutters of which Monet represented with a series of wild red and whitish painted lines on the primed canvas. Here Monet's gestures conveyed motion, which is contrasted to the solidity of the hotel itself, acting as a straight man for the jokester wind, made manifest in the flags. Monet went with his wife and son to the beach, and

[17] Information from the exemplary catalogues of Daniel Wildenstein, op. cit.

71 Claude Monet
Hôtel des Roches Noires, Trouville, 1870
Oil on canvas, 80 x 55 cm
Musée d'Orsay, Paris

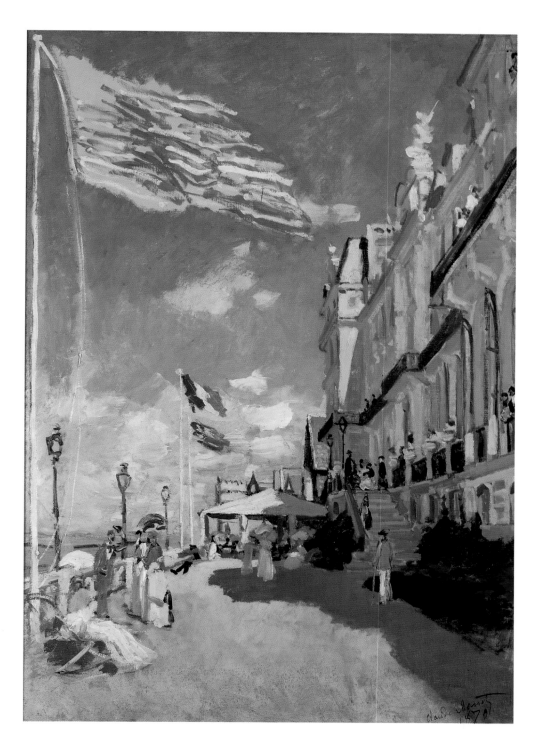

painted a group of small canvases in which the viewer-painter sits among or near
women and children. The proximity of the figures to the picture plane gives these
works a social intimacy that is correctly interpreted as familial, yet, although the figures
surely include Camille and her friends and relatives, the aim of Monet's transcription
was clearly not portraiture. Rather, he captured the summary effects of light and wind
on the clothing and hair of variously clad female figures and their companions in ways

72 Claude Monet
On the Beach at Trouville, 1870
Oil on canvas, 38 x 46 cm
Musée Marmatton–Claude Monet, Paris

that actually deny us access to their individuality. Even when Camille faces us, as she does in *On the Beach at Trouville* (fig. 72) and *Camille on the Beach at Trouville* (fig. 73), she acts almost as a staffage figure, against which we measure the livelier scenes of boats or figures behind her. In fig. 73 she wears a veil, effectively denying her identity, described by four strokes of pale blue and yellow-white paint. *The Beach at Trouville* (fig. 74) is by far the boldest in conception. Monet studied contrasting female figures— one in white, the other in black, one looking, the other reading. Both are evoked with a minimum number of painted lines, the majority of which were achieved in a single sitting, and the others (like the dot-described features of the two women and the wiry linear struts of Camille's parasol) in a manner little different in its immediacy and conciseness.

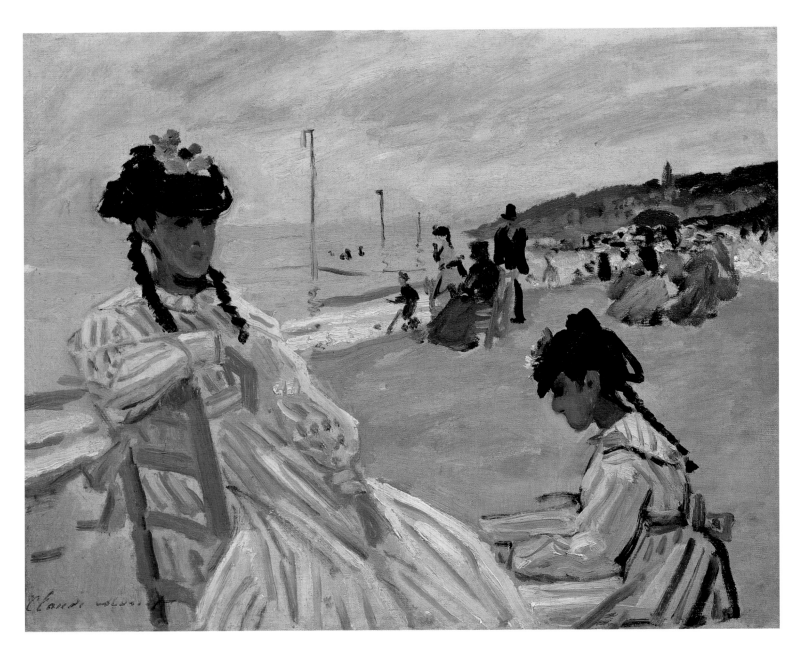

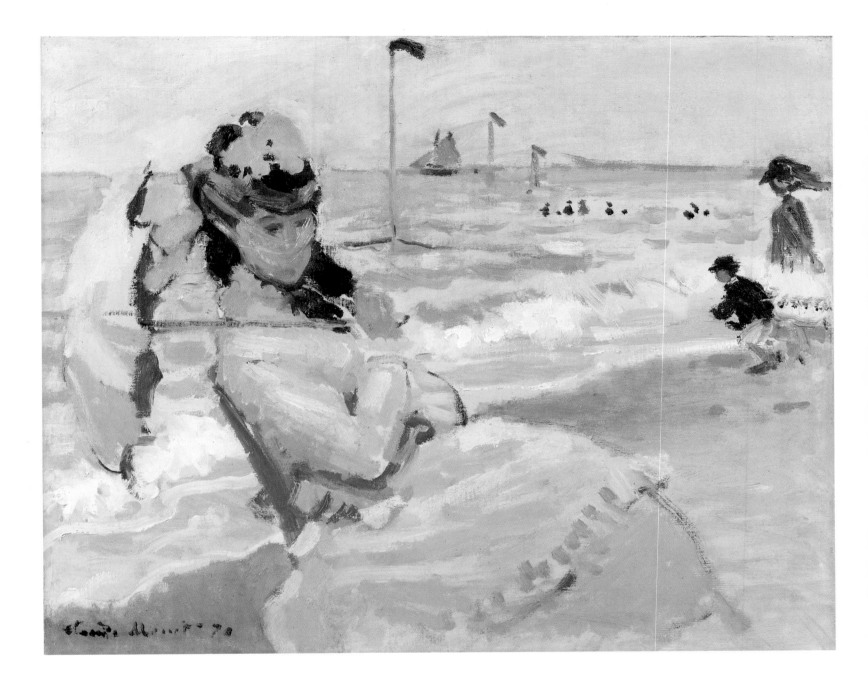

73 Claude Monet
Camille on the Beach at Trouville, 1870
Oil on canvas, 38 x 47 cm
Yale University Art Gallery, New Haven,
Connecticut
Collection of Mr. and Mrs. John Hay Whitney

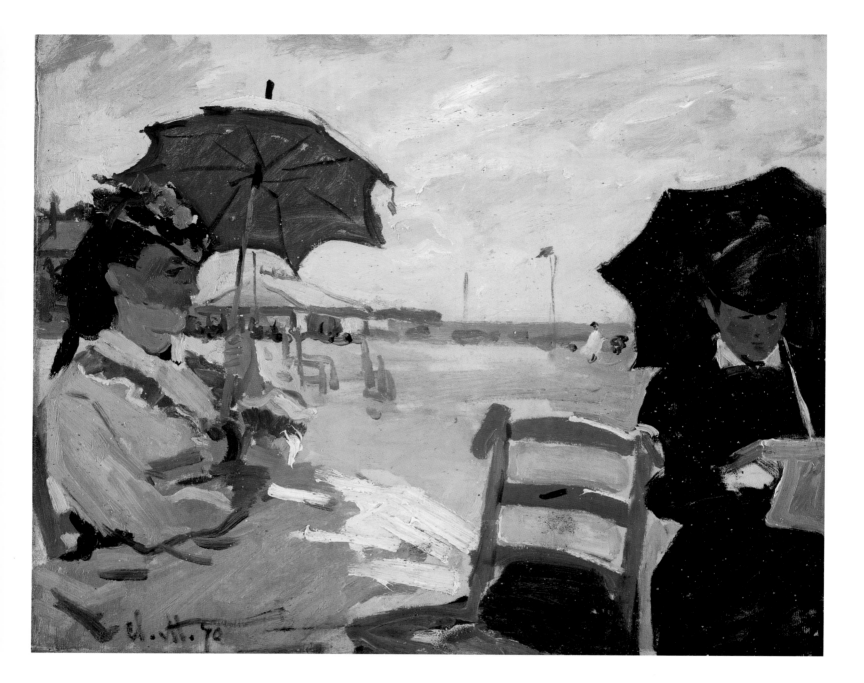

74 Claude Monet
The Beach at Trouville, 1870
Oil on canvas, 37.5 x 47.5 cm
The National Gallery, London

75 Claude Monet
Windmill near Zaandam, 1871
Oil on canvas, 41 x 72.5 cm
Ashmolean Museum, Oxford

Monet concentrated the bulk of his Impressions on the constantly shifting relationships between sky, water, and land. His riverscapes and seascapes in France, England, and Holland are among the most various in the history of art. They constitute an investigation of the two forces of nature—water and air—as they affect the land. The precedents for this elemental imagery are so numerous that they are virtually prototypes, and we rarely seem to see Monet reflecting on Ruisdael, Turner, Whistler, or Manet. Rather, he seems to have been totally consumed by his motifs; his ability to translate their rhythms into colored gestures seems unburdened by the considerable precedents of which other artists would have been conscious.

A wonderfully bleak study of wind and water in the country most devoted to battling these forces was painted in Zaandam, Holland, probably from a small dock that juts into the sea. *Windmill near Zaandam* (fig. 75) has a real immediacy. The water, churning with sand so that it is yellow and yellow-brown, pushes into the rushes, described by Monet in energetic directional strokes of green and brown paint. The sky, chock-full of clouds, is made of warm gray, white, and patches of pale blue. Monet added the dark forms of a windmill, a cargo boat, and bobbing, beflagged masts from the boats in Zaandam's protected harbor. The whole work is a study of pictorial force translated into gestures; it was so successful that it was purchased directly from Monet, just months after it had dried in 1872, by his first great dealer Durand-Ruel.

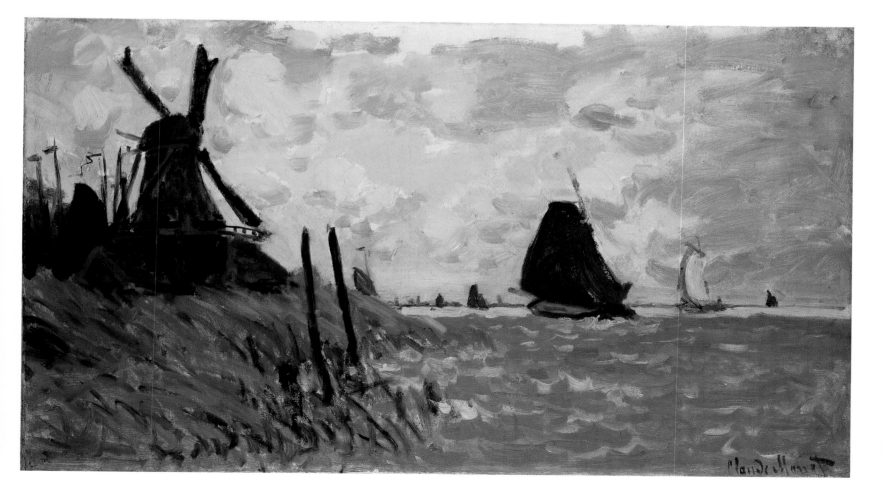

76 Claude Monet
The Seine at Petit-Gennevilliers, 1872
Oil on canvas, 43 x 73 cm
The John M. and Sally B. Thornton Trust

It is only a small leap from this work to another small, quickly painted study of the same natural forces. *The Seine at Petit-Gennevilliers* (fig. 76), signed in 1872, was, like the Zaandam canvas, sold shortly after it was made. Its subject is France's most famous river, viewed in its off-season when the sailboats were being repaired, repainted, and protected against the weather. Monet translated water and air into paint that appears still wet; we want to touch the painting to assure ourselves that it actually is dry, particularly in the area of the reflections, where the white strokes of paint intersect with the dark mass of red-orange, brown, and deep yellow-brown without ever becoming muddy. To make this extraordinarily direct painting, Monet needed at least three sessions—one for the water and sky, the second to add the land masses and reflections, and the third to draw in the linear elements before an equally linear signature. By this time in his career every aspect of this three-part performance would have been familiar to Monet; he would have known precisely what to do in each session for the completion of a small study in gesture.

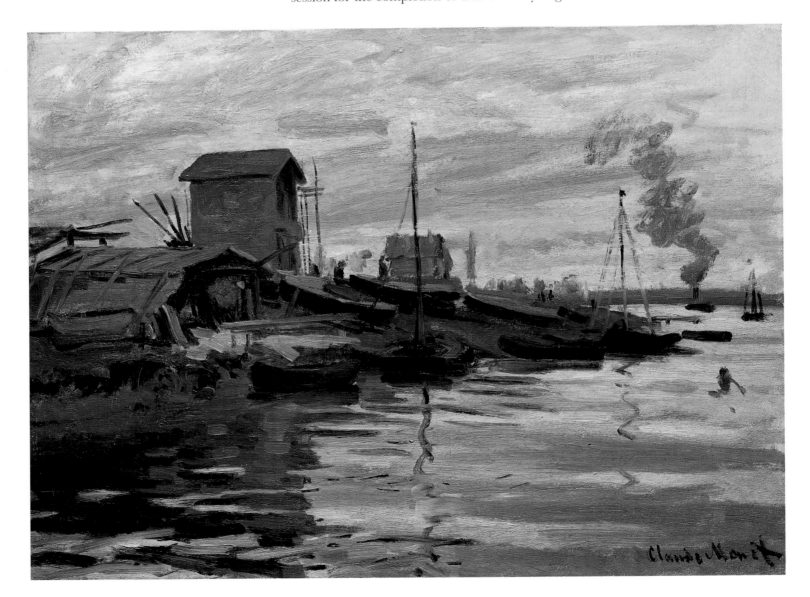

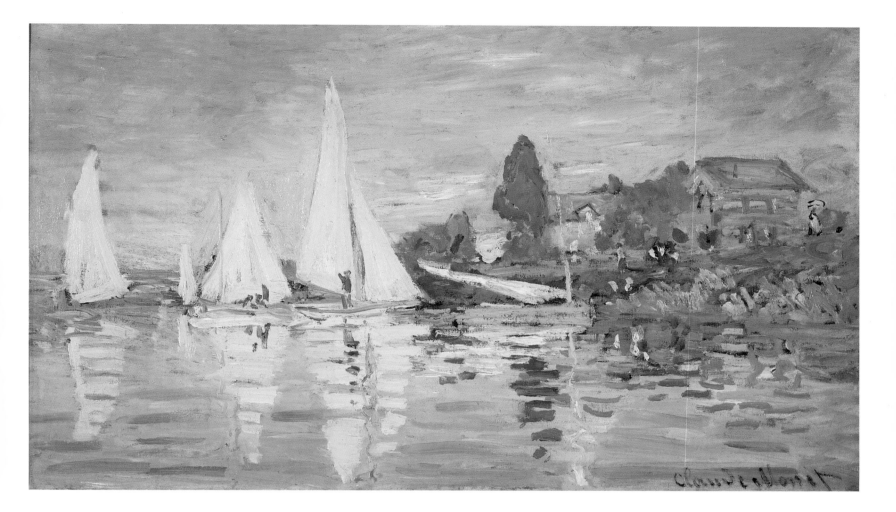

77 Claude Monet
Regatta at Argenteuil, 1872
Oil on canvas, 48 x 75 cm
Musée d'Orsay, Paris
Bequest of Gustave Caillebotte, 1894

Even so, neither of these superb small studies readies us for Monet's most painterly study of wind, water, and motion. The justly famous *Regatta at Argenteuil* (fig. 77) is, perhaps, the ultimate Impression. Painted at the end of one or two summer afternoons from Monet's studio-boat in the Seine, probably in 1872, it was acquired directly from the artist by the connoisseur-collector-painter Gustave Caillebotte, in 1876. It was not exhibited in the 1870s, but the many visitors to Caillebotte's apartment in Paris would have seen it as one of the glories of Monet's career. It can be related to the large-brush fantasies of Fragonard, and has the quality of a moment captured within its own brief duration. The subject—sailboats returning to their boathouses and docks at the end of the day—hardly qualifies as the "regatta" of the traditional title. The light has the intense warmth of a late afternoon in summer. The white sails are tinged to the color of old ivory, and the red of the boathouses becomes solar orange with the effect of the light. The water and the sky take on a brilliant blue to complement these oranges, and

Monet's brush evoked each sail, architectural facet, tree, and reflection with a terrifying competence. Each element of the picture—from the most substantial to the airiest—becomes equal in painted gestures, the fluency of which cannot be described. Whereas in the Zaandam picture Monet translated the real force of nature into paint, here there is a longer, less urgent sense of duration. Each boat could take another turn on the river. The sail being taken down in the green boat on the right could be re-furled. Nothing about the position of the boats seems premeditated. It seems as if Monet had experienced this scene so many times on so many perfect summer days that he was fully ready to translate its cumulative effects in a series of gestures, fewer than a hundred strokes, from which he conjured his fluttering motif.

Monet's most famous study of water and air is also, in some ways, his most traditional. In December 1873, he paid a visit to his hometown of Le Havre where he painted a series of canvases describing the port. This was not a picturesque fishing port like that of nearby Honfleur, but a bustling European center for mercantile shipping, particularly cross-Channel shipping, which had brought the town its prosperity. Monet knew it well, but had not painted it. His series of six canvases represent it during dawn, day, dusk, and dark and from varying viewpoints, some from the water itself and others from a hotel room looking down over the port. The most famous of these, *Impression, Sunrise* (see fig. 2), was shown in the first Impressionist exhibition. Less well-known, but as successful, is *Sunrise (Marine)* (see p. 26, note 6). Both derive from the practice of Corot and Daubigny in the 1860s and 1870s as well as from the seascapes and nocturnes of Monet's friend Whistler, several of which Monet had seen at an exhibition at Durand-Ruel's gallery in January of that year. A third canvas, *Harbor at Le Havre at Night* (fig. 78), a great night view, moves completely away from the Whistlerian precedent, and is among the most fully original works produced by Monet in the 1870s.[18] Just as Degas was beginning his decade-long investigation of Paris at night, Monet turned his attention to the color of night and to the vivid new kinds of port lighting and ship lighting that had transformed the night into a paintable motif. Against a nocturne of we might call natural night, evoked with pale robin's egg blue, deep blues, warm grays, and the darkest colored blue-blacks Monet could make, he set jewels of light and their spectacular reflections. We do not know how many sessions Monet needed to complete this masterpiece, but two would have sufficed. He painted in each session with an equal urgency, as if to record not only the scene from the window, but his own physical presence through gesture. In this one work—which remains unique in his oeuvre—he both subsumed and surpassed Whistler.

Monet spent the summer of 1874 painting with Manet and Renoir in Argenteuil, and many of the works he completed and signed that summer have the quality of Impressions. The two shown here are studies of water, air, and solid form, contributing new energy and compositional experimentation to this meta-theme. Both represent the great stone and cast-iron bridge at Argenteuil, one from Monet's studio-boat as it sat in the middle of the Seine almost under the bridge, and the other from the small boatyard that nestled beneath the bridge. Monet had made a brilliantly concise and emotional Impression of the same bridge early in 1872 (fig. 79), when he returned to war-ravaged Argenteuil after his exile in England. In this painted drawing, Monet reduced the temporarily repaired bridge to an elegant geometric calligraphy of

[18] It was shown in the great Monet retrospective at The Art Institute of Chicago in 1996 curated by Charles Stuckey, and reproduced in the catalogue: *Claude Monet, 1840–1926*, op. cit., p. 53, no. 30.

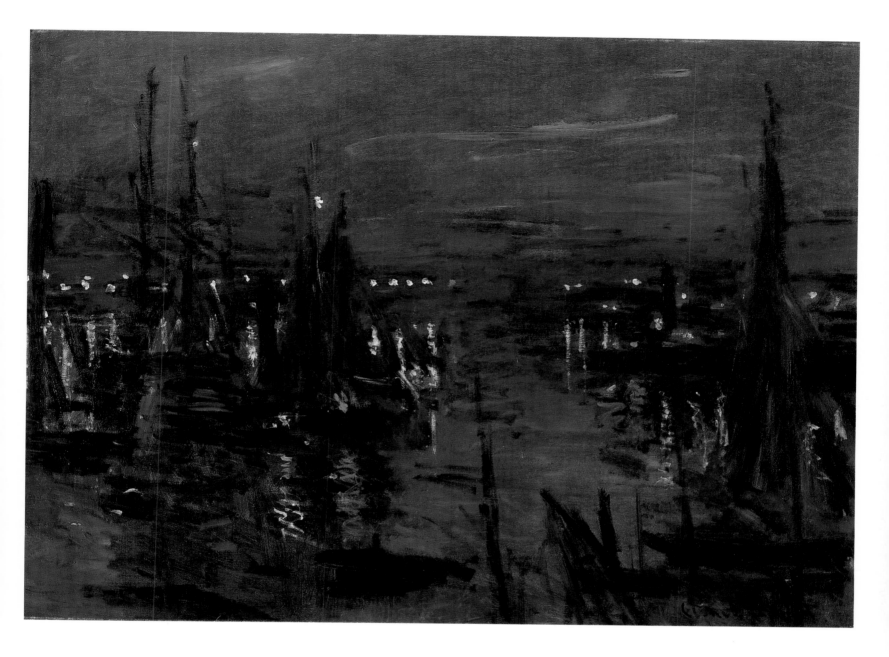

78 Claude Monet
Harbor at Le Havre at Night, 1873
Oil on canvas, 60 x 81 cm
Private collection

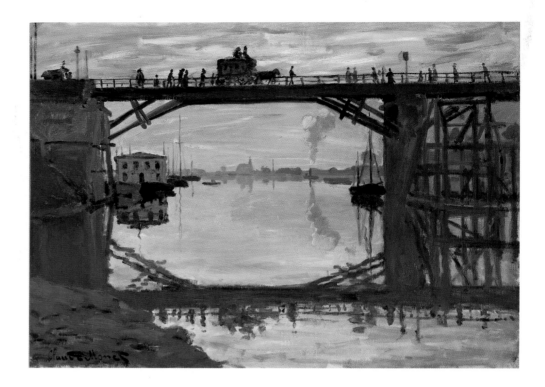

79 Claude Monet
The Wooden Bridge, 1872
Oil on canvas, 54 x 73 cm
Collection Rau, Zurich

brown-brushed lines against the pale gray-blue of the water and sky; it became a cipher for both suffering and survival. When Monet returned to the same theme two years later, the bridge had been modernized and rebuilt. In fig. 80, painted from the land, it is in an impossible position: Monet's viewpoint allowed him to see into its arches, but he placed it strictly parallel to the picture plane as if conjoining a frontal and a three-quarter view. The entire composition was painted on a primed canvas with a real economy of stroke, the tied-up boats in the foregournd little more than slab-like strokes of beautifully mixed color applied with large, flat brushes. Monet's paint "represents" paint, and we can see the ground in small areas throughout the canvas as if the work were actually a drawing in paint.

This summary and calligraphic mode of painting is more forcefully exaggerated in fig. 81. Here Monet represents the bridge from his studio-boat, which is anchored so near it that it looms across the top of the canvas, its reflection completely filling the lower portion. Few works in Monet's career have such graphic energy, and such a compositional prototype forced so powerfully upon us.[19] Supported in the picture by only one pier, the bridge seems almost impossibly light, framing two pictures—the one on the left of boat houses, and the one on the right of a mechanical barge whose smoke churns into the sky with deep purple-blue squiggles. The reflections of this substantial smoke reduce it to thin, wiry lines that sit as much on the surface of the canvas as they define the space-displacing surface of the water in it. There is perhaps no other occasion in Monet's oeuvre of the 1870s in which surface and depth, drawing and color are held in tighter check.

[19] The composition was inspired by Japanese woodblock prints; see Gabriel P. Weisberg et al., *Japonisme: Japanese Influence on French Art, 1854–1910*, Cleveland Museum of Art, 1975, and *Le Japonisme*, exh. cat., Le Grand Palais, Paris, 1988.

80 Claude Monet
The Bridge at Argenteuil, 1874
Oil on canvas, 58 x 80 cm
Neue Pinakothek, Bayerische
Staatsgemäldesammlungen,
Munich

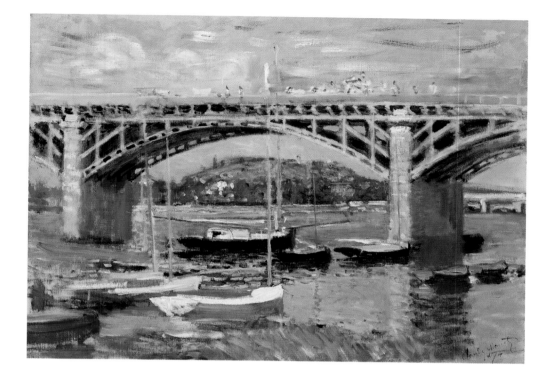

81 Claude Monet
The Road Bridge at Argenteuil, 1874
Oil on canvas, 50 x 65 cm
Private collection

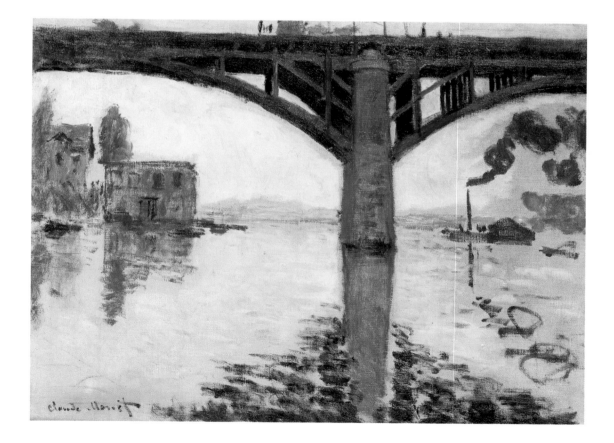

The Port at Argenteuil (1874; private collection), another work painted from the boat-yard beneath the Argenteuil bridge, shows the expressive and chromatic skill that Monet brought to the watery Impression in a different way.[20] The others of this group have considerably more complex surfaces, worked up in layer after layer of small-scale gestures applied over the initial Impression. But here Monet achieved a compositional and chromatic balance of painted lines and colors that mirrors the balance of the boats on the Seine. All is brought to an almost magical level when we realize that the tall male figure with a reddish beard walking out onto the small pier in the foreground undoubtedly represents Edouard Manet; it is the only depiction of him that we know by Monet. Monet goaded Manet into his last brilliance; the rivalry between the two, unspoken but actual that summer, was probably expressed only in paint. Here, Monet includes the older artist in a painting that is utterly his own, possibly done from the very same pier from which Manet represented him that same summer (see fig. 45).

In spring 1872, Monet painted Argenteuil during its annual fête, his first attempt to apply the lessons of rapid painting to a specific event (fig. 82). The results are fascinating. Monet took pains to separate himself from the scene, placing the group of townspeople at some distance. The work communicates this distance powerfully, and the combination of the engagement conveyed by Monet's gestures with the physical, social, and psychological separation between representer and subjects makes it peculiarly modern. The crowd is dressed soberly in blacks and grays, with several workers, distinguished by their blue over-shirts, appearing to show that classes rub shoulders easily in a small town. A little child in what must have been a new white dress adds a decorative note. Because Monet painted the sky with large, almost melodramatic gestures of gray paint and because the foliage seems to rustle in the wind, we can almost read the painting as the moment of retreat before a spring storm. Hence a social event and a natural one are conjoined by Monet to create a double sense of temporal instability. The Tricolors, moving slightly in the wind, suggest that what was officially a religious fête had undercurrents of patriotism that would have been powerfully felt by contemporary viewers (flying the Tricolor at a public event at this date was in fact illegal).[21] Monet's subtle observation surely makes the painting a masterpiece of socio-political observation as much as it is an Impression.

In 1878 Monet summoned all of his powers for the creation of an Impression of a major public festivity. On June 30, just after the close of the highly successful International Exhibition, Parisians were permitted to celebrate their recovery from the humiliating French defeat in the war with a vast city-wide spectacle of patriotic fervor. Completely disconnected from any date associated with the Revolution or any political event in the history of France, this event was designed to be a big urban party, linking generations and classes to suggest that these groups together constituted a nation. Many artists represented this event; the works by Monet and Manet have survived as the most compelling. Monet painted two views from rooms rented for the occasion, on rue Montorgueil (fig. 83) and 141 rue Saint-Denis (fig. 84). Both works were purchased, shortly after completion, in July 1878 and both were included in the fourth Impressionist exhibition of 1879. *Rue Saint-Denis, June 30, 1878* is much more immediate in its effect, showing little evidence of studio retouching. It projects an almost palpable sense of participation, as Monet used his wrist and elbow to create

[20] In a private collection, it is among the least known of the great river pictures from the winter of 1874–5. Signed, but undated, it belonged to the Rouen collector Françoise Depeaux, who owned at least sixteen major paintings by Monet.

[21] See p. 92.

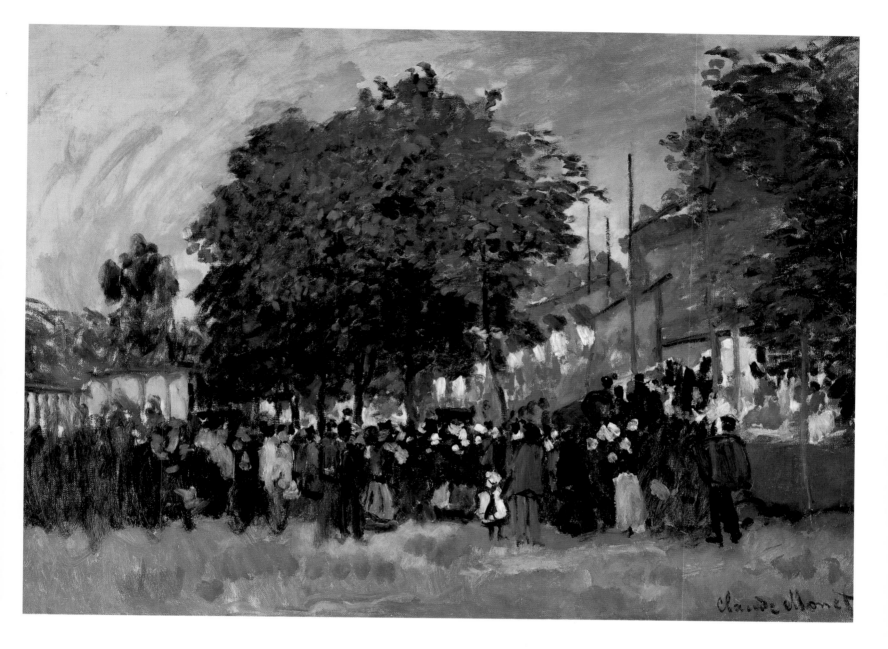

82 Claude Monet
A Festival at Argenteuil, 1872
Oil on canvas, 60.5 x 80.5 cm
Private collection, Dallas

83 Claude Monet
Rue Montorgueil, June 30, 1878, 1878
Oil on canvas, 80 x 48.5 cm
Musée d'Orsay, Paris

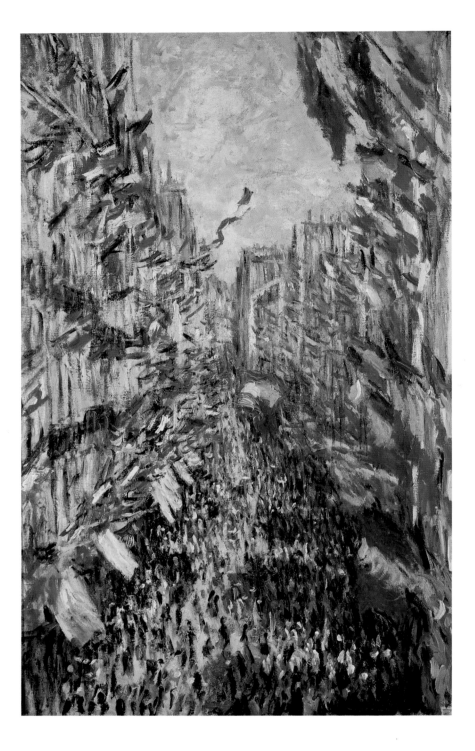

hundreds of gestures that represent fluttering flags, moving pedestrians, and wind-swept clouds. There is no real precedent for this painting in the history of western urban art; only Manet, who worked simultaneously on *Rue Mosnier Decked with Flags, 1878* (see fig. 52), could compete with its restless pictorial energies.[22] For Monet, the subject of the Impression had been transformed from a field of vision to a field of action, with the artist the central celebrant in this secular ritual of patriotism.

84 Claude Monet
Rue Saint-Denis, June 30, 1878, 1878
Oil on canvas, 76 x 52 cm
Musée des Beaux-Arts de Rouen

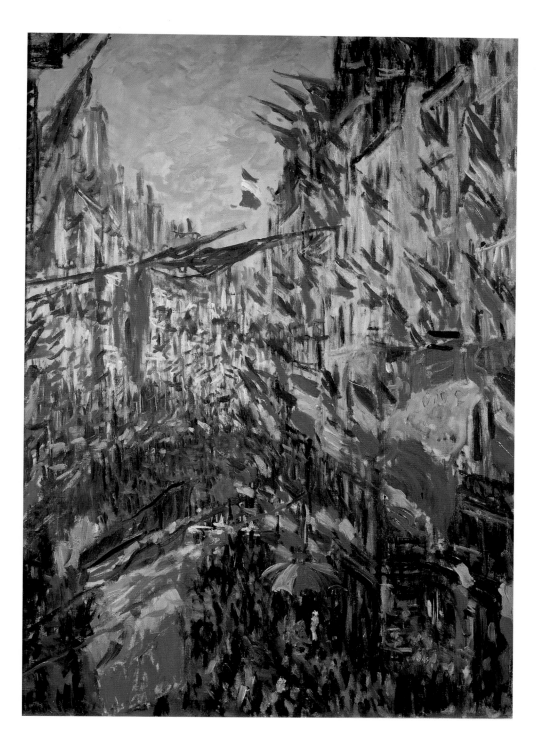

[22] See p. 92.

[23] For the iconological range of Monet's extraordinary train pictures, see Robert L. Herbert, *Impressionism: Art, Leisure, and Parisian Society*, Yale University Press, New Haven and London, 1988, pp. 24–28, and Richard R. Brettell, "The 'First' Exhibition of Impressionist Painters," in Charles S. Moffett et al., op. cit., pp. 193–202.

Long before Emile Zola thought to create his *bête humaine* in the form of a railroad engine, Monet had turned his attentions to the train.[23] Monet's train tracks, railroad stations, and railway bridges create a multi-pictured landscape series that would have been unimaginable to Turner, whose *Rain, Steam, and Speed* was the first great image of the train, made shortly before his death in 1851. An etching of Turner's picture was included in the first Impressionist exhibition of 1874, and the image was known to all

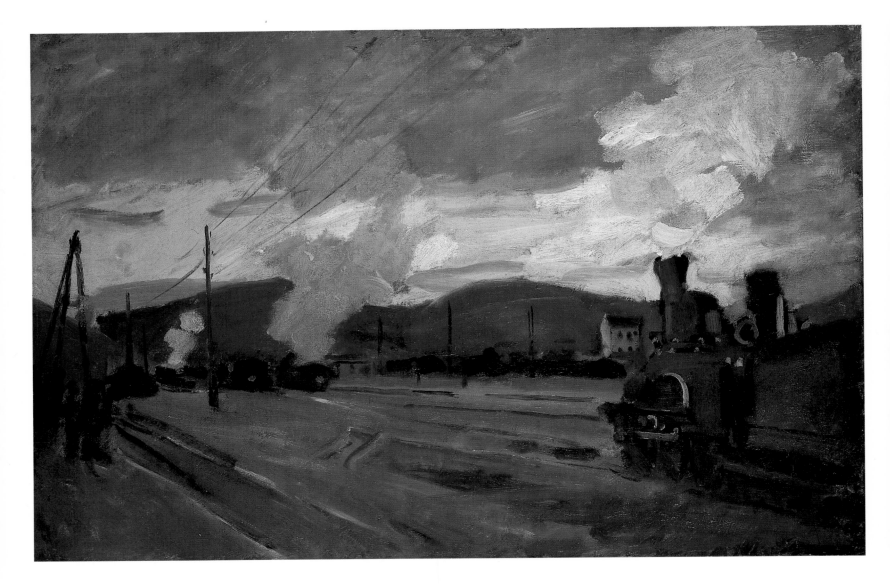

the young French avant-garde artists. One of the strategies they borrowed from their eccentric English master was modernity of subject. Turner had painted contemporary historical events—sea battles, the burning of the Houses of Parliament, the railroad —and the young French artists extended his rummaging through the actual to create modern landscapes and cityscapes of extraordinary verve.

The first train to appear in a Monet landscape looks like a toy train in the amusement park that was suburban Paris to the bourgeoisie of the city.[24] But in 1872, Monet took his easel to the yard of the railroad station at Argenteuil, and painted an incredibly bold Impression of steel tracks, belching engines, and cloud-streaked skies.[25] *La Gare d'Argenteuil* (fig. 85) is Monet's first real study of rail technology, and was painted with such gusto and energy that one can follow the artist in his struggle to entrap this elusive, but powerful, motif. Its blue and purple-grays, lead whites, smudgy clouds, and an almost telegraphic energy anticipate Monet's powerful Impressions of the Gare

[24] *Train dans la Campagne* (1870–1; Musée d'Orsay, Paris; Wildenstein cat. no. 153).

[25] It was immediately purchased from Monet, unsigned, by his dealer Durand-Ruel, proving that its experimental iconography was not too radical. It was sold four years later to the great collector de Bellio, possibly with a period back in Monet's possession first. It now resides in the Musée Tavet-Delacour, Pontoise, and is as a result little-known outside the northern suburbs of Paris.

85 Claude Monet
La Gare d'Argenteuil, 1872
Oil on canvas, 47.5 x 71 cm
Conseil Général du Val d'Oise, Pontoise

86 Claude Monet
The Bridge at Chatou, 1875
Oil on canvas, 60 x 100 cm
Museo Nacional de Bellas Artes, Buenos Aires

St. Lazare four years later. The most fascinating aspect of its bold composition is its relative emptiness. The engine broods just on the right, and two other trains snort steam in the middle distance, but the entire pink-tinged field is a vast void, waiting for action. Bounded by a few painted lines to define the telegraph wires and the steel tracks, Monet's space is an arena without an audience.

With this picture, Monet began to think about the representation of trains themselves. Within a short five years, he had them hurtling across bridges, arriving in wintry suburban stations, chugging through snow-filled landscapes, rushing by private gardens, and, finally in a series of twelve, coming and going in the glass-roofed shed of the Gare St. Lazare, Paris. No other painter of the decade was as assiduous in the study of trains, and many of these works have the quality of Impressions. Among the greatest is *The Bridge at Chatou* of 1875 (fig. 86). Monet stood amidst the trees lining the Seine, and looked up at the bridge just as a train steamed across it. To represent this momentary scene, he chose a long canvas—almost the format of a Daubigny river landscape—and rendered it with a restricted palette, and hundreds of small, jabbing

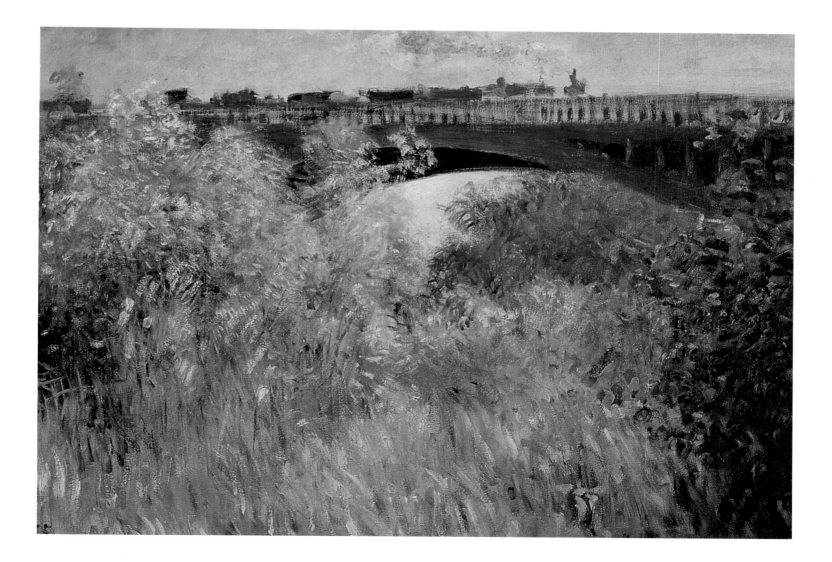

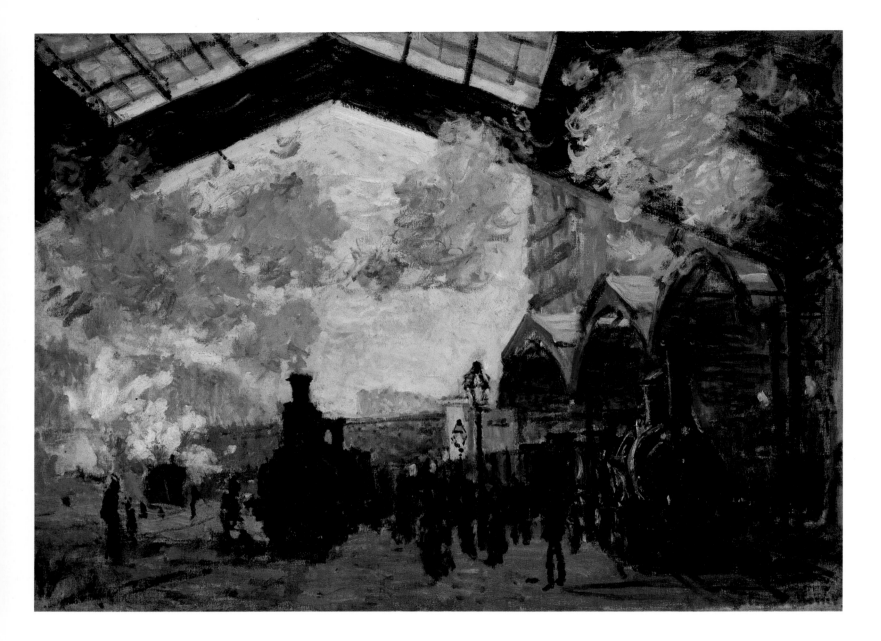

87 Claude Monet
La Gare St. Lazare, 1877
Oil on canvas, 54.3 x 73.6 cm
The National Gallery, London

[26] *Saint-Lazare Train Station* (1877; Musée d'Orsay, Paris; Wildenstein cat. no. 438) and *The Saint Lazare Station: Arrival of a Train* (1877; Fogg Art Museum, Harvard University, Wildenstein cat. no. 439).

[27] *The Saint Lazare Station: Arrival of the Normandy Train* (1877; The Art Institute of Chicago; Wildenstein cat. no. 440) and fig. 66 (Wildenstein cat. no. 441).

strokes of paint. We can almost hear the clattering of the train and the roar of its engines amidst the foliage of the trees fluttering in the breeze. The utter contrast of machine and nature, of momentary and seasonal time, is expressed in a canvas alive with gesture.

When Monet finally had the courage to take on a major station, he did so with suitable gusto. Of the twelve canvases in the series on the Gare St. Lazare, the range in levels of apparent finish is extraordinary, perhaps the broadest in his career. From the surfaces of two of them,[26] one learns of dozens of encounters, of wet paint being dragged over the complex skeins of dried paint below, and of other complicated procedural maneuvers. In others,[27] there is a much greater sense of gestural abandon and of the whole being conceived in one session and completed in one or two more.

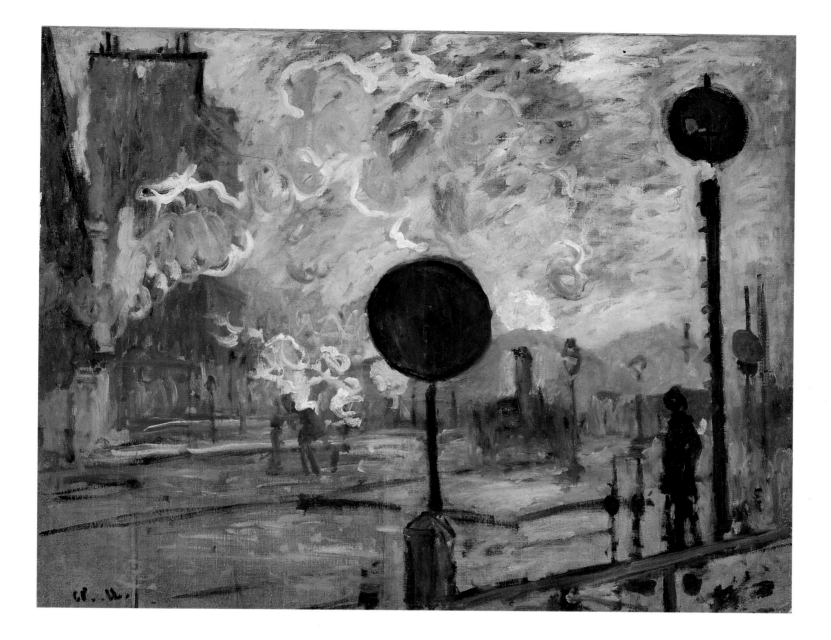

88 Claude Monet
La Gare St. Lazare (The Signal), 1877
Oil on canvas. 65.5 x 81.5 cm
Niedersächsisches Landesmuseum, Hannover

We know, for example, that when Monet planned fig. 87, he already knew not to paint the roof at the upper right, because it would be more visually effective in the representation of steam to allow the white ground of the prepared canvas to show through. But when we compare this relatively spontaneous impression to fig. 88, it is clear that we are dealing with yet another level of spontaneity. It is alive with gesture that seems almost to throb across the surface, and the sense of involvement is so total that we might be fooled into thinking that the work was made in one session. Yet close examination shows that it may have been the result of as many working sessions as fig. 87. The difference between them lies in their stylistic manner and their more-or-less informal compositions, not in the fact that one of them might have taken longer to paint than the other.

It would be tempting to conclude that Monet used exclusively the technique of rapid painting for the new motif of the train. Yet, in this, as with all areas of visual experience he tackled in the 1870s, he was never consistent. Rather than make links between ephemeral motifs and modes of painting, we have to conclude that Monet was a picture-maker who applied his entire arsenal of skills to every type of motif; in the end, no one motif is entirely associated with the Impression. Remarkably, in the first half of the 1870s he was satisfied with many of his Impressions; he signed, sold, and exhibited them with little regard for the differences between them and other works.[28]

Monet's production of Impressions began to wane gradually as the 1870s went on, but increased again in the years 1879–82, particularly in paintings that dealt with winter and the sea. By 1879 he had begun what was to be an almost total transformation of his subjects, from those involving human figures or their surrogates to those in which the human presence was overwhelmed or even completely negated. Oddly, his landscape iconography during the 1880s began to look decidedly Romantic or mid-century in its preference for secluded, pre-modern, or ruggedly natural places in which figures added to the immensity of the landscape rather than humanizing it. We might think that such an iconographic shift would have increased Monet's Impressions, because rapid painting was the kind most associated with inspiration and an artist's individuality. And there were occasions when Monet worked at a rush, using gestures and painted marks even more forceful than those he had developed during the 1870s. In general, however, he began to reject direct painting, preferring to work over and over to transcribe what came to be increasingly complex emotions.

In 1879 Monet was facing extraordinary problems. His wife Camille, who had given birth to their second child in 1878, died at the age of only 32. He subsequently lived with his own children, Alice Hoschedé (wife of his former friend and patron, Ernest Hoschedé) and her six children. This period of intense domestic and emotional turmoil coincided with a low point in the painter's finances and a particularly severe winter. Monet's state of mind at this time is generally held to be embodied in his famous portrait *Camille on her Deathbed* (fig. 89). Monet spoke about this portrait much later to his friend Georges Clemenceau.[29] He painted the entire work in a state of visual excitement and was himself surprised, and somewhat shocked, that, as his wife lay dying, he found himself unconsciously looking at her as an artistic motif. As he observed the shades of violet and blue that surrounded her, he could do little other than paint them; to Clemenceau he stressed the almost reflex quality of this act. He need not have felt such guilt; a writer would not so accuse himself. Yet what struck Monet was that it was not Camille herself he was painting, but his own sensations of color. The painting was for him a study in blue and violet, just as Whistler made studies in gray and gold. But the slashing linear strokes that both define and dissect its subject have a raw emotional power, the final stillness of death subsumed by the furious grief of the living. Monet could never have exhibited this painting, and he never did. After his own death in 1926 a sticky, ugly studio stamp was placed at the lower right; in its ghoulishly impersonal finality, it somehow links both deaths in the one representation.

[28] Some have argued for a kind of hierarchy of signatures in Monet's production—with sketches signed "C. M.," more finished works "Cl. Monet," and so on through "Claude Monet" to "Claude Monet 1874." But this is not the case. It seems rather that he signed and dated works as often at the point of sale as at the end of his working sessions, and that both dealers and buyers had as much to do with the mode of signature as did Monet himself.

[29] See Linda Nochlin, *Realism*, New York and London, 1971, p. 63.

89 Claude Monet
Camille on her Deathbed, 1879
Oil on canvas, 90 x 68 cm
Musée d'Orsay, Paris

Two other paintings from earlier in 1879 have a similar emotional rawness and authenticity. The fluttering, nervous observational rhythms of the Argenteuil Impressions are gone, replaced by thickly applied gestures that form a surface relief of paint. In the great *Vétheuil in Winter* (fig. 90), Monet worked with the paint while it was still wet and even tacky, to give the Seine a real density. It seems that the painting was made in two sessions, the first using rather thin paint applied with small brushes for the village and its reflection in the water, the second (possibly begun shortly after the first) laying in the snow and the viscous blue-gray water with large, flat brushes. The surface of the water all but consumes the reflection of the village, and, as if to make the whole even bleaker, Monet added two almost black boats, each with several

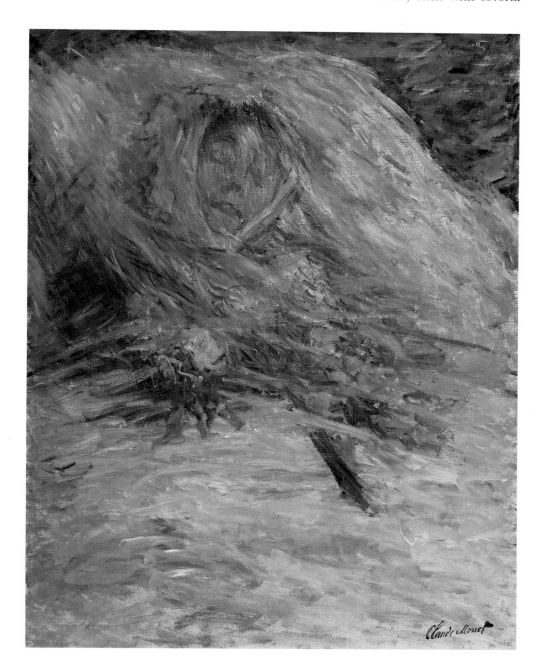

90 Claude Monet
Vétheuil in Winter, 1879
Oil on canvas, 69 x 90 cm
The Frick Collection, New York

figures. Their presence gives greater space to the painting, and their blackness seems to suggest that they are on some kind of rescue mission, perhaps bringing vital supplies or a doctor from one side of the Seine to the other. The contrast between the short, choppy gestures for the architecture and the figures, and the long, thick slabs of paint that embody the snow and water gives the work an almost unbearable sense of tragedy, and an icy beauty. One has to look to Zola for equally evocative descriptions of the Seine in winter, and the best of these, in *L'Oeuvre* (1886), postdate Monet's masterpiece.

The Seine at Lavacourt (fig. 91) is smaller and more humanized, with a painterly immediacy that fig. 90 lacks. It represents a small section of the river town of Lavacourt, opposite Vétheuil where Monet lived. He rowed alone in his studio-boat on a blustery, chilly day, to anchor just off the town so that a straggling row of poplars along the bank defines the center of his composition. Like fig. 90, the painting has a

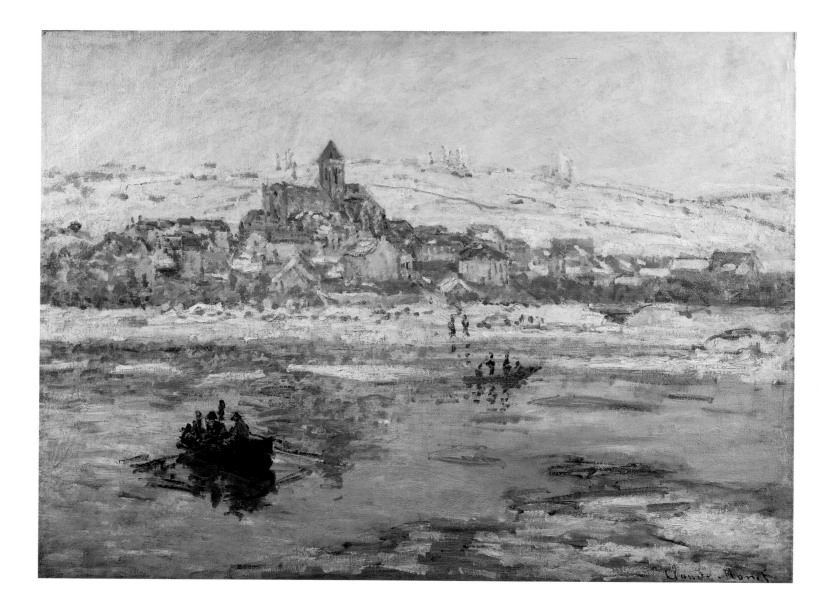

91 Claude Monet
The Seine at Lavacourt, 1879
Oil on canvas, 54 x 65 cm
Portland Art Museum, Oregon
Bequest of Charles Francis Adams

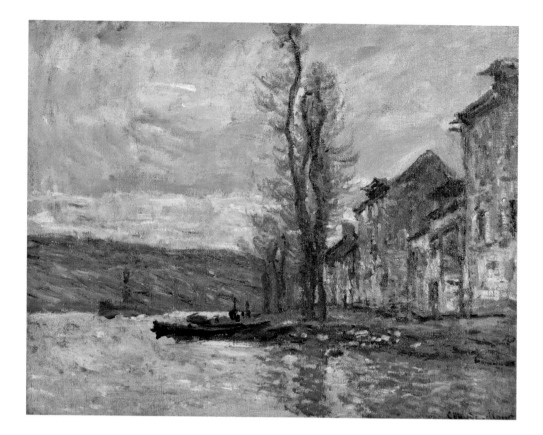

dual nature, but it was worked in the opposite order. Monet first defined the wind-swept sky, the trees, the hilly banks, and the houses with thick strokes of paint. After this, he worked dry-brush atop the crust of apparently wet strokes. From the little meteor of lead-white that shoots (accidentally?) across the sky to the dabs of brown-black, rust, yellow-beige, gray-green, and other decidedly mixed colors, the small strokes dance across nearly the entire surface of the canvas. Perhaps they suggest spring. Perhaps they bring a fluttery life to the windswept houses, but the three tiny figures, mere flecks of paint, do little to humanize this landscape. The houses that line the banks have neither windows nor doors to invite us in, and no smoke curls from the chimney in the middle distance to suggest the warmth of a fire. Monet is alone painting, and his evident despair must have been so strong that he projected it even in a domesticated landscape, which he could have made pleasant and warming. Both manners of painting—the thick, viscous strokes and the troubled, daubed, and fragmented over-layer—contribute to our feeling of unease. This and fig. 90 are in a different category from the socially modernist landscapes painted earlier in the decade at Argenteuil.

At this point, it is worth taking a detour to look at what we might call the politics of Monet's surface styles. In 1880, he completed two equally large horizontal landscapes, both evidently for public exhibition. *Lavacourt* (fig. 92), sent to the Salon in spring, was reproduced in a full-page print in the *Gazette des beaux-arts*. *Sunset on the Seine*,

92 Claude Monet
Lavacourt, 1880
Oil on canvas, 100 x 150 cm
Dallas Museum of Art
Munger Fund

[30] Monet's letter is quoted and discussed in context in Joel Isaacson's essay on the 1882 Impressionist exhibition, "The Painters Called Impressionists," in Charles Moffett et al., op. cit., p. 385.

Winter Effect (fig. 93) was withheld from exhibition until 1882, when Monet sent it to the penultimate Impressionist exhibition. Fig. 92 was based on a whole series of smaller plein-air paintings done along the Seine in 1879 and 1880. Its wonderfully varied surface shows a reliance on the well-established practice of Salon painters such as Corot, Daubigny, and Antoine Chintreuil; not even an unfriendly critic could call it an Impression. It represents the Seine surging with water during the spring, balancing that aspect of the motif with accurate painting of a village and surrounding hillsides and a study of wind, weather, and light. It is the kind of landscape conceived as a composite of sensations received and translated at different times and on different canvases. Monet himself referred to its surface as "bourgeois," and contrasted it with the rough and hand-worked surface of fig. 93, which he dubbed "my own manner."[30] The differences between the two are not so much in their imagery, but in their surface qualities, the role of gesture, and the sense in fig. 92 that the painting is *about* process. It has the quality of a direct painting, and its surface quivers with the life conveyed by Monet's gestures. Were it not so large, we could almost believe that Monet took the canvas with him and painted it on the spot. But there is an odd indirectness of composition and imagery, which is countered by the style derived from the direct

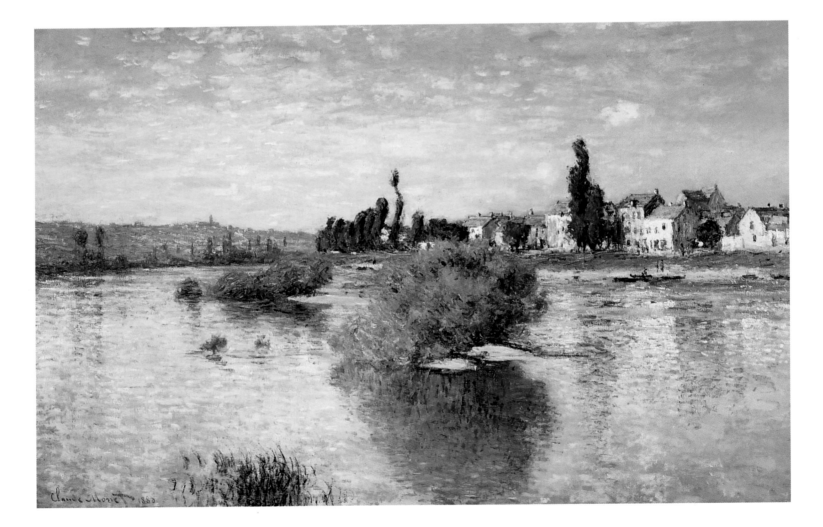

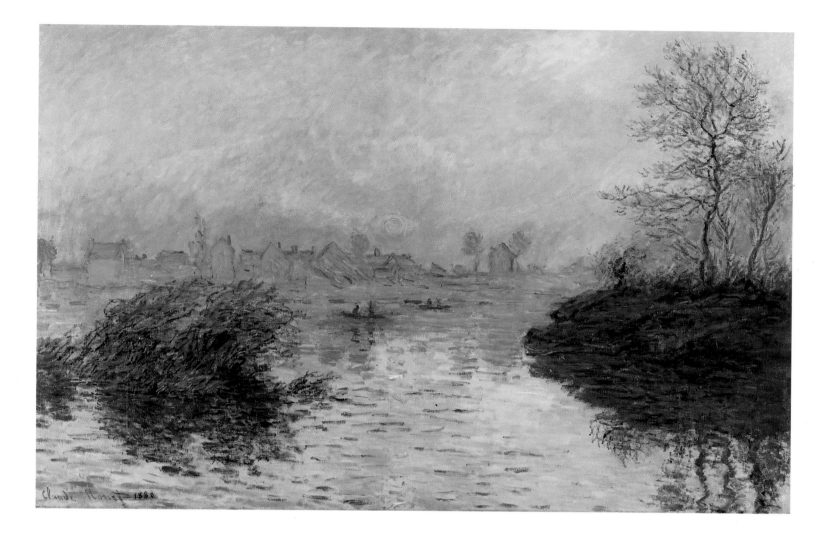

93 Claude Monet
Sunset on the Seine, Winter Effect, 1880
Oil on canvas, 100 x 152 cm
Musée du Petit Palais, Paris

painting that Monet had mastered more than a decade earlier. By this time, he had internalized the Impression. He knew how to paint in a way that looked like direct painting, and he could do it almost without the benefit of nature.

It is true that Monet painted increasingly in layers and that his working methods became more and more complex, but there are exceptions—and the vast majority of them are seascapes. *Marine near Etretat* (fig. 94) and *A Stormy Sea* (fig. 95) are just two from more than twenty from the first years of the 1880s that represent the English Channel, the central landscape feature of Monet's childhood. He grew up with the sea and was apprenticed to a painter, Eugène Boudin, who mastered its moods and varieties. Yet it was the example of Courbet that Monet recalled when he painted these works. They each have a different character: fig. 94 is almost glassy and calm, with long strokes of paint applied wet-on-wet to a primed canvas; fig. 95 is wonderfully agitated, with curved layers of paint cavorting on the surface with a graphic energy that suggests that Monet and the sea were both drawing—one in paint, the other in water. In each case, Monet was the master. He had rehearsed and rehearsed, and had gazed repeatedly at his ever-shifting motif. The result of the combined activities of the eyes and hand is a kind of "automatic painting" in which transcription was so easy that it appeared natural.

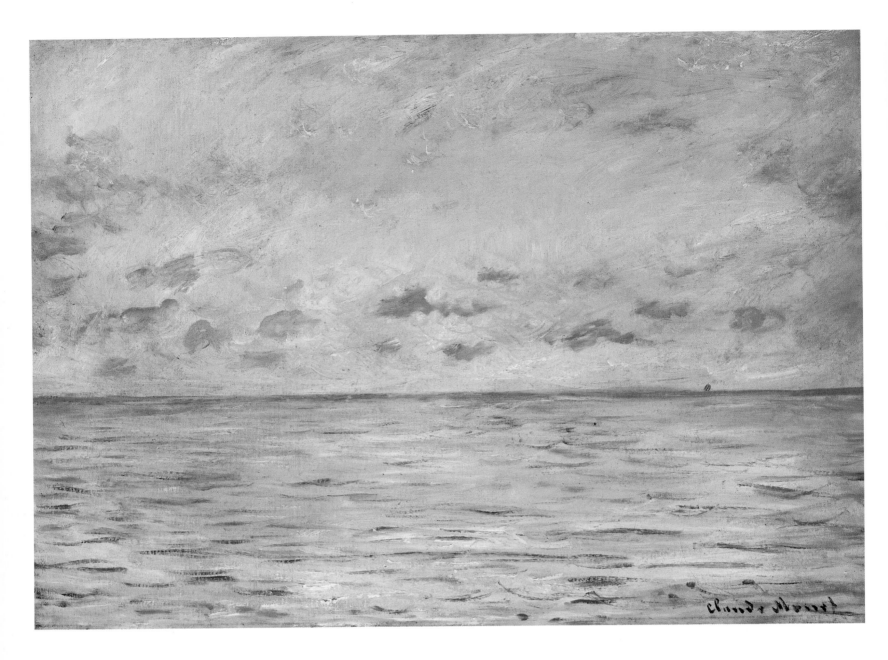

94 Claude Monet
Marine near Etretat, 1882
Oil on canvas, 54.6 x 73.8 cm
Philadelphia Museum of Art
Bequest of Mrs. Frank Graham Thomson

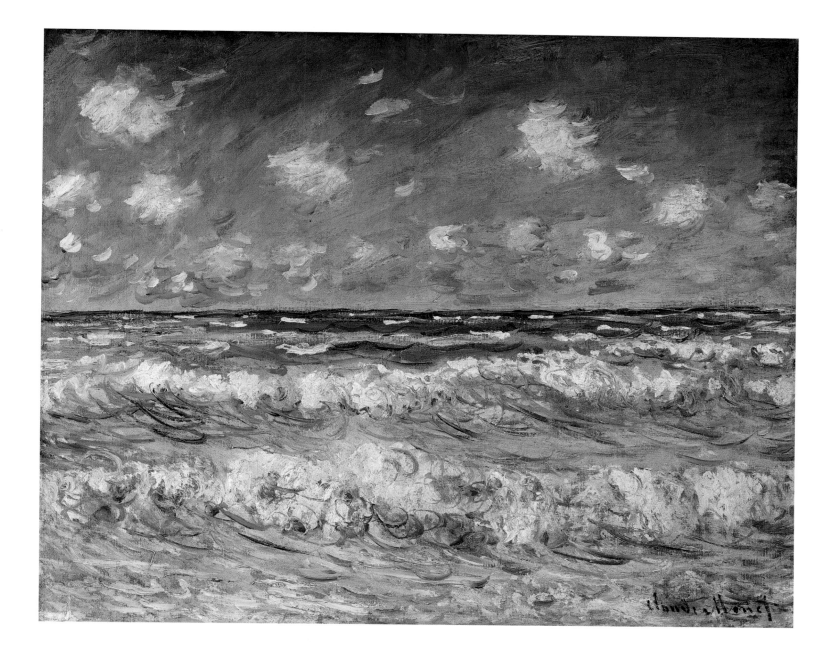

95 Claude Monet
A Stormy Sea, *c.*1884
Oil on canvas, 60 x 73.7 cm
National Gallery of Canada, Ottawa
Purchased, 1946

96 Claude Monet
Portrait of Père Paul, 1882
Oil on canvas, 64.5 x 52.1 cm
Österreichische Galerie Belvedere, Vienna

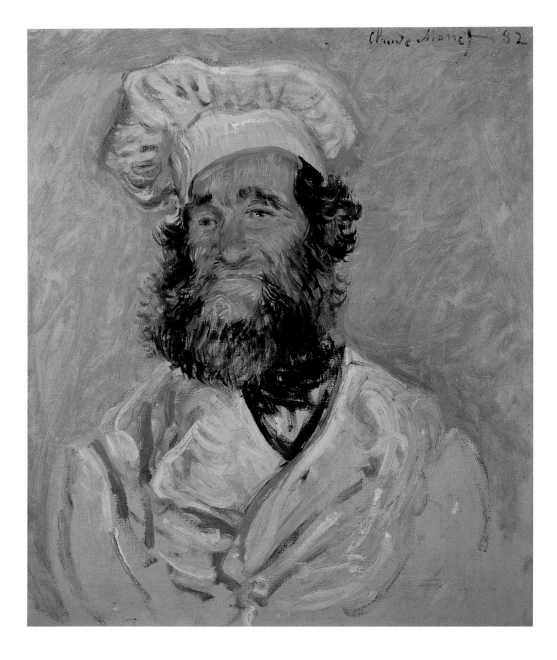

Although Monet almost completely neglected the human figure following the death of his wife in 1879, he did make exceptions. *Portrait of Père Paul* (fig. 96) was made in one, undoubtedly stormy, day, March 23, 1882, and portrays the Alsatian chef Paul Graff who ran the hotel-casino in Pourville where Monet was staying.[31] It reminds us of Monet's teenage years as a beach-side caricaturist, but his ability to draw quickly with paint and to use its combination of graphic energy and color to convey character is extraordinary.

During the 1880s Monet's preference was to work over and over on canvases, both in separate sessions *en face du motif* and also in his studio, where he brought works to finish in the presence of others for group exhibition and for sale. Yet he often

[31] Monet also made a portrait of Mme Graff, *La Mère Paul* (1882; Fogg Art Museum, Harvard University Art Museums, Cambridge, Mass.), and gave both to their subjects when he left.

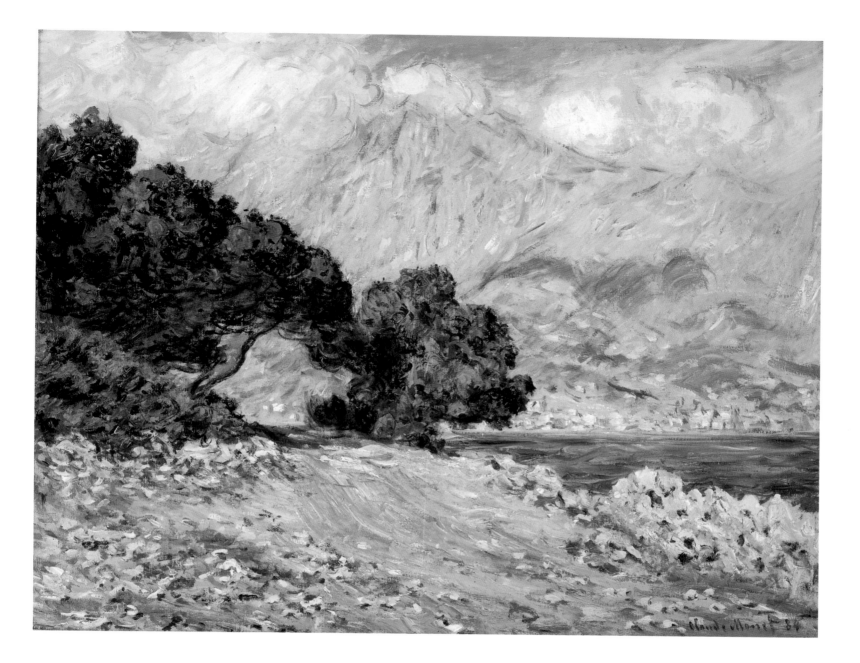

97 Claude Monet
Cap Martin, near Menton, 1884
Oil on canvas, 67.2 x 81.6 cm
Museum of Fine Arts, Boston
Juliana Cheney Edwards Collection

internalized and retained the graphic urgency of Impressions in these heavily worked paintings. One example is a highly finished, physically complex painting of 1884, *Cap Martin, near Menton* (fig. 97). When Monet worked to lay in the basic areas of color, he undoubtedly stood on this spectacular site on what may well have been a windy day. But in the layering of the hysterical lines on the rocky face of the mountains, the dense foliage of the trees, and the windswept clouds, and in jabbing the loaded brush onto the canvas to create the foreground rocks and background buildings, he worked on a canvas that was already dry, placing the energetic lines atop thicker slabs of undercolor so that the whole surface quivers with the life. The whole picture has the look of an Impressionist "machine," a picture about the subtle shifts in nature, but equally about

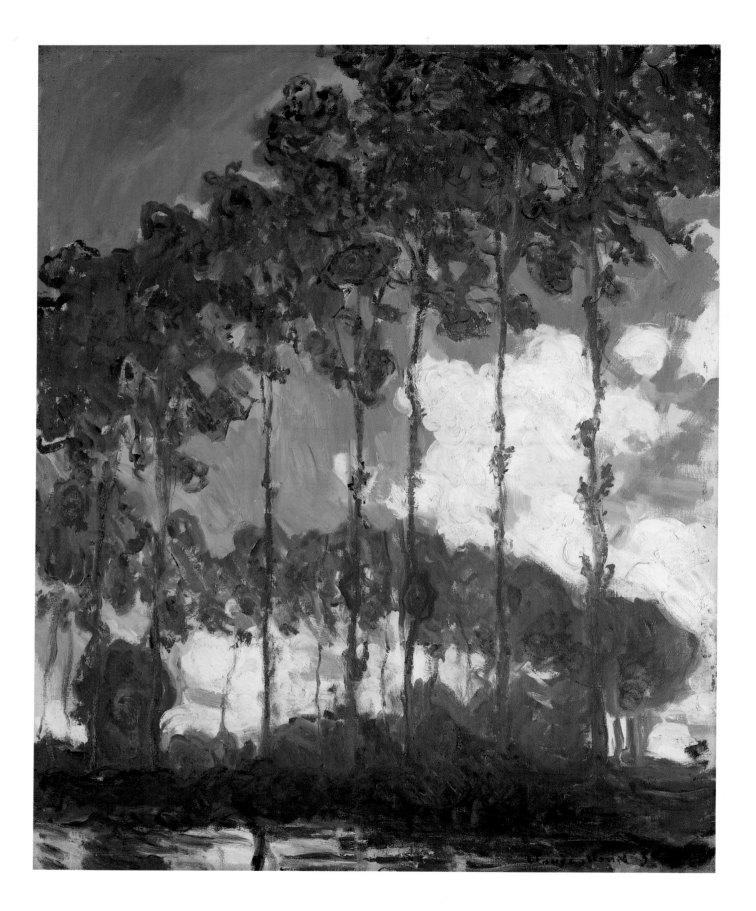

98 Claude Monet
Poplars on the Epte, 1891
Oil on canvas, 92.4 x 73.7 cm
Tate Gallery, London

the grandeur of nature and the integrity of its appearance. This work is so composed, so perfectly balanced, so contrived, that it seems less the result of transcriptional observation than of well-established pictorial formulas. But even if the rapid overpainting was made after a considerable period of reflection, it is no less immediate in its effect than if the artist had remained outdoors in the wind.

Two canvases by Monet serve as a sort of coda to this study. *Poplars on the Epte* (fig. 98) was painted in 1890–1 and was possibly included in the great 1892 exhibition of the poplar series at Durand-Ruel's gallery in Paris. If so, it was the only canvas dated 1890 (the rest were dated 1891). If this date is correct (rather than applied later and in error), this work is the earliest painting in the series to have been finished; it is also the only one that might be called an Impression. (The others share variously scumbled and layered pictorial surfaces, proving long gestation periods before they were signed and dated.) It is wonderfully vivacious and fresh, the paint applied in an almost pure state with brushes working it along the surface of the canvas while still wet. Clearly, certain of the linear trunks of the spindly trees were applied after the initial layer of bright blue sky, white clouds, and foliage was already tacky if not dry. Yet the effect of wetness and immediacy is everywhere, forcing us to read the painting as a representation less of the poplars than of the effect of wind on a blustery day. No canvas by Monet from the 1890s can compete for sheer gestural force, and one must look earlier in his career to find works that can hang comfortably with it.

The second of the coda works probably dates from the mid-1880s (perhaps 1883 or 1885, when Monet was at the site represented). *The Seine at Port-Villez (A Gust of Wind)* (fig. 99) was done by Monet from his studio-boat looking out at a landscape in almost violent motion. The wind literally whips through the foliage, causing the young willows to lean precariously. The sky is streaked with rushing clouds that scarcely have time to become reflections in the waters of the Seine. Monet transcribed this in such a rush of paint (much of which blurred as he worked wet-on-wet) that he seems to have been as affected by the wind as were the trees. There is, of course, a second stage of painting, in which he worked with a small brush loaded with ivory-white, mustard-yellows, pinks, and pale greens, making dry-brush gestures. The two layers of painting seem to push the sense of motion even further, forcing our eyes to move back and forth, as if mimicking the motion of the wind.

This work was given to France's greatest actor-director of the early twentieth century, Sacha Guitry, when he visited Monet in about 1924. A visit to Monet in the 1920s almost counted as social recognition of status in France: one had arrived at a level at which one would be recognized by the greatest living painter. Many distinguished men and women, French and foreign, flocked to Giverny to witness him at work, to lunch with him in his yellow dining-room, and to talk art, literature, and politics. We do not know exactly when Guitry visited Monet, but we do know that by 1924 he was very sophisticated about painting, having already worked closely with Vuillard, Bonnard, and Roussell, and having long inhabited a social circle of artists, musicians, and writers. When Guitry saw the work, it was not signed or dated; the signature and the mistaken date of 1884 in the lower left are surely those of the 82-year-old painter, whose memory occasionally failed, and would have been done at the same time as he inscribed the stretcher, "à mon Ami Sacha Claude Monet."

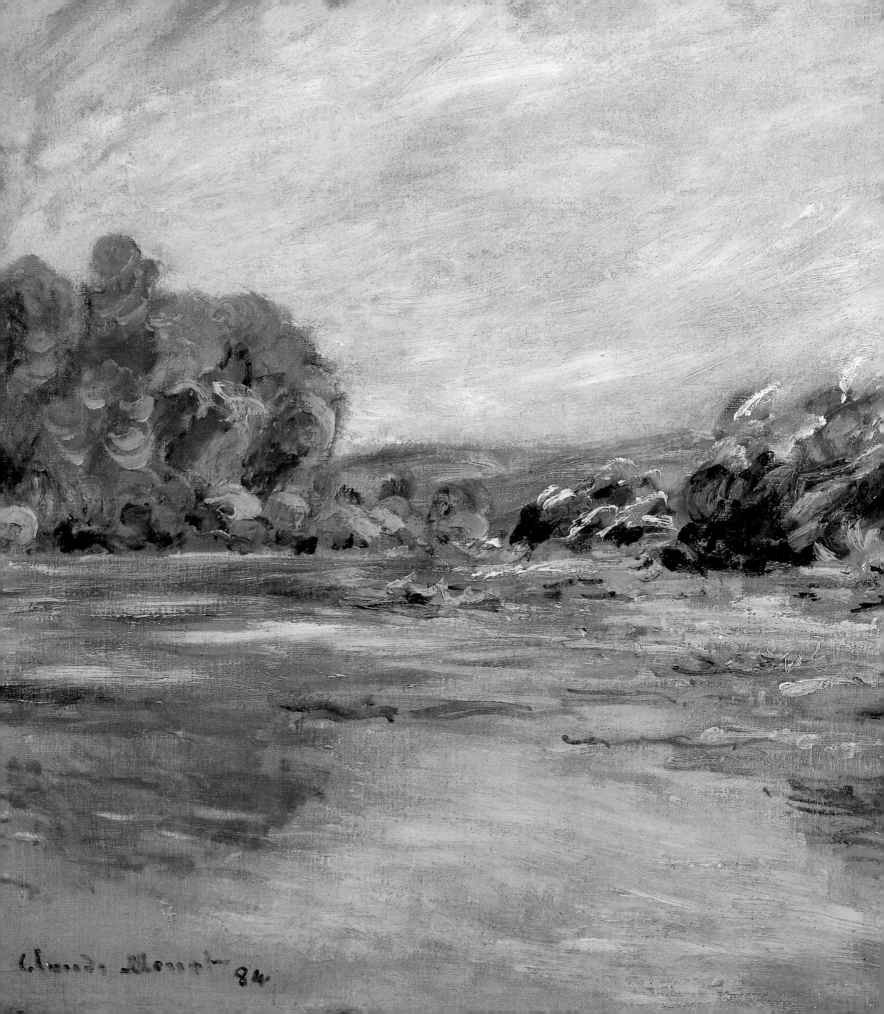

Claude Monet 84

99 Claude Monet
The Seine at Port-Villez (A Gust of Wind), 1883
Oil on canvas, 60 x 100 cm
Columbus Museum of Art
Gift of Howard D. and Babette L. Sirak,
the Donors to the Campaign for Enduring
Excellence, and the Derby Fund
(Detail opposite)

It is fitting to end with this gift, made just two years before Monet's death, because it raises by its very nature crucial questions about the relationship between painting and performance. In selecting a present for the performer Guitry (or maybe Guitry himself selected it from those in the studio, who knows?), Monet chose a work that he had begun and largely completed forty years ealier. Trapped on a single canvas is that pictorial rehearsal and—in the signature and date—his final performance.

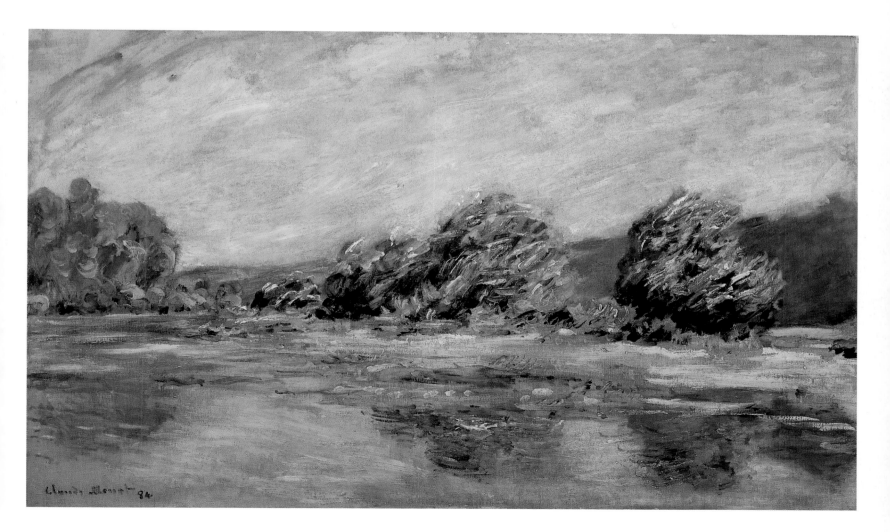

6 Berthe Morisot and Auguste Renoir: The wetness of paint and the sketch aesthetic

"If only Renoir were in less of a hurry to finish the subject he begins, he would certainly have the makings of a distinguished painter."[1]

"Never does Mlle Morisot finish a painting, a pastel or a watercolor. It is as if she were composing prefaces to books she will never write."[2]

Renoir and Morisot were often linked by critics during their lifetimes, and reviews of their work generally either praised it or reviled it for being unfinished, indeterminate, and hurried. Their work is treated together here, in recognition of their shared aims and sympathies. Their allegiance was most forcefully recognized in the third Impressionist exhibition of 1877, when Renoir's masterpiece *The Ball at the Moulin de la Galette* (Musée d'Orsay, Paris) appeared on a wall of its own, immediately adjacent to a long wall of paintings, pastels, and watercolors by Morisot. The Renoir painting was treated to a great deal of coverage in the press. His painted scene, lit by what one critic called "a great brutal light," was reminiscent of "that adorable Chinese princess of whom Henri [Heinrich] Heine speaks, who has no greater pleasure than to tear fabrics of satin and silk into shreds with her fingernails polished to the lustre of jade, and watch them as they swirl yellow, blue, pink, turning in the air like butterflies."[3] This glorious passage conjoins painting and literature that celebrate the beauties of destruction, in a way that predicts similarly gorgeous prose written later about the paintings of Morisot. When he saw Morisot's work at the Impressionist exhibition of 1878, Charles Ephrussi, art collector and owner of *La Gazette des beaux-arts*, was moved to write: "She grinds flower petals onto her palette, in order to spread them later onto her canvas with airy, witty touches, thrown down a little haphazardly . . . the whole giving the impression of vague and undecided opaline tints."[4] In 1880, the art historian and critic Paul Mantz wrote: "The artist has found the means to fix the play of colors, the quivering between things and the air that envelops them . . . pink, pale green, faintly gilded light sings with an inexpressible harmony."[5]

Whether shredding satin and silk or crushing flower petals, these two artists were viewed as being jointly creative and destructive, presenting works that forced the viewer to think less about the represented subjects than about the transformation of them on canvas. Both artists were perceived in the press as being predominantly attracted to the human figure and to scenes of modern life, both public and private. Hence their modes of rapid, or "hurried," painting presented critical challenges quite different from those that characterized the landscapes of Monet, Pissarro, and Sisley. Renoir's figures were "decomposing" to many critics,[6] and the metaphor of putrefaction was applied more than once to his figures in ways that would have been unthinkable in describing a similarly quivering landscape by Monet. Morisot and Renoir both allowed the human figure to be expressed in disconnected strokes or touches of paint that seemed to disembody it more than to form it. It was in its assault on the volumetric or physical integrity of the human figure that the Impression challenged convention most strongly, and Morisot and Renoir were the chief protagonists in that challenge.

In acknowledging the predominance of the figure in the critical response to their works, however, it is important not to neglect the contributions they made to

[1] Alfred de Lostalot, *La Chronique des arts et de la curiosité*, April 1, 1876; quoted in Charles S. Moffett et al., op. cit., p. 184.

[2] Paul Mantz, *Le Temps*, 27 April 1877; quoted in Alain Clairet et al., *Berthe Morisot, 1841–1895: Catalogue Raisonné de l'œuvre peint*, Paris, 1996, p. 89.

[3] Charles Flor O'Squarr [pseud.], quoted in Charles S. Moffett et al., op. cit., p. 235.

[4] Charles Ephrussi, quoted in ibid., p. 327.

[5] Paul Mantz, quoted in ibid., p. 367.

[6] See Ruth Berson et al., op. cit., pp. 117–202.

Berthe Morisot, *Child among the Hollyhocks* (detail of fig. 120)

landscape painting. Many of the works submitted by Morisot to the Impressionist exhibitions of 1874, 1876, and 1878 were small-scale landscapes that are among the most radically informal—one might almost say formless—paintings of the decade. Renoir was less enthusiastic about exhibiting his landscapes, but he painted, signed, and sold many of them during the decade.[7] Renoir remains the most persistently understudied and misunderstood major artist of the late nineteenth century, in contrast to Morisot, who has been assiduously revived by feminist art historians of both genders.[8] I have decided to include more works by Renoir than Morisot here, not because one career is valued more highly than the other, but because Renoir was infinitely the more prolific artist and the more discussed by his contemporaries.

Renoir appeared as an Impressionist artist rather later than Manet and Monet, who made, signed, sold, and even exhibited rapidly made paintings as early as the 1860s. Aside from the glorious winter landscape *Skating in the Bois de Boulogne* (later *The Skaters*; 1868; private collection), Renoir's canvases from before the summer of 1869 are tightly composed and highly finished.[9] Although he treated modern subject matter assiduously during the 1860s, his mode of execution remained decidedly traditional, even labored, as if he wanted approval on one level, while courting criticism on another. *The Skaters* is among the few exceptions, the black forms being treated almost in the mode of Asian calligraphy, as Renoir began to approach the style of Manet in 1868. His friendship with Monet, and his decision to join Monet, Pissarro, and Sisley in Louveciennes and Bougival in summer 1869, created the conditions for a real breakthrough in his manner of painting.

Because the group of friends often chose the same motifs during this collaborative venture, we are in the enviable position of being able to pair and contrast treatments of the same subjects. Renoir's *La Grenouillère* (fig. 100) seems never to have been exhibited in the 1870s, and its importance in his oeuvre was recognized only in the twentieth century. It was made in conjunction with a small group of other canvases, two of which share identical compositions with works by Monet. It cannot be determined which of the two artists settled on the compositional formulas adopted by both, but the fact that they decided together to create a kind of competition, in which composition was *not* a factor, is among the most interesting events in the history of art.

Renoir was somewhat better equipped to deal with this motif: he had already painted figural groups in numerous urban and suburban settings, and was somewhat more familiar with plein-air genre painting than Monet. What emerges from the competition is a clear demonstration that no work of art is an objective recording of a motif. Rather, each artist's proclivities and desires are embodied in a representation in which the motif is read and recorded in colors and gestures that are entirely personal. Monet was by far the more experienced in rapid painting, and his canvas projects a sense of immersion in a landscape brilliantly lit by the sun, observed at a particular time in a particular season. Renoir's painting looks muted, almost silvery, as if in imitation of the dreamy landscape light of the late Corot. If Monet was more sensitized to the qualities of light as it played across diverse forms, Renoir lavished his greatest representational attention on the human figures. The female figures in wonderful dresses on the left of Monet's painting (see fig. 70) are rendered with no more than a

[7] Renoir's landscape production is perhaps the most interesting and least studied aspect of his oeuvre.

[8] There are thorough-going catalogues of the paintings of Monet, Manet, Sisley, Pissarro, Morisot, and Caillebotte, but no such compendium for Renoir, save for a major monograph by Barbara Ehrlich White, *Renoir: His Life, Art and Letters*, New York, 1984; the catalogue of the 1985 Renoir exhibition in London, Paris, and Boston with entries by John House and Anne Distel, and a fabulously documented exhibition catalogue by Colin Bailey, *Renoir's Portraits*, Yale University Press, New Haven and London, 1997. By contrast, there is a rich literature on Morisot, rooted in a useful catalogue raisonné by Alain Clairet et al. (see note 2); the best recent books include Kathleen Adler and Tamar Garb, *Berthe Morisot*, Oxford, 1987; Anne Higonnet, *Berthe Morisot: A Biography*, New York, 1990; and Anne Higonnet, *Berthe Morisot's Images of Women*, Cambridge, Mass., 1992.

[9] See Barbara Ehrlich White, op. cit., p. 26.

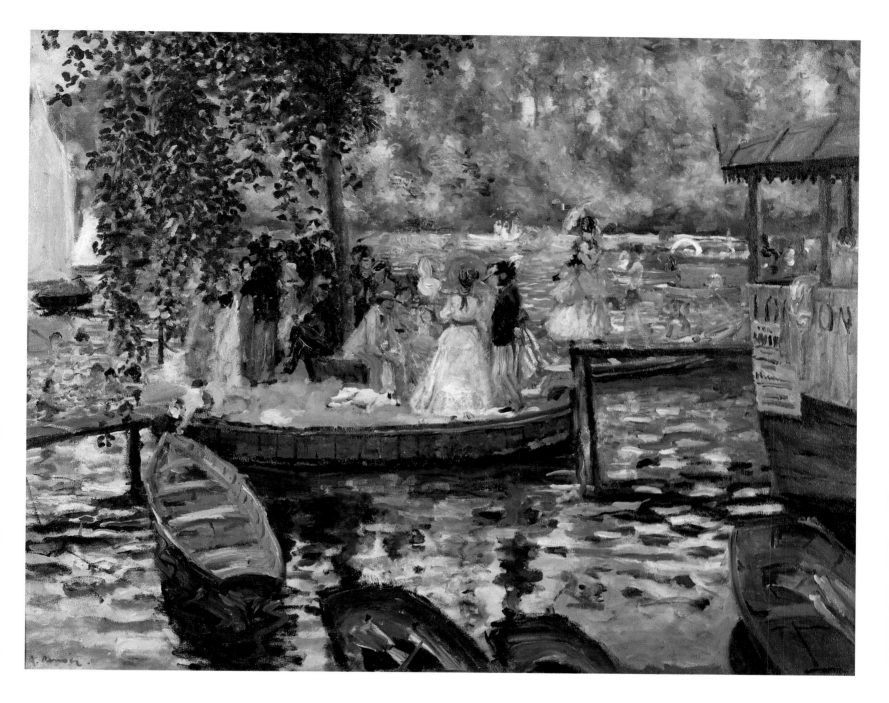

100 Pierre Auguste Renoir
La Grenouillère, 1869
Oil on canvas, 66.5 x 81 cm
Nationalmuseum, Stockholm

dozen separate strokes of paint, none of which defines the form as three-dimensional. The similar figures at the center of Renoir's painting are virtually caressed with touches of paint which render details of costume and the plays of light across diaphanous drapery. The hat of the central figure could virtually be duplicated by a milliner, and the dress of her companion being helped across the plank by a boy in green bathing trunks is similarly detailed and keenly observed. Although Renoir, like Monet, summarizes rather than defines forms, his summaries are more complex and filled with information.

101 Berthe Morisot
The Jetty, 1875
Oil on canvas, 24.1 x 51.4 cm
Virginia Museum of Fine Arts, Richmond
Collection of Mr. and Mrs. Paul Mellon

Renoir's silvery palette and his tendency to humanize his landscapes distinguish his representation from Monet's in major ways, but it is in his manner of handling paint that the deciding difference can be found. Monet preferred to use fat pigments which, when applied with flat-ended brushes, created harsh and clearly circumscribed strokes. Renoir's paint was comparatively thinned, so that his gestures spread in the paint and were slightly exaggerated. Monet's surface has a dry character, almost as if the paint itself resisted his gesture, while Renoir's liquid strokes were soft and yielded to his touch. Monet defines light, while Renoir caresses forms. Virtually every stroke on Renoir's canvas is curved or inflected by the gestures of his fingers, wrist, or arm. Even the white-gray-blue strokes that represent light in the foreground water have a soft plumpness that makes them volumetric. Renoir's canvas could not have been painted by Monet.[10]

The signatures of each artist at the base of their paintings, applied so confidently and so legibly, serve to indicate their satisfaction with their work as complete, even if not "finished" in a conventional sense. They also prove that, by 1869, Renoir had come to regard this experimental direct kind of painting as an important part of his oeuvre. His production during the next decade makes it clear that this immensely appealing painter annexed informal painting to his already considerable arsenal of techniques.

[10] Any more than its equally brilliantly painted companion, also titled *La Grenouillère* (1869; Oskar Reinhart Collection, Winterthur).

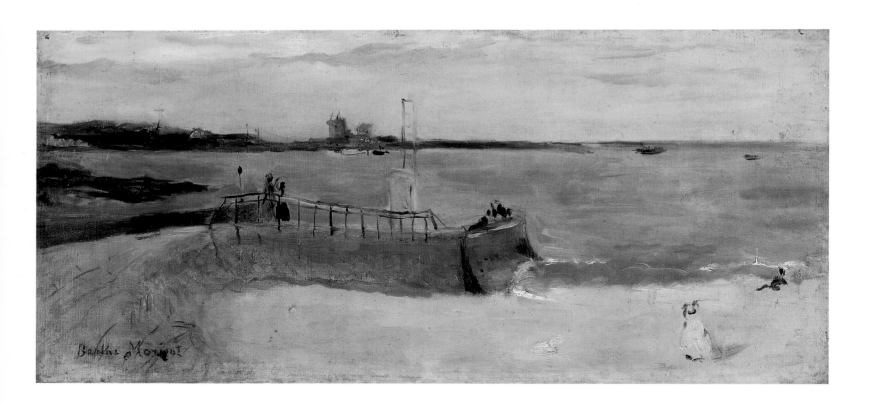

102 Berthe Morisot
Hanging the Laundry out to Dry, 1875
Oil on canvas, 33 x 40.6 cm
National Gallery of Art, Washington, D.C.
Collection of Mr. and Mrs. Paul Mellon

In 1874, just five years later, he submitted four paintings, and Morisot five, to the first Impressionist exhibition. Each artist included a small-scale work which could definitely be called an Impression. Morisot's *The Jetty* (fig. 101) was not mentioned by the press, but Renoir's *Harvest* (private collection, Switzerland) was mentioned by three critics, of whom two clearly thought it to be a work of consequence. Each artist also submitted paintings that were highly finished, Morisot showing two pastels and three watercolors. In the second exhibition of 1876, her submission was dominated by Impressions. The wonderful *Hanging the Laundry out to Dry* (fig. 102) and *View of*

103 Berthe Morisot
View of England, 1875
Oil on canvas, 27 x 36 cm
Private collection, courtesy of Galerie
Hopkins-Thomas-Custot

104 Pierre Auguste Renoir
Torso of a Woman in the Sun, 1875–76
Oil on canvas, 85 x 61 cm
Musee d'Orsay, Paris

105 Berthe Morisot
West Cowes, Isle of Wight, 1875
Oil on canvas, 46 x 36 cm
Private collection

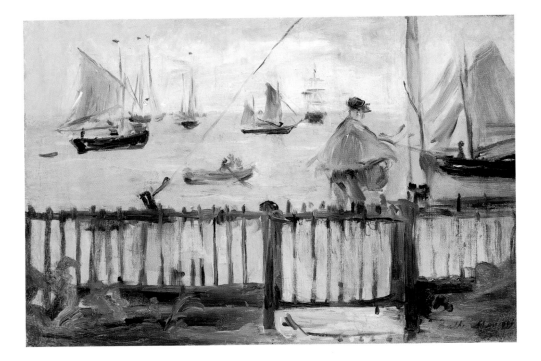

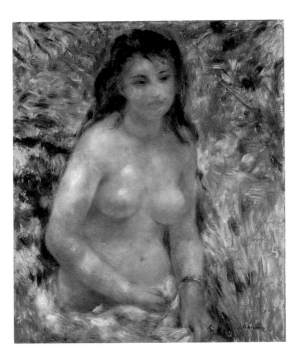

[11] Marium Chaumelin, quoted in Charles S. Moffett et al., op. cit., p. 182.

England (fig. 103) are each small paintings made with an overall pattern of representational gestures, most of which were applied with a confident ease that suggests rapidity. With high horizon lines, they are at once fields of vision and fields of action, in which the artist was sufficiently distanced from the represented subject to scatter its main elements across the surface in a relaxed and informal manner. Yet the works' small scale suggest that they were made as exercises or studies rather than as easel paintings; perhaps for that reason they were related more to her pastels and watercolors than to the larger-scale gestural landscapes of Sisley and Monet. *West Cowes, Isle of Wight* (fig. 105) may have also been included in the 1876 exhibition, but this is difficult to determine because Morisot's titles were vague and interchangeable. It has the same insistent informality and genially scattered composition as fig. 103, as well as the same timidity of scale. The boldest of the Impressionist group in some ways, Morisot attempted a modesty of size.

Renoir took a similar line. He submitted to the 1876 exhibition a group of informally composed, but highly worked, paintings, as well as three freely painted works. The latter category included a great nude, now known as *Torso of a Woman in the Sun* (fig. 104) but titled by the artist *Study.* Acquired from Renoir by Gustave Caillebotte, it was among the most discussed works of the exhibition. Most of the reaction was negative, largely because of the blotches of sunlight dappling the figure; one critic was even more disturbed by the background, professing an understandable inability to recognize, in the mass of wet-on-wet brushstrokes, a "fabric, a cloud, or a fantastic beast."[11] These strokes were perhaps the messiest sustained passage of painting in either the first or second Impressionist exhibition. By contrast, Morisot's paintstrokes, although similar in scale and character, had clear representational value—as a sail, a sheet, a boat's hull, a cloud, a figure, a puff of smoke, a trouser leg, or a tree.

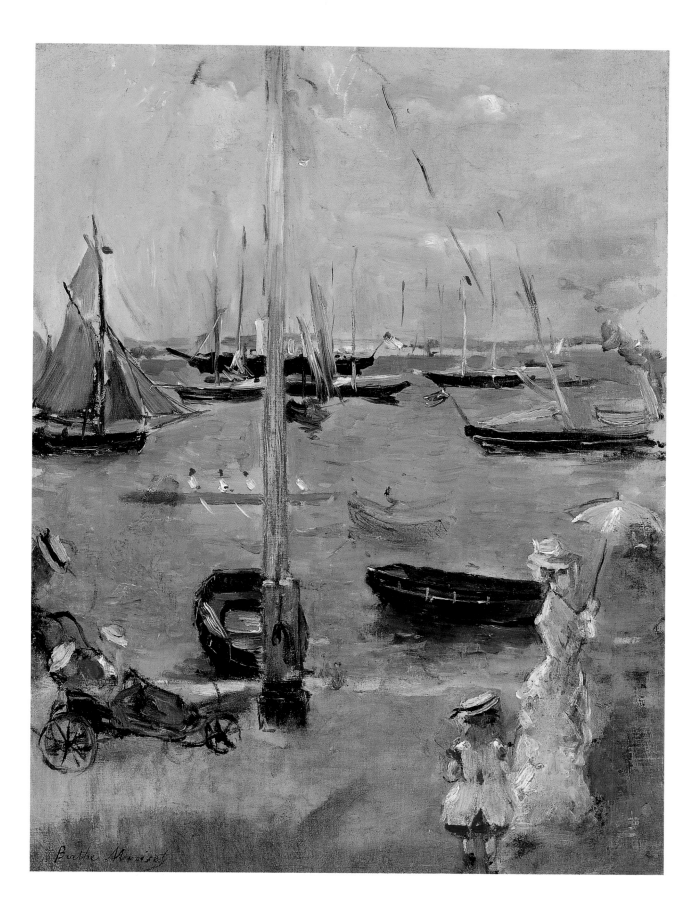

Berthe Morisot

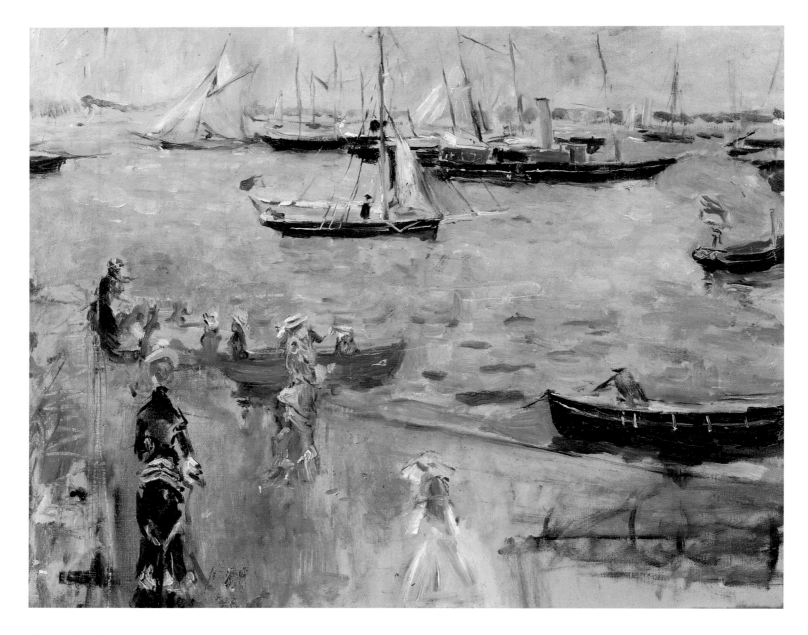

106 Berthe Morisot
Marine in England, 1875
Oil on canvas, 38 x 45 cm
Private collection

107 Pierre Auguste Renoir
*Self-Portrait, c.*1875
Oil on canvas, 39.1 x 31.7 cm
Sterling and Francine Clark Art Institute,
Williamstown, Massachusetts

[12] It was not included in the printed catalogue, so
must have been added at the last minute; it was
mentioned twice by critics.

Renoir's other freely painted submission in 1876 was the superbly fresh *Self-Portrait* (fig. 107).[12] As Renoir stared into the mirror, he minimized his task by omitting both the setting and his hands, and concentrating instead on his head and forthright gaze. The whole painting has a sense of being whipped up quickly—of being, in effect, an improvisation on the theme of self-portraiture. This was in contrast to two superbly finished male portraits in the same exhibition, one by Degas and the other by Renoir himself, a detailed and respectful portrait of Monet (painting indoors!). It also contrasts with a complex and detailed portrait of Renoir's principal patron, Victor Chocquet, listed in the catalogue simply as *Tête d'homme* (*c.*1875; Fogg Art Museum, Harvard University Art Museums). Renoir constructed the head and surroundings of the figure with thousands of discrete touches of paint in a manner as complex as any surface by Delacroix. He thus contrasted two modes of portraiture in one exhibition.

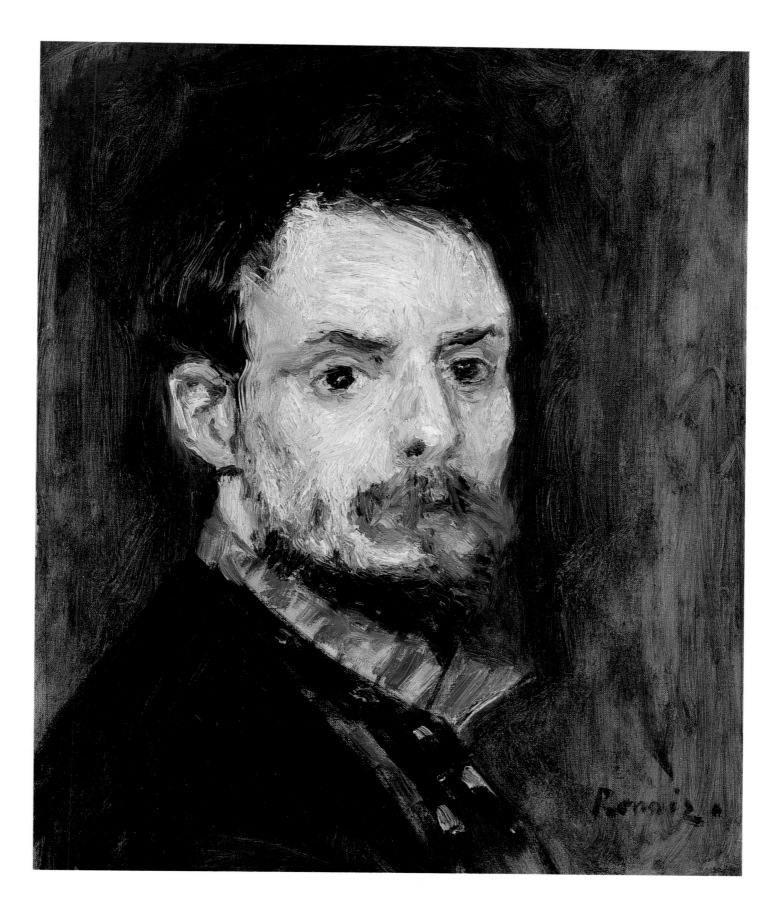

108 Pierre Auguste Renoir
Madame Monet and her Son, 1874
Oil on canvas, 50.4 x 68 cm
National Gallery of Art, Washington, D.C.
Ailsa Mellon Bruce Collection

Another Impression by Renoir of 1874 was made quickly and in competition with another artist. *Madame Monet and her Son* (fig. 108) was the result of a joint painting session with Manet and Monet, in which the latter's wife and son informally posed (see p. 88). Manet's work (see fig. 47), casual and elegant, has a surface animated by his gestures: its landscape background is so freely painted that it seems still wet. Renoir's smaller painting pushes its subject closer to the picture plane, becoming an exercise in observational gesture which is more concise than Manet's, if less eloquent. Manet's painting, with the addition of the figure of Monet himself at the right, was the result of several working sessions; it was most likely completed after a considerable corrective period in the studio. Renoir's has fewer painted marks, fewer forms, fewer hues, and more immediacy, perhaps showing the anxiety of the younger artist to beat the older one in precisely the arena of the Impression staked out by Monet. Renoir's work evokes the rapidly painted sketches of Fragonard and Boucher.

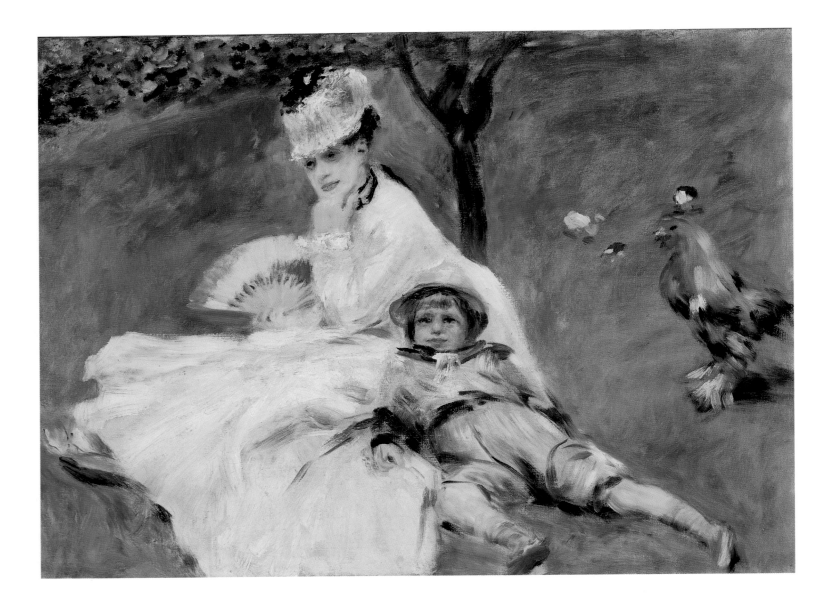

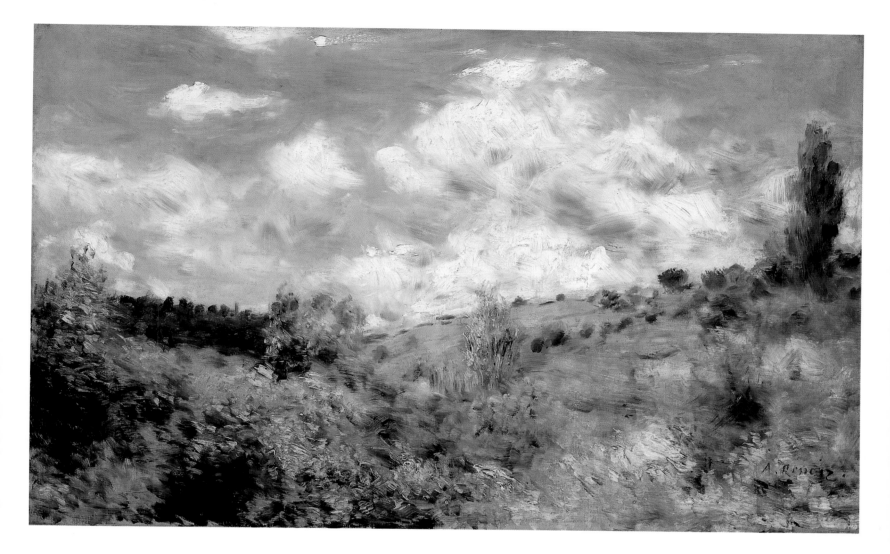

109 Pierre Auguste Renoir
*A Gust of Wind, c.*1878
Oil on canvas, 52 x 82.5 cm
Fitzwilliam Museum, Cambridge

The small-scale landscapes from the early and mid-1870s, unexhibited, were Renoir's boldest paintings from that period. *A Gust of Wind* (fig. 109) and *The Seine at Châtou* (fig. 110) are among the masterpieces of direct painting from that decade. The latter, conventionally dated to 1874, is devoted almost exclusively to the surface of the Seine, in which a small sailboat, tethered and empty, seems to bob without direction or control. The water dominates the surface not only by its scale (Renoir adopts a very high horizon line), but also because it is painted with such forthright gestures. Renoir's fingers and wrist seem almost to have danced across the surface, creating variably shaped and colored daubs, strokes, curves, and lines of paint that suggest wind interrupting the surface of water. With the cloud-filled and equally gestural sky, there is little in this work that is stabile. No painting by Monet, Manet, or Sisley approaches the radical instability and temporal flux of Renoir's little-known work from this period. Along with his other equally understudied landscapes from the mid-1870s, they constitute one of the most original contributions to landscape painting made by any of the Impressionists.

110 Pierre Auguste Renoir
The Seine at Châtou, 1874
Oil on canvas, 50.8 x 63.5 cm
Dallas Museum of Art
The Wendy and Emery Reves Collection

[13] Like most of Renoir's other landscapes of this period, it cries out to be studied.

A Gust of Wind, dated everywhere from 1873 to 1878, is equally indeterminate. Its subject is not unique in French painting—Corot and his colleagues among the so-called Romantic or Barbizon generation also essayed it. Yet where they tended to represent the unseeable wind by the bent branches and quivering leaves of a tree, Renoir allowed himself no such luxury. Instead, he represented wind as it coursed through a cloud-strewn sky, whipping the slender stalks of wheat, and guiding the motion of tiny birds. All is in shifting flux in this brilliantly original painting, which Renoir seems never to have exhibited in the decade of its making.[13] By contrast, *The Grand Boulevards* of 1875 was clearly conceived as a picture for exhibition and sale. Yet Renoir maintained the same indeterminate, almost inchoate facture for the last or "finishing" stage of a composition as he did for the informal landscapes just discussed.

The hallmark of both Renoir's and Morisot's Impressions from 1870–75 is their relatively small scale and informality of composition. These are not the independent easel pictures of Monet or Manet. Clearly, both Renoir and Morisot considered the Impression (whatever they called it) as one part of a spectrum of pictorial strategies that culminated in a large-scale and finished work of art. Morisot included in exhibitions both pastels and watercolors of a similar scale and finish to her Impressions, allowing the viewer access to the full range of her production. For both of them, as for Degas, the entire pictorial process was part of the public persona of the artist. As the decade went on, Morisot began to paint larger and more complex works completely in the style of her Impressions, without giving them titles that indicated any provisionary stature. This was a breakthrough for her, which was encouraged by her artist friends and also by her husband Eugène Manet, brother of the painter.

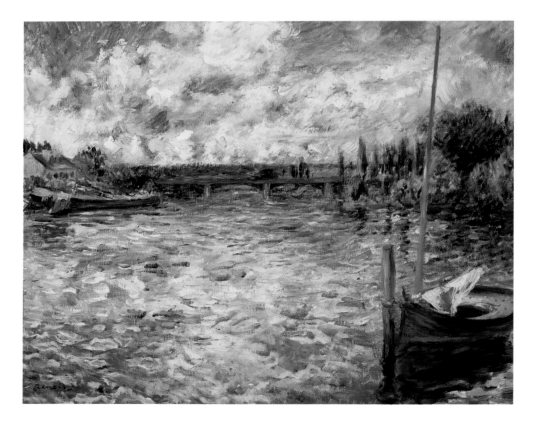

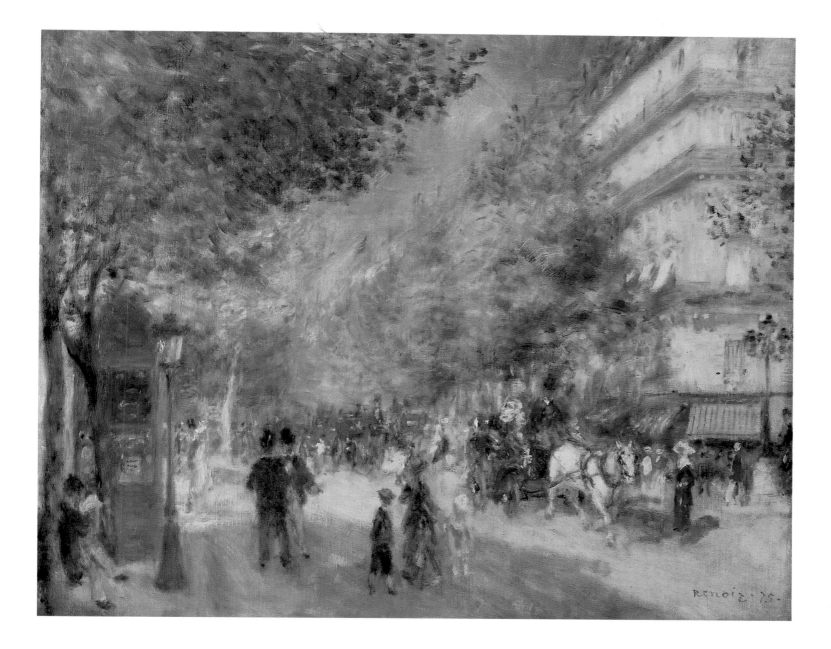

111 Pierre Auguste Renoir
The Grand Boulevards, 1875
Oil on canvas, 51.3 x 62.5 cm
Philadelphia Museum of Art
The Henry P. McIlhenny Collection in
memory of Frances P. McIlhenny

Renoir's *Ball at the Moulin de la Galette*, acquired by Caillebotte from the third Impressionist exhibition of 1877, was interpreted by Renoir's friend the critic Georges Rivière as an Impression, a work directly painted without preparatory processes. Rivière seized upon the momentary, fleeting instability of the subject and on Renoir's dancing facture to characterize the painting in this way. Yet we know from analysis (and Rivière himself undoubtedly knew) that this was not true. We know of two works that were made as part of Renoir's preparation for this painting. One, a rather somber and difficult oil sketch (fig. 112), conventionally dated 1875, was routinely dismissed as a first pass at the composition itself. Its existence, along with that of a variant much more closely related to the final composition, proves that Renoir was not at this time capable of executing a large, multi-figured composition directly onto the canvas. Rather, he seems to have proceeded first with a study of the composition, making final adjustments as he worked, and then with a study of the chromatic balance at a smaller scale before he finally tackled the large painting. This idea seems highly academic to those versed in Impressionist practice, and much has been written about it.[14]

Rather than condemn Renoir for the indirectness of his methods, however, it is probably wiser to interpret these variants not exactly as preparatory paintings or studies for the larger picture, but as *répétitions* (rehearsals) for it. Indeed, fig. 112 is so frantically direct, so filled with a flurry of gestures that define the subject, that it does suggest plein-air work. His brother later said that Renoir took his easel from his studio to the nearby Moulin de la Galette and worked from life. The relative darkness of this work, the large number of top hats among the dancing gentlemen, and the relative lightness of the out-of-door chandeliers indicate that Renoir first conceived of it as a dusk or a night view of the outdoor dance hall; only later did he transform the scene to a daytime display of healthy urban entertainment on the weekend. It can be seen in almost the same way as the most freely painted versions of Monet's Gare St. Lazare—as a variant rather than a study. Renoir later signed it and sold it to the great collector Chocquet, indicating that he was as happy with it as Monet was with his most freely painted and signed Impressions. This is Renoir's most freely painted work from the mid-1870s, displaying gestural abandon throughout a large surface. It is perfectly likely that he felt himself unable to do more work on it. Instead, he took another canvas, somewhat larger, transformed the time from night to day, replaced the silk top hats with straw hats and daytime bowlers, and lightened his palette.

We know from the recollections of Renoir's brother and from Rivière that the painter worked and lived just a short walk from the Moulin, and that his small garden and studio served as the place where his models amused themselves while Renoir worked. We also know that Renoir practiced continuously with various posed models in his garden and studio, and that he completed many small-scale Impressions of these casual figure groups in order to improve his transcriptional technique. Two of these groups are shown here, one painted before the final version of the *Moulin* and the other after it. *By the Fireplace* (fig. 113) is conventionally dated to 1876 and is among the most fluttering of Renoir's figural impressions from the mid-1870s. Rather than draw the contours of the two figures and the major elements of their setting, Renoir evoked them with hundreds of quickly applied, overlapping gestures that construct the scene from separately observed aspects of it. He confined his colors to descriptive areas so

[14] This research has been usefully summarized, with reproductions, in Barbara Ehrlich White, op. cit., pp. 64–73.

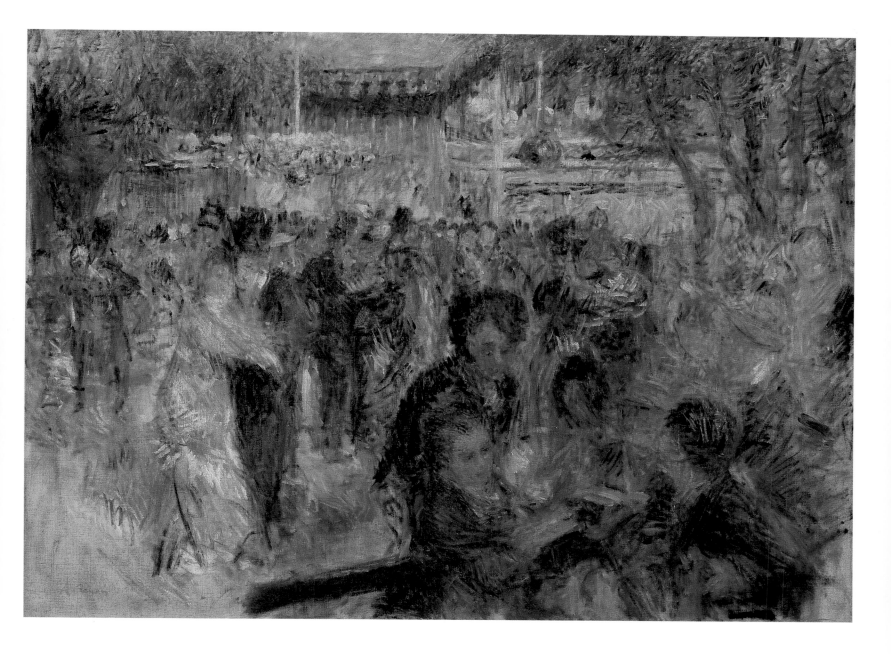

112 Pierre Auguste Renoir
Sketch for "Ball at the Moulin de la Galette," 1875
Oil on canvas, 65 x 85 cm
Ordrupgaard, Copenhagen

113 Pierre Auguste Renoir
By the Fireplace, 1876
Oil on canvas, 61.5 x 50.6 cm
Staatsgalerie Stuttgart

114 Pierre Auguste Renoir
At the Milliner's, 1878
Oil on canvas, 32.7 x 24.8 cm
Fogg Art Museum, Harvard University Art
Museums, Cambridge, Massachusetts
Bequest of Annie Swan Coburn

that the paints would not mix, thus implying that he worked in the hurried fashion he meant to suggest. The contrast between the relative stability and tranquility of the represented subject, and the urgent, visually disruptive mode of its transcription is fascinating. *At the Milliner's* (fig. 114), conventionally dated to 1878, represents a scene in a millinery shop like those that were soon to be studied by Degas. But it is more likely that Renoir posed his models in his own studio or garden (there is nothing specific to a millinery shop in the composition), and that he performed his transcription with what, by then, was an enviable fluency. The lines of liquid paint, thinned almost to translucency, and the linear squiggles that represent yarn or ribbon are extraordinary. He had by this time rehearsed his figural impressions to a point of confident mastery.

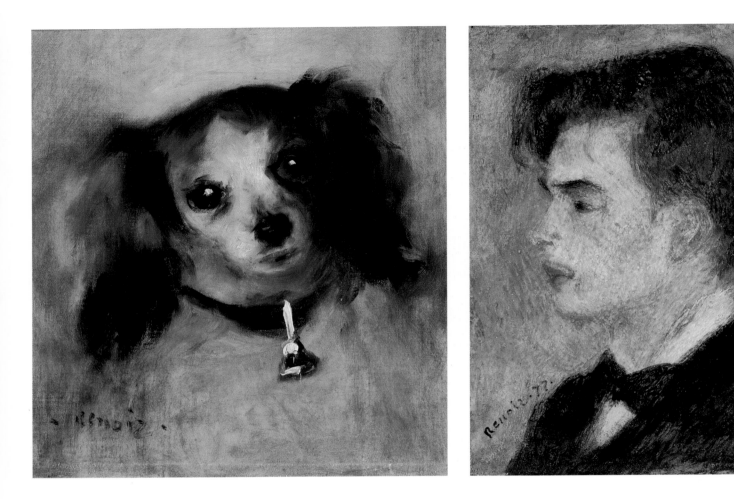

115 Pierre Auguste Renoir
Head of a Dog, 1870
Oil on canvas, 21.9 x 20 cm
National Gallery of Art, Washington, D.C.
Ailsa Mellon Bruce Collection

116 Pierre Auguste Renoir
Georges Rivière, 1877
Oil on canvas, 36.8 x 29.3 cm
National Gallery of Art, Washington, D.C.
Ailsa Mellon Bruce Collection

117 Pierre Auguste Renoir
Little Blue Nude, c.1878–79
Oil on canvas, 46.4 x 38.1 cm
Albright-Knox Art Gallery, Buffalo, New York
General Purchase Funds, 1941

Three small works by Renoir, equally Impressions, are so modest and charming that their aim was surely private. Like Manet, Renoir painted little keepsakes for his friends—portraits of dogs, small portrait heads, tiny still lifes, and nudes. These confections were never intended to be read as serious works of art; they are pictorial bon-bons, and their gestural style made them all the more personal. In *Head of a Dog* (fig. 115) we have a tiny King Charles spaniel with liquid eyes and a tiny silver bell; in *Georges Rivière* (fig. 116) a whipped-up portrait of the Impressionists' friendly critic. Together with the enchanting *Little Blue Nude* in a fluttering landscape (fig. 117), these works were made as embodiments of the Renoir's personal affections, as mementos, as gestural miniatures. They demonstrate his belief in the non-mechanical and personal nature of art: they could have been painted only by him. It is also likely that many of them were painted in the presence of their recipients, creating a distinctly non-capitalist link between making and giving—two different kinds of "gesture."

Morisot's entries to the 1880 Impressionist exhibition included a superb array of paintings that stressed the human figure. In *Summer's Day* (fig. 118), she juxtaposed two women in a boat, one in profile and the other from the front, with a waterscape as

diaphanous and loosely painted as any in her career. The women, at once seated and floating, are at the same time static with regard to the boat and moving through the water. This brilliant painting elides two worlds, using the figures of the women as a foil to issues of temporality and flux in the modern world. Throughout, the artist's technique is considered and rehearsed, but each gesture is applied in a way that suggests it was made casually and without premeditation.

Perhaps it was Renoir's practice in the mid-1870s that provided the impetus that propelled Morisot into her years of most sustained brilliance as a painter of Impressions. After 1877, her work became more confident, larger, looser, and more ambitious in composition than even her most experimental paintings of the first half of the decade. The sheer abandonment of her gesture and its increasingly non-representational role put her at the forefront of Impressionist experimentation. In the outdoor studies *Boats on the Seine* of 1880 (fig. 119) and *Child among the Hollyhocks* of 1881 (fig. 120), she scattered the elements of the composition in an almost uniform rhythm across the entire pictorial surface. The viewer is therefore encouraged to jump visually from element to element, each of which is a series of short painted marks that define the form with incredible economy. The riverscape pulls the diverse strokes together with painted black lines that

119 Berthe Morisot
Boats on the Seine, 1880
Oil on canvas, 25.5 x 50 cm
Fondation Corboud, permanent loan at the
Wallraf-Richartz-Museum, Cologne

represent linear forms. In the garden picture, Morisot makes her task a little easier by working on a brown-primed ground, against which the whites, pinks, pale blues, and greens of her garden are juxtaposed to maximum chromatic advantage. In both of these works, as in her small canvases painted on holiday earlier in the decade, Morisot's gestures are strictly tied to their representational function, each describing either a nameable form or a particular part or aspect of that form.

This representationalism was to stop as the 1880s continued, and Morisot became bolder with her painted lines. *The Artist's Daughter Julie, with her Nanny* (fig. 121) and the superb *Interior of a Cottage* (fig. 122) are glorious painted drawings in which each line is a color sensation. The light playing across the hair and clothing of the two figures in fig. 121 is applied with loose, buttery strokes of paint. The architecture and garden trellis outside the window are summarized to such an extent that they are mere ciphers for the represented forms. The same can be said for the extraordinary forms in *Interior of a Cottage*. Here, Morisot painted a landscape, a genre scene, and a still life in one composition, linking them all with a series of purposeful painted lines that seem almost to move around the forms rather than define them. The enlivening of this quotidian scene so that it becomes nervous rather than calm gives a completely

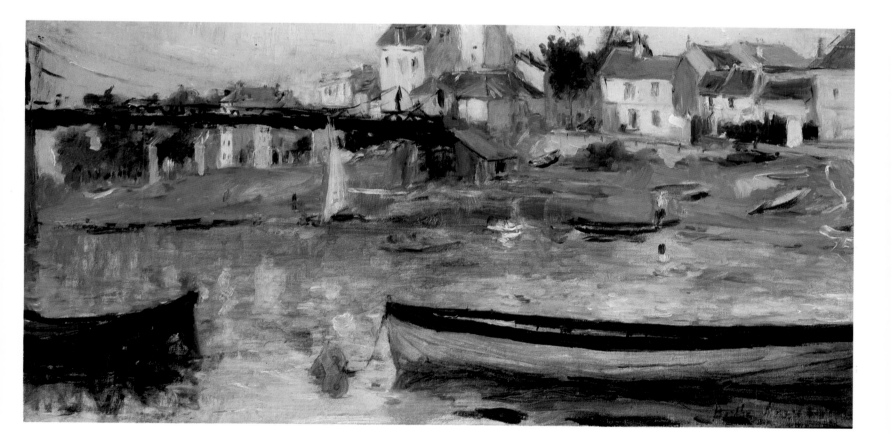

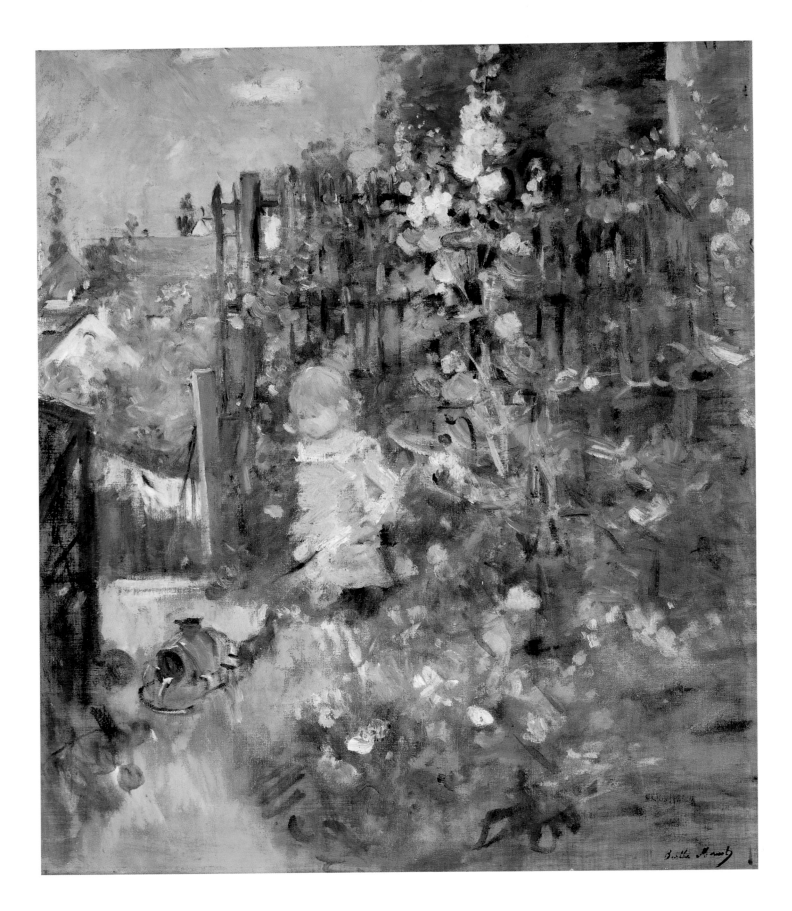

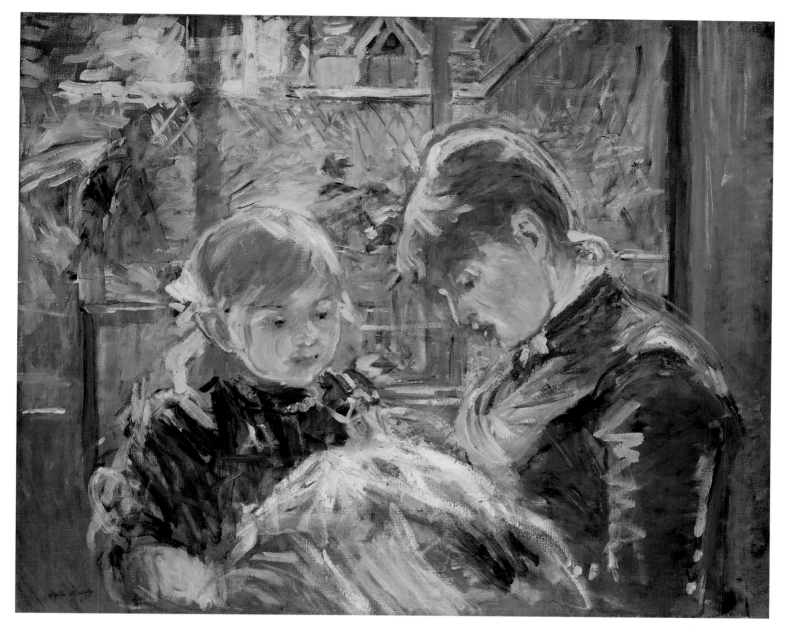

121 Berthe Morisot
The Artist's Daughter Julie, with her Nanny
(The Sewing Lesson), 1885
Oil on canvas, 59 x 71 cm
The Minneapolis Institute of Arts
The John R. Van Derlip Fund

FACING PAGE:
120 Berthe Morisot
Child among the Hollyhocks, 1881
Oil on canvas, 50 x 42 cm
Fondation Corboud, permanent loan at the
Wallraf-Richartz-Museum, Cologne

122 Berthe Morisot
Interior of a Cottage, 1886
Oil on canvas, 50.5 x 61.5 cm
Musée d'Ixelles, Brussels
Fritz Toussaint Collection

modern emotional quality to a genre of painting that had, since the Dutch masters, been associated with stability.

A good deal of the impetus for this energy came from Morisot's informed study of the decorative paintings of Boucher and the rapid painted sketches of Fragonard in the Louvre. The eighteenth-century informality of touch and its application to pleasant subjects clearly provided an example to Morisot—she painted a free copy (fig. 123) of a section of Boucher's famous *Forge of Vulcan* in the Louvre as a decoration for her own home in 1884. Her work makes the most explicit link between this style of painting and the improvisational style of the modern urban Impressionists. She surely tested her own skills not only against artists like Manet and Renoir, but also against the Old Masters.

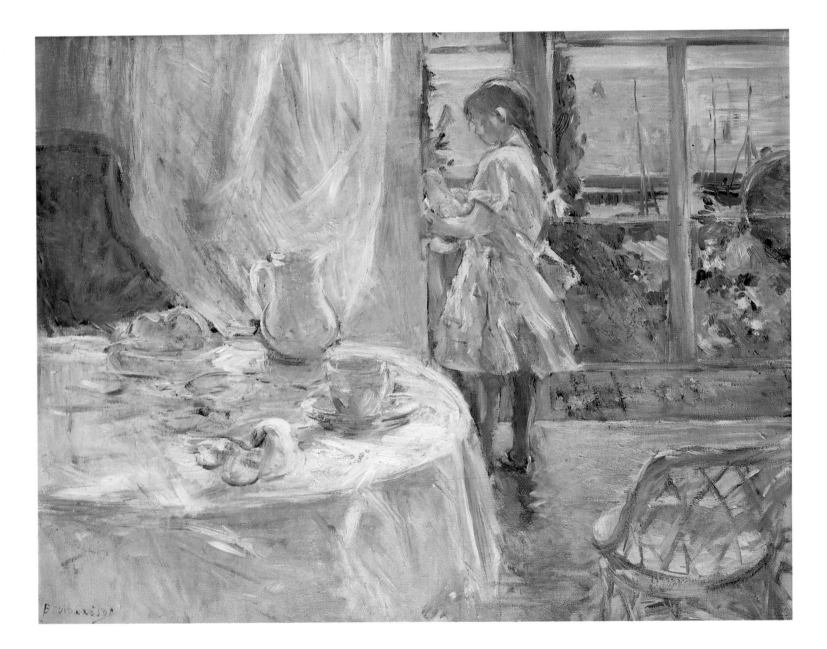

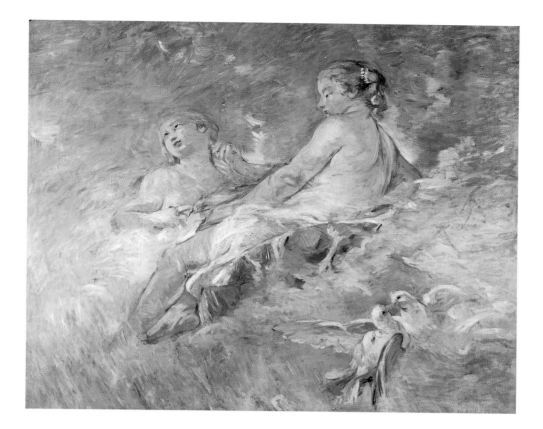

123 Berthe Morisot
Venus at Vulcan's Forge, 1884
Oil on canvas, 114 x 138 cm
Private collection, courtesy of Galerie
Hopkins-Thomas-Custot

In the context of this revival of the eighteenth century, it is fascinating to compare the improvisational still lifes of Renoir and Morisot. In *Roses in a Vase* of 1876 (fig. 124) Renoir painted a lush bunch of roses and perhaps reddish-pink peonies stuffed into an Asian ceramic vase. This central element is mysteriously perched on the very edge of a marble-topped table, as if about to fall into the tufted armchair with its big white cushion. Just visible in the upper part of the composition is a painting in a large gilded frame, thus the senses of touch, smell, and sight are joined in a meditation on the nature of painting. Renoir was careful to reveal nothing of the composition, the subject, or the identity of this depicted painting, preferring to evoke it through a series of gestures that we struggle to read as anything other than gestures. But the squiggles of paint in the vase, the great dry-brush strokes of paint on the cushion and the table-top, and the messy wet-on-wet impasto of white and red paint that represents the flowers—all of these have a directness that forces us to think less about the painted subject than about Renoir as its master. Our central delight in this *tour de force* of painting is the feeling that we could simply reach over to the vase and, with a touch, knock the entire still life apart.

Morisot is a good deal more conservative in the composition of her *White Flowers in a Bowl* (fig. 125). She placed a ceramic water pitcher of conventional design next to a bunch of small chrysanthemums lying unarranged in a painted ceramic bowl. It is casual, as if Morisot were studying the makings of a floral still life rather than painting the finished arrangement. The facture is almost rushed, with lines of paint almost violently jabbed at the canvas, particularly in the background and the passages that

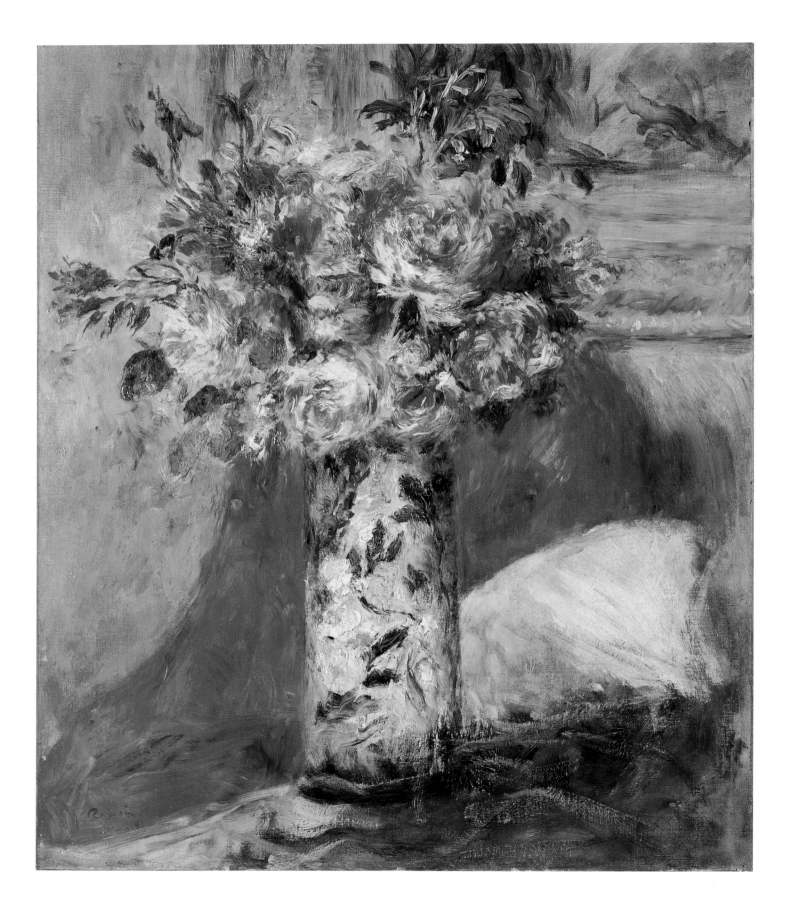

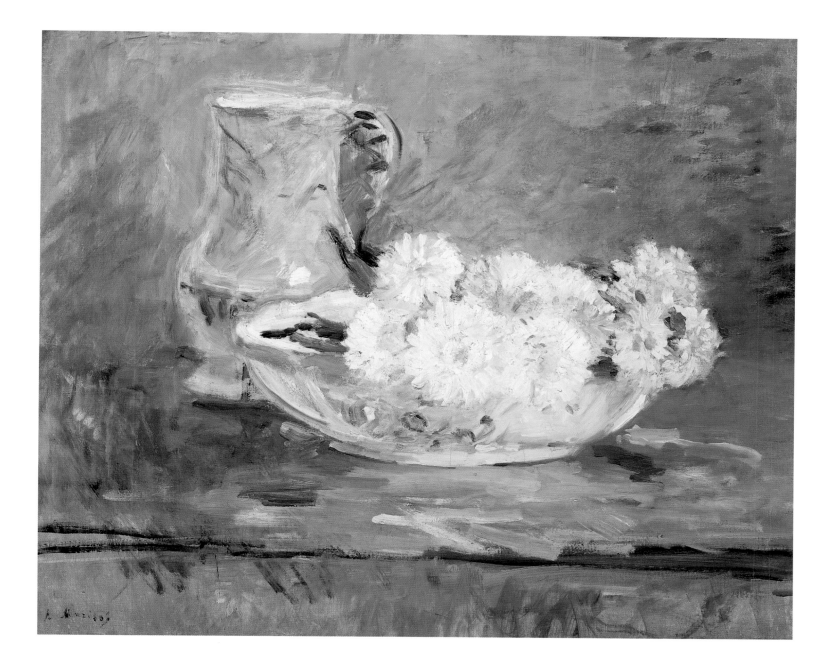

125 Berthe Morisot
White Flowers in a Bowl, 1885
Oil on canvas, 46 x 55 cm
Museum of Fine Arts, Boston
Bequest of John T. Spaulding

FACING PAGE:
124 Pierre Auguste Renoir
Roses in a Vase, 1876
Oil on canvas, 60.7 x 51.4 cm
Private collection

evoke the foreground table. In this welter of painted lines, the whiteish flowers at the center of the composition are delightfully dainty, but they too are evoked in such a way as to make an elision between single, short gestures and the petals they describe. Thus Morisot literally constructed the flowers in ways not at all dissimilar to Manet's construction of his peonies more than a decade earlier (see fig. 33). But Manet's strokes were at once fluent and beautiful as painted gestures, whereas Morisot allowed no such easy luxury. Instead, her marks are decidedly aggressive even though they describe a subject that is calm, filled with traditional time, even easy. Her composition reminds us of the simplest still lifes of the great Chardin, but her manner of painting is far bolder than that of her other hero, Fragonard.

Renoir's career after 1881 has often been seen as a repudiation of the transitory aesthetic of the Impression. There is ample evidence for this in the large-scale exhibition paintings with which he made his reputation; we also know that his first visit to Italy in 1881 had a profound effect on him.[15] Yet while it is true to say that Renoir began to paint highly complex and conventionally finished exhibition pictures in greater numbers after 1882, he also continued to experiment with the colored gestures that characterize his most radical innovations. To demonstrate the continuity in his career, we need only compare two major paintings from 1879 with a group of works made in 1881 and 1882. Among the grandest, freest, and most gesturally positive landscapes of Renoir's career is *Road at Wargemont* of 1879 (fig. 126). It arranges what we might call the French curve of a rural road in the center of a large, distant landscape of hills and trees. The rhythms of the road are matched by those of Renoir's own arm, elbow, and wrist as he recreates them in viscous paint. As in the small *A Gust of Wind* (see fig. 109), everything quivers with movement. Wind gusts through the trees, sends clouds scudding across the sky, and prevents the rain from striking the earth. Although the road itself dominates the composition, it does not prevent us from marveling at an entire range of painted strokes—pools of liquid painting, little touches from a large brush for distant trees, scrubbed passages in the lower right for wind-worn foliage, etc. What is fascinating about Renoir's impressions of this type is the comparative thinness of his paint. In this he differed from Monet and Manet, who preferred thicker paint that resisted their gestures. In his decision to thin his paint in large areas of the canvas, Renoir ensured that it dried more efficiently, and it acts as a kind of pictorial and gestural counter to the shorter, thicker gestures he also makes.

Another painting of 1879 is equally loosely painted and, in a way, closely connected with Morisot's production during those years. Oddly called *The Dreamer* (fig. 127), it can be linked to Morisot's *Le Corsage Noir* of the previous year (fig. 128). Although Morisot's composition is a conventional three-quarter-length portrait, she evokes her subject with a series of thick, boldly painted lines that push laterally along the canvas with an energy completely absent from the subject. Renoir's subject, although arranged with asymmetrical modernity to avoid the portrait format, is painted with viscous layers of paint and a filigree of nervous marks that suggest wallpaper, lace, fabric, and foliage, all seemingly in motion. The coy pose and silly eroticism of the woman's gesture link the painting to the aesthetic of Fragonard and Boucher, both of whom provided real impetus for Morisot as well. In this case, though, Morisot's gestures were far more aggressive than Renoir's, who preferred to create a connoisseur's variety of marks.

Renoir's trip to Italy in 1881 has been accorded such an important role in the mythology of Impressionism that we would do well to look again at the paintings he actually made on it. After achieving success as a Salon painter, winning the affection of decidedly wealthy bourgeois collectors, and establishing himself with major Parisian dealers, Renoir was truly independent from the Impressionist group. Almost in recognition of this, he made a major trip to Naples, Rome, and Venice, a journey that he himself considered a turning point in his life. He visited major museums and monuments, and took in all the conventional tourist sites. He also painted, and his

[15] See Barbara Ehrlich White, op. cit., pp. 108–24.

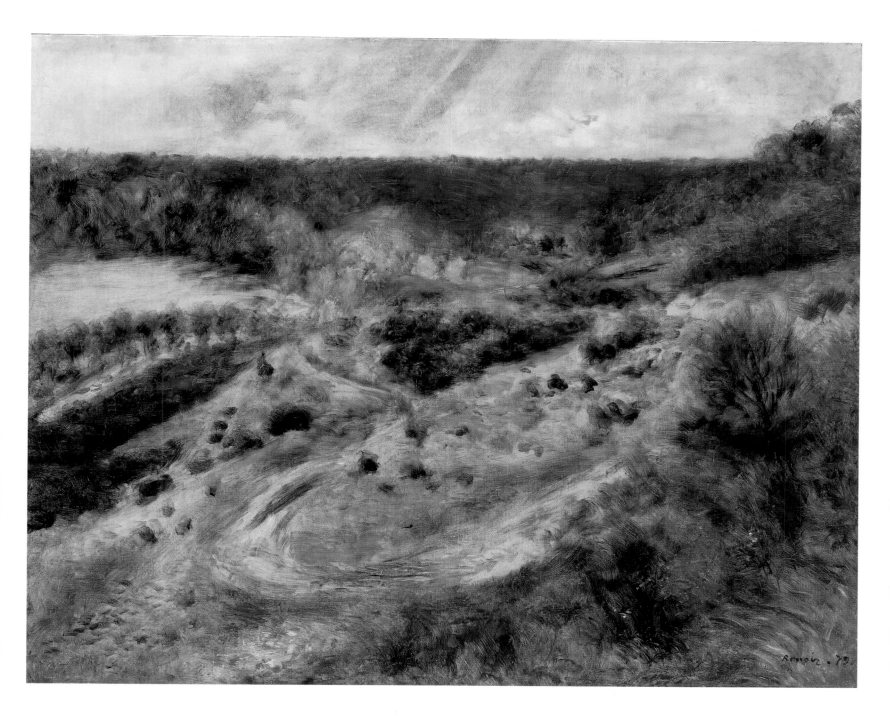

126 Pierre Auguste Renoir
Road at Wargemont, 1879
Oil on canvas, 80.6 x 100 cm
The Toledo Museum of Art
Purchased with funds from the Libbey
Endowment, Gift of Edward Drummond
Libbey

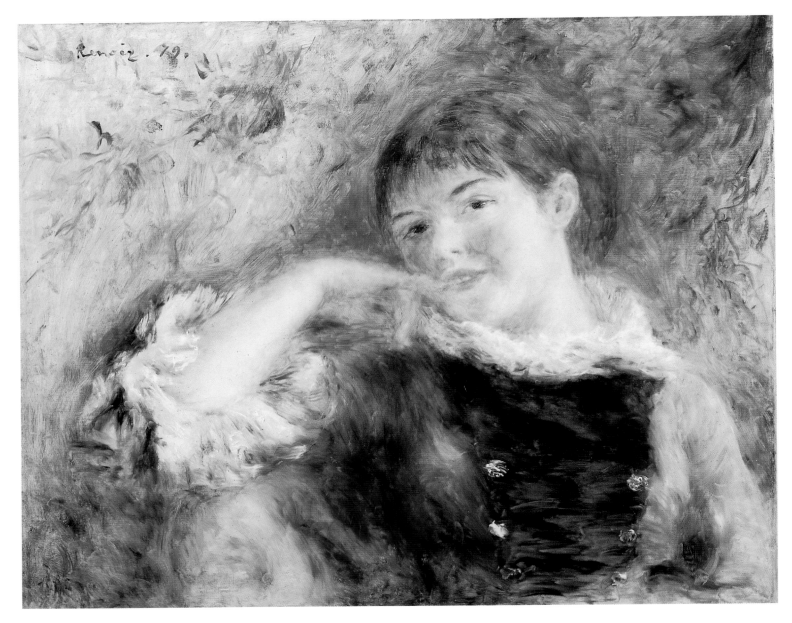

127 Pierre Auguste Renoir
The Dreamer, 1879
Oil on canvas, 49.5 x 59.7 cm
The Saint Louis Art Museum
Purchase

FACING PAGE:
128 Berthe Morisot
Le Corsage Noir, 1878
Oil on canvas, 73 x 65 cm
The National Gallery of Ireland, Dublin

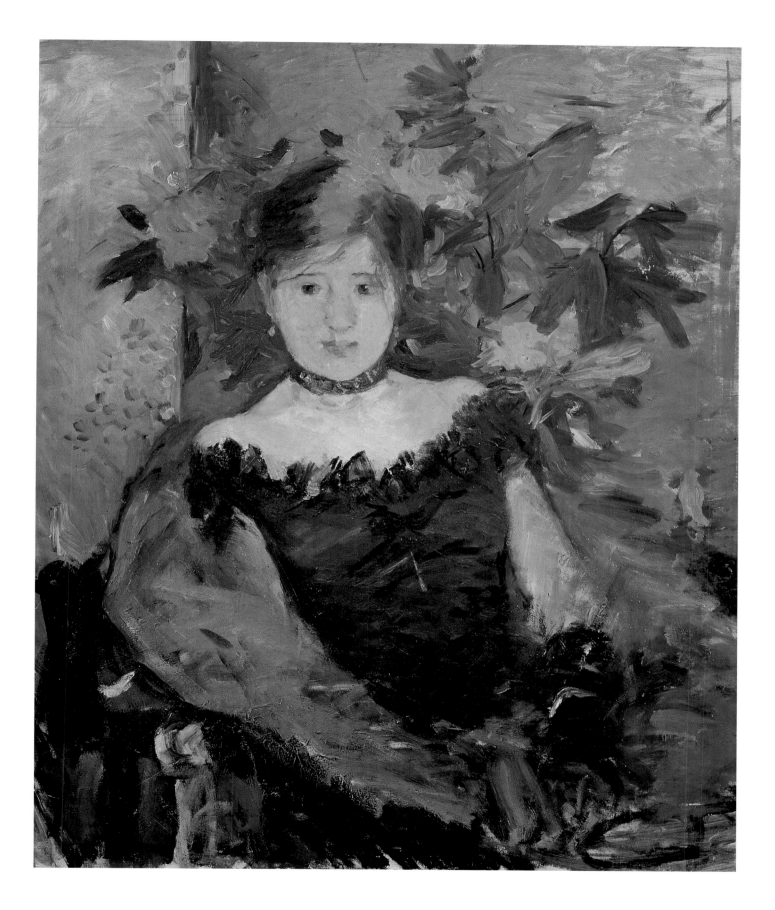

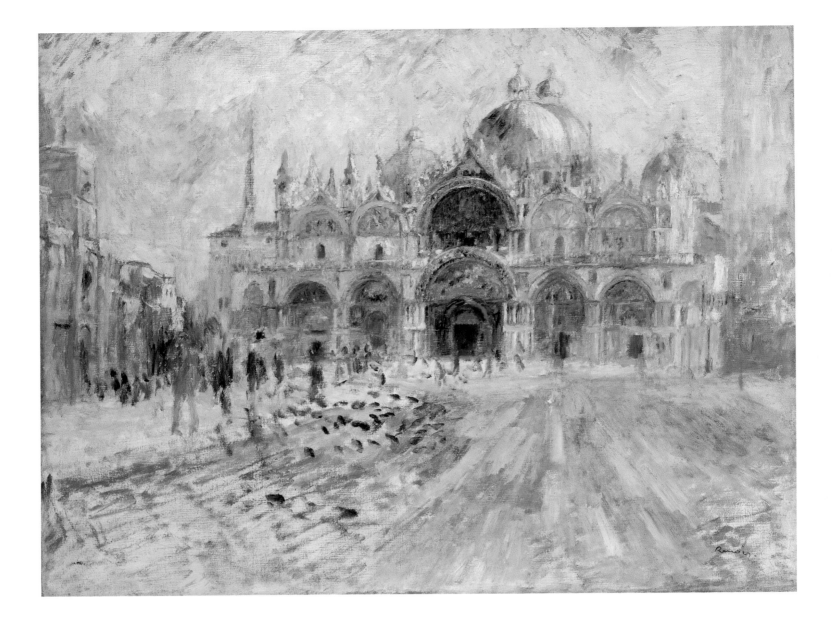

129 Pierre Auguste Renoir
Piazza San Marco, Venice, 1881
Oil on canvas, 65.4 x 81.3 cm
The Minneapolis Institute of Arts
The John R. Van Derlip Fund
(Detail opposite)

extraordinary view of *Piazza San Marco, Venice* (fig. 129) is surely one of the most directly painted responses to this great architectural space in the history of art. When Renoir set up his easel, sufficiently distant from the cathedral façade so that it could be rendered with a series of short gestures, he managed better than any other painter to evoke both the emptiness of the piazza and its wind-swept, pigeon-filled excitement. All of this serves as a foil for his gloriously frenzied representation of the church's complex façade and domes. Renoir also painted a view of the Grand Canal in fog, which is equally an Impression—with buttery pale-yellow paint and viscous strokes of white, beige, gray, and brown, he captured the sensation of the thick fogs of Venice in winter in a way not surpassed even by Monet when he visited the city in 1908.

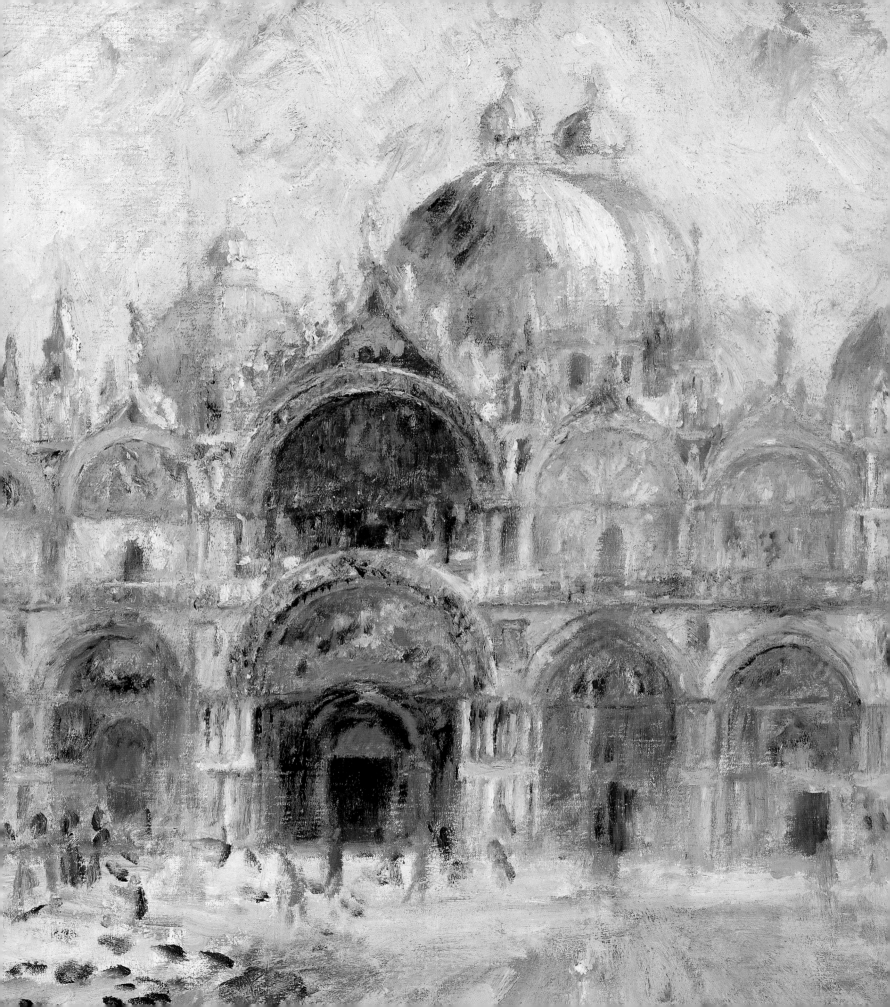

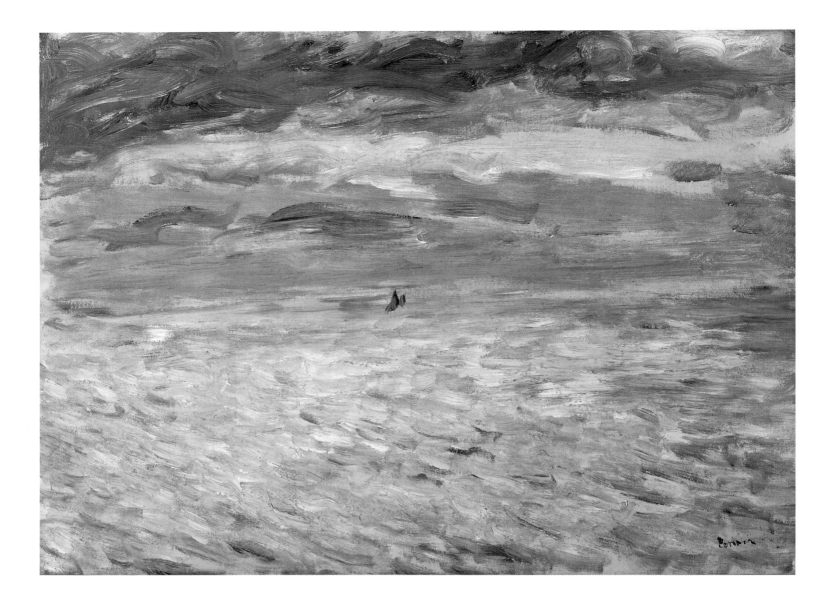

130 Pierre Auguste Renoir
*Sunset at Sea, c.*1883
Oil on canvas, 45.7 x 61 cm
Sterling and Francine Clark Art Institute,
Williamstown, Massachusetts

[16] It is difficult to know which of the many surviving
representations of waves were included in the 1882
Courbet exhibition. Undoubtedly the largest version
(Musée d'Orsay, Paris) was there; others are today in
the Städelsches Kunstinstitut in Frankfurt, the
Kunsthalle in Bremen, the Nationalgalerie in Berlin,
and the Dallas Museum of Art.

Like Monet, Renoir reserved his most fluent strokes for the representation of sea water. Two contrasting studies of the sea from the early 1880s were both painted on the north coast of France. *Sunset at Sea* (fig. 130) was painted in a single session with three or four colors and two or three brushes on a small canvas. Even today, it still seems wet, as if the painter had just left the easel for a moment. Its signature is at once a badge of pride and Renoir's own acknowledgment that he was fully a master of this most evanescent kind of painting. He succeeded during the short span of a sunset in capturing its rosy, pearly light on water—represented time and time of representation have completely coincided.

He gave himself a more difficult task in 1882, when he left Paris in the spring after seeing one or more of Courbet's great wave paintings of the 1860s and 1870s in the retrospective of that year.[16] He went almost immediately to the north of France, and decided to paint a wave with even greater visceral power than Courbet. Renoir's *The*

131 Pierre Auguste Renoir
The Wave, 1882
Oil on canvas, 53.3 x 63.5 cm
The Dixon Gallery and Gardens,
Memphis, Tennessee
Museum purchase from Cornelia Ritchie
Bivins and Ritchie Trust No. 4

Wave (fig. 131) is literally slathered in paint. Thick white paint, applied in loopy curves, represents the foam from the wave playing on the beach. Yellow-beige paint, staining the water, is the sand pulled up by the undertow. The water itself was troweled onto the canvas with a palette knife, then modified wet-on-wet with brushes. Renoir finished the painting by using the dry tip of his palette knife to remove blue paint from the background water and sky, to suggest the spray from the wave dancing in the air. The whole fabulously evocative attempt to make oil paint represent water was completed by Renoir with a signature and date, both of which were applied to the painting while it was still wet. How more immediate could one get? No other Impression survives that succeeds so completely at becoming its subject.

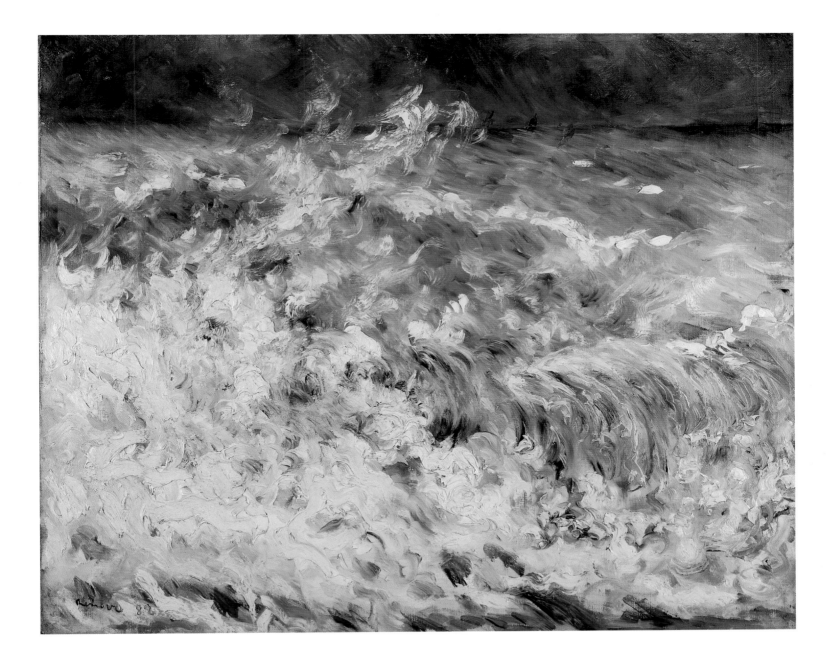

7 Alfred Sisley: The Impression, graphism, and automatic writing

Alfred Sisley was the most committed Impressionist, remaining faithful to the tenets of direct painting from nature until his death in 1899. Perhaps only Morisot rivaled him in this unfashionable steadfastness, and both suffered relative neglect after their deaths when the critical fortunes of the Impressionist movement declined around the turn of the century. Sisley was regarded as "merely" an Impressionist—an artist who never seemed to recognize the inherent limitations in the movement's aims. In recent decades, however, certain scholars have written eloquently about him, creating a subtle discourse associated with a more widespread reproduction of his work in color.[1]

Sisley's works have always appealed more to private collectors than to museum curators. Few major museums in France, England, or the United States have purchased his paintings, although they have acquired them by bequest.[2] For this study, we have brought together paintings from the 1870s and early 1880s that show the range of Sisley's achievement as a direct painter of the suburban landscape around Paris. Though less numerous and less artistically daring than contemporary paintings by Monet, these works are nevertheless worthy of sustained analysis. They reveal an artist with a distinct and personal manner quite different from Monet, Renoir, and Morisot, to whose works they can most readily be compared.

Sisley's approach to the landscape Impression was graphic rather than painterly. Although he proved a masterful manipulator of paint and a superb colorist, it is the fundamentally graphic energy of his painted marks that gives his landscapes a distinct identity. With the exception of a few paintings from the early 1870s composed in slabs of color, like those of Monet, Sisley preferred to construct his landscapes with small brushes, creating hundreds, sometimes thousands, of colored lines on the surface of the canvas. His work therefore has a close relationship to the drawn *croquis* of artists like Corot and Daubigny and to the plein-air etchings of the artists of the Barbizon school (see pp. 50–57). An accumulation of rapidly made lines with the character almost of straw or rain is the hallmark of his style. In this way he minimized risk: he allowed himself so many gestures that no one of them could be perceived as a mistake. This results in an aesthetic of accumulation rather than selection.

Among the most original of Sisley's oeuvre is an undated and unsigned small painting from 1873 or 1874, *The Lesson* (fig. 132). It has a visual status similar to Monet's wonderful portrait of his son sleeping (see fig. 67) or Morisot's late studies of her daughter Julie. Probably forced by the weather to paint indoors, Sisley used his children as models. Everything about this work—from the summary painting of the faces and fabrics to the abundant primed white ground that shines throughout the lower left quadrant—suggests that it was made as his children were studying, thereby linking the time of representation and the represented time. A familial intimacy reigns in this supremely private painting, and many aspects of its construction and facture link it to the domestic interiors of Edouard Vuillard dating from the 1890s. Yet, quickly made as the gestures were, they were undoubtedly not placed on the canvas in a single sitting. Rather, Sisley observed his children in their work smocks at an habitual time over two or three days, the interruptions allowing the paint to dry and him to prepare his next attack. This is particularly strongly felt in the contrast between the upper left and the lower right quadrants of the painting. The former is beautifully

[1] By far the best and most complex study of Sisley is that of Richard Shone, *Sisley*, Harry N. Abrams, New York, 1992 (repr. paperback, 1999). For detailed entries on individual works of art, see MaryAnne Stevens et al., *Alfred Sisley*, exh. cat., The Royal Academy, London, 1992.

[2] As a result of these haphazard policies, the major institutional collections of Sisley's works do not have the structure of collections of works by Monet, Manet, Renoir, Morisot, and Pissarro.

132 Alfred Sisley
The Lesson, *c*.1873–74
Oil on canvas, 41.3 x 47 cm
Private collection, Texas

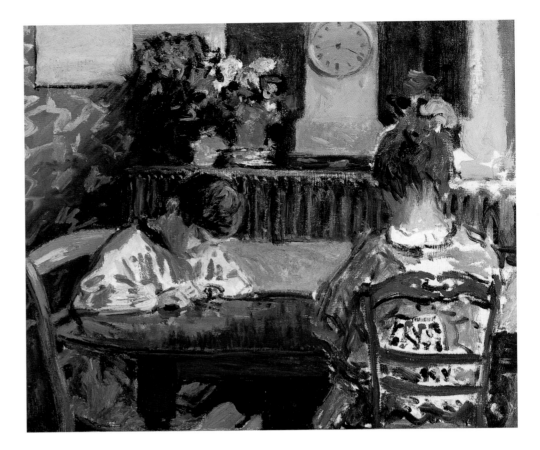

layered in the wallpaper and the still life of potted flowering plants; the latter is as open as any passage in Sisley's oeuvre up to this point—indicating that, although the work was carefully planned, it was made with real spontaneity and gestural flair.

Aside from this rare work, the remaining paintings by Sisley in this study are landscapes. Sisley strayed so rarely from landscape painting that his oeuvre can be compared to that of his countryman, John Constable. We know, however, from a single surviving sketchbook in the Louvre dating from the early 1880s that Sisley planned his landscape compositions graphically before tackling them with canvas, brush, and paint.[3] This practice marks a real departure from that of the other Impressionists, who preferred not to make advanced studies of the landscape in drawn form, but to respond to the motif directly on the canvas. Although we have no direct proof that Sisley made such drawings before 1880, given the methodical nature of the surviving sketchbook it is logical to assume that the practice was habitual.

The implications of this graphic preparation are considerable. By planning a composition using a rapidly drawn pencil *croquis*, Sisley could integrate his experimental graphism into the work. The major rhythms of trees, buildings, water, clouds, reflections, and figures could be worked out on a small sheet of paper; from the evidence of the sketchbook, Sisley did this in a manner that was later described by Gustave Fraipont.[4] Looking fixedly at the motif, he evoked the main character of the landscape elements in pencil without ever looking at the drawing. This practice linked the hand and eye directly without mental oversight or critical intervention, and provided Sisley

[3] This sketchbook is reproduced in its entirety in François Daulte, *Gli Impressionisti: Alfred Sisley*, Fabbri, Milan 1971, pp. 84–93.

[4] Gustave Fraipont, *L'Art de prendre le croquis et de l'utiliser*, Paris, 1886; see p. 17, note 10.

133 Alfred Sisley
A Turn in the Road, 1873
Oil on canvas, 54.5 x 64.7 cm
The Art Institute of Chicago
Charles H. and Mary F. S. Worcester Collection

with an improvised visual scaffolding for his later painting. In all likelihood, he then used this *croquis* as the basis for a larger, pointed-up drawing on the canvas, on which he laid in background colors in large areas; over this, he would work with small brushes in subsequent sessions. Planning the composition before he began to paint freed him from thinking about it later, so that he could then respond immediately and without adjustment to chromatic stimulae as he worked in color.

This ideal, or theoretical, mode of working was not practiced with perfect rigor by Sisley—and we would perhaps be somewhat disappointed if he turned out to have been the Mondrian of Impressionism! Like Monet, he adjusted his mode of transcription to the landscape and to his own moods and humors. But his practice was among the

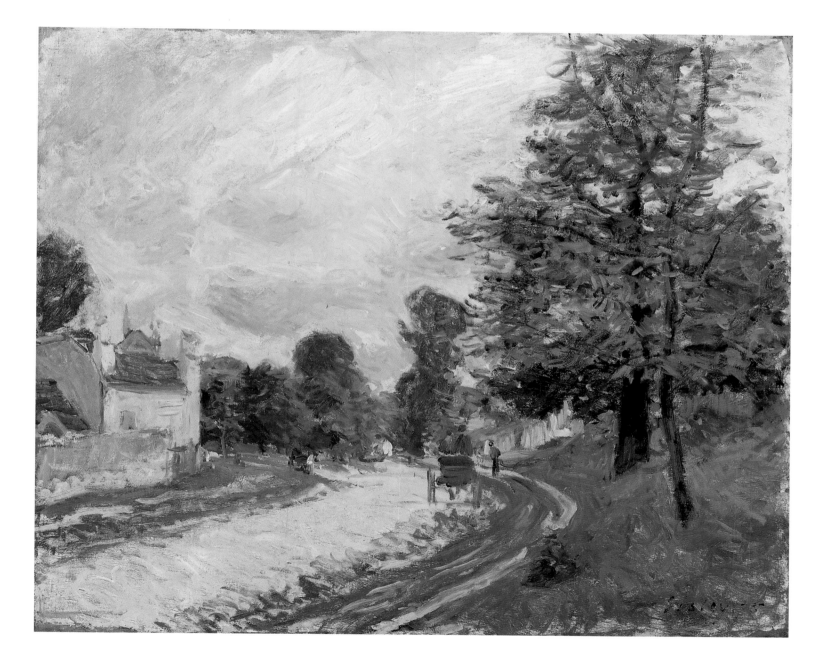

most classical or ordered of any of the Impressionists, largely because of its fundamentally graphic nature.

A Turn in the Road (fig. 133) is among his most accomplished landscapes of 1873. Signed and dated, it records a small rural road in Marly-le-Roi as wind swept through the grass and foliage on a blustery summer day. The painting is a wet-on-wet construction of overlapping strokes, with slight variations of hue and value in areas of gray-blue, gray-green, and gray-beige with accents of red, red-orange, and blue. It is clear that Sisley painted both the sky and the landscape below the horizon in one session, before later working on the figural elements, and the trees which overlap the blue-gray sky. The figures were probably painted in the same session as the trees, as none of them overlaps each other or the trees. So the entire picture had a simplicity of production that resulted in an Impression. We do not sense that Sisley had second thoughts, or that he altered any major aspects of the composition as he worked. Rather, he planned it, and painted it as planned, as he stood in the landscape. The sense of wetness that the painting retains to this day adds to its temporal freshness, and was close as Sisley ever got to the landscape practice of Renoir.

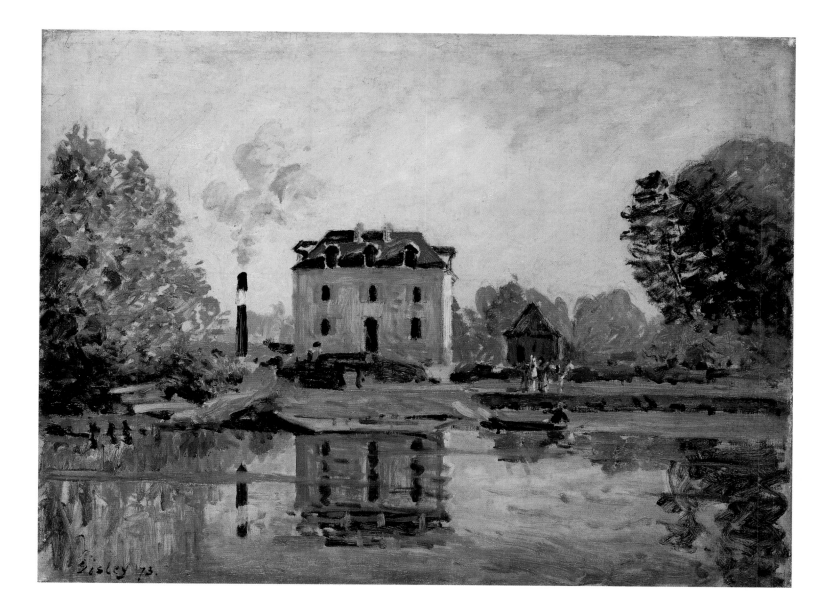

134 Alfred Sisley
Factory in a Flood, 1873
Oil on canvas, 50 x 65.5 cm
Ordrupgaard, Copenhagen
(Detail opposite)

[5] The title is surely a modern invention: the painting does not represent a factory, but the house of the lock-keeper on a stretch of the Seine between Bougival and Port Marly, just west of Paris.

In the same year, Sisley painted one of the principal masterpieces of his career, *Factory in a Flood* (fig. 134).[5] The painting has an immediacy of touch rare in Sisley's work before this. He seems to have used a large brush to paint virtually the entire canvas a pale blue, on which he arranged a beautifully constructed landscape composition dominated by strict horizontal and vertical lines. Its sheer geometric rigor was vivified by his use of large, flat brushes to lay in the principal trees, buildings, and their reflections with viscous paint. The entire painting has a freshness and openness to process that he rarely attained again in the first half of the 1870s; he allowed evidence of a light under-drawing in paint to remain visible behind the major trees and architectural elements. The forthright signature and date, painted in the same brownish black that he used for the chimney of the tug, the doors and windows of the house and their reflection, proves that he was satisfied with the painting while he was still working on it. It captures the evanescence of autumn leaves, a flood, and the puffing of smoke.

Sisley reached a higher level as a painter of Impressions with *Regatta at Molesey* (fig. 135) of 1874. He included athletes, waving flags, and gesticulating onlookers, represented with jabbed strokes of paint and set under a wind-whipped sky covered with great gray painted gestures that suggest clouds, wind, and impending rain with an economy rare in Impressionist painting to that date. When compared with Monet's slightly earlier painting of the Argenteuil festival (see fig. 82), Sisley's is far more successful in its experimental verve and in the variety of its gestures. He must have painted the setting for the race a day or so earlier, adding just the figural and heraldic elements as he stood amidst the scene on the day. The painting's immediacy set a standard for others, principally Monet and Manet, to attain and surpass.

In the winter of 1874–5, Sisley painted a number of extraordinary winter scenes, one of which, *The Watering Place at Marly-le-Roi* (fig. 136), he submitted to the 1876 Impressionist exhibition. It was probably done in a single sitting, on a prepared white ground already tinted with pale brown. The fact that it represents a bitterly cold day and was probably painted out of doors makes us sympathize with the artist, forcing us through this sympathy to interpret it as a rapidly made work of art. Many winter landscapes by the Impressionists, especially those that were painted outside rather than from the protection of a windowed interior, are not surprisingly among the most rapid of their paintings. The chromatic structure of this work consists of two more-or-less celadon blues and blue-greens, in which Sisley drew subtly with a dark brown and a very pale orange. Much of the forms are rendered with thinned paint, in a few simple gestures manipulated by wide, flat brushes over an under-painting applied very thinly and allowed to show through. Others also considered this work to be highly successful: when Sisley sent it to the 1876 exhibition it was already sold to a private collector.

In the same year, 1875, Sisley also painted a concise and exciting picture of a small village celebration, *The Fourteenth of July at Marly-le-Roi* (fig. 137). He recorded the sodden, rain-soaked banners arranged on temporary scaffolding from a spot less than a hundred yards from where he had painted his winter landscape. He seems to have been standing in a room on the upper story of a building, perhaps on a roof terrace, overlooking the watering place at Marly-le-Roi, which appears at the left. Although this work is more complex in its layering, Sisley was emphatic in completing it with a series of squiggly gestures of pale-blue paint that represent pools of rainwater on the street. These activate the space around the two black-clad figures with their umbrellas, struggling through the rain apparently oblivious of the banners. The artist's decision to opt for a quotidian study of the banners in rain (rather than, say, a specific event during the fête) gave him longer to plan the three or four separate campaigns that resulted in this unusually fresh canvas. It seems, though, that the addition of the figures, flags, and reflected rainwater was a spontaneous act at the very end of the process. First he conceived and painted the "set" for the fête, and then added a carefully conceived, but rapidly made, series of gestures shortly before signing and dating the painting. It therefore joins the distinguished small group of Impressions that represent occasions, but it does so in a way that stresses the temporal spread of these provincial festivities, which usually take place over several days.

In the second half of the 1870s, Sisley's mode of painting began a gradual shift away from these well-orchestrated performances in several movements. He began to

135 Alfred Sisley
Regatta at Molesey, 1874
Oil on canvas, 66 x 91.5 cm
Musée d'Orsay, Paris

de-emphasize the intricate compositions that had obsessed him, and instead paint landscapes with a low horizon line and many small forms crowding the middle distance. His prior emphasis on dramatic foregrounds and complex, spatially active arrangements of form gave way to simple, almost panoramic, compositions which were, in effect, standardized. He treated the landscape as a distant arrangement of uniformly small-scale forms, united by the conditions of light and weather in which he observed them. The landscape thus became collective and unified, and under these conditions Sisley began an extensive experimentation with the small-brushed, linear facture that was to become his trademark. It is significant that these landscapes are not among the favorites of Sisley's career; they court banality to such an extent that they often succeed in representing it! Yet the four works chosen here are as startlingly different in mood and facture as the works from the first half of the decade. What they reveal is that Sisley changed his emphasis without losing his experimental flair.

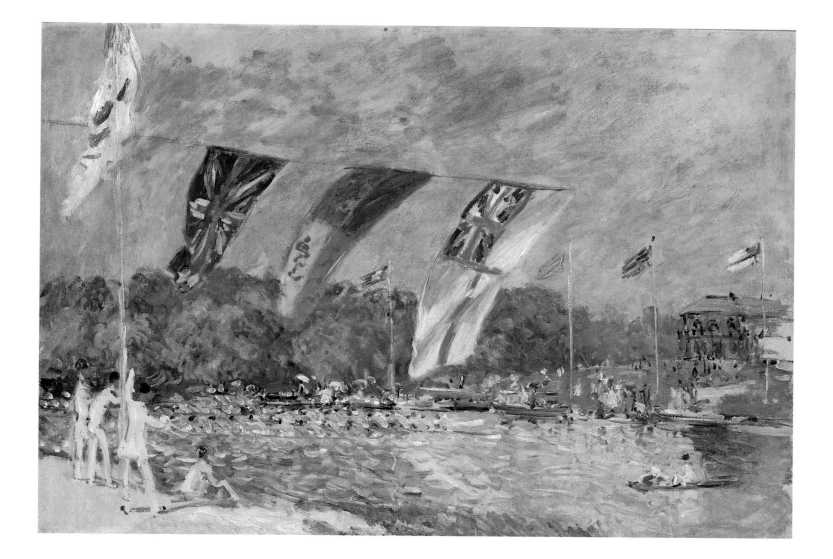

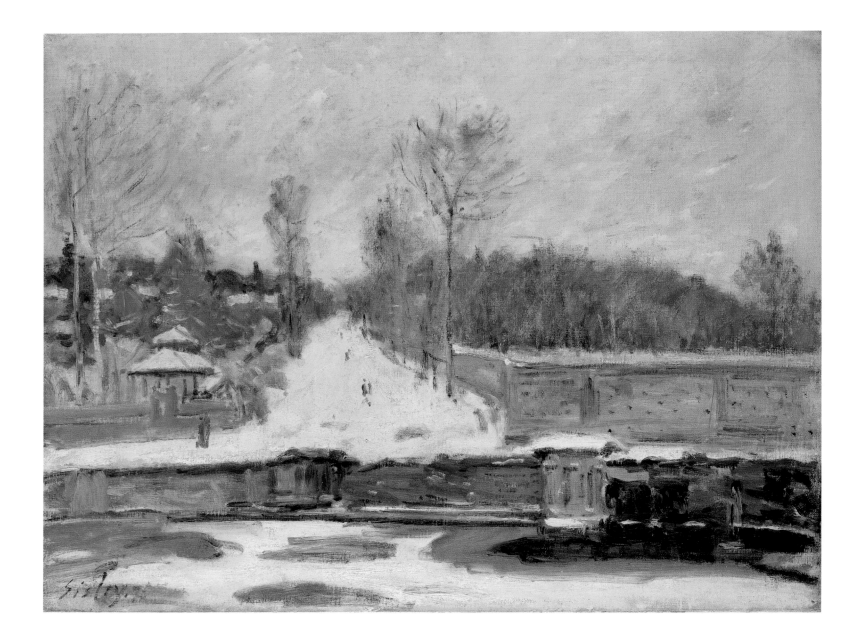

136 Alfred Sisley
The Watering Place at Marly-le-Roi, probably 1875
Oil on canvas, 49.5 x 65.4 cm
The National Gallery, London

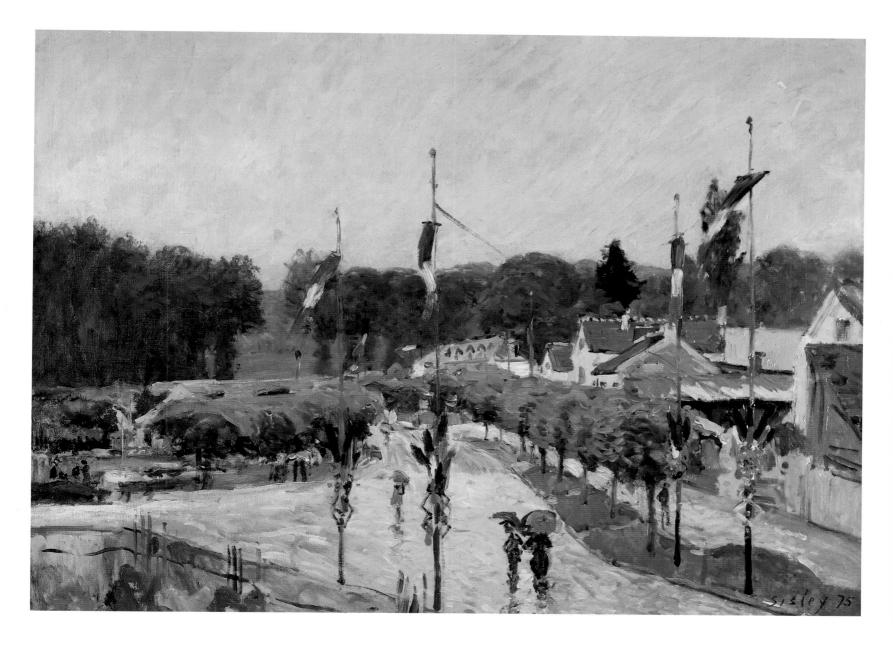

137 Alfred Sisley
The Fourteenth of July at Marly-le-Roi, 1875
Oil on canvas, 50 x 65 cm
Bedford Borough Council, England

138 Alfred Sisley
The Seine at Billancourt, 1877–78
Oil on canvas, 37.5 x 54 cm
The Dixon Gallery and Gardens,
Memphis, Tennessee
Gift of Montgomery H. W. Ritchie

The earliest is *The Seine at Billancourt* of 1877–78 (fig. 138), a work that almost crackles with energy. Sisley juxtaposed the painterly wet-on-wet strokes of the sky with the frenzied calligraphy of the landscape beneath. Boats, grass, rippling water, buildings, the figure, and distant trees are all quivering with the motion imparted to them by Sisley's wrist as it applied short, gesturally charged bursts of linear color to the canvas. The landscape portion of this canvas is so alive with short linear gestures that it is immediately reminiscent of the plein-air etchings of Corot, Daubigny, and Rousseau from the 1850s and 1860s, works equally animated by hundreds of short wrist-gestures in a waxy ground painted on a copper plate (see pp. 55–56). What Sisley did with this graphic conception of landscape was to enlarge his gestures to the scale of his canvas, and always to apply them with color. His attempt to solve the age-old dichotomy between line and color was so startlingly simple that its originality has not truly been recognized.

Three further landscapes from the late 1870s would, if hung adjacent to each other, look virtually identical in everything but palette. *Boats on the Seine* (fig. 139), *The*

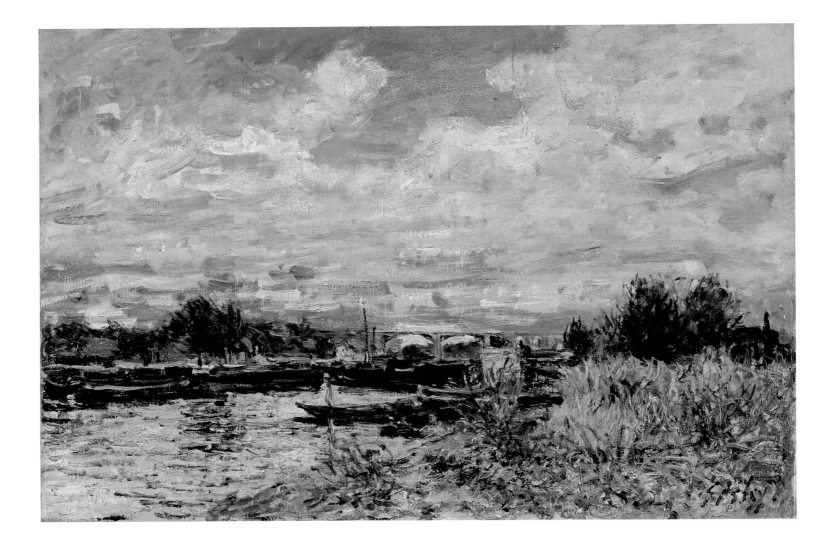

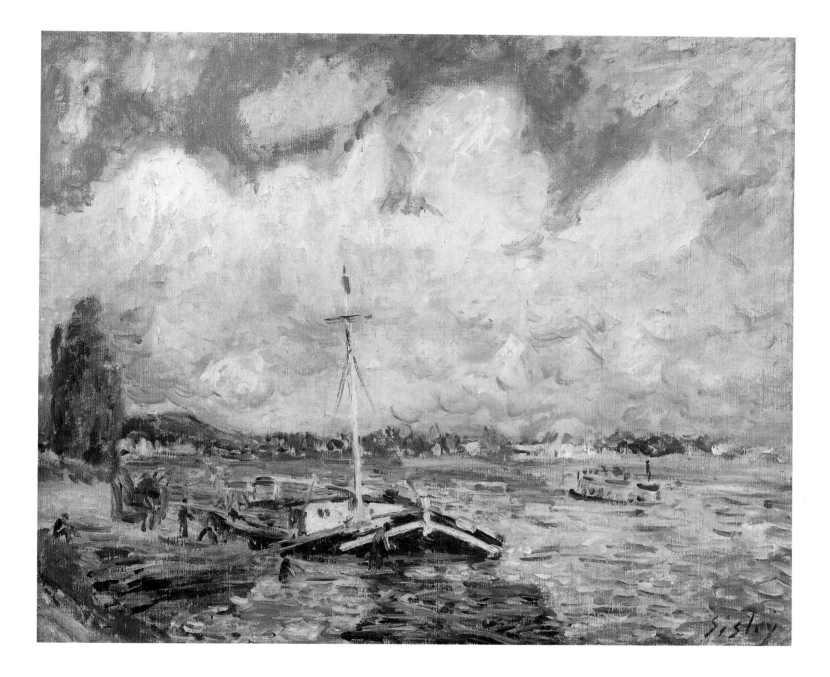

139 Alfred Sisley
Boats on the Seine, c.1877
Oil on canvas, laid down on plywood
37.2 x 44.3 cm
Courtauld Gallery, Courtauld Institute of Art,
London

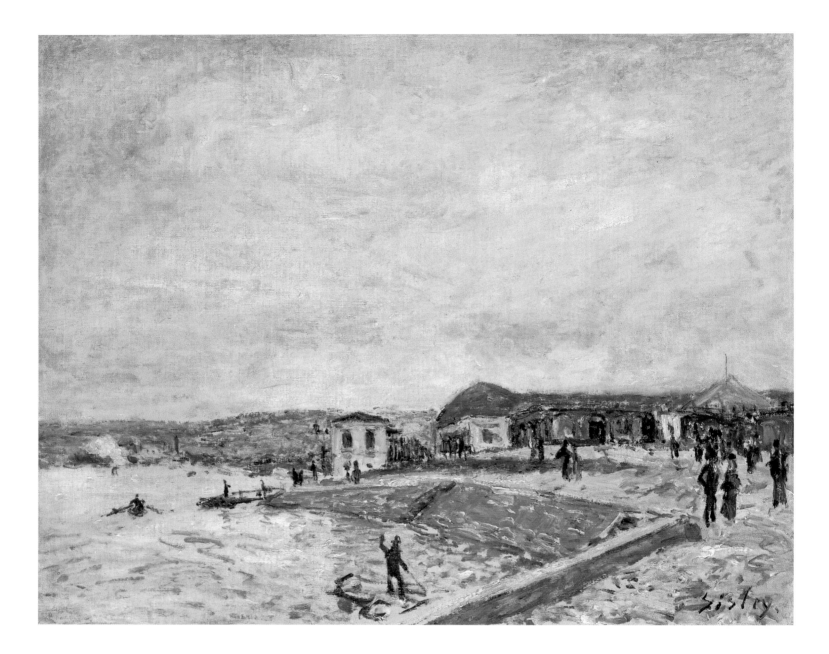

140 Alfred Sisley
The Seine at Daybreak, 1878
Oil on canvas, 37 x 45 cm
Gemeentemuseum, The Hague

Seine at Daybreak (fig. 140), and *The Bridge at Sèvres* (fig. 141) could all be characterized as nervous, trembling, agitated—and, of course, banal. In not one of them did Sisley represent a landscape with any intrinsic interest. Rather, the opposite is the case: the buildings are not architecture; the trees are not well formed; the boats are in no way remarkable or unusual; the figures are so tiny and humble as to defy explanation as to why he painted this one or that one or put it here or there. Sisley consciously avoided painterly motifs more aggressively than any other landscape painter of the 1870s. He failed to glorify the working landscape—thought ugly by many Parisians, but painted by left-wing artists such as Guillaumin and Pissarro. And he de-emphasized the landscape of summer and weekend leisure, in which Monet, Renoir, and Manet had staked their claims.

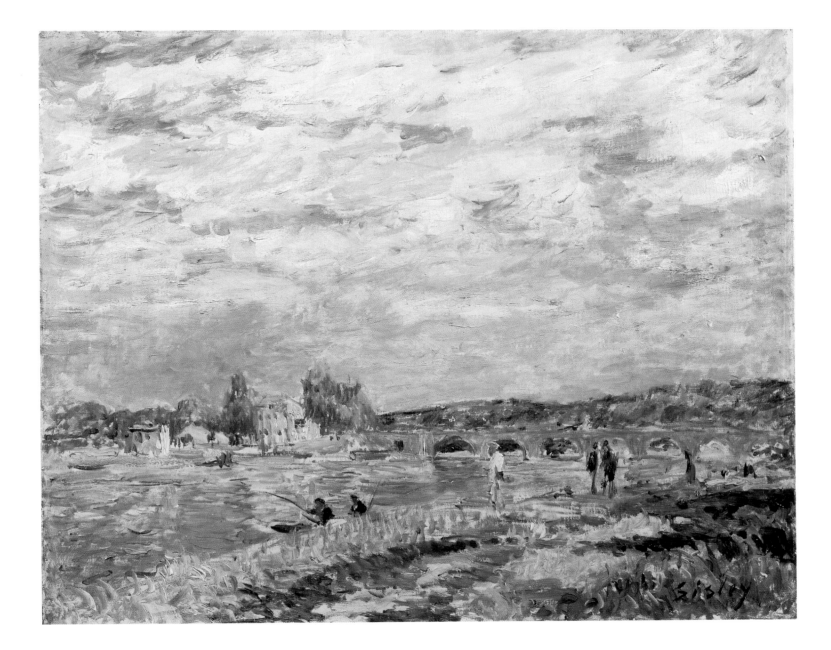

141 Alfred Sisley
The Bridge at Sèvres, 1877
Oil on canvas, 38.1 x 46 cm
Tate Gallery, London

But the remarkable thing about these pictures is the way they court not only banality but disorder. The all-over rhythms refuse a graphic or compositional hierarchy to the scenes: everything from figure to shrub, cloud to water-ripple, has the same visual status. In fig. 140, Sisley seems almost to be scribbling with paint: the small lines and daubs have so little sense of purpose that we feel he cannot have applied them in any kind of preordained order. They attain an almost unconscious transcriptive quality, like that of a pencil *croquis*, as if the painter's hand was guided not by an act of will, but by a confused set of visual stimulae to which he rushed to respond. They are a remarkable combination of purely pictorial activity with aesthetic passivity.

The final work by Sisley shown here is an autumn view, *The By Road at the Roches-Courtaut Woods* of 1881 (fig. 142). Sisley omitted everything but water, sky, and trees from

142 Alfred Sisley
The By Road at the Roches-Courtaut Woods;
St. Martin's Summer, 1881
Oil on canvas, 59.1 x 81 cm
The Montreal Museum of Fine Arts
Purchase, John W. Tempest Fund

his view and painted a landscape of contrasts—blue and orange, still and moving, calm and nervous, large-brush and small-brush, painterly and linear. The frenzied drawing of the trees was accomplished within a narrow range of hue and value, allowing him to work wet-on-wet without compromising the graphic intensity of his technique. The sheer fecundity of Sisley's linear gesture gives this painting its energy and sense of risk. Because his landscape conception was so simple and eloquent, it is easy to accept his calligraphy not as frantic but rather as somehow inevitable.

In these canvases, Sisley is the artist who dares most to fail by creating a unified compositional strategy that allows him to abandon himself to sensations. Thus the pictures court disorder and disequilibrium with an almost grim determination. The only other works from the period that tremble so on the brink of disintegration are to be found in Sisley's 1880s sketchbook. They take us forward to the aesthetic of automatic drawing developed almost two generations later by the Parisian surrealists as a mode of transcribing or writing the unconscious. These canvases, which seem the least prepossessing—indeed, the least ambitious—of any Impressions in this study are, for this reason, perhaps the boldest and most prophetic.

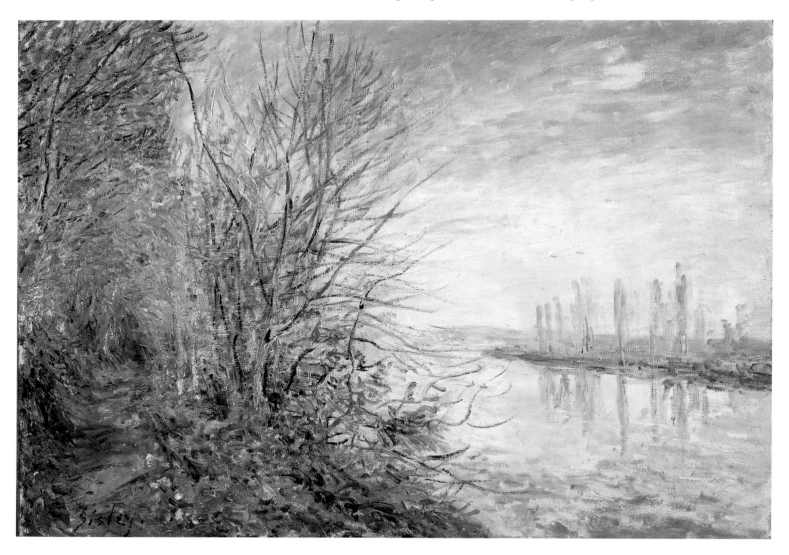

8 Could Edgar Degas paint an Impression?

The immediate answer to the question posed here is, surely, no. Degas prided himself time and again on the artificiality of his craft. He made works in every medium, the inter-relationships among which are so complex that they continue to fascinate technically minded interpreters. He returned time and again to works that he had earlier abandoned, refreshing, altering, resizing, or scraping in a career of relentless self-criticism. If an Impression is a direct painting, Degas was an indirect painter, virtually incapable of abandoning himself to an assault on the canvas, to an unplanned pictorial improvisation. No art is less casual and more premeditated than his—or so he and most of his most intelligent critics and commentators would have us believe.

But we should look again at Degas's direct painting. In the works he made and exhibited in the 1870s and 1880s is a minority counter-discourse to that of the planned, cerebral majority discourse. For every ten works that appear to be "as carefully plotted as the perfect crime" (to use Degas's own metaphor),[1] there is one in which he seems to have abandoned himself to his medium, allowing gestures to remain just that—gestures. These works take their place with the most brilliant of Manet's Impressions and with certain of those by his friend Morisot as masterpieces of the figural Impression. They raise an entire series of questions about the concept of finish which is central to the very idea of the Impression.

The second Impressionist exhibition of 1876 was a challenging installation of over 250 paintings, drawings, and prints by nineteen artists. Degas submitted 24 works—his largest exhibition to date. Among them were four that raise fascinating issues about direct painting and the role of finish in his oeuvre. Two were titled as an *esquisse* and an *ébauche*, *Madame Théodore Gobillard* (fig. 144) and *Yard of a House* (fig. 145), and they have the appearance of unfinished works or initial stages of work to which the artist would later return. However, both were signed by Degas, most probably before the exhibition, proving that he considered them finished, in spite of their apparently provisionary or indeterminate state. They show evidence of reworking and, particularly in fig. 145, of a fascination with the independent emotional and representational value of the painted mark. Degas took a broad, flat brush and worked white paint in and around the group of children in such a way that the brushstrokes at once describe light falling on their clothing and force us to participate in the artist's own process of painting that light. This manner is countered within the sketch by the carefully planned architectural setting in which the children are placed, and by the evident scraping-out of earlier stages of the figural composition.

These two works were perhaps safe in the context of this exhibition, because of the inclusion of the words for oil sketch in their titles. The two other works that were as fluently painted were not called sketches, however, and thus pushed the stakes higher. The odder of these, the small *Peasant Girls Bathing in the Evening Sea* (private collection), was painted in such an apparently summary manner that it is surprising to learn that Degas submitted it twice, in 1876 and 1877, suggested that he himself held it in some admiration. We must not assume, however, that it looked then exactly as it does today: it is now so scraped and reworked that it might have looked completely different when Parisians first saw it. *A Woman Ironing* (fig. 143), on the other hand, must be unchanged, since it was signed prominently and sold shortly after the exhibition. Degas's scrapings

[1] See Douglas W. Druick and Peter Zegers, "Scientific Realism, 1873–1881," in Jean Sutherland Boggs et al., *Degas*, exh. cat., The Metropolitan Museum of Art, New York, 1988, pp. 197–211. This deals with Degas's "scientific" pursuits and with his fascination with criminality. The single most useful source of information about Degas's work, it is essential to any library devoted to Impressionism. Most of the technical information in this chapter was verified by consulting this one book.

and violent white brushwork in and around the arms of the laundress would therefore have been visually linked in the exhibition to the white passages in fig. 145. He makes clear connections between the woman's process of ironing and his own process of painting—her hands and arms become surrogates for his. It is surely no accident that he signed this work with a cursive "Degas" immediately beneath the laundress's iron! Both, we are intended to think, worked with their hands and arms.

These works were intended by Degas to pose questions to the viewer—about modernity, appearance, and visual hierarchy. The questions were provoked by the overt intervention of the hand of the artist in the process of representation, both through negative gestures such as scraping out with a palette knife, and through positive gestures made with brushes and, occasionally, with his hands and fingers. The same questions were also raised in two paintings from the early to mid-1870s, each representing a female figure. *Ballet Dancer with Arms Crossed* (fig. 147) is at once a painting and what we might call a painted drawing. Every aspect of the representation has been clearly made by the hand of the artist, who refused to play a transparent or invisible role. The forthright orange strokes that push and jab into the space around the dancer were made with large brushes that allowed full physical expression to

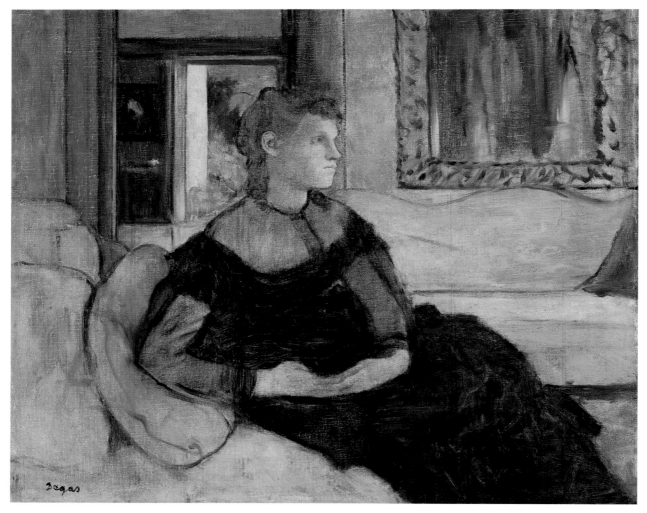

143 Hilaire-Germain-Edgar Degas
A Woman Ironing, *c*.1874
Oil on canvas, 54.3 x 39.4 cm
The Metropolitan Museum of Art, New York
H. O. Havemeyer Collection, Bequest of
Mrs. H. O. Havemeyer, 1929

144 Hilaire-Germain-Edgar Degas
Madame Théodore Gobillard, 1869
Oil on canvas, 54.2 x 65.1 cm
The Metropolitan Museum of Art, New York
H. O. Havemeyer Collection, Bequest of
Mrs. H. O. Havemeyer, 1929

145 Hilaire-Germain-Edgar Degas
Yard of a House, 1873
Oil on canvas
60 x 73.5 cm
Ordrupgaard, Copenhagen

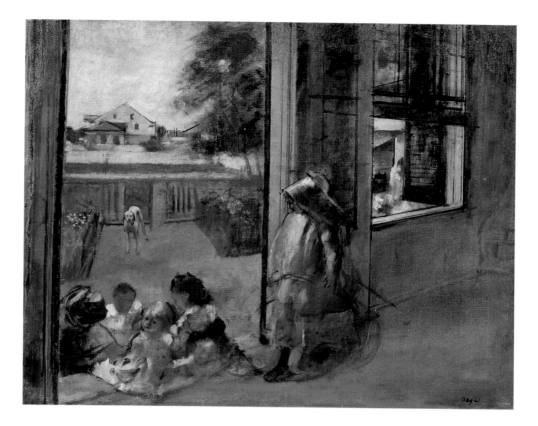

Degas's gestures. These slabs of color contrast with the elegant black lines that define her figure and face. Some of these lines were applied quite early in the process and others at the very end; they were made with a pointed brush dipped in thinned black paint, lending the painting the quality of Asian calligraphy. The bodice, skin, and hair of the dancer were applied in thinned washes, sometimes scraped and other times strengthened with the brush; they play an oddly virtual role in the context of the actual passages of orange-red and black. The whole is presented to us with just the bare primed canvas filling the entire lower right corner of the sheet—the *toile* (material) of the dancer's tutu represented by the *toile* (canvas) of Degas's support.

The second freely painted portrait is an utterly perplexing work, called *Portrait of Madame de Nittis* (fig. 146). This little-known work has always been catalogued as a portrait of the French wife of the Italian painter Giuseppe de Nittis, and there is certain circumstantial evidence that this was the case.[2] Yet everything about Degas's painting conveys that the sitter was not a woman at all, but a stuffed, full-scale studio doll, of the kind used as a prop for the painting of drapery.[3] The weird lifelessness of this "sitter" and the odd angle of her head, which looks propped on the swooping rattan structure of the chair, gives the painting an almost spooky quality, in which Degas evidently delighted. One can imagine him borrowing a chair and a dress from Madame de Nittis, dressing and posing a studio doll in order to continue background work on a portrait, then finally deciding to paint a portrait of the doll itself! In so doing, he created a wonderfully loosely painted construction. The dress is represented with large brushes, playing in easy, informal rhythms across the surface of the picture. The row of ruffles is little more than a series of painted lines, and the entire costume

[2] A portrait of his wife by De Nittis represents her in an identical rattan chair, in a similar dress (Marzotto Collection, Milan).

[3] Degas is famous for having painted just such a doll in his wonderful portrait of a painter in his studio, *Portrait of Henri Michel-Lévy* (*c*.1878; Fundação Calouste Gulbenkian, Lisbon).

146 Hilaire-Germain-Edgar Degas
Portrait of Madame de Nittis, 1862–82
Oil on canvas, 74.3 x 55.2 cm
Portland Art Museum, Oregon
Gift of the Adele R. Levy Fund, Inc.

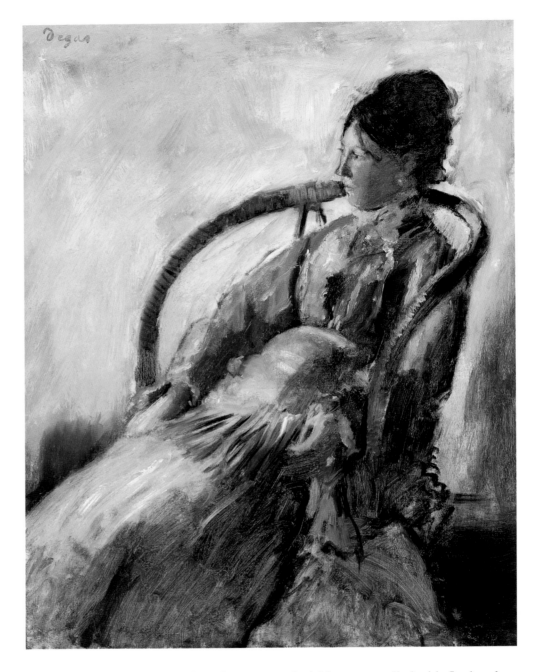

is a wet-on-wet confection of strokes, many of which were applied with flat brushes. As with fig. 147, Degas reserved his largest, most confident strokes for the ivory-colored background. These thick slabs of paint cavort with the figure's head and hair, and have the same electric energy as Degas summoned to paint the clean laundry in fig. 143. His gestures reign supreme, from the black squiggles at the back of her chair to the dancing calligraphy of his signature in the upper left. How odd that so much pictorial life was lavished on a mere doll—but perhaps it was only with such a model that Degas was able to paint an Impression.

The seemingly contradictory practice of Degas—his simultaneously immediate and premeditated working method—is in fact no different from that of Monet,

147 Hilaire-Germain-Edgar Degas
*Ballet Dancer with Arms Crossed, c.*1872
Oil on canvas, 61.4 x 50.5 cm
Museum of Fine Arts, Boston
Bequest of John T. Spaulding

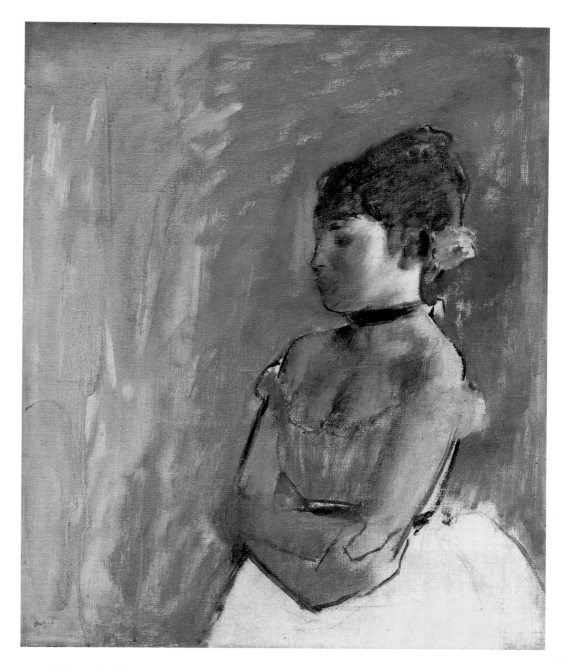

Manet, Morisot, and Renoir, each of whom attacked their canvases in a few separate working sessions with plenty of time to meditate in between. But, like Manet, Degas derived a good deal of the impetus for his direct painting from his thorough knowledge of academic practice. Both artists made free copies of Old Master European paintings, and there is plenty of evidence that Degas continued to do this well into the 1890s. Such a practice was completely foreign to Monet, and even Renoir, who copied works by Delacroix into the 1870s, but never in a really free manner. Two superb works by Degas about the viewing and representing of Old Master painting are included here because they raise direct questions about the role of the free copy in Impressionist practice.

148 Hilaire-Germain-Edgar Degas
Visit to a Museum, 1879–80
Oil on canvas, 91.8 x 68 cm
Museum of Fine Arts, Boston
Gift of Mr. and Mrs. John McAndrew

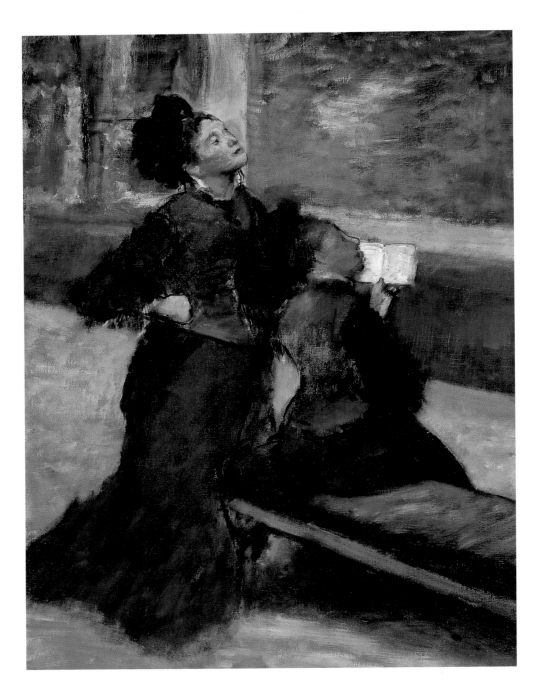

4 They were immediately linked with a group of
prints of Mary Cassatt and her sister in the Louvre,
made in 1879. Recently, however, scholars have
argued for a later date, around 1885, when Degas
signed and dated a pastel made on or over an
impression of one of the 1879 prints. This was about
the time that he developed a close friendship with
the English painter Walter Sickert, who saw one or
both of these paintings in the early 1890s. Both dates
are possible, since Degas frequently reworked earlier
paintings.

Visit to a Museum (fig. 148), with its pair of female figures conventionally (but uncon-
vincingly) identified as Mary Cassatt and her sister, has rarely been seen next to *Woman
Viewed from Behind* (fig. 149), which certainly shows Mary Cassatt at the Louvre. The
two are marvels of painting about painting. Because both were in Degas's possession
at his death and made their first known public appearances only with the posthumous
sales from his estate, neither can easily be dated, and it is not at all certain that Degas
would have considered them finished (they are not signed). In the context of works
such as *Portrait of Madame de Nittis*, it is clear that they succeed as completely as do
works known to have been exhibited by Degas in the 1870s and 1880s.[4] They are

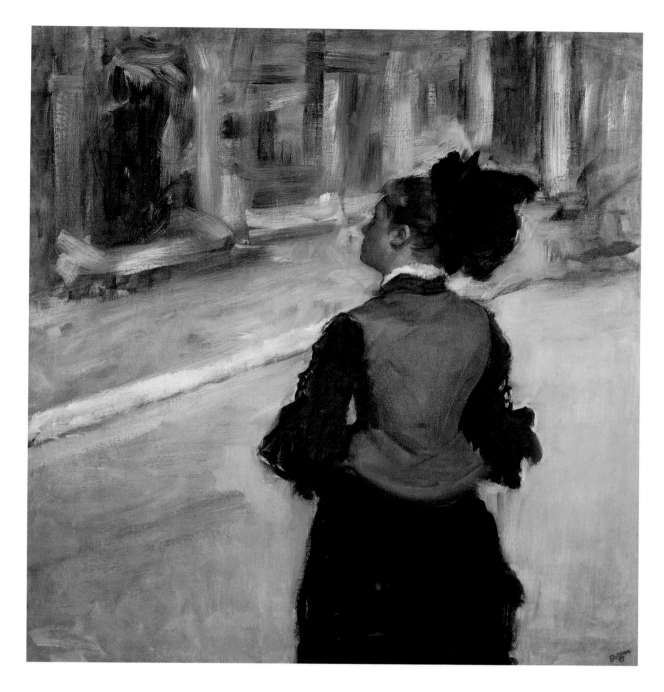

149 Hilaire-Germain-Edgar Degas
*Woman Viewed from Behind, c.*1879
Oil on canvas, 81.3 x 75.6 cm
National Gallery of Art, Washington, D.C.
Collection of Mr. and Mrs. Paul Mellon

extraordinarily direct and fluent. They engage in the age-old pictorial struggle of figure and ground, by activating each and conceiving of the picture as being about the visual engagement of the figure with her ground. *Visit to a Museum* surely represents the large room of Italian paintings in the Louvre in which the immense *Marriage at Cana* by Veronese was hung, and that is probably the large painting that dominates the upper right corner. Sickert described coming upon Degas one day "glazing a painting with a flow of varnish by means of a big flat brush. As he brought out the background with a few undecided strokes, suggesting frames on the wall, he said with irrepressible merriment, 'With this I must give some idea of *The Marriage at Cana.*' " [5]

[5] Boggs et al., op. cit., pp. 440–42.

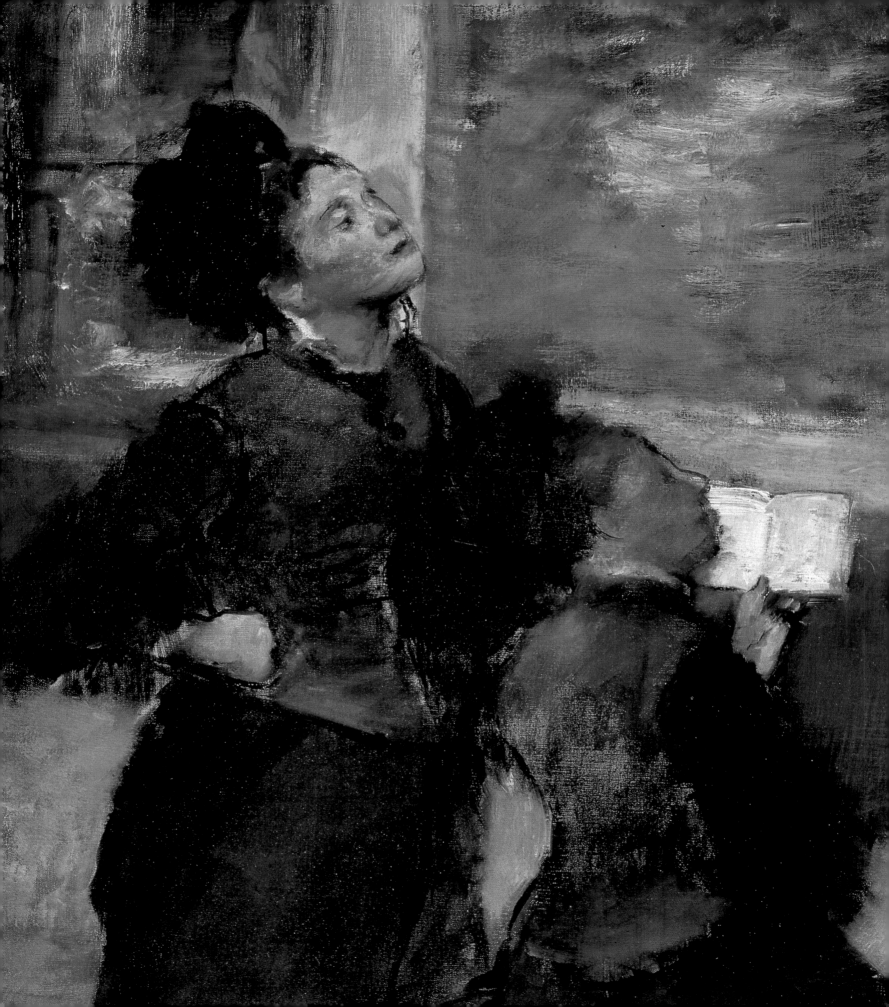

Degas used a big flat brush to do more than varnish these paintings. Their painterly verve is remarkable. In the context of Manet's free copy after Delacroix's *Barque of Dante* (see fig. 14), these two works make it clear that direct painting from works of art was as important to Impressionist practice as was direct painting from nature. For Degas, the motif needed to be actual, but it did not have to be from nature: the motif of contemporary women studying Old Masters (one of them with a guide book) was as modern as a railroad bridge or a regatta to Monet. Whereas Monet had acquired a license to copy in the Louvre in the 1860s in order to paint the view, Degas took the game to another level and went to the Louvre to represent the gallery-goers looking at the paintings. These works are as directly painted, as improvisatory, as anything in Degas's oeuvre.

There is, however, a distinct contrast between the two paintings. *Visit to a Museum* is much more heavily worked, and thus more consistent in its level of finish than *Woman Viewed from Behind*. Each passage of the former shows evidence of the painter's hand, but the parts of the painting stay quite conventionally in plane: the gilded frame is distinctly "behind" the head of the reading woman and her guide book. There is evidence that Degas scraped the painting several times in order to achieve its final appearance. The latter work, by contrast, is quite thickly, even lusciously, painted, often with large brushes applying pigment wet-on-wet. The confident rectilinear strokes that define the frames, the dado, and the plaster columns in the Louvre's Grande Galerie are pictorially balanced with the wonderfully cursive lines and curvilinear strokes that make up the dress and hat of the woman. Since her gaze is somewhat oblique, we do not know at which picture she gazes—perhaps one located off stage. This frees us to gaze at her and at the room against which she is juxtaposed, without our being able to evaluate her own process of gazing. (It also suggests that perhaps Degas was going to the museum to gaze not at art, but at young, attractive, unaccompanied women!) It seems, and is, every bit as direct as any landscape by Monet or any seascape by Manet. Its painterly conciseness is extraordinary, as Degas tried to simplify his process by suggesting forms with the minimum number of gestures. The enormous empty portions of the composition devoted to the parquet floor are activated, not by detailed drawing that reveals its patterns, but by effulgent gestures of the artist's hands and arms.

Degas was as fascinated by the materials and techniques of oil painting as he was by those of graphic art, to which he devoted much more of his energy. It is clear, however, that for Degas there was less room for experimentation in oil painting, which is perhaps why he made comparatively fewer oils after 1880. Perhaps the arena of the Impression was already full, with artists like Monet, Morisot, Sisley, and Renoir all staking their claims.

Degas did not join Manet and the others in the summer of 1874 to paint. His planning processes involved elaborate compositional contrivances which were not natural to a process of direct improvisation. But he did flirt with this kind of improvisatory painting. In the four works shown here he did abandon himself to his brushes and paints, allowing his pictorial urges to be represented in lavish gestures of the brush. Did he ever paint an Impression? Probably not. *Could* he have painted one? Decidedly yes.

9 Gustave Caillebotte and Camille Pissarro: Impressionists without Impressions?

It may perhaps seem odd in a study devoted to the Impression to include a handful of works by two artists who persistently avoided seemingly spontaneous paintings. Although of different generations, nationalities, ethnic backgrounds, temperaments, and lifestyles, Gustave Caillebotte and Camille Pissarro were alike in being obsessed with complex, layered processes of pictorial creation. Few of their surviving works could be considered in a study devoted to rapid painting, largely because both were committed to the creation of major works that reflect in their physical nature their making over a long period of time and careful planning before that. Seldom did either artist take an easel out into nature and entrap a motif in the course of one or two short working sessions. Pissarro, by contrast, was obsessed with a kind of pictorial time that the French call *la longue durée*: his landscape subjects are, by and large, traditionally rural with figures performing activities that similar figures had performed for centuries. He avoided sailboats, and made only one small foray into industrial imagery. He rarely painted the trains that are so common in the landscapes of Monet.

Caillebotte was certainly more attracted to modern subjects—both urban and suburban—and to the representation of interaction between the classes in Paris, but his mode of working was rooted in the methods of the academy, with long preparatory periods, drawings, *croquis*, the *esquisse*, *ébauche*, and, finally, *tableau*. One rarely feels that Caillebotte ever applied a brush to his canvas without first knowing the function, position, and scale of the planned stroke; in many ways, he avoided making pictures in which paint itself and the gestures of the painter are an important part of the viewer's experience.

It must have been difficult for these two deliberate men to work around and exhibit with Monet, Renoir, Manet, and Morisot without being affected by their style. Hence there is a handful of spontaneous pictures in each of their careers, and an understanding of them is as important to an appraisal of the Impression as are the numerous works of those artists more closely identified with its aesthetic.

Among the large production of Pissarro, the more important of the two painters, are several unfinished canvases that his family allowed to be sold and catalogued after his death. The earliest and, in some ways, most important of these looks very little like a Pissarro; it is its anomalous nature as well as its pictorial achievement that makes it worthy of attention. *Dulwich College, London* (fig. 150) was painted in the autumn of 1871, when the Pissarros were living in self-imposed exile from the war in France in the southern suburbs of London. This work is an almost miraculous indicator of Pissarro's skill as a direct painter. Its achievement, almost on a par with Monet's Impressions of the same period, makes us wish that Pissarro had stopped work earlier in the life of his paintings more often! Clearly he valued this work, although it was neither shown nor sold during his lifetime, because he tended not to keep such paintings. Done with large, flat brushes in two or three sessions *en face du motif*, it records the light of a bright, hazy fall day with complete assurance. We are allowed to witness the artist's compositional doubts and shifts, particularly in the area of the central building and the two flanking trees; a careful look at the building reveals that an earlier version had been scraped off the canvas, and the new strokes of pinkish brown were placed far enough apart for us to see the scrapings beneath. He also adjusted the angle of the

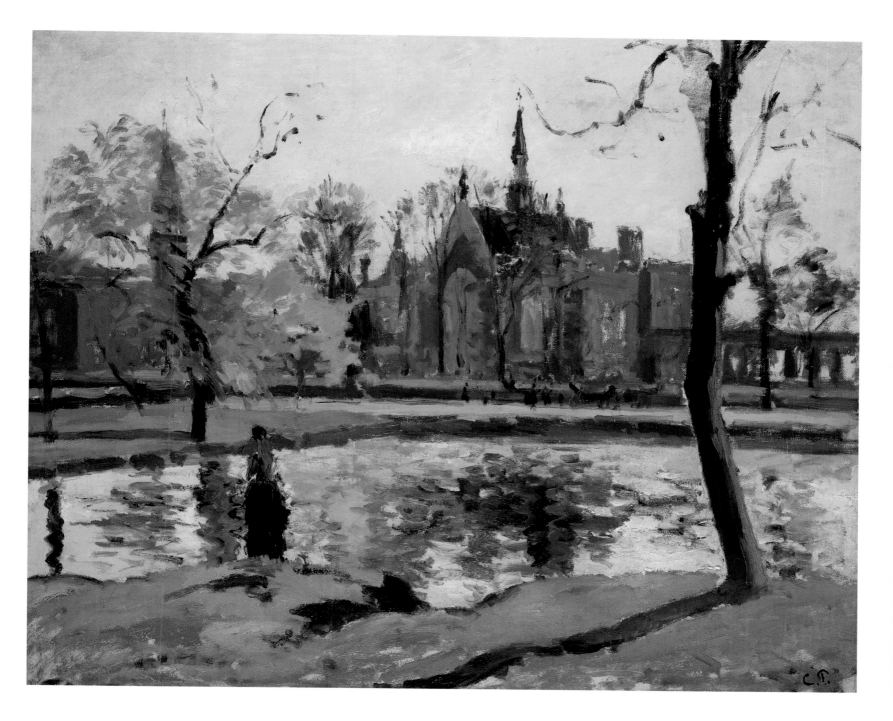

150 Camille Pissarro
Dulwich College, London, 1871
Oil on canvas, 50 x 61 cm
Fondation Bemberg, Toulouse

151 Camille Pissarro
Bouquet of Pink Peonies, 1873
Oil on canvas, 73 x 60 cm
Ashmolean Museum, Oxford

tree at the far right, insufficiently masking his alteration so that it is clearly visible. On the left side of the canvas, Pissarro seems to have added the yellow-clad tree at a late stage in the composition, and even the brilliant tones of its reflection in the central lake are part of his last attack. Thus the painting is at once direct and indirect, with one or two periods of careful consideration between bouts of rapid painting. He clearly knew the general plan in advance because, with the exception of the yellow tree and the overlapping foliage of the background trees, few forms physically overlap. The water goes up to, but not behind, the trunk of the repoussoir tree at the left as the ground approaches, but does not quite touch its shadow. This *is* direct painting, and Pissarro clearly stopped it at this stage, very much as did Monet and Morisot.

152 Camille Pissarro
Self-Portrait, 1873
Oil on canvas, 56 x 46.7 cm
Musée d'Orsay, Paris

A few other rapidly made pictures date from the early 1870s. Two of these, a still life of peonies (fig. 151) and a self-portrait (fig. 152), were both signed and dated in 1873. The still life is clearly an homage to Manet, whose paintings of his signature flower, the peony, were well known to Pissarro. Taking large brushes and a simple, predetermined palette, Pissarro approached the vase of pink blooms with a performative directness rare in his earlier painting. Like Manet, he performed the flowers with countable strokes of paint intended to represent their petals and leaves. He also allowed himself a certain gestural play with the jazzy scribbles that enliven the surface of the polished wood table. He was communicating his prowess as a direct painter in making this work, a prowess that was equally important for him in his first major self-portrait.

Pissarro was 43 years old in 1873, and he represented himself in fig. 152 as fully in possession of his years. A balding head, and iron-gray hair and beard dominate the center of the composition; perhaps wisely, the painter seems to have simplified his task by omitting any references to his own activity. There are no hands, brushes, nor palettes. In contrast to Manet, who used his later self-portrait as a way of asking questions about the nature of painting (see pp. 68–70), Pissarro distanced himself from this overtly ontological kind of art. Yet his resolute self-gaze, and the fact that the painting was very simply constructed in a few sessions, force us to ask those questions anyway. Pissarro juxtaposed himself with a wall in his home-studio, on which he placed two painted sketches which he re-performed on this canvas. Neither of the little paintings survives, but their presence in the self-portrait remains as proof that, at least in 1873, performative study of the landscape was an integral part of Pissarro's working method. He seems not to have reached the point at which he could exhibit such works (even the self-portrait remained unexhibited until 1920), but he made them and associated them with his own image as a painter.

In 1876, Pissarro seems to have been inspired by the second Impressionist exhibition to adjust his methods closer to those of his younger colleagues, and his imagery shifted as well. Movement-filled water landscapes began to take their place alongside his traditional rural scenes, and his surfaces became decidedly more painterly. Amidst these new works were a few that can legitimately be called Impressions, though they are not typical of his work.[1] Pissarro was an artist who transformed himself throughout his life, and opened himself continuously to pictorial developments around him. In this case, the impetus seems to have been the landscapes of Sisley and Renoir rather than those of Monet. The rich, buttery paint handling suggests Renoir's landscapes of the early and mid-1870s, but the compositions are more closely linked with the landscape practice of Sisley.

After the Rain, Quay at Pontoise (fig. 153) was signed and dated 1876; if it had not been, it would be difficult for any student of Pissarro to accept it as finished. Its broad execution, its cursive strokes of paint, and its summary character are quite untypical of this cerebral, premeditated painter. Yet it takes its place among a group of paintings he made that year, which share a modern industrial subject and an overtly Impressionist mode of execution. Even the title evokes a particular time, after a rain storm, and the huge cumulus clouds and reflective puddles in the foreground give the painting a temporal immediacy rare in his landscapes. Throughout the work the viewer may see through the painting to the prepared ground of the canvas beneath, suggesting that it was made in a very short duration. The artist could not have painted the middle-ground trees, the smokestack and its smoke, nor the wonderfully loose foliage that peeks in at the far left while the painting was still wet. Yet as with the impressions of Sisley, Renoir, and Monet, he worked hard to make a two- or three-step process look like a one-step process. Each part of his mode of production has the appearance of immediacy.

It would be hard to make a conclusive identification of *Study of a Sunset, Pontoise* (fig. 154) as a painting by Pissarro at all, if it were not signed and dated 1877.[2] Vast white cumulus clouds fill the sky, and a small steam train puffs away in the middle distance. All is painted with a love of the medium and an almost messy delight in its

[1] None has been included in any major exhibition devoted to Pissarro.

[2] Ludovic-Rodo Pissarro, who catalogued this painting in 1939, cannot have studied it closely, for there is little in it to suggest a sunset; see Ludovic-Rodo Pissarro and Lionello Venturi, *Camille Pissarro*, Paris, 1939, vol. I, no. 410.

153 Camille Pissarro
After the Rain, Quay at Pontoise, 1876
Oil on canvas, 46 x 55 cm
The Whitworth Art Gallery,
University of Manchester

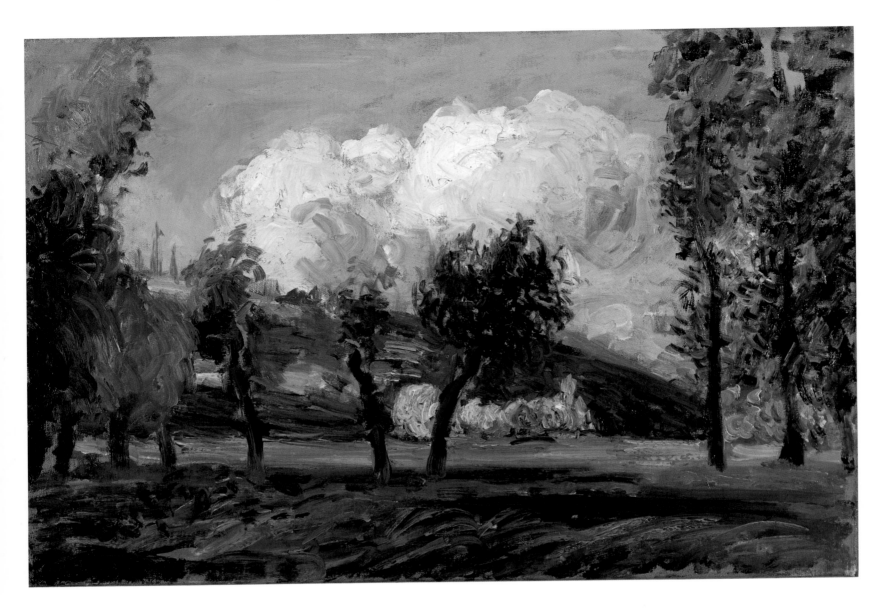

154 Camille Pissarro
Study of a Sunset, Pontoise, 1877
Oil on canvas, 38.5 x 56 cm
Charles B. Key, M.D.

wetness that is very unusual for Pissarro. The artist seems to be playing with the paint, refusing restraint of any kind. All is casual, as if invented on the spot. No work by Pissarro can match this one for improvisatory verve. Perhaps for that very reason, it has remained in private collections, and has never before been exhibited.[3] Could it perhaps be the *Plain at Pontoise* sent by the painter to the third Impressionist exhibition of 1877, which has never been identified?

Other works by Pissarro from the years 1876–78 share with these two certain deliberately rushed qualities. *A Gust of Wind, Pontoise* (fig. 155) reveals the brilliance and confidence of his mastery of the Impression, making us wish that other works from this little-studied phase in his career could be rediscovered.[4] The wrist gestures that embody a wind-bent tree have a complete assurance, shared by the mastery of color. Here, gesture has a double function—it is at once representational and rhythmic. Other gesturally positive, small-scale paintings of wind, rushing water, and changing weather were used by Pissarro as oil sketches for larger, later works.[5]

In the late 1870s and throughout the 1880s, Pissarro became obsessed again with the slow, deliberate preparation of paintings. This was the part of his career associated with Neo-Impressionism, the most premeditated mode of avant-garde painting in the nineteenth century. But his work broadened again after 1893, when he again made a handful of gestural paintings that we can read as Impressions. Perhaps the most

[3] This neglect by the art establishment has saved the painting from conservation work: it remains unlined, on its original canvas and stretcher, as if time had stood still in 1877, when a satisfied Pissarro signed and dated it.

[4] When Ludovic-Rodo Pissarro published his catalogue raisonné in 1939 (see note 2), he knew only of a pen-and-ink drawing of *A Gust of Wind* in a letter by the artist; the painting had disappeared from view. It was published for the first time in an auction catalogue in 1996.

[5] This practice became familiar with Seurat, whose plein-air panels for complex exhibition paintings have been exhaustively studied; they have never been related to the earlier practice of Pissarro.

155 Camille Pissarro
*A Gust of Wind, Pontoise, c.*1877
Oil on canvas, 38 x 46 cm
Private collection

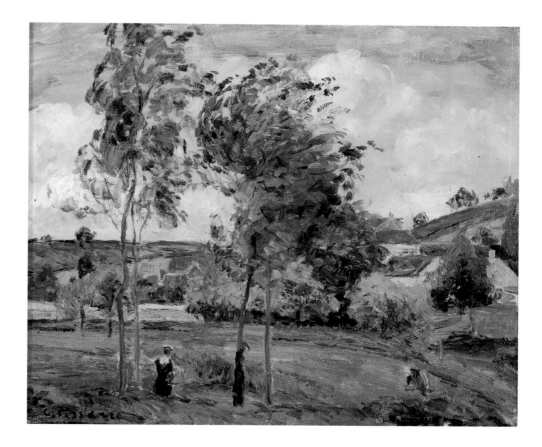

156 Camille Pissarro
The Boulevard Montmartre at Night, 1897
Oil on canvas, 53.3 x 64.8 cm
The National Gallery, London

original and brilliant of these is *The Boulevard Montmartre at Night* of 1897 (fig. 156). Here—as in one or two of his urban snow scenes painted from the Hôtel du Louvre and his apartment on the Ile de la Cité—Pissarro used large brushes and loosely mixed colors to paint his motif as rapidly as possible. The theme of night in the rain was becoming popular among foreign collectors of Parisian views; many artists—including the American Childe Hassam—had explored it before Pissarro. Yet no one did so with such complete confidence, signaling that the Impression was still alive and well in the 1890s.

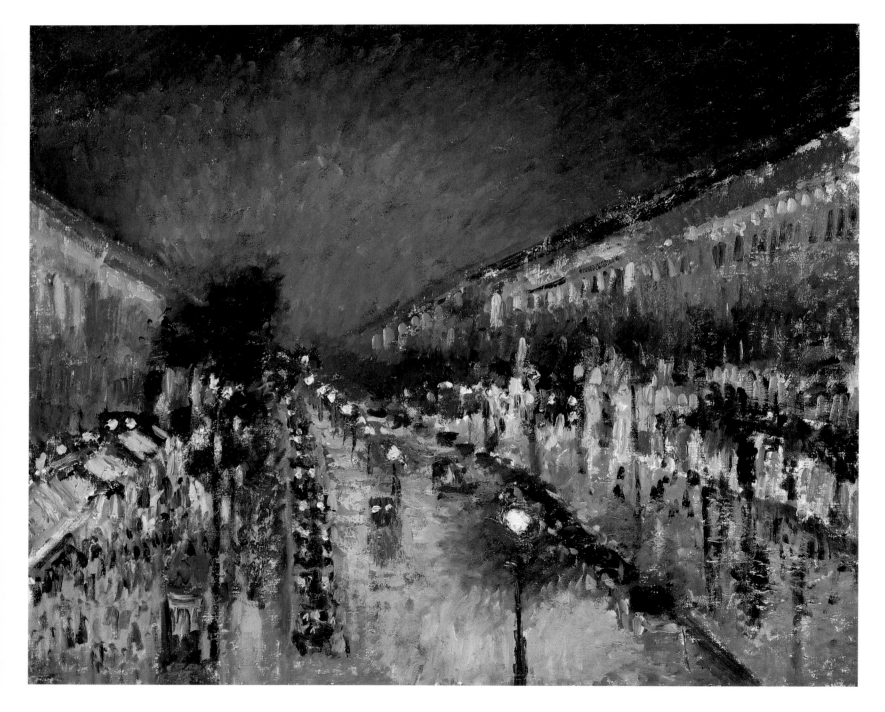

157 Gustave Caillebotte
View through a Balcony Grille, 1878–79
Oil on canvas, 65 x 54 cm
Private collection, courtesy Brame
and Lorenceau, Paris

Pissarro's old friend Gustave Caillebotte had died in 1894—his career, well known and well received in the 1870s, had already begun to suffer the beginnings of a long period of neglect. Caillebotte made two urban pictures in the late 1870s that might fairly be called Impressions. The most important and dramatic was *View through a Balcony Grille* of 1878–79 (fig. 157). This boldly painted and brilliantly composed work is one of the most original cityscapes of Paris by any Impressionist painter. Because it is unsigned,[6] it would be tempting to regard it as unfinished and to ascribe its apparent modernity to its preliminary nature. But it is very likely to have been the work submitted, unsigned, by Caillebotte to the fifth Impressionist exhibition of 1880, entitled *Vue prise à travers un balcon*. We know that Morisot, Cézanne, and possibly others exhibited unsigned works in the Impressionist exhibitions.

The work was painted in three planar stages—the background street view first, the balcony second, and highlights, including the plant at the lower right, third. Each

[6] The apparent signature at the lower left is a posthumous estate stamp.

158 Gustave Caillebotte
Rue Halévy, View from the Fifth Floor, 1878
Oil on canvas, 59.7 x 73.3 cm
Private collection

stage shows evidence that Caillebotte rethought every element of the composition with each campaign. The pinkish red lozenge in the pavement, for example, was extended in the second campaign. A good many elements in the background were reworked while he painted the iron grille, and perhaps again when he was applying other highlights in the third stage. Like many others in this study, it represents an Impression in three sittings, but Caillebotte strove to minimize the viewer's distraction and encourage a reading of the work as a direct, one-session painting.

Rue Halévy, View from the Fifth Floor (fig. 158), the only other contender for the 1880 exhibition submission, is also painted with a pictorial élan rare in his oeuvre. In both works, the artist used gesture and wet-on-wet passages to add a kind of visual drama to the urban scene. In the context of a Caillebotte retrospective both of these works would seem anomalous, but in the context of a study of Impressions, they are perfectly at home. How one wishes he had painted a few more!

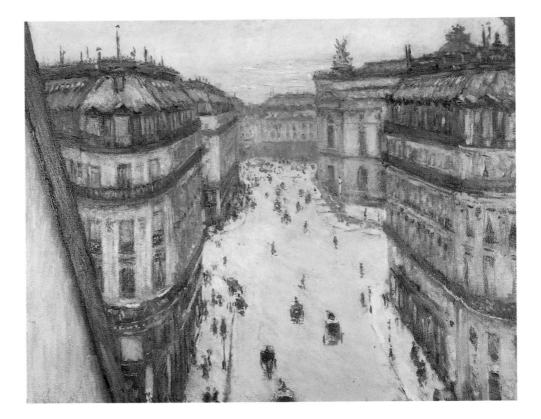

10 Coda: Was van Gogh an Impressionist?

The repudiation of Impressionism was pervasive among advanced artists throughout Europe at the end of the nineteenth century.[1] The Impressionists themselves, though never enthusiastic to abandon an increasingly commercially useful name, took pains to put some distance between themselves and their earlier interest in mere appearance. It is against this background that we present as a coda to this study a small group of paintings by Vincent van Gogh. When seen in the context of an exhibition of rapidly painted Impressions, van Gogh's paintings seem almost inevitable—they are an extension of an aesthetic, made at a time when it was already being rejected. By contrast, a wall of paintings by Cézanne, Seurat, or Gauguin—the three masters whose roots were in Impressionism—would look completely out of place.

Throughout his career, from his first oil paintings in 1882 to the very last made before his early death in 1890, van Gogh painted with a voluptuous love of materials and a gestural urgency that find their only true precedents in the painting of the Impressionists. While Cézanne, Seurat, and Gauguin tried, as it were, to slow painting down, to re-deliberate its discourses and processes, van Gogh speeded it up. Literally: few artists in European history produced as many paintings as rapidly as he did in the last five years of the 1880s. Van Gogh's oeuvre rivals in size that of longer-lived artists such as Caillebotte, Pissarro, Morisot, Cassatt, and Sisley, yet his entire production was made in less than a decade. If anyone painted quickly, it was Vincent van Gogh.

Why have we chosen van Gogh, and not other important painters of the late nineteenth and early twentieth centuries? An entire exhibition could be made of rapidly painted, gesturally positive pictures by John Singer Sargent, Anders Zorn, Giovanni Boldini, Mancini, Sorolla, Zuluaga, Repin, Serov, and others that would seem to derive naturally from the work of Manet, Monet, Renoir, Sisley, and Morisot. Fluent brushwork came to be associated with greatness in painting, an idea that must (it seems) have had its origins in the experiments that produced Impressionism. But is this actually true?

The answer is decidedly no. There is, in the end, a kind of brutality to Impressionism which is quite foreign to the production of Sargent, Boldini, or Zorn. In spite of superficial similarities, it is difficult for their works to be hung together. For the great men who made society portraits for the capitalist élite of the new economy, fluency of gesture and the ability to do quickly what others labored to produce was tantamount to brilliance. How far this is from the scribbles, flailing marks, blobs, and jabs of the Impression. It was ease, not awkwardness, that defined this new art of elegance; Robert Browning's poetic evocation of Andrea del Sarto sums up the distinction. According to this wonderfully damning poem, del Sarto was so good and so fluent that his work was empty of everything *but* eloquence.[2]

Of course, there are exceptions, Sargent's extraordinary landscape paintings of the early and mid-1880s have a tangled vitality that is anything but affable, and many of his late landscapes and genre scenes also court chaos. The same can be said for certain paintings by Serov and Levitan in Russia, and for the smaller genre paintings of Zorn. But for every exception, the rule of ease and elegance is strengthened. Even Roger Fry, who had become the keeper of an idea of modernism rooted in tradition, found Sargent's posthumous exhibition flimsy and thin. It is no accident, however, that all of

[1] Certain historians have referred to this phenomenon as "the crisis of Impressionism" or "the end of Impressionism"; see Joel Isaacson et al., *The Crisis of Impressionism, 1878–1882*, The University of Michigan, Ann Arbor, 1979.

[2] Robert Browning, "Andrea del Sarto," *Men and Women*, 1855.

159 Frans Hals
*Malle Babbe, c.*1640
Oil on canvas, 74.9 x 64.1 cm
Staatliche Museen zu Berlin–Preußischer
Kulturbesitz, Gemäldegalerie

160 Vincent van Gogh
Head of a Woman with her Hair Loose, 1885
Oil on canvas, 35 x 24 cm
Van Gogh Museum (Vincent van Gogh
Foundation), Amsterdam

[3] In some senses, the works of the Dutch artist van
Gogh form a kind of closing parenthesis to this
study, to balance the opening parenthesis of the
small group of mid-nineteenth-century French
paintings bought by the Dutch artist Mesdag in the
1870s and 1880s; see p. 50.

[4] Van Gogh had worked for a French gallery, Goupil,
as early as 1873.

these painters were immediately considered to be "great," were collected and shown by museums along with Old Master paintings, and thought of as exemplars of art rather than as rebels. When Sargent died in 1926, he was given immense retrospectives at the Tate Gallery, London, the Metropolitan Museum, New York, and the Museum of Fine Arts in Boston. When Monet died in the same year, the Museum of Fine Arts in Boston followed with a retrospective, but all the other memorial exhibitions—in New York, Paris, and Berlin—were held in commercial galleries. The Musée de l'Orangerie in Paris did not get around to mounting a Monet retrospective until 1931.

The painters who are the subject of this study were most often working beyond fluency; most of their boldest experiments were derided as awkward, inelegant, and, of course, unfinished when they were exhibited. They seem to have worked in the ways they did to challenge both the public and themselves into new ways of thinking about art and its mimetic functions. They were not being merely fluent, just as they were not, in the end, concerned with mere appearances. Perhaps the only exception to this rule is Edouard Manet, who courted an aesthetic of beautiful gestures and elegant construction which has its roots as much with Titian, Velazquez, Rubens, van Dyck, Hals, Fragonard, and Delacroix as it does in the experimental practice of the Impressionists. It was Manet's followers who made paintings that strain to hold together in the midst of a virtual chaos of gestures. For Monet, Sisley, Morisot, and Renoir, the beauty of the painted mark was not of primary importance. Rather, the urgency and sheer energy of its application were more important than elegance.

In the end, of the followers of the Impression, van Gogh alone created a body of paintings that extended rather than refined their sources.[3] *A Pair of Shoes* (fig. 161), made in 1885 or early in 1886 before he went to study art in Paris in March, has roots in its brutal brushwork and brown tonalities in the painting of Hals, Corot, Rousseau, and Daubigny, and it shows how familiar van Gogh had become with the tradition of gestural painting on the fringes of the academy.[4] He might even have made a trip to Brussels in 1873 to see Frans Hals's great *Malle Babbe* (fig. 159), which appeared in two exhibitions there in that year. Few other works in Hals's career would have struck van Gogh so forcefully. Van Gogh's early studies of the heads of peasants, made in an attempt at rural portraits, have clear debts to Hals: *Head of a Woman with her Hair Loose* (fig. 160) is almost unthinkable without the example of the earlier Dutch painter, particularly when one looks at the strongly linear brushstrokes.

Van Gogh had come quite late to oil painting, and a study of the origins of his career shows clearly the graphic nature of his art. Yet he learned quickly that it was possible to draw with paint as forcefully as with charcoal, pencil, or pen. The sheer materiality of oil paint, which van Gogh accepted eagerly in the summer of 1882, was as important to him as were the colors it allowed him to use. In a letter to his brother Theo that year, together with a drawing of his first palette, he informed him that he bought large tubes of paint (because they were cheaper than small ones!). The works from that summer show his willingness to use paint liberally and to stress its physicality and viscosity. *Haagse Bos with a Young Girl in a White Dress* (fig. 162) represents a landscape in which the ground beneath the trees seems almost to heave with life, while the sky is an invasion of thick strokes of light-colored paint descending over the darker trees. The body of the lone woman is rendered in directional blobs

161 Vincent van Gogh
A Pair of Shoes, 1885–86
Oil on canvas, 37.5 x 45 cm
Van Gogh Museum (Vincent van Gogh
Foundation), Amsterdam

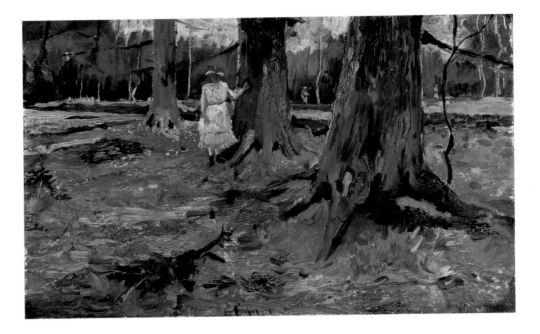

162 Vincent van Gogh
Haagse Bos with a Young Girl in a White Dress, 1882
Oil on canvas, 39 x 59 cm
Collection Kröller-Müller, Otterlo,
The Netherlands

163 Vincent van Gogh
Red Cabbages and Onions, 1887
Oil on canvas, 50 x 64.5 cm
Van Gogh Museum (Vincent van Gogh
Foundation), Amsterdam

thick enough almost to define her form in relief. Van Gogh loved paint as much as any artist of the nineteenth century. He arrived in Paris in March 1886 to spend almost two years living with his brother, drinking in the heady atmosphere of the city. As a painter, he was completely open to the most experimental works of Monet, Renoir, Pissarro, Sisley, and others, and from them he learned both chromatic and gestural lessons.

It is, perhaps, odd that this young foreigner breathed life into the kind of painting that the middle-aged Impressionists were then abandoning, disowning, and re-defining. Van Gogh created his own style, an extension of the Impression, at a time when the careers of Seurat and Gauguin were in the ascendant and in the full knowledge of these supremely cerebral, and slow, artists. We know of the startling contrast between the neat and orderly Gauguin and the impetuous and messy van Gogh when the two painters lived together in Arles late in 1888, but there is much earlier evidence of van Gogh's love of disorder and visual chaos, in his life as well as his work. This courting of messiness and disorder, which is at the very heart of the aesthetic of the Impression, was perfectly acceptable to Vincent van Gogh, perhaps even natural.

Few paintings in van Gogh's oeuvre were made slowly, and virtually any of his works would meet our criterion of rapid painting.[5] His modestly scaled *Portrait of a Woman in Blue* (fig. 164) has a nonlinear ease in the painted marks that indicates the young painter's transcendence of his seventeenth-century Dutch and realist French prototypes. The wonderfully fluent handling of the background and, particularly, of the model's hair has few prototypes in his earlier work, and shows that he looked at Impressionism both carefully and passionately. Even the informal and asymmetrical composition is comparatively daring, and suggests that van Gogh was beginning to look at the painting of Degas and Toulouse-Lautrec.

In the still life *Red Cabbages and Onions* of 1887 (fig. 163), the complementary colors of reddish purple and yellow that van Gogh had learned from Seurat were found in

164 Vincent van Gogh
Portrait of a Woman in Blue, 1886–87
Oil on canvas, 46 x 38.5 cm
Van Gogh Museum (Vincent van Gogh
Foundation), Amsterdam

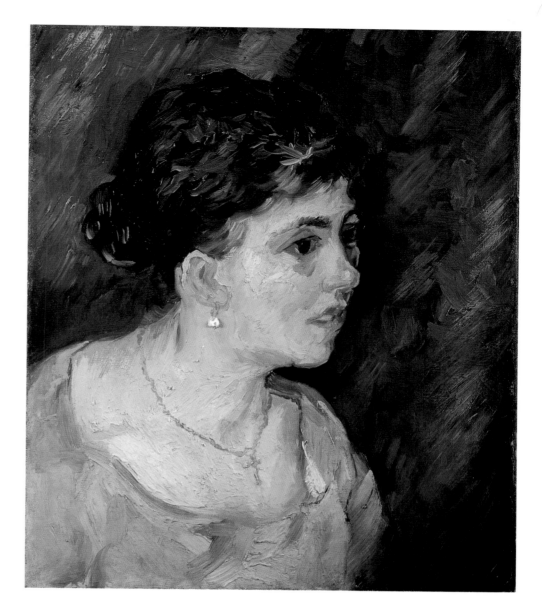

[5] Because he sold essentially nothing during his lifetime and exhibited very little, the same rules of selection that prevailed for the works by Manet, Monet, Morisot, and Renoir could not be applied to van Gogh. We have selected from the definitive collection of the Van Gogh Museum in Amsterdam, largely because its range is so wide that it can supply works from all periods of the artist's life.

nature as red cabbages and yellow onions. He splayed his market purchase on a table top, looked down upon it, and literally drew it with painted lines of violet, yellow, red, orange, and blue that form both solids and shadows with equally palpable marks. The gestures are insistently linear—short, chopped lines that are allowed only a slight curvature to represent the spherical forms of the vegetables. Perhaps in order to work with maximum efficiency, van Gogh segregated the red cabbages from the onions, allowing chromatic accents from one realm to invade the other, as neo-Impressionist color theory demanded. His touch in this work is both less varied and seemingly less spontaneous than in earlier still lifes, and there is considerable evidence that he struggled to create his own methodical variant on the dot or point of Seurat, Signac, and Pissarro. But aside from the fact that all of van Gogh's touches are linear, there is little else grammatical about them. They vary in length, width, direction, and degree

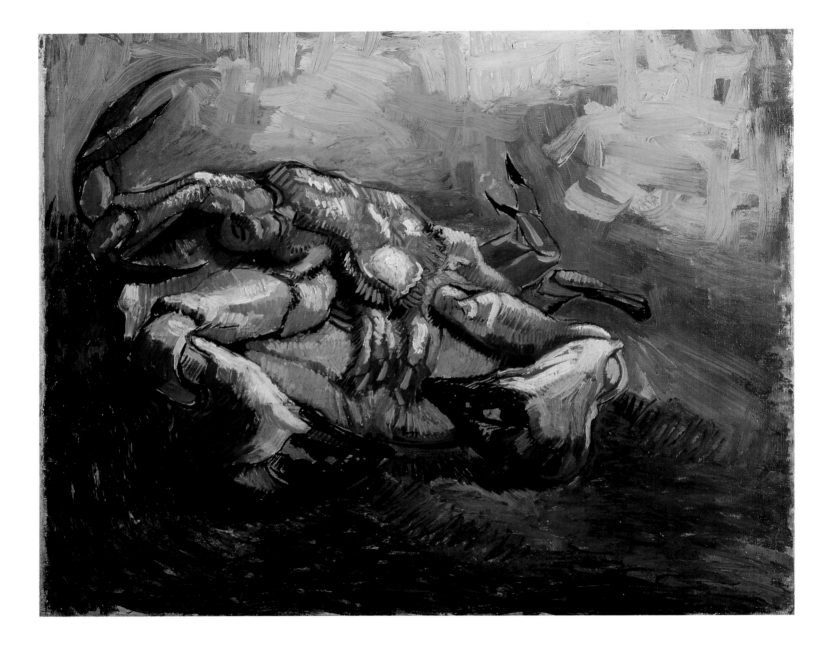

165 Vincent van Gogh
Crab on its Back, 1889
Oil on canvas, 38 x 46.5 cm
Van Gogh Museum (Vincent van Gogh
Foundation), Amsterdam

of curve to such an extent that they cannot in the end be called systematic. And the very fact that they are lines with a directional character links them to the act of making more insistently than to the acts of observation or transcription.

Among the more original work in our selected group is a still life, *Crab on its Back*, of 1889 (fig. 165). This work demonstrates clearly that van Gogh continued to draw with paint, constructing the body of the crab with lines of paint that mimic its geometrical armor. But, as with many artists discussed here, it was for the background that he reserved his boldest gestures. It is perhaps easy to see why an artist voluntarily incarcerated in an asylum might find visual poetry in the body of a crab, and also why he would contrast its hard and defensive form with the softer and freer passages of paint that surround it. The squiggles of dark green that emanate from its claws and

166 Vincent van Gogh
Seascape, 1888
Oil on canvas, 51 x 64 cm
Van Gogh Museum (Vincent van Gogh
Foundation), Amsterdam

the space-filling broad-brushed passages in the upper right corner contrast utterly with the confined drawing of the crab itself.

Van Gogh's famous Arles period is a virtual symphony of painted gestures—daubs, dots, thick lines, viscous and curved strokes. The experimental *Seascape* (fig. 166) vies for attention with similar subjects by Renoir, Morisot, and Monet. In it, van Gogh worked wet-on-wet for the water, paradoxically giving a seeming solidity to the waves by representing them with groups of parallel linear strokes given life by the addition of curved overstrokes. Van Gogh's hand—much more importantly than his eye—is the subject of this painting, and we are urged by the marks he made to imagine him in action, moving his hands with a restless energy as he eyes surveyed the sea. Van Gogh seems to have emphasized the haptic over the optic in his painting to such an extent that he reinvented the Impression, forcing it to become less a passive response to visual stimulus than a personal action prompted by the visual.

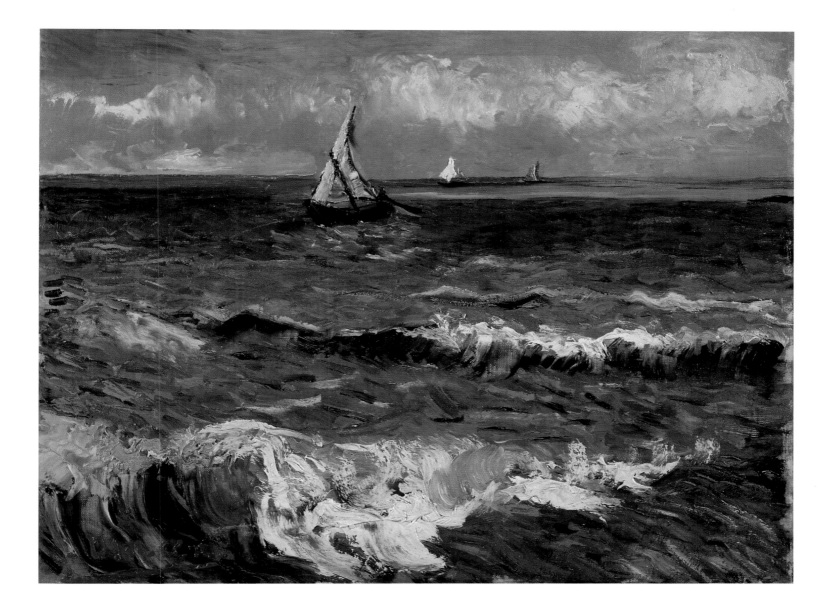

167 Vincent van Gogh
Trunks of Trees with Ivy, 1889
Oil on canvas, 47 x 64 cm
Van Gogh Museum (Vincent van Gogh
Foundation), Amsterdam

Two paintings made in St. Rémy, where he spent time in an asylum before his death in 1890, are among the most extraordinary. The earlier, *Trunks of Trees with Ivy* (fig. 167), is one of three closely related canvases painted outside the hospital, all of which are now in the collection of the Van Gogh Museum. In painting them, the artist recalled both the *sous bois* tradition of the Barbizon School and his own experiments with cropped trees painted in 1887. In making three versions of the composition, van Gogh permitted himself to rehearse his gestures so that they attained greater power through repetition (again, we are reminded of the French word for rehearsal, *répétition*). The daubs are both straight and curved—the latter both simple and complex, as his wrist twirled with thick pigment to define the contours of tree trunks and coiled ivy.

The later of the two St. Rémy paintings, *Entrance to a Quarry* (fig. 168), is simply stunning in its sheer gestural energy. Van Gogh avoided a horizon line, preferring to

168 Vincent van Gogh
Entrance to a Quarry, 1889
Oil on canvas, 60 x 73.5 cm
Van Gogh Museum (Vincent van Gogh
Foundation), Amsterdam

concentrate on the interplay of rocks and vegetation on a comparatively small rectangular surface. The painting is virtually a colored drawing, so fundamentally linear is its facture. The only precedent for such energy in the painted marks lies in the work of Monet, whose slightly earlier landscapes at Belle Ile share with this work a painterly power unusual in nineteenth-century art. It is safe to say that van Gogh rarely made a painting with greater graphic energy.

The latest of the works presented here was made in the final weeks of the painter's life in the great wheatfields of Vexin Français, which stretched in endless horizontal rhythms above the village of Auvers-sur-Oise. These same fields had been painted by Pissarro and Daubigny, and van Gogh was well aware of these precedents. Perhaps in response to them, he adopted a very long, panoramic format and represented the fields under a vast sky of a threateningly intense dark blue (see fig. 159). Both the

169 Vincent van Gogh
Wheatfield under Thundercloud, 1890
Oil on canvas, 50 x 100.5 cm
Van Gogh Museum (Vincent van Gogh
Foundation), Amsterdam

yellow of the distant fields and the blue of the sky seem almost to have been troweled onto the canvas. Van Gogh worked in the paint while it was still wet to add just enough chromatic and value diversity to give space and interest to the areas of pure color. Using both a very large and a medium-sized brush, he added thick white strokes to the sky while the blue underpaint was still wet. And he gave a broken rhythmic character to the foreground with small, separated strokes of paint that contrast with the long strokes of the wheat and the sky.

In contemplating this painting, we confront a work that could very well have been made in the kind of psychic and perceptual conditions defined earlier in the decade by Jules Laforgue (see Appendix, pp. 235–37). The artist worked so quickly and with such familiarity with his medium that his strokes verged on being automatic physical responses to optical stimulae. His confidence in making this Impression was supreme —indeed, unwavering—and, as he made it, all but one of the artists who had revolutionized art by developing the Impression were still alive.[6]

Van Gogh's almost extreme adherence to the aesthetic of the Impression gave his art a unique ability to engender other powerful vanguard forms of action painting. The art of the Fauves, particularly Derain and Vlaminck, is unthinkable without van Gogh, as is the extraordinary experimental painting of the German Expressionists. All of them reinvigorated the kind of rapid painting started so forcefully by the Impressionists in the last four decades of the nineteenth century. And the passage from van Gogh to Hans Hoffman is not so great as we might think—a powerful link can be observed between Impressionism and New York action painting from the second half of the twentieth century.

[6] Of the artists featured here, only Manet predeceased van Gogh. The others outlived him, Monet by more than 35 years.

APPENDIX
Laforgue's essay on Impressionism

Jules Laforgue (1860–1887), best known as a Symbolist poet, also served as art critic for the *Gazette des beaux-arts*. His writing on Impressionism incorporates the ideas of his close friend Charles Henry (1859–1926), an eclectic French scientist and philosopher who wrote treatises on the science of aesthetics, the aesthetics of music, and color theory. The following essay was composed on the occasion of a small show of French Impressionism held at the Gurlitt Gallery in Berlin during October 1883. It was translated by Susan Barrow from *Mélanges posthumes* (Paris, 1903), a posthumous anthology of the poet's works.

IMPRESSIONIST ART

The physiological origin of Impressionism. The prejudice of drawing. It is agreed that if the pictorial work springs from the brain, from the soul, it does so exclusively by means of the eye, and that in art the eye plays a role identical to that of the ear in music. The Impressionist is a modernist painter gifted with an exceptionally sensitive eye who has succeeded in re-adjusting this eye to a natural vision, in order to see naturally and to paint what is in front of him without artifice. The Impressionist painter accomplishes this by forgetting all the paintings stockpiled in museums over the centuries and the curriculum of optical education (drawing, perspective, and coloration), and by abandoning precise forty-five-degree studio lighting, to live and to see in an honest and unfettered fashion amidst the luminous spectacle of the plein air in the streets, the countryside, or in interior settings. I shall explain:

Besides the twin illusions of art endlessly chewed over by aesthetic theorists, whether Absolute Beauty or the Absolute of Human Taste, the technicians of painting have sworn by three undying illusions: drawing, perspective, and studio lighting. Corresponding to these three second natures by virtue of habit are the three evolutions which constitute the Impressionist formula. In Impressionism, forms are obtained not by contour drawing but solely by means of vibrations and contrasts of color. Theoretical perspective is replaced by the natural perspective of the vibrations and contrasts of colors. The consistency of studio lighting and the convenience of working in the studio at any hour are replaced by working outside the studio *en plein air*. The painting, whether it depicts the street, the countryside, or an interior such as an illuminated salon, is to be accomplished in front of its subject in the briefest amount of time possible, even at the risk of impracticality, taking into consideration the rapid variation in the lighting of objects. We shall review how these three points, these procedures of a dead language known as drawing, perspective, and studio lighting, can be undone as in a schoolboy's exercise and replaced by the sole resource of the play of light—Life itself.

Drawing is an old and ingrained prejudice whose origins are to be found in the earliest experiences of human sensation. In its most primitive state, the eye could only discern pure white light and totally undifferentiated shadow; consequently, unaided in its task by the resource of distinguishing coloration, the eye was assisted by tactile sensation. Therefore, by this habitual association of cooperative effort, and later, through the hereditary modification acquired between the faculties of the tactile organs and the visual organs, the apprehension of form evolved from the fingers to the eye itself. As the eye in its primitively developed state was not the primary source of the final definition of form, and as the eye through practice and refinement had opted to facilitate its experience with the conception of clean outlines, hence arose the childish illusion of the translation of three-dimensional living reality by means of contour drawing and applied perspective.

Essentially, the eye should only know luminous vibrations, just as the acoustical nerve knows only vibrations of sound. This is because the eye, having begun by the appropriation, refinement, and systematization of the tactile faculties, has since developed and instructed itself while maintaining its illusion through centuries of drawings. As a result, the eye's evolution as an organ of luminous vibrations has been retarded relative to the development of the ear, for example, and remains a rudimentary intelligence regarding color. While the ear in general easily analyses harmonics, like an auditory prism, the eye sees synthetically and essentially only light and has only vague powers to break it down into the spectacles of nature, in spite of the three small retinal fibers or fibrils named by Young, which compose the facets of the optical prism. Therefore a natural eye (actually a refined one, since this organ, before progressing, must return to its origins by eliminating tactile illusions), is an eye that abandons tactile illusion and its facile dead language, the contour drawing, and acts only in accordance with its faculty of prismatic sensitivity. The natural eye succeeds in seeing reality within the living atmosphere of forms, differentiated, refracted, reflected by beings and objects in constant variation. Such is the first characteristic of the Impressionist eye.

The academic eye and the Impressionist eye. Polyphony of color. In a landscape bathed in light in which living beings are modeled like colored monochromes, the academic sees only white light in its pure state, covering the entire scene. Instead of perceiving this scene bathed in a deathly whiteness, the Impressionist sees a multitude of vibrant oppositions, a breakdown of a wealth of prismatic tones. Where the academic sees only the exterior outline enclosing the form, the Impressionist sees actual living lines without geometric form constructed by a thousand irregular brushstrokes establishing life [viewed] from a distance. Where the academic sees elements being placed within their respective, regular planes according to a formula reduced to pure theoretical drawing, the

Impressionist sees perspective established by a thousand strokes of tiny gradations of tone, by the variety of states of the atmosphere which are constantly in motion. The Impressionist eye is in short the most advanced eye in human evolution, the one that has succeeded in grasping and rendering the most complicated combination of nuances known.

The Impressionist sees and renders Nature such as it is, that is, solely in terms of colored vibrations. Putting aside the childish classifications of drawing, light, form, perspective, and shading, all of Nature can be reduced to colored vibrations and must be obtained on canvas strictly in terms of colored vibrations.

In the small and selective show at Gurlitt's [gallery], this formula is especially evident in the Monet . . . and the Pissarro . . . where the effect is obtained by a thousand small brushstrokes dancing in all directions like colored straws, in a lively competition for the impression of the ensemble. No longer an isolated melody, the entire work is a symphony of life in its spontaneity and variety, like the "Voices of the Forest" in Wagner's theories, in lively competition for the "Great Voice of the Forest," just as the Unconscious, the Law of the Universe, is the great melodious voice resulting from the Symphony of the Consciousness of diverse peoples and individuals. Such is the principle of the school of plein-air Impressionism; the eye of the master will be that which will discern and render the gradations, the most sensitive breakdown of tones, all on a simple flat canvas. This principle has been applied, not systematically but with genius, by certain French poets and novelists.

False education of the eye. As is well known, we do not see the colors of the artist's color scheme or palette in themselves, but first of all according to the light transmitted to us by the palette, influenced by the illusions corresponding to the education we have received from centuries of painting. (Make a photometric comparison between Turner's most dazzling sun and the flame of the most humble candle.) What may be termed an automatic perception of innate harmonic agreement is established between the visual sensation of the landscape and the sensation of the resources of color spread across the palette. This is the proportional language of the painter, which he enriches proportionally to the richness of the development of his optical sensitivity. The same holds true for height and perspective. Dare I state that in this manner the palette of the painter is to real light and its play of color on reflective and refractive surfaces what perspective on a flat canvas is to the depth and to the actual planes of reality in space? These two conventions are the painter's resources.

Mobility of the landscape and mobility of the painter's impressions. Art critics, you who codify Beauty and guide Art, let us take as an example a painter who has just set up his easel in front of a landscape with fairly stable light, as exists in the afternoon. Suppose that instead of painting the landscape in a few sessions, the artist has the good sense to establish the life of its tones in *fifteen minutes*; in other words, he is an Impressionist. The painter arrives at this spot with his own special optical sensitivity. At this hour, depending on the stressful or energy-conserving states that he has experienced up to then, this sensitivity will be either at its height or in a resting state. This is not the sensitivity of a sole organ [the eye], but the three sensitivities in lively competition of the three retinal fibrils described by Young. In these fifteen minutes the lighting of the landscape has varied infinitely: the living sky, the terrain, the greenery . . . all amidst the immaterial web of the rich atmosphere, with the life of its incessantly undulating, reflecting, or refractive invisible particles. In a word, the landscape has lived.

In these fifteen minutes the optical sensitivity of the painter has been subject to ceaseless variation; it has lost the continuity of its appreciation of the proportional consistency of the relativity of the interacting tones of the landscape. Imponderable fusion of tones, opposing perceptions, small distractions, variations in the power of reaction of the three tiny retinal fibrils with outside reality: infinite and infinitesimal struggles.

Just one example out of millions: I see a certain violet and lower my eyes toward the palette to mix it, and the eye is involuntarily attracted to the whiteness of the shirt-sleeve. My eye has changed and my violet will reveal the consequences . . . (etc.)

In this manner it may be concluded that despite these brief fifteen minutes in front of a landscape, the painting will never be the equivalent of fleeting reality. Instead, the work is a summing up of a certain unique optical sensitivity existing at a moment that will never be repeated identically for the individual artist, under the stimulus of a landscape at a precise interval of its luminous life, which will never again exist in a state identical to this very instant.

Note the three main stages of the physical state of the painter's eye before a landscape: the increasing acuity of optical sensitivity under the stimulus of a novel view, the summit of acuity, followed by a decrease in sensitivity due to fatigue of the nerves.

Add to this the infinitely variable atmosphere of the best gallery where the picture will be displayed, and the life of the minute, ongoing existence of the tones of the painting ceaselessly working against one another. And finally, each viewer brings to the work an individual sensitivity made up of an infinity of unique moments of sensitivity.

The subject and the object are therefore forever in motion, undefined and indefinable. It is the sparks of identity between subject and object which are the mark of genius. The attempt to codify these bursts of energy is a pointless scholarly exercise.

Double illusion of Absolute Beauty and Absolute Man. Innumerable human instruments. Old-fashioned aesthetics has prattled on alternatively on the subject of two illusions: Absolute, Objective Beauty, and the Subjective Taste of Absolute Man.

Today we have a more exact idea of life within and outside of ourselves.

According to criteria of race, milieu, social condition, and the timing of his stage of individual evolution, each man is an instrument or keyboard upon which the exterior world plays in a certain fashion. My instrument is perpetually changing and there is none identical to mine. All instruments have their legitimacy.

In the same way, the exterior world is a perpetually changing symphony. (According to Fechner's Law, the perception of differences decreases in inverse proportion to their intensities).

The optical arts are the domain of the eye and only of the eye.

There exist no two pairs of eyes identical as organs or faculties.

All of our organs are in perpetual competition: in the painter the eye dominates; for the musician, the ear; for the metaphysician another faculty, etc.

The eye most worthy of admiration is that which has gone furthest in the evolution of that organ, and consequently the most admirable painting will be the one which will reveal this eye by the refinement of its nuances or the complexity of its lines, rather than painting representing the pipe dreams of various schools: "Hellenic Beauty," "Venetian Color," "Cornelius's Thought," etc.

The circumstances most favorable to the freedom of this evolution are the suppression of schools, juries, and medals, the childish accessories of government patronage and the parasitism of witless art critics. On the other hand, nihilist dilettantism and the anarchic open-mindedness of the majority of French artists to all influences encourage today's laissez-faire attitude of "Let each artist be free to do as he pleases." From above, overlooking humanity, the Law follows its fixed path and the Unconscious whispers it suggestions where it will.

Definition of plein-air. The notion of plein-air painting was a formula that was applied first and foremost by the landscapists of the Barbizon School (a village near Fontainebleau). Yet this is not its meaning. The plein-air of the Impressionist landscapists is a fundamental principle informing the entirety of their work. It signifies the painting of living beings and objects within their own specific atmospheres: landscapes, candlelit salons or modest interiors, city streets, the backstage of theaters lit by gaslight, factories, indoor markets, hospitals, etc.

Explanation for the apparent exaggerations of the Impressionists. The ordinary eye of the public and the non-artist critic is brought up to see reality in terms of the established harmonies laid down by the crowd of mediocre painters. This eye is overruled by the sensitive eye of the [Impressionist] artist more attuned to variations in luminosity. This artist, noting in a natural way the nuances and the relationship of these rare, unexpected, and unknown nuances on canvas, will arouse the protest of the blind against what they perceive as calculated eccentricity. One might even explain this apparent "incoherence" as an eye which may be naturally, even voluntarily, aggravated in the haste of working with impressions noted in the rush of sensory exhilaration before a reality selected for its unusual qualities and unpredictability. Compared to reality, the language of the palette constitutes a conventional language capable of being enriched by new "seasonings." Is the Impressionist approach not more artistic, more alive, and consequently more promising for the future than the sad and staid recipes of academic coloration?

Agenda for painters of the future. The group of painters who are the most alive, the most sincere, and the most audacious yet to appear (they exist in virtual poverty, treated with either indifference or snide comments), in cooperation with the voice of a certain minority sector of journalists, demand that the State cease to concern itself with art. The School of Rome (The Villa Médicis) should be sold, the Institute closed; let there be no more medals or other honors; let the artist live amidst the anarchy that is life; in other words, each according to his own resources, neither annihilated nor blocked by the weight of academic teachings rooted in the past. No more official designation of beauty; on its own the public will learn to see independently, and it will be attracted to the painters who create interest in a modern style, not Greek or Renaissance. Let there be no more official Salons or medals than those available to writers of literature. Just as novelists and poets write independently and seek to have their books displayed in the shop windows of publishing houses, so painters will follow their own path and will seek to have their works shown by art dealers. This will be their Salon.

The frame in relation to the work of art. The exhibitions of the Independents have replaced the traditional gilt frame with moldings, stock-in-trade of the Academy, with an intelligent and refined variety of artist-designed frames. A sunny green landscape, a blonde winter scene, a sparkling interior of chandeliers and formal attire: all require different frames which only their individual painters would know how to create, just as a woman alone knows how to select the shade of fabric, the makeup, and the intimate setting that will enhance her particular complexion, expression, and personality. We have seen frames that are plain, others in shades of white, pale pink, green, and jonquil-yellow, with some outrageously daubed in a thousand tones in as many ways. The effect of this fashion in framing has been felt in the official Salon, but so far it has only resulted in various novelties in the bourgeois taste. . . .

Bibliographical essay

The twentieth-century literature devoted to Impressionism is vast enough to require a book-length study of its own. Not only did the movement spawn hundreds of books and memoirs by men and women who were friends and close followers of the artists, but critical literature, distant from the production of the paintings, has flowed without end from the initial reviews of the eight Impressionist exhibitions to the present day. The early critical literature has become the bedrock of Impressionist studies; major scholars such as John Rewald, Robert L. Herbert, and T. J. Clark have made extensive use of this material. Yet until 1996 it was accessible only through selected quotations scattered throughout the secondary literature. In that year, The Fine Arts Museums of San Francisco published a nearly definitive and magisterial two-volume compilation, edited by Ruth Berson, which is essential to any scholarly library of the history of modern art and which will revolutionize Impressionist studies. *The New Painting, 1874–1886: Documentation* consists of a massive volume, *Volume I. Reviews*, which includes the majority of the contemporary reviews of the eight group exhibitions in their original languages. Although canonical reviews by Louis-Emile-Edmond Duranty, Stephane Mallarmé, Joris-Karl Huysmans, and Felix Fénéon, to name only the most famous, have long been known, the nuggets of brilliance in reviews by lesser and anonymous writers have made it possible to explore the full range of meanings ascribed to the works when they were first exhibited. This volume is joined by *Volume II. Exhibited Works*, which features short entries and small black-and-white reproductions of the works identified by modern scholars as having been included in the eight exhibitions. Although the second volume is a necessary complement to the first, it is much more problematic. With fewer than half of the works positively identified and others included for questionable reasons, it cannot be used with the same ease and confidence as the volume of criticism, and must be considered a "work in progress."

For readers who want access to the best material in print, several recent books are of real quality. James H. Rubin's *Impressionism* (Phaidon, London, 1999) is the best—jargon-free, full of insight, and very handsomely designed. It also contains an up-to-date bibliography of the scholarship in English (although the type is so small and printed in such a pale gray that it is difficult to read). Because Rubin's book is organized thematically and by artist, it is read most productively in conjunction with *The New Painting, 1874–1886*, a detailed study of each of the eight exhibitions compiled and co-authored by Charles S. Moffett and Ruth Berson (The Fine Arts Museums of San Francisco, 1986). These, when joined with John Rewald's war-horse *The History of Impressionism* (London and New York, 4th revised edition, 1973), make a perfect summary library of scholarship on the Impressionist movement.

Most of the greatest advances in Impressionist studies have been made in an area that might be called the "iconography" of the paintings. Here, works are treated as representations of modernity and their subjects are analysed in considerable detail. The masters of this mode of analysis are T. J. Clark, *The Painting of Modern Life: Paris in the Art of Manet and his Followers* (London and New York, 1985), and Robert L. Herbert, *Impressionism: Art, Leisure, and Parisian Society* (Yale University Press, New Haven and London, 1988). These books can be read in conjunction with the studies of Impressionist landscape geography by Paul Hayes Tucker, *Monet at Argenteuil*, and Richard R. Brettell, *Pissarro and Pontoise: The Painter in a Landscape* (both Yale University Press, New Haven and London, 1982 and 1990). For a more general study of landscape geography involving the work of all the Impressionists, see Richard R. Brettell et al., *A Day in the Country: Impressionism and the French Landscape* (Los Angeles, 1984). Numerous other studies of urban iconography in the work of Degas, Morisot, and others are largely summarized in Francis Francina et al., *Modernity and Modernism: French Painting in the 19th Century* (Yale University Press, New Haven and London, 1993).

The present study involves itself with another branch of Impressionist scholarship—that stemming from museum conservation departments, and the close physical examination of works by art historians. This technical history of Impressionist painting has made giant strides in recent decades, and the best writing associated with it has enabled the general public to become more directly engaged with the works of art. The most accessible is David Bomberg et al., *Art in the Making: Impressionism* (exhibition catalogue, The National Gallery, London, 1990). I have also responded to many complex observations of paintings by scholars including Anthea Callen, *Techniques of the Impressionists* (London, 1982); Robert L. Herbert's innovative article "Method and Meaning in Monet" in the journal *Art in America* (September 1979), and John House, *Monet: Nature into Art* (Yale University Press, New Haven and London, 1986), particularly the chapters on open-air painting and studio work.

The notes for each chapter in this book are largely confined to essential and accessible sources, which deal in greater detail with the careers of individual artists.

Checklist of exhibited paintings

Jean Baptiste Camille Corot
(French, 1796–1875)

Well among the Dunes, c.1854 (fig. 26) A, W
The Marsh at Arleux, 1871 L

Charles François Daubigny
(French, 1817–1878)

The Banks of the Oise, 1872 (fig. 25) A, W
April Moon (La Lune Rousse), 1875 (fig. 27) A, W

Honoré Daumier (French, 1808–1879)

An Artist, c.1870–75 (fig. 1) L, A, W

Hilaire-Germain-Edgar Degas
(French, 1834–1917)

Portrait of Madame de Nittis, 1862–82 (fig. 146)
 L, A, W
Ballet Dancer with Arms Crossed, c.1872
 (fig. 147) L, A, W
Woman Viewed from Behind, c.1879 (fig. 149) W
Visit to a Museum, 1879–80 (fig. 148) L, A, W

Vincent van Gogh (Dutch, 1853–1890)

A Pair of Shoes, 1885–86 (fig. 161) L, A, W
Portrait of a Woman in Blue, 1886–87 (fig. 164)
 L, A, W
Seascape, 1888 (fig. 166) L, A, W
Crab on its Back, 1889 (fig. 165) L, A, W
Trunks of Trees with Ivy, 1889 (fig. 167) L, A, W
Entrance to a Quarry, 1889 (fig. 168) L, A, W

Edouard Manet (French, 1832–1883)

Copy after Delacroix's "Barque of Dante," c.1854
 (fig. 14) L, A, W
Study for "The Surprised Nymph," 1860 (fig. 13)
 L, A
The Races at Longchamps, 1866 (fig. 37) L, A, W
The Funeral, 1870 (fig. 38) L, A, W
Snow Effect in Petit-Montrouge, 1870 (fig. 42)
 L, A
Marine View in Holland, 1872 (fig. 43) A, W
Grand Canal, Venice, 1875 (fig. 47) L, A, W

Before the Mirror, 1876 (fig. 48) W
Woman Reading, 1878–79 (fig. 58) L, A, W
Georges Clemenceau, 1879–80 (fig. 57) L
Sketch for "The Bar at the Folies-Bergère," 1881
 (fig. 55) L, A, W
Moss Roses in a Vase, 1882 (fig. 59) W

Claude Monet (French, 1840–1926)

Towing a Boat, Honfleur, 1864 (fig. 60) L, A, W
Bazille and Camille, 1865 (fig. 62) L, A, W
Jean Monet Sleeping, 1867 (fig. 67) L, A
The Sea at Le Havre, 1868 (fig. 65) L, A, W
Bathers at La Grenouillère, 1869 (fig. 70) L, W
Red Mullets, c.1870 (fig. 68) L, A, W
Camille on the Beach at Trouville, 1870 (fig. 73) L
The Beach at Trouville, 1870 (fig. 74) L, A, W
Windmill near Zaandam, 1871 (fig. 75) L, A, W
The Seine at Petit-Gennevilliers, 1872 (fig. 76)
 L, A, W
Regatta at Argenteuil, 1872 (fig. 77) L, A, W
A Festival at Argenteuil, 1872 (fig. 82) L, A, W
La Gare d'Argenteuil, 1872 (fig. 85) L, A, W
Harbor at Le Havre at Night, 1873 (fig. 78) L
La Gare St. Lazare, 1877 (fig. 87) L, A, W
The Seine at Lavacourt, 1879 (fig. 91) L, A, W
Marine near Etretat, 1882 (fig. 94) L, A, W
Portrait of Père Paul, 1882 (fig. 96) L, A, W
The Seine at Port-Villez (A Gust of Wind), 1883
 (fig. 99) L, A, W
A Stormy Sea, c.1884 (fig. 95) W
Cap Martin, near Menton, 1884 (fig. 97) L, A, W
Poplars on the Epte, 1891 (fig. 98) L, A, W

Berthe Morisot (French, 1841–1895)

The Jetty, 1875 (fig. 101) L, A, W
Hanging the Laundry out to Dry, 1875 (fig. 102)
 L, A, W
West Cowes, Isle of Wight, 1875 (fig. 105)
 L, A, W
Marine in England, 1875 (fig. 106) L, A, W
Le Corsage Noir, 1878 (fig. 128) L, A
Summer's Day, c.1879 (fig. 118) L, A, W
Boats on the Seine, 1880 (fig. 119) L, A, W
Child among the Hollyhocks, 1881 (fig. 120)
 L, A, W
*The Artist's Daughter Julie, with her Nanny
 (The Sewing Lesson),* 1885 (fig. 121) W
White Flowers in a Bowl, 1885 (fig. 125) L, A, W
Interior of a Cottage, 1886 (fig. 122) A, W

Camille Pissarro (French, 1830–1903)

Dulwich College, London, 1871 (fig. 150) L
After the Rain, Quay at Pontoise, 1876 (fig. 153)
 L, A, W
Study of a Sunset, Pontoise, 1877 (fig. 154)
 L, A, W
The Boulevard Montmartre at Night, 1897
 (fig. 156) L, A, W

Pierre Auguste Renoir (French, 1841–1919)

La Grenouillère, 1869 (fig. 100) L
Head of a Dog, 1870 (fig. 115) L, A, W
Madame Monet and her Son, 1874 (fig. 108) A, W
Self-Portrait, c.1875 (fig. 107) L, A, W
The Grand Boulevards, 1875 (fig. 111) L, A, W
Sketch for "Ball at the Moulin de la Galette," 1875
 (fig. 112) L, A, W
By the Fireplace, 1876 (fig. 113) L, A, W
Roses in a Vase, 1876 (fig. 124) L, A, W
A Gust of Wind, c.1878 (fig. 109) L, A, W
At the Milliner's, 1878 (fig. 114) L, A, W
Little Blue Nude, c.1878–79 (fig. 117) L, A, W
Road at Wargemont, 1879 (fig. 126) L, A, W
The Dreamer, 1879 (fig. 127) L, A, W
Piazza San Marco, Venice, 1881 (fig. 129) L
The Wave, 1882 (fig. 131) L
Sunset at Sea, c.1883 (fig. 130) L, A, W

Théodore Rousseau (French, 1812–1867)

The Crooked Tree by the Carrefour de l'Epine,
 1852 (fig. 28) A, W

Alfred Sisley (French, 1839–1899)

A Turn in the Road, 1873 (fig. 133) L, A, W
Factory in a Flood, 1873 (fig. 134) L, A, W
The Watering Place at Marly-le-Roi, probably
 1875 (fig. 136) L, A, W
The Fourteenth of July at Marly-le-Roi, 1875
 (fig. 137) L, A, W
Flood at Port Marly, 1876, oil on canvas, 50 x
 61 cm, Carmen Thyssen-Bornemisza
 Collection L, A
Boats on the Seine, c.1877 (fig. 139) L, A, W
The Bridge at Sèvres, 1877 (fig. 141) L, A, W
The Seine at Billancourt, 1877–78 (fig. 138)
 L, A, W
The Seine at Daybreak, 1878 (fig. 140) L, A
*The By Road at the Roches-Courtaut Woods; St.
 Martin's Summer,* 1881 (fig. 142) L, A, W

Index